SUZANNE LACY

SUZANNE
spaces between
LACY

Sharon Irish

University of Minnesota Press
Minneapolis
London

The University of Minnesota Press gratefully acknowledges the financial assistance provided for the publication of this book from the Creative Research Award of the University of Illinois at Urbana–Champaign College of Fine and Applied Arts.

Portions of chapter 4 were previously published as "Shadows in the Garden: 'The Dark Madonna' Project by Suzanne Lacy," *Landscape Journal* 26.1 (2007): 98–115; reprinted courtesy of the University of Wisconsin Press.

Published by the University of Minnesota Press
111 Third Avenue South, Suite 290
Minneapolis, MN 55401-2520
http://www.upress.umn.edu

Library of Congress Cataloging-in-Publication Data

Irish, Sharon, 1952–
 Suzanne Lacy : spaces between / Sharon Irish.
 p. cm.
 Includes bibliographical references and index.
 ISBN 978-0-8166-6095-7 (hc : alk. paper) — ISBN 978-0-8166-6096-4
(pbk. : alk. paper)
 1. Lacy, Suzanne—Criticism and interpretation. I. Lacy, Suzanne. II. Title.
 III. Title: Spaces between.
 N6537.L26A4 2009
 709.2—dc22

 2009010470

Printed in the United States of America on acid-free paper

The University of Minnesota is an equal-opportunity educator and employer.

17 16 15 14 13 12 11 10 10 9 8 7 6 5 4 3 2 1

for Reed

CONTENTS

ILLUSTRATIONS

PREFACE AND ACKNOWLEDGMENTS

ON A CLOUDY SPRING DAY IN 2008, I am sitting in a second-story office on campus, breathing, tired, a little bit hungry, stiff from yesterday's activities, and always impatient to get on with the next task. I want to extend my hand to you and feel your touch.[1] Instead I am touching a keyboard in my lap and imagining future readers, where and how you might be sitting, who you might be. These hypothetical relationships are in my head, and it is difficult to acknowledge my body in relation to yours as I sit here, alone. Words are between those of you who have picked up this book and me. But these sentences are also bridges between us, representing ideas and potential connections. It is likely that many of you will only glance at my words and turn to the illustrations. Those pictures, too, can serve as bridges between us, even though the actions they depict are immobilized on the page. Just as my ideas are more or less represented by words, Suzanne Lacy's art is represented between these covers by still images, some in color, most in shades of gray.

This gesture toward relationships among us, this acknowledgment of the gaps between us, this calling on art to receive a response, in words, or handshakes, or shared food, are what occur at exhibit openings, artists' talks, and in catalog entries. But conversations about art also take place at kitchen tables, on park benches, in parades, and while driving. Depending on the conversationalists, the vocabularies used to talk about art in a parade may be in sharp contrast to those in an art catalog. Nevertheless, I hope to strike a balance between the imaginary kitchen table and the art history classroom or museum space. The latter needs the balance offered by a kitchen table exchange: informal, even intimate, and with an urgency emerging out of common concerns.[2] I hope to explore with you the ways in which Suzanne Lacy's work pushes us to move beyond traditional art spaces and conversations.

My interest in Suzanne Lacy's art has been sustained on a number of levels—physical, emotional, and intellectual. First is the affirmation in her work that the body harbors wisdom that each of us can tap. Dancer Yvonne Rainer put this truth firmly: "[T]he body speaks no matter how you try to suppress it."[3] Second, both in art and in life, individuals acting in concert can, at times, have significant impacts on public policies that nurture the common good. Third, Lacy's uses of spatial strategies to question power relationships have shaped her projects but also informed us about urban and architectural spaces. Fourth and last, obvious throughout much of art's histories, art in many forms provides not only solace and pleasure but also a not-quite-life space for gaining useful perspectives on violence, conflict, and pain. At a slight remove from the very real anguish and destruction of "actual" life, that distance is one tool that allows for confrontation while at the same time buffering some of the heat generated by real-life emotional distress. That space between life and lifelike art promises the opportunity to heal and to change. As performance scholar Peggy Phelan noted, "It is in the attempt to walk (and live) on the rackety bridge between self and other—and not the attempt to arrive at one side or the other—that we discover real hope."[4] Lacy's embodied work has been poised between difference and commonality on Phelan's rackety bridge.

I first met Suzanne Lacy in 1992 after corresponding with her the previous year, and I was marginally involved with her *Full Circle* project in 1993 in Chicago. I began researching her work in earnest in 2000. Since then I have traveled repeatedly to three states (California, Minnesota, and New York) to archives related to her work and visited the sites of many of her performances, as well as interviewed her and more than fifty people who have collaborated with her.

I am an inveterate reader of authors' prefaces because I am always eager to learn about the process behind the book. That process is usually evident in the thanks offered to all those who helped support and shape the book. This book has been quite a journey (is any book not?), and with pleasure I name the amazing people who walked alongside me, often multiple times.

Beginning any new project is a bit unnerving, so I began where I was most comfortable: in Minnesota, where I had lived for seven years (1963–71) with my birth family. My husband, Reed Larson, had a sabbatical from the University of Illinois in 1991–92, and our family moved into a rental house next door to my father, Don Irish, in St. Paul. I had learned of Lacy's work the previous year at the Women's Caucus for Art conference in New York City. The Gulf War (also known as Operation Desert Storm, January–February 1991) had spurred me to find ways to better integrate my activist life with my scholarly life. Thus, during that year in St. Paul, I began to investigate Lacy's *Whisper Minnesota* project, an approach to art making and political

organizing that seemed to offer ways to animate scholarship with social justice concerns.

My first interview was with Nancy Dennis, who had been administrator of *Whisper Minnesota*. Meeting her in her office at the downtown Minneapolis YWCA and learning of a number of family friends who had participated in *The Crystal Quilt* performance (Avis Foley, Grace Gibas, Bea Swanson) set me off on the right foot. Keeping with the walking metaphor, though, it took quite a while for my left foot to swing forward, because I veered off, as I am wont to do. I spent the next five years writing a book on the architect Cass Gilbert.

The next phase of my Lacy inquiry began in a most unlikely place. Another sabbatical year found us living in and traveling around the Indian subcontinent. I was visiting McLeod Ganj in northern India, the home of the Tibetan government-in-exile, in spring 1999, and I had the unbelievable good fortune to meet Stacy Raye and Heather Mitchell, two dynamic, smart, fun-loving, and supportive women who live in Oakland, California. In so many ways—from welcoming my son into their fantastic Monkey Business summer camp in the hills above Oakland to introducing us to fabulous food in the Bay Area, from helping to keep my panic (somewhat) under control as I drove the California freeways to setting us up as house sitters in Berkeley for two consecutive summers—Heather and Stacy smoothed my path in researching this book.

Unfortunately I returned from India with severe chronic back pain and giardia, both of which slowed my progress considerably. The giardia, while stubborn, did finally leave, but the back pain contorted me into a desperate student of my own body. During that time (1999–2002), I met two very important teachers: Sharon DeCelle, a physical therapist in Urbana, well versed in qigong, yoga, Feldenkrais, and Alexander techniques, and Jan Alden, a friend of one of my sisters in Oakland and Lacy's chiropractor. After three years the pain did abate, meanwhile teaching me to attend to my body in ways that I had never imagined. Finally, in 2002, I could focus on this book. Because of my back, this is a different book; I became more receptive to Lacy's own embodied work.

I have organized my thanks geographically, but many of my engagements have continued by phone or e-mail. I am so grateful to the feedback from anonymous readers for the University of Minnesota Press, one of whom read the manuscript twice. In cyberspace, I thank the following people who responded so promptly to my queries: Kelly Sumiko Akashi; Marilyn Brakhage; Ann Butler, director of Library and Archives, Center for Curatorial Studies at Bard College; Krista Coulson of the University of Wisconsin Press; Amina Dickerson; Robert Haller, director of Collections and Special Projects, Anthology Film Archives, New York, New York; and Catrina Neiman. Everyone else I mention I have met in person, sometimes

only briefly. Whether a handshake followed by conversation, a presentation, a walk, or an interview, all contributed to my multisensory understanding.

In Chicago: Kathleen and Dan Cummings; Mary Jane Jacob; Ward Miller, executive director, Richard Nickel Committee; the staff at the Video Data Bank; John Vinci; Faith Wilding.

In Kentucky: Nina Aragon; Tim Belcher; Susan Leibovitz Steinman (visiting from Berkeley).

In Los Angeles: Jerri Allyn; Anne Bray; Meiling Cheng; Cheri Gaulke; Jennie Klein (guest speaker, as well as a reader of my penultimate manuscript); Laurel Klick; Leslie Labowitz-Starus; Sue Maberry; Susan Mogul; May Sun; Linda Vallejo; Willow Young.

In Minnesota: Sharon Roe Anderson at the Humphrey Institute for Public Affairs at the University of Minnesota; Barb Bezat at the Northwest Architectural Archives at the University of Minnesota in Minneapolis; Nancy Dennis; Susan Doerr, Mary Keirstead, Pieter Martin, Rachel Moeller, Richard Morrison, Daniel Ochsner, Andrea Rondoni, and Kristian Tvedten at the University of Minnesota Press; the staff of the Minneapolis College of Art and Design Library.

In New York: Pamela Hepburn; Susan Leonard, former librarian, Center for Curatorial Studies at Bard College.

In Berkeley, Oakland, and San Francisco: Jan Alden; Jacques Bronson; Martha and Anthony Brown; Celeste Connor; Amana Harris; Unique Holland; Grant Kester (guest speaker); Yutaka Kobayashi; Heather Mitchell; Stacy Raye; Moira Roth; Flo Oy Wong.

In Seattle: Dean Dresser (visiting from New York); Pilar Riaño-Alcalá (visiting from Vancouver); Sharon Siskin (visiting from San Francisco); Carol and Rob Wilson.

In Urbana/Champaign, starting with institutions: the UIUC Center on Democracy in a Multiracial Society (CDMS); the Illinois Program for Research in the Humanities (IPRH); the University of Illinois Libraries; the UIUC Research Board; the Schools of Architecture and Art and Design; the Creative Research Fund of the UIUC College of Fine and Applied Arts; the Community Informatics Initiative, its codirectors Ann Bishop and Caroline Haythornthwaite, and the Graduate School of Library and Information Science.

Reading groups at the University of Illinois, Urbana–Champaign, and their committed participants have been invaluable to my thinking. Thanks to members of the Arts and Humanities in Civic Life group (Kate Brown, Betsy Delacruz, Norman Denzin, Pradeep Dhillon, Lisa Fay, Jeff Glassman, Laurie Hogin, Sarah Kanouse, Pattsi Petrie, Sheila Radford-Hill [guest speaker], Julian Rappaport, Emily Talen, Dawson Weber, Valeri Werpetinski, Desiree Yomtoob); IPRH Fellows group on cities (Michael Bérubé, Bill Maxwell, Bob Ousterhout, Edward Soja [guest speaker], Mark Steinberg); members of

the Critical Studies of Whiteness group (Alison Bailey, Pem Davidson Buck [guest speaker], Jorge Chapa, Kevin Dolan, Tim Engles, Dianne Harris, Suk Ja Kang, Brian Locke, Erin Murphy, Perzavia Praylow, David Roediger, Beth Simpson, Lisa Spanierman, Maurice Stevens, Thandeka [guest speaker], Carmen Thompson, Nathan Todd); members of the Performance Studies Working Group (Laurie Newcomb, Maurice Stevens, Melissa Tombro, Julia Walker, Brian Walsh, Yutian Wong, Gillen Wood); members of the Critical Spatial Practices group (Nicholas Brown, Ryan Griffis, Kevin Hamilton, Sarah Kanouse, M. Simon Levin [guest speaker], Laurie Long [guest speaker], Jane Rendell [guest speaker], Sarah Ross).

Many of my colleagues and friends overlap circles, as is often the case in small towns like Urbana. For making central Illinois an amazing place, thanks to Paul Adams, Jennifer Allen, Kathy Anthony, Conrad Bakker, Susan Becker, Brett Bloom, Marilyn Booth (now in Edinburgh), Nicholas Brown, Ruth Nicole Brown, Robert Cagle, anna callahan (now in Seattle), Chris Catanzarite, Bette Chapman, Copenhaver Cumpston, Amira Davis, Linda Duke (now in Indianapolis), Bonnie Fortune, Rayvon Fouché, Rebecca Ginsburg, Arlene Goldbard (guest speaker), Kevin Hamilton, Martin Holland, Ryan Griffis, Dianne Harris, David Hays, Jim Holiman, Carol Inskeep, John Jennings, Eric O. Johnson, Jan Kalmar, Sarah Kanouse (now in Iowa), Lucy Lippard (guest speaker), Kristin LoDolce, Shelley Masar, Walter Matherly, Ashlee McLaughlin, Vera Mitchell, Jennifer Monson, Lisa Nakamura, Bea Nettles, Angel David Nieves (visiting from Hamilton College), Safiya Umoja Noble, Will Patterson, Andy Pickering (now in Essex), Susan Rodgers, Sarah Ross, D. Fairchild Ruggles, Ken Salo, Christian Sandvig, Amita Sinha, Sam Smith, Carol Spindel, Sharra Vostral, Deke Weaver, Martin Wolske, Philip Yenawine (visiting scholar), and the staff of Caffé Paradiso.

In Vancouver: Barb Clausen, Susan Gordon, Joslin Kobylka, Joyce Rosario, Alix Sales.

In Virginia: Roann Barris.

Beyond geography, my family has provided emotional sustenance and enduring love, physical distraction and frequent laughter. I am blessed with the presence in my life of Reed, Miriam, and Renner Larson; Don, Gail, Gemma, and Terry Irish; Jean, Mark, and Curt Larson; Mark Berven; Steve Budas; and Mary Kennedy. My mother, Betty Osborn Irish (1920–1985), was strong in body and spirit, ever supportive of my explorations.

Without Suzanne Lacy there would have been no scaffold to support my peripatetic wanderings. She has been patient, generous, fun, and challenging every step of the way. She deserves far more thanks than a few sentences, thus the chapters that follow. Those chapters, of course, are my responsibility, but I hope that respectful critique and deep engagement with some of the issues that she has addressed demonstrate my gratitude for her open door and heartfelt work.

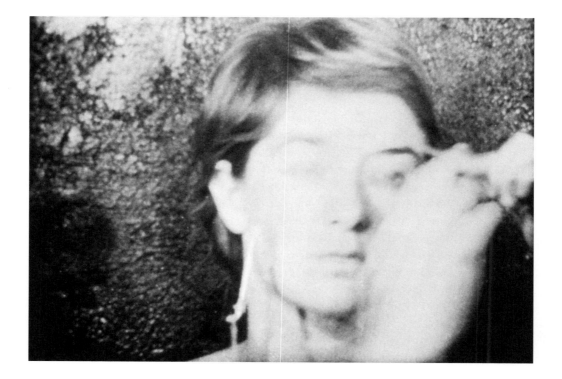

INTRODUCTION

POSITIONALITY, PERFORMANCE, AND PARTICIPATION

IN A 1975 PERFORMANCE TITLED *Under My Skin: A True Life Story*, artist Suzanne Lacy peeled off her "face" (Figure 1). Having applied white glue to her skin, she then pulled it off after it dried, transparent against her own white skin.[1] This self-flaying image evokes Lacy's urgent need to remove the barriers between herself and her surroundings, to climb out of her skin, to look under her skin, for deep truths. Congruent with her desire to erase boundaries was a frustration at the very impossibility of doing so. In a series of performances in the mid-1970s, including *Under My Skin*, Lacy expressed her thwarted efforts by slamming her body into walls (Figure 11). That none of us can really leave our skin compels us to connect to others or remain confined to our narrow, limited positions. Lacy's connections, and attempted connections, in her life and her art have been at once profoundly personal and political, grounded in everyday individual experiences of oppression yet linked to structures of power that shape lives. These "spaces between" self and other, art and life, and the body and urban physical structures in Lacy's work provide the focus for this book.[2]

A key figure in the West Coast art and feminist circles of the 1970s and since then active internationally, Lacy began making art in Southern California during a time when challenges to existing norms, categories, and assumptions were especially intense. To convey these seismic shifts artistically, Lacy chose to use her body and to collaborate with other bodies to animate her concerns and questions during a time when identity politics both defined groups and wrenched them apart. Using compelling visual imagery, Lacy engaged people in interactions about violence against women, roles and perceptions of women, the status and engagement of young people, and public health, at times penetrating macroscale social

Figure 1. Suzanne Lacy, film still from *Under My Skin: A True-Life Story*, The Annual, San Francisco Art Institute, 1975, and Institute of Contemporary Art, Chicago, 1977. Courtesy of the artist.

1

policies. Her multimedia approaches to visual art—which she labeled "new genre public art" in 1989—have expanded the methods of creating art, multiplied the venues for displaying art, and included more people in the creative process.[3]

Lacy's art has ranged from videos and set-up photography to collages, from installations to performances, from theatrical characterizations to conceptual maps, from research events like potluck dinners to street marches, from hiding out in her studio to large-scale, durational organizing projects. This variety indicates her ceaseless experimentation and challenges her critics and audiences both in labeling her art and in knowing what to expect with each new work. But in most cases, social relationships and their visual forms have been principal factors in Lacy's creations. Physical objects often serve as catalysts to bring people together, but the aesthetic impact also exists in establishing relationships among the participants and the setting.

By the late 1970s, Lacy was creating "performance structures" that allowed others to join, communicating with her, each other, and the art project.[4] Groups of women performed together or in sequence using forms and content that had been mutually developed. In building these structures, Lacy adapted approaches from experimental cinema, civic pageants, and political theater, conflating popular culture and "fine art" in her large-scale projects. Thus Lacy's own embodied work joined the body politic.

Art historian Jonathan Harris noted that a "genuine, critical inquiry insists on examining precisely the relations between 'social' and 'artistic' without collapsing or conflating these categories and the things to which these terms refer."[5] I understand this to mean that a rigorous inquiry into social and artistic dimensions may foster a dynamic interchange that at once deepens our understanding of social structures, informs an analysis of relationships among artist(s), artistic production, and observer(s), and avoids glossing over power differentials in the social realm. The conflation of "relations between 'social' and 'artistic'" has led critics to ignore or dismiss political art because of the significant challenges of balancing the two realms. Artists who insert their art making into the public sphere point to dislocations in our lives that often prevent or discourage creative responses to seemingly intractable social problems. And by dislocating their art—leaving museums and galleries, for example—artists receive more passionate critiques of who, what, and how they represent and embody provocative concerns.

For Suzanne Lacy to have a career as an artist, to support herself in the art world, and to learn from those whose experiences were quite different from hers required assertive, energetic, often single-minded application to see her projects to completion. To be an artist in the United States, and particularly a female artist, even a white one, requires a dedication and passion that continually centers *the work,* however it is evolving, even if the artist

is simultaneously examining her own location(s). To create her art in line with her vision, Lacy has made substantial sacrifices in terms of opportunities, income, and fame. Since the mid-1980s, she has worked full-time as an arts administrator, producing her projects in the spaces between her job and life maintenance. To finance her work, she has raised funds from foundations and corporations, receiving little in the way of remuneration for her art projects. While she has remained a committed daughter and sister and has bonded deeply with several young people, she is a single woman creating ways to survive well on her own.

This introduction offers some frameworks that I have used in my analyses of Lacy's work in the context of contemporary art and life in the United States in the late twentieth century. After summarizing some of the labels that have been applied to Lacy's work, I then explain the network model that I have adopted to help assess Lacy's process-oriented art. Then I elaborate on three *P*'s: positionality, performance, and participation. I look at positionality in terms of feminism, essentialism, and embodied art. I examine performative aspects of identity that offer alternatives to entrenched social behaviors, and how coalition building fosters collaborations across difference. I also consider the importance of place in Lacy's performances. Finally I discuss the varieties of participation in Lacy's art. Each of these nodes or clusters of ideas comes up again in the chapters that follow because they contribute to my understanding of Lacy's art.

Lacy's art has been labeled body art, conceptual art, performance art, feminist art, political art, and new genre public art. The proliferation of descriptions makes evident the deep and messy efforts to come to terms with this art by those of us who investigate it. Sociologist Stephan Fuchs commented on what happens when people try to make sense of artistic border crossings: "[S]uch switching of contexts and networks will require elaborate theorizing and commentary, especially when a piece of art-in-the-making has had a long tenure outside of art, or keeps that tenure afterward as well, so that it now has multiple statuses and identities."[6]

Lacy's commitment is linked to an earlier, modernist "desire to speak as a collective voice . . . of some unfulfilled or underfulfilled universal human potential," as Blake Stimson and Gregory Sholette described it.[7] Her work then has often been a bridge between past collective actions and current ones.[8] While Lacy claims authorship of particular works, "community-based art" describes some of her large-scale art projects in which she took a specifically community development approach.[9]

Her multisensory, embodied art relates as well to conceptual and body art. In her work, Lacy questions the art object, challenging prioritization of the visual and exploring the artwork in relation to site, distribution, and audience, questions also posed by conceptual art.[10] Body art, as Amelia Jones defined it in her eponymous book, challenges modernist assumptions about

mind/body duality using performative strategies, an approach that Lacy shares. This art is often explicitly sexual as well as overt in addressing other particularities, such as race, class, and gender.[11] Feminist body art further critiques the ways in which women's bodies have been defined and represented, but it also runs the hazard of being subsumed by the very definitions and representations it critiques.[12]

Lacy's work has often appeared in major compilations about art related to feminism, such as *The Power of Feminist Art* (1994) and *Art and Feminism* (2001), to name just two.[13] Assuredly, feminism in its many variations has been crucial to Lacy's development. In a 1990 interview, Lacy concisely defined feminist: "'Feminist' mean[s] a politicized version of a woman's sensibility, and politics [is] the evaluation of power and the attempt to distribute power equally, to reassess the nature of power."[14] As artist Mary Kelly has argued, however, the term *feminist art* implies too cohesive an approach, and thus, with Kelly, I am inclined to use the phrase, "informed by feminism," when discussing Lacy's art.[15]

Not gender specific like "feminist art," political art is still concerned with power relationships or, more narrowly, with commenting on a topic of current social concern. Both feminist art and political art often were dismissed by art critics as being driven by content and not of notable aesthetic value or interest. Recent criticism has recognized that the interplay between aesthetic form and social content is subtle, complex, and worthy of close examination.[16] Other labels for "political art" include activist art, art of engagement, socially engaged art, and protest art. Lacy is also known as a social interventionist artist.[17]

Lacy has often been called a performance artist, based on her earliest solo and collaborative works and the large-scale tableaux that have become her best-known works.[18] Performance art, also known as live art, is a hybrid art form that takes place in real time with real bodies in front of a live audience.[19] Lacy's work remains on the edges of theater, performativity, and documentation.[20] Often the documentation of her performances, in video, still photographs, or instructions, is as well known as the performances themselves. I write about her work, when applicable, as "performance art."

I prefer Lacy's own term *new genre public art* because it captures her commitment to insert art into the public arena, using whatever genres best serve her aesthetic and political goals, *and* it is a flexible phrase that allows what is "new" to change over time. In her 1995 edited volume *Mapping the Terrain,* Lacy wrote that new genre public art was "visual art that uses both traditional and nontraditional media to communicate and interact with a broad and diversified audience about issues directly relevant to their lives. . . ."[21]

Other critics have suggested dialogical art, littoral art, relational aesthetics, conversational art, and dialogue-based public art to capture the en-

counters and interchange in contemporary artistic practices. I discuss more of these terms in the section on participation.

A Network of Nodes

Lacy's interest in contingency and relationships has been manifested in her extensive work with the form and content of networks. Her early small-scale performances as well as her large productions beginning in the late 1970s have guided me toward a network scheme, which might be graphically represented as a three-dimensional diagram with a work of art at its center.[22] Arrayed around that central artwork, at different distances in time and/or space, at different scales, and *in motion,* are nodes; sometimes those represent points of view, for example, or material conditions. It is challenging enough writing about the range of responses to a painting on a wall—those of the painter, his or her studio assistants, the suppliers of materials, the subject(s) of the artwork, the critics, the art dealers, the art institutions, the historians, the novice viewers. When the art involves hundreds of people over months or years, however, and the subject matter is current and controversial, the mental diagram can become a jumble of ideas bumping crazily against each other and ricocheting off at different angles. A jumble is difficult to unwind. Some sort of structure is necessary to keep things straight. My structured approach feels (and is) misleading, because so much is left out and even that which is discussed as static is in fact *always moving.* The still nature of the pages between the covers of a book requires that you the reader help to animate the ideas and images here.

I have chosen a network of nodes as a way to represent the complex interactions of creation, responses, and further creation that particularly characterize Lacy's art. In 1986, philosopher Michel Foucault noted that "[w]e are in the epoch of simultaneity: we are in the epoch of juxtaposition, the epoch of the near and far, of the side-by-side, of the dispersed. We are at a moment, I believe, when our experience of the world is less that of a long life developing through time than that of a network that connects points and intersects with its own skein."[23] This schematic network allows me to move among nodes, to elaborate on different aspects of a project. The nodes in my artificial network are not necessarily equivalent. I want to move across scales, sometimes considering the point of view of the artist, sometimes the points of view of a group, an institution, or an ideology. I have done my best to indicate these nodal shifts with headings and subheadings.

While each of the nodes—feminism or racialization, for example—are distinct, with their own histories and vocabularies, a crucial aspect is that they are connected to each other and to other nodes. These connections are not fixed, or even agreed upon! Certainly many white feminists were unwilling to confront their own racism, and there are continuing debates

about the extent to which that is true. Still, one of Lacy's most significant contributions is making art in the *spaces between* changing feminisms and critical studies of whiteness, for example, between the nodes of interrelated ideas and people. If working "in between" is almost canonical in U.S. contemporary art now, I believe that Lacy's practice contributed early and important examples of how artists might use liminality.

Stephan Fuchs noted in 2001: "[N]otions of systems and networks . . . start with the assumption that everything could be otherwise or different from what it is, and that what things are depends on the other things to which they are connected."[24] For my purposes, this dynamic network model supports a variety of viewpoints (nodes) and their interrelationships. As Fuchs stressed, the nodes are defined by "the other things to which they are connected," not by essences.[25] Who makes the connections and which ones they make alter the network. The artist is a *key* participant in the network, drawing distinctions along with all the others.[26] Note my stress on "key": I do not mean to diminish the agency of an artist such as Lacy. Still, she is within the network of nodes, many of which exist whether she connects them via an art project or not, whether she recognizes them or not. The same is true for me: I cannot observe networks from the outside.

Moving between nodes takes time and effort. The various points in the network cannot be engaged with simultaneously.[27] This, then, is the challenge: to include various views, including Lacy's. To manage this complexity, I have limited my discussion to just a few, but significant, aspects of Lacy's work. Admittedly, limiting the discussion this way is reductive, but otherwise the writing gets bogged down with numerous qualifiers. I write well aware of the ongoing and very real individual and systemic abuses based on unqualified, reductive characteristics such as race, gender, class, and other markers.

The few nodes that I consider here exist in an interrelated network. Related to *positionality*, I discuss feminisms and essentialism. Under *performance*, I examine whiteliness, place, and coalition building. In the last section, *participation*, I look at different labels for and problems of that act in an art context.

Positionality

Interactions of bodies over time and in space provide the substance for much of Lacy's art. Increasingly sophisticated analyses of gender, race, and class since Lacy began her career contribute now to a fuller understanding of her work. When an artist chooses human relationships as her subject matter, her own identities, the identities of those involved in her projects, and those of the observers, myself included, become key aspects in assessment. *Identity* itself is a slippery term because each of us has multiple social locations. In an excellent article on the politics of location, social scientist Julie Bettie quoted Stuart Hall, who wrote in 1989: "'Cultural identities come

from somewhere, have histories,' even as they 'undergo constant transformation.' Cultural identity is 'not an essence, but a *positioning.*'"[28] The cluster of characteristics with which each of us starts life—some genetic, some cultural—is *essentially* who we are at a point in time and place. Our social location is a starting point, *not* who we are becoming.

Feminisms

Over the course of her career, Lacy changed her focus and expanded the themes she considered in her art, but the analyses of feminism have been basic to her approach. If feminism involves challenging dispositions of power, by extension art informed by feminism uses visual forms to engage with and question those power arrangements. The ways in which this can happen are richly varied. Ruth Wallen in 2001 enumerated some aspects of feminist art: the telling of and support for women's experiences; the honoring of women's work/crafts; the use of collaboration; an appeal to a large audience of women; and activism, the effort to motivate a process or new way of thinking that extends beyond the work itself.[29] All of these factors were significant in Lacy's work.

Just as Lacy's art has changed over time, so too have feminisms. It helps to recall some conditions for U.S. women in the early 1970s (which still persist to some degree): violence against women was not recognized as an international human rights issue; marital rape was legal; there were few domestic violence shelters; and hard-core pornography increasingly appeared in mainstream media contexts.[30] Most banks denied women credit and accounts in their own names; loans required a husband's or father's signature; mortgage companies often refused assistance to women to purchase real estate; women were regularly denied sexual health care and reproductive control; some women were forcibly sterilized, others could not get abortions; emergency shelters were for men only; and there were few athletic options in public parks or schools.[31] The legal term *sexual harassment* did not exist; jobs were advertised separately for men and women.[32]

Sara Evans's influential book *Personal Politics: The Roots of Women's Liberation in the Civil Rights Movement and the New Left* (1979) rather uncritically argued "that strong black women were the models for feminism that young white women took back with them into the other movements of the 1960s and that became the basis of the youthful, radical women's movement."[33] As Wini Breines pointed out, however, while activism by women of color *was* influential for white women, black and Chicana feminists faced "different contexts and conditions." When white women claimed their situations were similar to that of blacks, for instance, the differences were all the more glaring to those who confronted racist practices and attitudes.[34] Additionally, though white women perhaps felt inspired by "strong black women," many did little to address the racism that black women were

battling and imposed "strength" on black women to boot. Too slowly, but eventually, most white feminists came to understand that cognizance of the intersections of racialization, sexuality, and class with gender was essential to collaboration among women. I will return to intersectionality in the section below on "whiteliness," but let me stress here how segregated people in the United States were in the early 1970s: when some white feminists claimed their experiences were similar to those of black women, they often spoke in the abstract, because they had had very few experiences with those who were racialized differently.

These divisions in the social arena had repercussions in the cultural sector, of course. Cultural feminism, a label sometimes applied to Lacy, valued what was seen as female wisdom in matriarchy and feminine survival skills. But cultural feminism also was used to describe art related to goddesses and myths about earth and nature, approaches that held little interest for Lacy.[35] The women's culture that Lacy wanted to cultivate had a spiritual aspect to it, to be sure, but not in terms of goddess worship or representations that fused female bodies with nature imagery. Rather, the embodied female spirit had political agency. In a 1984 interview with critic Lucy Lippard, Lacy queried, "Isn't that . . . one of the major themes of the women's movement—to express a particular female experience as *part* of a universal consciousness? . . . The experience of love that can be evoked when people consciously come into communion with each other—particularly when they are an oppressed group. It's a heightened spiritual experience. . . ."[36] Contained within this question is Lacy's commitment to witnessing the diversity of women's experiences—"people consciously com[ing] into communion with each other"—as well as the recognition that the sharing of women's experiences in intentional relationships can have spiritual and political power. Contemporary art scholar Jennie Klein wrote of her own realization that cultural feminism, at least as Lacy and like-minded others practiced it, also resisted the status quo: "Far from derailing activist art, feminist spirituality made it possible."[37]

Another approach, by socialist feminists, stressed the imbrication of patriarchy and capitalism.[38] Socialist feminists distanced themselves from "liberal" feminists, claiming that equality for women could not be accomplished within an unequal society. In the political arena, "liberal" women organized around labor issues such as equal pay for similar work, and increased representation by women in government bodies.

Lacy's work has long supported feminist alternatives to the mainstream. Rituals in her art were inspired by daily or routine actions rather than religious rites. Her artistic structures provided support for diverse representations and expressions, whether cultural, liberal, socialist, or other designations. In the early 1970s, however, distinctions among feminisms were embryonic and not clearly demarcated. As Lacy remarked, "We all

knew each other."[39] Curator Maura Reilly, in her introduction to the catalog *Global Feminisms: New Directions in Contemporary Art,* offered a number of labels to describe the shifts in emphasis over the years, including "transnational feminisms, relational multicultural feminism, . . . and scripts of relational positionality."[40] Phrases like these underscore the connections among positionalities and performance.

Essentialism

Essentialism is the belief that there is a core, an "essence," common to all who are identified, in this case, as women.[41] Lacy's interest in and love for women have been labeled essentialist. Negatively labeling Lacy's work as essentialist, however, undercuts her importance and also ignores the positive aspects of essentialism. Art critic Grant Kester noted that "it is possible to define oneself through solidarity with others while at the same time recognizing the contingent nature of this identification."[42]

In Lacy's relational art, positions shift and essences are challenged.[43] While we may place ourselves in relation to a particular group identity, this relationship is likely to change. Further, perceptions of what was essential about a woman's identity in the 1970s shifted in the 1980s, and continue to do so. Lacy has pointed out that in the 1970s, she and others thought in negative terms about "constructed" identities because they viewed female sexuality, for example, as being determined by sexist media. Actual female bodies, on the other hand, were essential to cultural transformation because they enabled women to recenter themselves on their own needs and desires.[44]

Essentialism as I conceive it is linked to positionality. Chandra Talpede Mohanty noted that one begins from a "location as I have *inherited* it" and the "self-conscious, strategic location as I *choose* it now," either of which could be seen as essentialist positions.[45] Thus, it is a political strategy on my part (and I think Lacy's as well) to focus on positionality(ies), because becoming aware of one's own location(s) in relation to others may lead to challenge and change.[46]

As Bettie noted, "It is difficult at times not to see the radical decentering and displacement practiced in some poststructuralist and deconstructionist enterprises as a process of absorption and co-optation. While this problem is not necessarily *inherent* in antiessentialist discourse, it can easily be put into practice in this fashion."[47] I reject celebrating bodies and ideas because they are primarily perceived of or represented as female or male at the same time I support strategically using the category of "gender" to explore alternatives for social organization and economic transformation.[48]

Performance

Because her female body was the means she often chose to communicate her ideas—and often not in an art gallery but rather on a street or in a car—

Lacy performed as a woman and as an artist in public. In this way, then, body, art, feminism, and performance are interrelated. Rebecca Schneider, in her book *The Explicit Body in Performance,* noted that women artists beginning especially in the 1960s fused their gender and their art for political impact; they "incorporated and emphasized the explicit body of the female *artist* in the art work."[49] So the position of the artist—as a white, working-class woman, say—exists in relation to her art as a performer and activist in public.

Feminists developed multidisciplinary performance art in several important ways, in part because so many women explored the possibilities of the genre.[50] In a history of the Los Angeles Woman's Building, Terry Wolverton identified the following contributions by feminists: developing alternative characters, using self-revelatory texts that emerged from consciousness-raising groups as well as from contemporary women's literature, focusing on spirituality and ritual, and creating performances that were also planned as media events.[51] Of course, none of these contributions was isolated from history. Alternative characters, for example, include Rrose Sélavy, Marcel Duchamp's persona, as early as 1920.[52] Like Happenings before them, performances in public places often attracted media attention.[53] Lacy's collaborations with Leslie Labowitz, however, did not just *attract* media attention, but their performances were *designed* with news media in mind, as interventions in popular culture and as insertions of mass media techniques into the arts.[54]

Whiteliness

In addition to gender, the majority of Lacy's works have addressed class and race in some respect, particularly by including participants from many sectors of society. Lacy has long been attentive to those outside the (shifting) mainstream in terms of class, sexual orientation, race, and gender. She has struggled to create contexts for discussions about difficult topics like racism that citizens who identify as white generally prefer to avoid.[55] (People not identified as white cannot avoid racism.) In bringing people together, Lacy has addressed social and economic injustices and challenged herself through her activism and art.

The work of philosopher Alison Bailey has been crucial to my analyses of the racial dimensions in Lacy's work. Bailey linked racism not only to physical differences but also to behaviors. These performative qualities are important to keep in mind while discussing Lacy's embodied art because many of her pieces focus on gesture, posture, and conversation. The nodes of racialization, performance, and gender, then, are intertwined in the networks that I am using to discuss Lacy's art.

We expect particular "performances, attitudes, and behaviors" from particular people, Bailey asserted; our expectations then sometimes reinforce

oppressive rankings. Further, many of us habitually follow "scripts" associated with our racial group (and class). Bodily gestures and movements accompany these scripts when we relate to "persons who we think of as being unlike ourselves."[56] While Rebecca Schneider noted "[t]he raging '90s impulse to herald identity as performative rather than fixed, natural, essential, or foundational," the performative aspects of identity (even if they were all the rage) offer possibilities for movement away from damaging orthodoxies. I agree with Schneider, though, that we "must at all times acknowledge . . . that certain markings of identity bear the historical weight of privilege and others the historical weight of disprivilege."[57]

Bailey used philosopher Marilyn Frye's term *whiteliness* to describe a cluster of behaviors, attitudes, and values that we who are white are trained in, "a deeply ingrained way of being in the world."[58] In other words, we learn "whitely" behavior: having white skin, however, does not require that we perform in a "whitely" manner, any more than having a penis requires "masculine" behavior. Bailey then argues that by focusing on "whitely" performance, we underscore the process in which we can choose to move away from or toward "whiteliness" (for example). Congruent with Bailey's ideas about behavior are those of Richard Shusterman, who, in explaining "somaesthetics" has written about the "body's crucial role in the creation and appreciation of art." "Much ethnic and racial hostility," Shusterman pointed out, "is not the product of logical thought but of deep prejudices that are somatically marked in terms of vague, uncomfortable feelings and thus are engrained beneath the level of explicit consciousness."[59] Thus performance may help expose these engrained attitudes, sparking awareness through movement.

The majority of artists, including women artists, are not social activists. When I wrote in an earlier draft of this book that "women artists classified as white in the 1970s were hindered by their obliviousness to their own racialization," Lacy reminded me that few white female artists were even interested in, much less hindered by, social injustices except those that were impediments to their own careers.[60] Few white-identified artists were linked to movements for black and Latino/a civil rights, even though those movements were fundamental to white feminism. Since white feminism at least gave lip service to gaining power for marginalized groups, this neglect was especially damaging. While in no way excusing "whitely" behavior, I want to acknowledge that moving away from whiteness is difficult, painful, and endless in U.S. society, which is structured around white supremacy, colonialism, and patriarchy.

While subtle, Lacy's working-class scripts and gestures have intersected with whiteliness; she identified with racial oppression in ways that many middle-class women did not, yet she was also surrounded by white culture.[61] Class-coded verbal and nonverbal language further complicated

collaborations across difference. Lacy has strengthened and refined her abilities to interrupt "whitely" and classist scripts and gestures as she and her collaborators, as activists and artists, have shifted among realities, centering different bodies and representations.

Place

Another way that Schneider's "historical weight" of privilege and disprivilege may have bearing is in the spaces in which we act and interact. Geographer Edward Soja noted that "life stories [are] as intrinsically and revealingly spatial as they are temporal and social."[62] Thus, in addition to gender and racialization, my discussion includes the particular sites of Lacy's art making. Anne Enke's 2007 book *Finding the Movement: Sexuality, Contested Space, and Feminist Activism* is exceptionally valuable in that her

> analysis focuses on the ways in which women intervened in public landscapes and social geographies already structured around gender, race, class, and sexual exclusions and on the ways that these processes in turn shaped feminism. A focus on contested space, as opposed to a focus on feminist identity, helps explain how feminism replicated exclusions even as feminists developed powerful critiques of social hierarchy.[63]

Examining the actual spaces involved in Lacy's art making offers insights into how her projects critiqued everyday urban areas, or not. Geographic aspects often join with our behaviors to normalize hierarchies that remain unquestioned by many of us. Thus, when a performance occurs in public, connecting, say, oppression, visual form, and urban site, the impact increases through linkages of these nodes in an imaginary network.[64]

Coalition Building: Traveling Between

Coalition building is hard because it requires finding some common ground on which to come together, creating enough trust to hold that space open, while recognizing simultaneously that substantial differences exist. For Lacy, the subjugated status of women in this patriarchal society provided that common ground. Affirming that personal experiences among women vary widely, Lacy nevertheless has maintained that women can and should join together to address oppressions that affect us all. These joint efforts then are carried out as allies, although "sisterhood" still echoes through her work.[65]

What Lacy has called "[t]he 'expanding self' became a metaphor for the process of moving the boundaries of one's identity outward to encompass other women, groups of women and eventually all people."[66] Lacy's curiosity, generosity, and outrage compelled her to explore what life was like be-

yond her individual body for those different from her in race, ethnicity, age, and life experiences. In a 1993 article, critic Lucy Lippard described Lacy:

> An inveterate border-crosser, she has long been almost inde-
> cently curious about everyone else's experiences, charging into
> new areas where angels fear to tread—a vicarious chameleon,
> or perhaps a beneficent cultural cannibal, cultivating multiple
> selves as a way of understanding injustice and survival.[67]

Lacy's "indecent curiosity" fueled her indefatigable coalition building, a node that links to participation, positionality, and public performance art.

To the extent possible, Lacy placed herself within different human con-figurations, physically, mentally, spatially, and historically.[68] Her art forced her to shift realities, to "travel." Although, of course, she could never fully reproduce the worlds of others, she "traveled between" these contrasting worlds, exploring a liminal space that philosopher María Lugones defined as "the place where one becomes most fully aware of one's multiplicity."[69] Lugones used the term *traveling* to describe a person's movements among different social groups or "worlds," which themselves are no more stable than an individual's identity.

To make art in coalition, moving beyond unexamined or unified iden-tities, promises an art that forges flexible connections, allowing ongoing dialogue. But without an insistent and continual analysis of power relations, especially one's own, the art may well serve to reinforce the status quo and trendy, "decorative" multiculturalism.[70] Lacy's friendship with artist Judy Baca, among other relationships, challenged her to think more deeply about the complexity of race and racist attitudes in the United States.[71] In order to "cross over" into another's existence, she began to collaborate with others from whom she could learn.

Participation

While Lacy herself usually was the catalyst in a process that culminated in an art project, she often collaborated with others. Lacy thus shared agency for a work of art with participants who joined her in its creation. Curator Lars Bang Larsen wrote in 1999 about the ways in which "social and aes-thetic understanding are integrated into each other" as "social aesthetics." This sort of "osmotic exchange" in Lacy's work sometimes produced an in-tegrated result but also presented the possibility for unresolved or multiple endings.[72] Just as the creation of her art existed along a continuum, so too did the reception of it, what I call "participatory reception."[73] In 1995, she wrote, "Of interest is not simply the makeup or identity of the audience but to what degree audience participation forms and informs the work—how it functions as integral to the work's structure."[74]

Lacy's art challenges assessment of it because participants helped create representations of the ideas at the same time they observed those representations. The meanings they perceived during the collaborative process at times altered the imagery, and the meanings evolved. Lacy has written that "[m]any of the forms we have come to assume as part of community-engaged art—its multivocality, for example, its pluralism of styles of presentation and its postscript-like conversations—are aesthetic evolutions developed through confrontation and resolution of conflict during the making."[75]

While certainly the imagery in any one of Lacy's projects has its own merits, intrinsic worth, and interest and can indeed be evaluated aesthetically, "traditional" formal evaluation is not sufficient for new genre public art. The compelling aspect of Lacy's approach is the degree to which she pushes art into the public so that questions of aesthetics, ethics, audience, reception, and creation are amplified. Once amplified, these issues and people's responses to them provide feedback into the art process itself, contributing to that reception loop.[76]

Lacy has long worked between theory and practice—writing, teaching, directing, making. Her writings formulated theory for new artistic configurations.[77] She has diagrammed artistic positions on an axis moving from private actions of the artist as experiencer, then reporter and analyst toward public activism.[78] She herself then has been an indispensable participant in meaning making, contributing to public discussions about oppression, privilege, and liberation. Her contribution, in theory and in practice, has been to close the distance between production and reception.[79]

Further, she suggested a model for analyzing the audience "as a series of concentric circles with permeable membranes that allow continual movement back and forth." The genesis of a work—a circle at the center of this diagram—is encircled by rings of collaborators, volunteers, and performers, those watching the event ("immediate audience"), and the media audience. Lacy labeled the final ring the "audience of myth and memory" (Figure 2). Lacy's "target" diagram helps distinguish among the various layers of audience; the center—"the creative impetus"—is labeled "origination and re-

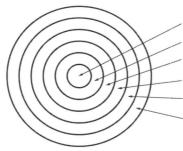

Figure 2. Diagram illustrating the audience as a series of concentric circles, from Suzanne Lacy, ed., *Mapping the Terrain: New Genre Public Art.* Courtesy of Suzanne Lacy.

Origination and responsibility
Collaboration and codevelopment
Volunteers and performers
Immediate audience
Media audience
Audience of myth and memory

sponsibility."[80] While I appreciate that Lacy takes responsibility for her art as well as includes herself in the credit for its genesis and that she states that the circles are "permeable," I find my nodes-in-networks model more useful. The artist is an essential node, but including her in the network of collaborators, performers, and audience stresses the reciprocal nature of Lacy's approach to public art. Rebecca Schneider asked, "What can reciprocity look like? How can we *do* it? . . . Reciprocity suggests a two-way street but it does not necessarily reconstitute the delimiting binaries which feminists and postcolonial theorists have been fighting to undermine."[81] Reciprocity and "how to do it" have been fundamental to nearly all of Lacy's projects.

"The public" in the sense I am using it here includes person-to-person encounters, group dynamics, institutional responses, and social networks. These interactions shift and influence the art process on many levels. Artistic practice such as Lacy's embodied art lends itself to an exploration of the terms of engagement—art arises from an individual artist, is shaped by that artist's identities and concerns, but also by those who cocreate the piece. Cocreators may include an arts commissioner, a mayor, or people in the art production, for example. Art functions as a tool for reflection: there is a reciprocity between the practice of art making and the theory that informs that practice.[82]

Strategies to communicate effectively with people not ordinarily attentive to the arts have long occupied Lacy. This challenge underlies her involvement in media literacy, press conferences, performances outside of galleries and museums, and collaborations with communities outside of art circles. In 1995, she commented:

> [T]here's also an appropriate contradiction between, on one
> hand, the way in which artists are trained to express self and
> to make meaning by drawing on interior sensibilities, and, on
> the other, the demands of a new public arena for dialogic and
> collaborative modes. I personally find it a very exciting conflict
> because it is essentially the metaphor of self and other. . . . Con-
> sequently, what we have to resolve, spiritually, is the sense of
> no-self or an encompassing all-self, and, in art, we have to do at
> least some negotiating between our reality and other realities.[83]

Naming Participation

Grant Kester's 2004 book *Conversation Pieces: Community and Communication in Modern Art* discussed what he called "dialogical art," an "inclination" in art that foregrounds interchange and process. Lacy's work with teens in the 1990s in Oakland, California, is featured prominently in his book. He labeled Lacy's work as transitional, meaning, I believe, that her art drew upon both community arts and "the post-Greenbergian diaspora

of arts practices," such as Happenings. She also retained control of the visual image to a degree that some of the younger practitioners he discussed do not.[84]

Kester usefully formulated a philosophical background for dialogical art, discussing discourse ethics and feminist interpretations of specific contexts for interactions. He stressed that this approach to art is "durational rather than immediate."[85] *Conversation Pieces* deepened my analysis of Lacy's art by suggesting that we "need a way to understand how identity might change over time—not through some instantaneous thunderclap of insight but through a more subtle, and no doubt imperfect, process of collectively generated and cumulatively experienced transformation. . . ."[86] The book enumerated three aspects of a dialogical aesthetic: first, art functions as "a more or less open space within contemporary culture"; second, it involves "a form of spatial rather than temporal imagination"; and third, it aims to achieve "these durational and spatial insights through dialogical and collaborative encounters with others." The spatial imagination, what Kester described as "the ability to comprehend and represent complex social and environmental systems," and the creation of artistic structures to facilitate encounters are particularly salient in Lacy's work and help to link the social dynamics of participation to the place and form of Lacy's projects.[87] In keeping with my nodal scheme, I will examine *both* interactions over the long-term and the immediate embodied responses related to Lacy's art projects.

Kester named other terms similar to dialogical art: Ian Hunter and Celia Larner used the label "littoral art," a geographical term describing a shoreline and thus evoking a place where two different "bodies" touch. Other critics have discussed "conversational art" (Homi Bhabha) and "dialogue-based public art" (Tom Finkelpearl). Nicolas Bourriaud's *Relational Aesthetics* focused on art of the 1990s that involved the art audience as a microcommunity; his analysis concerned art's role as "be[ing] ways of living and models of action within the existing real, whatever the scale chosen by the artist."[88]

Problems of Participation

In my experience, when an artist engages with politics as Lacy has done, some advocates for social change get their hopes up during the preparatory stages—tackling a social problem—and then experience bitter disappointment when the artist moves on. Some critics claimed that while Lacy's art challenged the status quo in political arenas locally and nationally, the artist then departed, adding another community to her résumé while leaving local folks to wonder what actions should come next. Yet Lacy's practice has been a complicated amalgam of arrivals, departures, and returns. As early as 1982, she asked, "What is the artist's responsibility to her collaborators, performers, and audience after the performance is over?" She then offered

several examples of long-term, community-based art but also suggested a larger model, "a network of women across the country who are working together on a single project with local goals as well as a sense of belonging to a nation-wide project." Ever questing, she vowed to continue "to struggle with the problems of sustaining energy within specific communities . . . ; clarifying the relationship of action-oriented goals to broad-based coalition building; . . . and generating a sense of participation in a national vision with women in geographic locations."[89]

Her efforts to re-create "metaphors of community, over and over" involved substantial travel, tightly scheduled with her job and other commitments.[90] Some projects no doubt left some participants feeling they had been given short shrift. I suggest that "in-betweenness" is both the problem and the resolution in her work; she is moving among nodes when others expect her to commit to stasis. In spring 1978, in an interview with artist Richard Newton that was published in *High Performance* magazine, Lacy tellingly explained her artistic process and how it contrasted with political organizing: "I am trying to represent myself to the feminist community as an artist and not as an organizer: I greedily hold on to the ability to make my own images, and make clear-cut distinctions about how much organizing I'm going to be involved with."[91] Lacy's art emerged from the relationships among her, her collaborators, and audience members; in other words, these interactions were not in themselves the art, but they were crucial to her art making.

French curator Nicolas Bourriaud's *Relational Aesthetics* had a large impact in the Anglophone art world when it was initially translated into English in 2002.[92] Bourriaud's optimistic and sketchy book attempted to set the terms for an approach to art in the 1990s that created a community with an art audience, such as the work of Rirkrit Tiravanija. Claiming that art "tightens the space of relations" and "produces a specific sociability," Bourriaud's arguments have eluded me because I remain puzzled by just how the disparate artists he names—from Vanessa Beecroft to Liam Gillick, from Felix Gonzalez-Torres to Philippe Parreno—either fit into "relational aesthetics" or share aesthetic criteria. The "hands-on utopias" offering a "rich loam for social experiments" that Bourriaud described do indeed share a "co-existence criterion" that "permit [the viewer] to enter into a dialogue," but the range of issues and options on display by the artists under consideration do not seem to me to cohere into anything but the designation "art."[93] Furthermore, the relationships that interest Bourriaud seem to be apolitical.

Perhaps the reason that Bourriaud's work has been cited so widely is because there remains a need for ways to discuss relational art; for me, his contribution has been in framing some questions and generalizations. "[W]hat does a form become when it is plunged into the dimension of dialogue?" "As part of a 'relationist' theory of art, inter-subjectivity does not

only represent the social setting for the reception of art, which is its 'environment' its 'field' (Bourdieu), but also becomes the quintessence of artistic practice." Detailing what happens to forms-in-dialogue and trying to be precise about intersubjectivities are what I try to do here in relation to Lacy's art practice. Bourriaud's statement—"The nineties saw the emergence of collective forms of intelligence and the 'network' mode in the handling of artistic work"[94]—validates my own network schema, although I suggest that Lacy pioneered this "network mode" with others in the 1970s, for political, feminist purposes.

Bourriaud's interest centered on evaluating the quality of the relationships that unfolded in the work of various artists, but he never fully defined what the artists he considered might mean by "community."[95] This criticism by Claire Bishop highlights a key problem in relational art: artists and participants coming together do not necessarily a community make, nor does being together in art inherently promote democratic processes. Bishop claimed that for Bourriaud "all relations that permit 'dialogue' are automatically assumed to be democratic and therefore good."[96] Anthony Downey further noted that "relational art practices do not necessarily mirror—although they may replicate—the conditions of the social milieu in which they exist; rather they generate and propagate those very conditions."[97]

The goals of Lacy's works are not always as "convivial" as those of the artists that Bourriaud promoted. Instead of fostering a "feel-good" community, Lacy has often aimed to create structures for conversations that name and discuss difficult issues rather than resolve them, fully aware that dissent will be as much a part of those interactions as agreement.[98] In part antagonism is inevitable given the lack of common discursive frameworks among some of the participants. Bodies coming together, however, also introduce nonverbal ways of knowing that complicate performances and life with a range of tacit behaviors.

Lacy's works invariably involve conflict, some unpredictable and unintentional outcomes, and some heated criticism, in part because of the provocative themes involved and in part because the "spaces between" in her art allow for multiple interpretations, ambiguity, and disagreement. In her large-scale works, Lacy has insisted on providing an aesthetic and social context for many points of view. Lacy's performances have offended some who have felt that she overstepped, seemingly speaking *for* those whose voices she intended to amplify. Others have objected that her focus on women as a group has minimized their differences, discounting very real challenges of race and class.[99]

Participation in the Art World

Negotiation between realities—particularly the world of contemporary art in the West and folks usually outside of those art circles—has been at the

foundation of Lacy's art-making process. Lacy often sought connections among her peers, arts as they are practiced in communities, and the historic avant-garde. Since contemporary experimental art is anathema to many—at best we tend to dismiss it as just weird—accessibility to her art forms has been crucial to Lacy. She noted the difficulty of bridging these two worlds, "audiences outside of the art world" and "our own concerns."[100] By inviting members of the public into her performances, as cocreators, participants, and observers, she linked other nodes in the network, shaping both the artistic performance and the reception of it by the general public.

The avant-garde as I use it here refers not just to experimental imagery created as an alternative to established forms and media but also to the ways in which the art was produced.[101] Lacy's generation experimented with avant-garde modes of production that included collective or collaborative methods of creation and presentation or exhibition outside of the usual gallery or museum settings. These approaches challenged the status quo and helped younger artists tackle the star system of authorship more directly. Yet by "avant-garde" I do not mean an unchanging response, because clearly issues both within and outside of the art world have shifted and continue to do so. By placing the emphasis on production, on the social and economic position of art, the forms and media used do not necessarily have to be in the vanguard; they can bridge between different audiences.

This interest in linking disparate groups has been generative throughout Lacy's career. She has deliberately and consistently sought collaborators beyond the art world. In 1975, while living in Los Angeles, she developed a close working relationship with Evalina Newman, a woman in her midfifties who had been forced to leave her cleaning job due to reactions to the chemicals at work. Ms. Newman, with time on her hands, had filled her apartment with a quilting frame and organized a sewing and crafts circle for other women in the Watts housing complex, the Guy Miller Homes for the Elderly, where she lived. The Miller Homes and the community center had been built on sites that sustained major damage during the 1965 Watts uprising.[102] While the women sewed, they shared their personal histories and their fears about actions of the neighborhood teens. They also crocheted pot holders and covers for tissue boxes, along with stitching quilts. Lacy joined this art-making circle as part of her job with the Comprehensive Employment and Training Act (CETA). As a CETA artist, she "wanted to explore with a single community how performance might combine with their self interests and how it might, as well, enable that community to interface with other communities."[103] Lacy created a photo-quilt series about her friendship with Ms. Newman (Figure 3).

Over the course of three years, Lacy and the Women of Watts did a series of installations and performances in and around the Guy Miller Homes. For example, they displayed their art in the recreation hall and invited

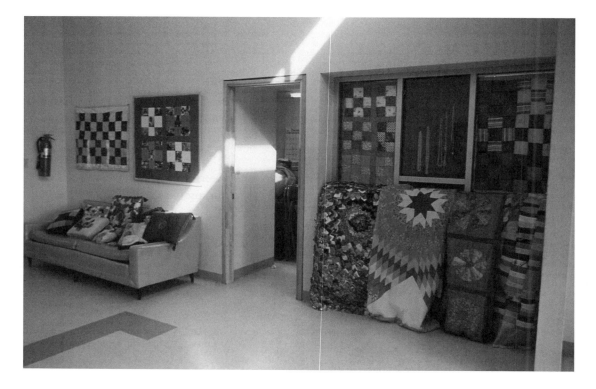

Figure 3. Suzanne
Lacy, Evalina
Newman, and the
Women of Watts,
"Living Here,"
photo-quilts and quilt
display from *Evalina
and I: Crimes,
Quilts, and Art*,
1978, Guy Miller
Homes Community
Center, Watts, Los
Angeles. Courtesy
of the artist.

neighbors, politicians, and Los Angeles–area artists to their exhibits in order
to alert officials to their concerns about crime. Lacy asked in 1980, "What
makes one person's environment a home, another's an artwork?" She rec-
ognized a shift by a number of her contemporaries toward engagement with
extra-artistic concerns, while still drawing on past ideas in the art world.
She wanted to assess conceptual art by her peers, like Linda Montano, Jo
Hanson, and Martha Rosler, among others, in terms of "the success of their
intentions in 'real life' as well as in the art milieu."[104]

In activities with the Women of Watts, as with her other works, Lacy
was interested in creating spaces, literally and figuratively, where everyone's
creative output could be valued without placing it in a hierarchy of artistic
quality. While she certainly claimed authorship of this work in the art world,
she also moved into other, really much larger worlds, where her aesthetic
interests coexisted alongside those of others. Lacy's training in zoology,
psychology, dance, visual art, and community organizing provided her with
skills and concepts to perform in a rapidly shifting social milieu. She moved
between science and art, between ideas and enacted forms, and between
adaptive behavior and resisting actions. Hers is a "both/and" approach, in
which she attempts to be present in several arenas simultaneously.

Lacy has shown an enduring commitment to using art in public to in-
form people about issues of common concern and to affect policy. I suggest

that the "spaces between" in her art provide openings that might be transformative for selves that are permeable and multiple. Diana Fuss noted in 1991, "The problem, of course, with the inside/outside rhetoric, if it remains undeconstructed, is that such polemics disguise the fact that most of us are both inside and outside at the same time."[105] We perform, moving between art and life, built space and human flesh. This "betweenness" creates tension, at once dynamic and troubling. To enact these relationships in reality, on the ground so to speak, is especially difficult given the separation from, indeed denial of, our bodies. Lacy's art has embraced the body, deepened into spirit, and enhanced bodily wisdom with strategic, intelligent analyses of politics. Her international career has demonstrated the power, problems, and possibilities of art between the spaces of our diverse lives, as she has attempted to create structures that might give shape to a nonsexist, multiracial democracy.

1 VISCERAL BEGINNINGS

EACH PERSON'S PARTICULAR BODY and life experience matter. That is not to say that one's race, class, gender, sexual orientation, or family history determines everything, but these social categories and fundamental facts are key. They have always been important in Suzanne Lacy's work. Identifiable features such as white skin and ample breasts carry significant, multiple meanings in U.S. culture, for example, although these bodily characteristics hardly sum up anyone's identity.[1] Since race and gender have been among the central concerns of Lacy's art, I begin, as she did, with her white, female body.

Suzanne Lacy was the eldest child of three, born in 1945 in Wasco, California, to working-class parents in their early twenties, Betty Little Lacy and Larry Lacy. Her father worked first as an electrician and then as an insurance salesman, and her mother was a clerk at a gas company. Beginning at Bakersfield Community College (formerly Bakersfield Junior College; about twenty miles from Wasco) in 1963, Suzanne Lacy was the first in her family to go to college. All through high school, Lacy vacillated between art and medicine as career directions, noting how in dissecting the two interests came together: "I found the insides of bodies incredibly beautiful—an aesthetic response."[2]

With a state scholarship, Lacy then transferred from Bakersfield to the University of California at Santa Barbara (UCSB) in 1965, completing her degree there in zoology with a minor in chemistry in 1968, after switching from a philosophy major. Throughout her undergraduate years, she also studied art and modern dance. After a short stint in 1968 in Volunteers in Service to America (VISTA), she began a graduate program in psychology at Fresno State College in California (FSC, now California State University at Fresno).

While brief, Lacy's time in VISTA was crucial because she was introduced to radical politics for the first time. Her youthful predilection for service—donating money to local causes, collecting clothes to wash and pass along to those in need—was redirected by VISTA's trainers into an organizing model in which those who were excluded from power directly challenged power structures.[3] While at age twenty-three Lacy's understanding of multiple oppressions was inchoate, her political analyses quickly sharpened through ongoing, consistent engagement with social justice issues upon her return to California.

Lacy was both a student in Fresno's graduate psychology program and a teacher, since she organized a course in feminist psychology for her peers. In 1969, feminist psychology and all-women group meetings were new approaches; Lacy's wholehearted participation brought her a reputation as "that angry woman."[4] She and a white graduate student in English, Faith Wilding (born 1943), also coordinated a highly successful feminist reading course called The Second Sex in the Experimental College.[5] Together with Wilding, Lacy organized groups in settings that enabled their immersion in feminist theories and actions.

In colleges and universities across the nation, the late 1960s and 1970s were years of resistance against structures of domination, ranging from racist business practices to entrenched academic narrow-mindedness, from federal government infiltration of anti–Vietnam War and Black Power groups, to police brutality against blacks and Native Americans and Latino/as, from undercutting union activism to anti–free speech efforts. It was a time of ferment in both senses of the word: excitement and agitation. In 1968 and for several years thereafter, Fresno State was one of the hottest spots of unrest. Nearly a dozen Fresno State administrators were fired or resigned under pressure from various factions, and about fifteen faculty members were summarily fired for political reasons, including 60 percent of the teachers in the newly created ethnic studies programs (including Black Studies, La Raza/Chicano Studies, and Native American Studies). Funding for the ethnic studies programs was also cut or eliminated altogether, and about a third of the student body of twelve thousand actively boycotted classes and protested policies.[6]

Students at Fresno State were primarily commuters, mostly white and working-class, from the Central Valley. While the San Joaquin Valley also had a substantial number of Latino/as, few attended FSU, although Latino/as, blacks, Asian Americans, and Native Americans were leaders in social change movements in the 1960s, particularly in California.[7] In 1969, when a group of about fifty women students, nearly all white, led by Lacy and Wilding began independently to explore personal issues in conversation and reading, "women's liberation" was sometimes intertwined and other

times at odds with other civil rights movements. White women who were receptive could learn much politically and culturally from observing and working in coalition with people of color. Lacy and Wilding, older than the undergraduates, were increasingly aware of the broader issues linking feminism to other civil rights because they were actively organizing in support of the United Farm Workers, a union for migrant agricultural laborers, and against the war in Vietnam, as well as against the Fresno State administration's treatment of its activist faculty, including those from ethnic studies.[8]

Feminist Art Program, Fresno, 1970–71

Artist Judy Chicago (born Judith Cohen in 1939) came to Fresno from Los Angeles to teach in 1970, after Lacy's first year there.[9] Chicago, who had been active in the Los Angeles art world since her undergraduate days at the University of California at Los Angeles in the early 1960s, arrived on a scene already vibrant with social change, including the Second Sex reading group. In 1970 Chicago was rethinking her abstract, "finish fetish" approach to painting, seen, for example, in the *Pasadena Lifesavers* series (1969–70).[10] "Pasadena Lifesavers Yellow No. 4," a representative work from the series of fifteen, has four lozenge shapes spray-painted in candy colors on the back of a five-foot square of clear acrylic backed with white.[11] Chicago intended for these "Lifesavers" to read as "masculine," "feminine," and "in retreat," according to their color schemes. Repeated openings depicted what she came to call "central core imagery," which she viewed as particularly female.[12] The industrial materials, precise geometries, and smooth, airbrushed hues in these works continued Chicago's explorations of West Coast minimalism, which had made her known in the Los Angeles art world.[13] The feminist agenda developing in Chicago's abstract work, however, was overlooked by the art world in which she circulated in Los Angeles.

The talented, ambitious Chicago felt that her art was misunderstood and thwarted, often due to sexism. The advertisement for her fall 1970 show at California State University, Fullerton, depicted her against the ropes in a fight ring, dressed in boxing gear and announcing her name change to Judy Chicago (after her birth city). Her artistic interest in female sexuality was conveyed by a variety of media. By 1970, she had made sculptures and lithographs, paintings on car hoods and Plexiglas, and performances with tinted smoke called *Atmospheres*.[14] In addition to the *Pasadena Lifesavers* series, the Fullerton exhibit included her intimately scaled, three-dimensional acrylic *Domes* and documentation for her *Atmospheres,* which were photographs of works she had executed in the desert with painted nude female performers and colored flares. The critics of her 1970 exhibition at Fullerton focused on the materials and the forms of Chicago's works, not on her

content. Her anger about these critical responses caused her to seek a more supportive environment among women.

With her move to Fresno, Chicago hoped to create an entirely new artistic context for herself and her art.[15] Identifying and celebrating a "female sensibility" was an urgent issue for many feminist artists in the 1970s, and Chicago was energetically promoting her ideas on both coasts. Fresno offered Chicago a chance to pull back from "LA cool" and build alternative structures of support for her art and teaching. Her arrival in Fresno also galvanized young women like Lacy and Wilding. As a graduate student, Lacy had moved outside of psychology; she was studying race relations and feminism. Lacy was eager to join Chicago's fledgling feminist group, which Chicago resisted because she felt Lacy was not going to be a professional artist. Although the political activism of Lacy and Wilding set them apart from both Chicago and other art students, Chicago admitted both of them to what became Fresno's Feminist Art Program (FAP) after some lobbying by the two of them. Lacy incorporated her activism into art in ways that she might not have had she been an art student initially. After selecting fifteen women, Chicago arranged for the class to meet off campus so that the women could have substantial autonomy. Lacy recollected that "we just renovated [an old] building, that's where I learned carpentry."[16]

Because there was no model for feminist art studies within an academic setting (an early women's studies program had just been launched at the University of Washington in 1969), the structure emerged out of Chicago's experiences and that of the women students working with her. Her "audacious contribution to feminist pedagogy" arose from her own struggles in the male-dominated mainstream art world of Los Angeles and the lived experiences of the young people in Fresno.[17] Chicago reflected in her first memoir, *Through the Flower*:

> [W]e did a kind of modified consciousness-raising, which combined the expressing of common experiences with my trying to help the women understand the implications of those experiences in order to change their behavior patterns. . . . One of the most important discoveries of the year was that informal performance provided the women with a way of reaching subject matter for art-making.[18]

The small group of women sharing their stories off campus discovered instances of rape and other violence in their personal histories and created art linked directly to their bodies, their traumas, and their creative impulses.[19] For Lacy, these intense, deeply felt sessions were sources of growth in her art and life. For Chicago, these young women helped her redefine her own art making, as together they devised a new critical context for art informed by feminism.

CalArts, 1971–73

In fall 1971, the Feminist Art Program moved from Fresno to the California Institute of the Arts (CalArts) in Valencia (just north of Los Angeles), and Judy Chicago teamed up with artist Miriam Schapiro (born 1923) to direct it at that institution.[20] Lacy also transferred to CalArts as a graduate student, finding the social design program there compatible with her political interests. While she was not in the Feminist Art Program (and thus was not directly involved with Womanhouse, perhaps the best-known production of that program), Lacy continued to associate with FAP women. Writer Deena Metzger taught at CalArts as well.[21] The art historian Arlene Raven (1944–2006) also joined the faculty of CalArts for one year, 1972–73.[22]

Raven was teaching at the Maryland Institute College of Art when she first met Chicago and Schapiro at the first East Coast conference on women in the visual arts in 1972. In the week between the conference and Raven's departure to visit Los Angeles, she was raped.

> I was completely distressed from having been raped, very brutally, and kidnapped by two people. That was a very politicizing experience for me, and it allowed me to see, in a personal way, what role social institutions were going to play in my life. . . . I had been working in the civil rights movement, I had been in the SDS [Students for a Democratic Society] and the Labor Committee, and was a feminist, and I was going to consciousness-raising at the time. Still, I completely changed my life, toward increasing my commitment to feminist/political work.[23]

Raven was an important friend and colleague of Lacy's, as was Metzger.

While Lacy continued to work with Chicago—in a site-specific sculpture class called Route 126 in 1972, for example—she was also the teaching assistant for Sheila Levrant de Bretteville (born 1940), a graphic designer and theorist who was teaching in the CalArts social design program.[24] De Bretteville encouraged the sort of broad thinking toward which Lacy was inclined, and she motivated students to grapple with then-current aesthetic and political concerns.

The artistic experiments at CalArts in the early 1970s were often not of the sort that the institution's major funder, the Walt Disney Corporation, would have approved. Walt Disney, who died in 1966, in general supported blending disciplines, collaborations among individuals, and international links. When CalArts was incorporated in 1961, it was "the first degree-granting institution of higher education in the United States to combine the visual and the performing arts."[25]

In contrast to Disney's corporate approaches were the artistic antics of

the loose association of artists known as Fluxus, which had a strong presence at CalArts because many of these artists taught there, if only briefly. Fluxus included Yoko Ono, Nam June Paik, Simone Forti, and Alison Knowles, along with Dick Higgins and Emmett Williams. Lacy took classes with Forti and Knowles and knew Emmett and Ann Williams.[26] Visitors to CalArts also included dancer and filmmaker Yvonne Rainer, Austrian performance artist Valie Export, and Eleanor Antin, each of whom became significant to Lacy's work.[27] Many of these creators had met between 1956 and 1959 in John Cage's composition classes at the New School for Social Research in New York City and then traveled extensively, disseminating their ideas nationally and internationally. While Fluxus "Events" changed over the years and were distinct from "Happenings," for my purposes, the stimulating interplay at CalArts among Events, Happenings, conceptual art, and pop art provided rich material for Lacy and other students.

Kaprow the Un-artist

At the same time that the Feminist Art Program was developing under Chicago and Schapiro, "CalArts had temporarily been turned into an avant-garde institution—though still very much a male-dominated one," as Faith Wilding has written.[28] While insufficiently acknowledged, the Feminist Art Program influenced many of the faculty, who had just come together at the new campus in Valencia, having been hired by provost Herb Blau and School of Art dean Paul Brach (spouse of artist Miriam Schapiro), assisted by Allan Kaprow.[29] Despite all the apparent innovation at CalArts, Lacy recalled that she "was also working on bridging that gap between what I always felt to be the strangely esoteric and elitist environment of CalArts with the real world. I felt, as a working-class kid, like I was from the real world."[30] She has stressed that in the early 1970s CalArts was predominantly white. Thus her milieu at that time was white, middle-class, and male-dominated. Lacy's working-class background and graduate training in psychology, I believe, strengthened her analysis of personal and political interconnections. While her work initially was female-centered, to forge interracial connections, she had to leave the privileged world of CalArts and the social conditions of the art world in general.[31]

If primarily white feminist artists formed one circle in a Venn diagram of influence for Lacy, cultural theoretician Allan Kaprow (1927–2006) and his cerebral, philosophical approach overlapped with that circle. Kaprow intermingled life and art and crossed media boundaries within the arts, bringing sound, movement, and visual art together in performance pieces he called Happenings.[32] Kaprow was hardly alone in these explorations that heightened experience, but Lacy's direct connection to him invites a closer look. Lacy stated in an unpublished 1981 interview with Kaprow that "the structure of [his] work provided one of the few formal art models for femi-

nists," although Kaprow also recalled that consciousness-raising groups provided him with new forms.[33]

After obtaining an undergraduate degree from New York University, Kaprow studied painting at the Hans Hofmann School of Fine Arts (1947–48) and obtained a master's degree in art history from Columbia University in 1952.[34] While studying art history with Meyer Schapiro and aesthetics with Albert Hofstadter, he mixed with the group of experimental artists at the New School who were influenced by composer John Cage. Kaprow created his earliest Happenings as assignments for Cage's classes. By 1958, Kaprow had become well-known in New York art circles as a writer, teacher, artist, challenger of the status quo, and promoter of vanguard art. In 1966 he published his landmark book, *Assemblage, Environments and Happenings*.[35] In 1969, he and his family moved from Long Island to Los Angeles, and Kaprow took the job at CalArts.

By 1970, Kaprow had moved beyond Happenings, for the most part, to smaller, more intimately scaled works. Jeff Kelley recounted that "he was especially interested in the writings of sociologist Ray Birdwhistell, who explored the way body movements carry precise meanings within specific social groups, functioning as a kind of language that helps illustrate, clarify, intensify, regulate, and control the back-and-forth nature of conversation."[36] Kaprow's approach was particularly focused on his own body, often with thorough monitoring of various bodily indicators, such as pulse and breathing. According to Lacy, Kaprow's move from the East Coast to the West Coast was also a

> move from the grand, expressive gesture to a different kind
> of concern. . . . I watched him work with his body, work with
> his pulse. He'd spit on his hand and note how fast it dried. . . .
> Allan casually mentioned how when he was a child, he was
> so intensely allergic that even to this day, if he eats a nut, his
> whole body literally blows up. And I sat there thinking, "My
> God, that's what's going on. This man has this relationship to
> his body that's at once kind of quizzical and distanced and yet
> threatening, tragic."[37]

Kaprow brought to CalArts, then, nearly fifteen years of experience with Happenings, Cagean music, modern dance, pedagogical experiments, and pragmatist philosophy, as well as a personal interest in the body as an expressive form. As Robert E. Haywood has emphasized, "Kaprow's aim [was] to promote the reintroduction of social reference in art largely abandoned by the abstract expressionist painters. At the same time, Kaprow strove to generate and expand radical experimentation which had withered after Jackson Pollock's drip paintings of the late 1940s and early 1950s."[38]

Social Design at CalArts

Social design at CalArts brought together graphic designer Sheila de Bretteville, psychologist Richard Farson, architects Peter de Bretteville and Craig Hodgetts, and political scientist Jivan Tabibian. Broadly speaking, "social design" was a product of cross-fertilizing sociology, design, and psychology, inspired in part by the civil rights movement, "to correct the misalignments between people and their built environments."[39]

As scholar George Lipsitz has pointed out, the movements for social change in the 1960s often replicated the hierarchies and racialized and gender privileges of the society they were working to alter. Fortuitously, Lacy's two years at CalArts coincided with the presence of an array of artists like Kaprow and Sheila de Bretteville who were committed to self-reflection and critiques that then could be applied both to "macrosocial institutions and microsocial practices."[40] Many of these artists and thinkers had been deeply affected by the "dramaturgical turn" evidenced in the published works of Erving Goffman: *The Presentation of Self in Everyday Life* (1959) and *Interaction Ritual* (1967) analyzed social exchanges using theatrical performance as a parallel.[41] In other words, from the very beginning of Lacy's graduate career, in Fresno and at CalArts, there was a dynamic tension between roles of art and life, between what critic Claire Bishop has described as the "contradictory pull between autonomy and social intervention."[42]

In the early 1970s, in her midtwenties, Lacy was immersed in the shifting feminist movement, yet receptive to avant-garde processes being developed by men and women across the arts. Just as VISTA had introduced Lacy to radical politics, CalArts provided her for the first time with resources on vanguard art practices. Lacy's political inclinations were strengthened by her associations with Sheila de Bretteville, a child of radical parents and a powerful leader.[43] For Lacy, the links among mass media, profit-driven urban cultures, oppressions by race, class, and gender, and her own life were all too clear. Thus, she continued to experiment with activism as art and vice versa.

Lacy's feminism and background in zoology primed her fascination with living in a body vulnerable to pain and destined to die. Meiling Cheng has pointed out that Lacy claimed that many of her early works were concerned with the "human body's status as *mortal* rather than *gendered*."[44] Still, Lacy's images arose from collaborations with other women and her *female* body as well as from literature. When a student was raped on the CalArts campus in 1971, this violence was gendered as well as life-threatening.[45] Real-life events like rape were usually the foundation for Lacy's artistic explorations of the monstrous and the vulnerable.

Rape Was . . . and Is

Little was said in public about rape in the 1960s, even within the fledgling women's movement. As Maria Bevacqua noted, "[S]exist and racist attitudes created an environment in which rape's seriousness was routinely dismissed, victims were disbelieved or blamed for bringing on their own assaults, and poor men and men of color were considered more likely to be rapists than other men."[46] By the early 1970s, however, many feminists had reconceptualized rape as a significant social force that controlled (primarily) women's psyches and movements.[47]

In September 1971, Lacy's contemporary and acquaintance Susan Griffin (born 1943) published a pioneering article in *Ramparts* magazine, "Rape: The All-American Crime." Griffin wrote,

> I, like most women, have thought of rape as part of my natural
> environment, something to be feared and prayed against like
> fire or lightning. . . . But though rape and the fear of rape are
> a daily part of every woman's consciousness, the subject is so
> rarely discussed by . . . male intellectuals . . . that one begins
> to suspect a conspiracy of silence.

Griffin challenged the heterosexual male Left to examine the "apologetics of rape" where "male eroticism is wedded to power."[48] One could extend the accusation of a "conspiracy of silence" to some feminists as well, since many were not antirape or antiracism activists. Thus, when Angela Davis wrote that "the failure of the anti-rape movement of the early 1970s to develop an analysis of rape that acknowledged the social conditions that foster sexual violence as well as the centrality of racism in determining those social conditions, resulted in the initial reluctance of Black, Latina, and Native American women to involve themselves in that movement," she accurately identified the failings of part of the feminist movement.[49]

While the intersections of race and gender were under discussion among white feminists in the early 1970s, the analyses were rudimentary. Moreover, crossovers between art informed by feminism and feminist activism were infrequent. Among white feminists, Lacy and a handful of other artists as well as some writers were at the forefront in pressing for antirape activism that was also antiracist. What has often been obscured in recent discussions of the 1970s is the complexity of interactions among artists working in various media and locations to foster critique and celebration, analysis and accessibility, equity and networking, antiracism and art workers' coalitions.[50] Issues central to feminists—reproductive cycles and choices, childbirth and parenthood, aging, equal pay, violence, eroticism, objectification—were points of common experience *but also* of division among women.

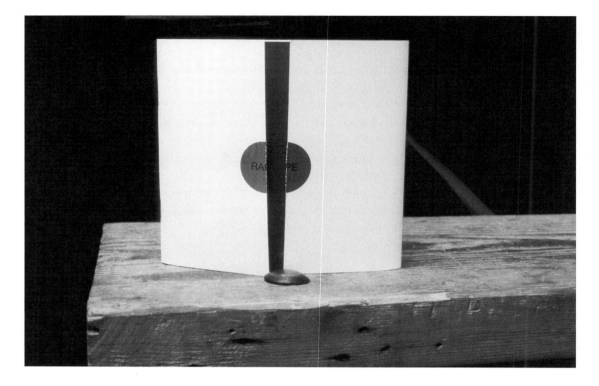

Figure 4. Suzanne Lacy, *Rape Is,* artist's book with seal broken, May 1972. Courtesy of the artist.

Lacy identified ways in which rape sustained patriarchy in her artist's book *Rape Is* (1972) (Figure 4). To open the book, one had to break a red seal, and inside, within blood red covers, were forty-two statements about rape, such as "When the man next door exposes himself and you feel guilty for having looked," and "When you are thankful to have escaped with your life."[51] These statements evoked "little rapes" as well as sexual assaults and articulated a continuum of "numerous and interrelated forms of sexual abuse; this insight, in turn, helped to garner feminist support for the anti-rape movement."[52] *Rape Is* was produced during a time of heightened and significant antirape organizing in the early 1970s, as well as theorizing about sexual violence.

Ablutions

In the last year and a half of Lacy's program at CalArts, 1972–73, beef kidneys and live mice became central to her imagery in photographs and performances. These visuals were often drawn from literature. In an excruciatingly grim chapter of *The Death of Ivan Ilyich,* a tale that Lacy consulted, Leo Tolstoy contemplated the void of death. Ilyich was despairing: "First there was nothing confronting him but a kidney or intestine which had temporarily declined to perform their duties, then there was nothing but unknown awful death, which there was no escaping."[53] Kidneys represented

the fragility of life, among other ideas; these distinctly shaped organs make the difference between life and death.

While still a student, Lacy joined with Judy Chicago, Sandra Orgel, and Aviva Rahmani to create *Ablutions* in 1972, one of the best-known works of 1970s feminist art.[54] Performed in June 1972, in sculptor Laddie (John) Dill's studio in Venice, California, the piece was a collaborative work about rape. *Ablutions* was a ritualistic healing ceremony as well as an attempt to expose people to women's perspectives about sexual assaults.[55] In the male-dominated culture, depictions of violence against women overwhelmingly objectified the woman's body.[56] *Ablutions* insistently presented the subjective female body to the Los Angeles art world.

In spring 1971, Chicago and Lacy had taped seven women telling accounts of their rapes. In the performance of *Ablutions* a year later, these voices provided the aural environment for a studio defined by broken eggshells, piles of rope and chain, and animal organs scattered on the concrete floor. One naked white-skinned woman was led into the space and seated, then another woman bound her entirely in white gauze. Meanwhile two other fully dressed women (Lacy and Jan Lester) nailed fifty beef kidneys at three-foot intervals on the white walls. Two other unclothed women slowly moved in and out of three metal tubs set in the middle of the room, bathing themselves each time (Figure 5). One tub held one thousand eggs;

Figure 5. Judy Chicago, Suzanne Lacy, Sandra Orgel, and Aviva Rahmani, *Ablutions*, June 1972, studio of Laddie (John) Dill, Venice, California. Courtesy of Suzanne Lacy.

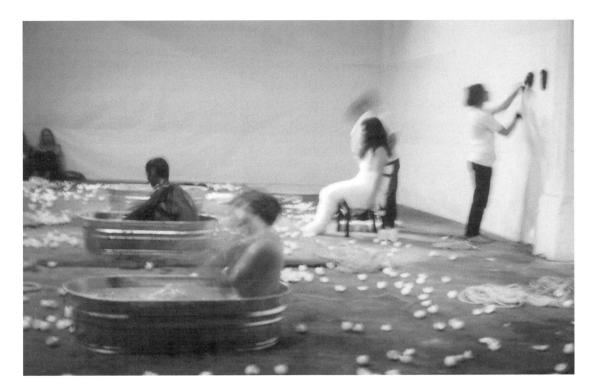

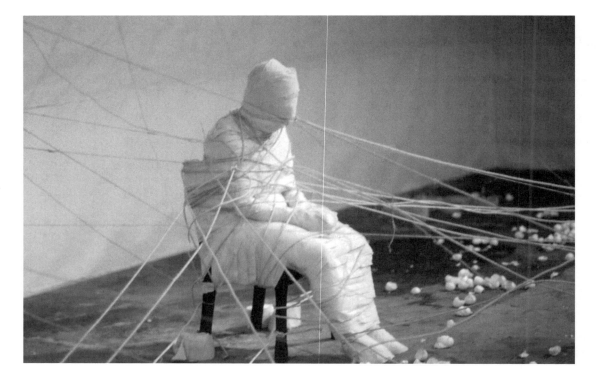

Figure 6. Judy
Chicago, Suzanne
Lacy, Sandra Orgel,
and Aviva Rahmani,
Ablutions, June
1972, studio of
Laddie (John) Dill,
Venice, California.
Courtesy of
Suzanne Lacy.

the second, cows' blood; and the third, watery gray clay. After these ablu-
tions, blood on the women's bodies could be seen between the cracks in
the dried clay slip. They were then wrapped in white sheets, and they lay
down. Finally Lacy and Lester moved slowly—"like giant spiders"—to im-
mobilize the other performers in a web of string and rope that connected
the tubs, figures, and kidneys (Figure 6). The two women then left the space
as the tape repeatedly played, "and I felt so helpless all I could do was just
lie there. . . ."[57]

Ablutions was both a *Trauerarbeit* ("work of mourning") in the Freudian
sense and a declaration of healing. Eric Santner has explained "[t]he work
of mourning [as] a process of elaborating and integrating the reality of
loss or traumatic shock by remembering and repeating it in symbolically
and dialogically mediated doses."[58] This ritualization can give a sense of
distance that is crucial to the survivor's healing, in part by breaking the
experience down into smaller parts, in part through repetition. A victim
rarely assimilates a violent act initially. *Ablutions* recognized that we must
feel the anxiety and pain of rape, but to heal afterwards, we must not be
overwhelmed by the trauma. It provided a means to experience some of
the pain, indeed, experience pain that may have been unknown during the
trauma itself, and a means to include the violent act in reforming identity
after the fact. Santner, in writing of post-Holocaust societies, noted the

importance of feminist critiques in facing the tasks of processing traumas. These tasks include

> a radical rethinking and reformulation of the very notions of boundaries and borderlines, of that "protective shield" regulating exchange between the inside and outside of individuals and groups. The goal of such reformulations is . . . the development of a capacity to constitute boundaries that can create a dynamic space of mutual recognition (between self and other, indigenous and foreign); in the absence of such a capacity it would seem that one is condemned to produce only rigid fortifications. . . .[59]

Ablutions thus expanded upon an individual woman's experience of rape by including the audience as listeners to testimonies and as witnesses of embodied female perspectives. A rape victim's emotions were validated and given visual expression in concrete ways. I believe that this exceptional piece helped shape a collective responsibility for the conditions of a rape culture. Performance art like *Ablutions* gave meaning to the aftermath of sexual violence by connecting a visceral understanding of assault and victimization to an analysis of social structures that contributed to violence.[60]

Mendieta and Ringgold

A typical art historical "node" would compare Lacy's early works about rape with what her contemporaries were doing. Doing so is useful in that it highlights others who were treating a similar topic from different perspectives, and Lacy's early work acquires a national dimension. Ana Mendieta and Faith Ringgold, both artists, were also addressing violence against women in the 1970s.

Ringgold (born 1930) had been an artist and activist in New York City since the early 1960s, and was a founder of Women, Students, and Artists for Black Art Liberation (WSABAL) in 1970, which collaborated with the Art Workers' Coalition, among other groups, to protest the exclusion of black and female artists from exhibitions at institutions like the Whitney Museum of American Art. Lacy was acquainted with both Ringgold, who was fifteen years older than she, and Mendieta, who was three years younger. Cuban-born, U.S.-based Mendieta (1948–85) was a graduate student in Iowa, although she eventually relocated to New York City.

Made between 1970 and 1973, Ringgold's *Slave Rape* series was in the form of sixteen unframed *thangkas* showing enslaved African women who were depicted without clothes but armed, "both the seer and the surveyed, the creator and the object."[61] (*Thangkas* are Tibetan paintings of Buddhist subjects with brocaded cloth borders. Traditional *thangkas* were created for important life events such as birth, illness, death.)[62] The *Slave Rape* series

reclaimed the victim's body and being, transforming them into powerful statements of active survival and even triumph.[63] The acrylic-on-cloth panels with elaborate fabric borders were made together with her mother, Willi Posey; they recalled quilts, appliqué, and other woman-identified crafts.

Mendieta did a set of works in 1973 in response to the rape and murder in 1972 of Sara Ann Otten, a student at the University of Iowa, where Mendieta was a graduate student in painting and intermedia arts from 1969 through 1977. She re-created Otten's murder in her apartment *(Untitled [Rape Scene])* for others in her intermedia arts class, in which they "happened upon" the grisly tableau of Mendieta's naked, bloodied torso tied to a table surrounded by signs of violent struggle. A second version was staged in the woods near campus: Mendieta, half-dressed and face down, with stage blood on her legs, created a horrible scene for someone to encounter.[64]

These three artists—Lacy, Mendieta, and Ringgold—each responded to the antirape movement in distinctive ways. In the early 1970s, Lacy created an artist's book, *Rape Is,* which named aspects of sexual harassment, victimization, and sexual violence, and collaboratively performed *Ablutions* about subjective experiences of rape. In contrast to Lacy's work, Mendieta's re-creations of Otten's rape were far more confrontational and shocking, representing the dead victim of a violent sexual attack with her own body. Each observer was directly implicated in the assault by virtue of "accidentally" coming upon the scene, and Mendieta's live presence made denial and escape less likely. Lacy was never willing to assume the role of a victim and risk that victimization being normalized; her work abstracted sexual violence in a powerful way to address the politics of rape.[65] Ringgold's series broadened the feminist depiction of rape by linking violence against women not only to patriarchy but also to racist institutions such as slavery. While she and her daughters were models for the figures in the *thangkas,* they were meant to represent enslaved women in general.

Meiling Cheng and others have pointed out that *Ablutions* downplayed differences among women, generalizing the experience of rape.[66] That is not to discount the testimonies of the seven women whose reactions were audiotaped, but rather to stress that the performance spoke for the women who participated, in an effort to communicate with a specific art audience.[67] In 1972, the art world in Los Angeles was comprised overwhelmingly of people categorized as white. For Lacy, *Ablutions* was the start of a long-term artistic investigation into sexual and domestic violence that grew in complexity and sophistication. By the mid-1970s, her investigations were multiracial and cross-cultural.

2 EMBODIED NETWORKS

In 1973, with an MFA from CalArts, Suzanne Lacy moved into the fragmented art world of Los Angeles. To be sure, there were some established art schools, museums, and galleries, but the far-flung city also had many pockets of temporary and shifting art spaces and gatherings focused on a particular event, cause, or group, often dispersing afterward.[1] Demonstrations and protests were mounted, and alternative schools, exhibition spaces, and educational efforts were created. For example, the Los Angeles Council of Women Artists (which included Sheila de Bretteville, Ruth Weisberg, and June Wayne) had protested the exclusion of women in 1970 from an art and technology exhibit at the Los Angeles County Museum of Art (LACMA). In another action at the end of 1972, Gronk, Willie Herrón, and Harry Gamboa Jr., who then comprised the art performance group Asco, spray painted their names on every entrance to LACMA after a curator declined to include any Chicano artists in the museum's exhibitions.[2]

Intransigence in the museum world, perceived and real, fostered the growth of other options. The year-old Galería de la Raza sponsored an exhibition in 1971 of art by Third World women; Womanspace Gallery, organized in 1972, moved into the Woman's Building near downtown when it opened in 1973, along with Grandview Gallery and Gallery 707. To raise the profiles of professional women artists, June Wayne taught the nitty-gritty aspects of establishing an art career in her Joan of Art workshops in 1971.[3] Judy Baca organized the creation of the monumental mural *The Great Wall of Los Angeles* in 1976, shortly after she founded the Social and Public Arts Resource Center (SPARC) in Los Angeles.[4] Samella Lewis established the Museum of African-American Art in 1979.[5] These newly established

organizations joined slightly older, "funk" spaces such as Ferus Gallery (founded 1957).[6]

Activities by white women and artists of color were hardly confined to the West Coast (or the United States), of course. Faith Ringgold, mentioned previously, was organizing in New York City to obtain greater representation in museums and galleries for artists of color, particularly women; in 1970, as a member of the Ad Hoc Women's Art Group she protested at the Whitney Museum of American Art.[7] There were increasing efforts in California to connect with women's actions in the New York and international art worlds, as evidenced by West East Bag (WEB), started in 1971 by Judy Chicago, Miriam Schapiro, Lucy Lippard, Ellen Lanyon, Marcia Tucker, and others. Lippard affirmed this interaction: "Feminism is rooted in networking, a concept that embraces both the immense and the intimate. A feminist network is the sum of innumerable one-to-one relationships expanding into the distance. . . ."[8]

Utopia and Dystopia in Los Angeles

Art in Los Angeles in the last half of the twentieth century, and performance art in particular, must also be considered in relation to the movie industry, the war industry, and the "peculiar historical dialectic that . . . shaped Southern California." According to urban theorist Mike Davis, Los Angeles had a "double role of utopia *and* dystopia for advanced capitalism," being the corporate home for "defense" research laboratories of Hughes Aircraft, TRW, and Rand, among others.[9] Anti–Vietnam War protests and demonstrations and their performative aspects had an immediacy due to the proximity to weapons research facilities. Complicating the reality of profiting from war, Hollywood projected cinematic versions of violence on a large, profitable scale.[10] Further, as critic Peter Plagens suggested, Los Angeles was also an urban assemblage of "consumer goods, trash, violence and poetry" as seen in the sculptures and installations of artists Bruce Conner and Edward Kienholz, for example.[11]

In microcosm, Lacy's graduate school, CalArts, also exemplified this "fault line" in the arts (especially in film) in Los Angeles. Lacy had benefited from the institutional combination of visual and performing arts, and the coexistence of vanguard and mainstream media. Her sophisticated strategies for using mass media were honed by exposure to commercial movie and television production during her graduate studies. She consciously interrogated and interrupted aspects of popular culture throughout the 1970s.[12] In addition to her own knowledge of media, for nine years (1974 to 1982) Lacy and Robert Blalack lived together as partners. Blalack's visual effects business (Praxis Filmworks) reinforced Lacy's own awareness of developments in Hollywood.[13]

Feminist Studio Workshop

While Lacy was developing her own artistic directions initially begun at CalArts, her work was very much embedded in the women's art community in Los Angeles. Judy Chicago had left CalArts in spring 1973, and together with art historian Arlene Raven and designer Sheila de Bretteville had started the Feminist Studio Workshop (FSW) as an integral part of the Woman's Building in Los Angeles.[14] The Woman's Building was in many ways a utopian project, with de Bretteville especially shaping its initial public presence by using art to connect with people all over the city and thereby aiming to create more equitable systems. De Bretteville "saw the Building as Women in public. It's almost as if the Building was a living creature in my mind as a woman on the street. And she was going to be . . . honored . . . and she would [bring] the feminine with her into the public realm."[15] Later, de Bretteville was brought up short by other women who viewed the Woman's Building more as a retreat and a safe space from the world outside rather than an extension into public life.[16]

The Feminist Studio Workshop was modeled on the earlier programs at Fresno and CalArts but was distinguished this time by its independence from existing educational institutions. (Needless to say, its financial survival was tenuous.) Raven was instrumental in theorizing what was unfolding at the Woman's Building, in essence providing ways in which the art that was being made there connected with previous histories. In the early 1970s, little scholarship existed on past contributions by women to art and culture. Judy Chicago had begun this research in earnest in 1971, and similar efforts were under way by others.[17]

At the same time that Lacy was performing her own pieces, she was helping to organize performance events at the Woman's Building: a show at Womanspace Gallery in 1973 that Moira Roth called "likely the first exhibition devoted exclusively to women's performance art," and then in March 1974, a collaborative month-long event, "Performance!" that made visible the national and international contacts developed among feminists in the early 1970s.[18] Organized together with Ellen Ledley, Candace Compton, Roxanne Hanna, Signe Dowse, and Nancy Buchanan, the activities included a three-day conference packed with workshops and performances, featuring, among others, New Yorkers Yvonne Rainer, Martha Wilson, and Joan Jonas; Eleanor Antin, Rachel Rosenthal, Bonnie Sherk, Linda Montano, and Lynn Hershman from Los Angeles and San Francisco; and Pauline Oliveros from San Diego.[19] Helen Harrison made strawberry jam from plant to product, in an early version of the "life-cycle" projects of Helen Mayer Harrison and Newton Harrison; Eleanor Antin and Rachel Rosenthal both created among the earliest of their performances; Ulrike Rosenbach from Germany and Marta Minujín from Argentina came to Los Angeles and did pieces at

the conference. Both on the East and West Coasts, then, there were visibly vital feminist structures—publications, political and consciousness-raising groups, educational and exhibit facilities, collectives, and conferences—that reinforced each other and formed "a movement."[20]

In fall 1974, the Feminist Studio Workshop expanded and hired Ruth Iskin to teach art history, Helen Alm (Roth) to teach printmaking, Deena Metzger to teach writing, and Lacy to teach performance (until 1977). Metzger was another significant contributor to Lacy's development; they co-taught on occasion in the 1970s. Metzger's 1992 book *Writing for Your Life: A Guide and Companion to the Inner Worlds* summarized Metzger's teaching philosophy throughout her career, and similar approaches are evident in Lacy's pedagogy. Metzger asserted,

> If . . . we do not reveal our inner selves, we will not have models of honesty and openness and we will be ignorant of the reality of our lives. Speaking openly is the gift we give each other. . . . And so, while we must be careful not to reveal ourselves prematurely, we cannot cloister our inner selves either or we will find ourselves bereft of one of the essential components for the process of transformation: interchange.[21]

This interchange provided the heat, the material, and the support for Lacy's art.

Net Construction

One of an early series of performances, *Net Construction* literally tied Lacy to animal organs and the audience, acting out emotional, social, and biological linkages. In several versions of *Net Construction* (1973, at Womanspace, at the University of California at Santa Barbara, and at the University of California, Irvine, as *Exchange,* 1974), body parts gave an immediacy to human interconnectedness. Lacy hung beef kidneys on a five-by-five-foot rope net (Figure 7).[22] At Santa Barbara, the net was an interface between a nude Lacy and the audience. People were connected through the kidneys to Lacy. If an audience member or Lacy moved, the other had to move in response. This rather somber performance explored human psychological interconnections. In another iteration, *Exchange,* at Irvine, the performance was circuslike, more "Felliniesque," according to Lacy.[23] The setup was similar, except Lacy was clothed, wore a mask, and was manipulated by the audience with the strings as if she were a puppet (Figure 8). Further, peppy band music played while artist Susan Mogul appeared in a top hat and auctioned off animal organs (in plastic bags) that had been placed inside a headless, hollowed-out torso. Lacy then entered the audience and exchanged an organ for part of their body—a fingernail or a lock of hair.

Figure 7.
Suzanne Lacy,
Net Construction,
1973, University
of California, Santa
Barbara. Courtesy
of the artist.

While the physical body was the starting point for Lacy's art, her interest in the outreaching self also meant that the literal and metaphorical spaces between bodies, or networks, mattered for the aesthetic meanings of her work. She sought to give visual form not only to embodied female experiences but also to the relationships among experiences. Lacy was intrigued with how people's interconnections might be represented and what transpired between a representation and those enacting it. To do this, she often used an exchange of some sort to animate the viewer and the viewed, and to confound one with the other. Some of these social exchanges were measurable (trading organs in a baggie for hair, say); others were open-ended, ongoing, and immeasurable (emotions triggered when Lacy tugged). Like Allan Kaprow, Lacy framed certain social rituals: some, like clipping nails, seemed commonplace and apparently worthless; in other ways, an exchange of organs, for example, represented life or death.

Lacy's works considered not only the aesthetic aspect of certain relationships but also sociological and economic dimensions. Some pieces investigated the use value—the material usefulness—of organs, for example, but also the exchange value of sharing organs or other objects in performances with groups. How are bodies interconnected in this culture of increasingly high-profile medical experiments? For example, how does identity change if you have someone else's heart or kidney? What is a heart

Figure 8. Suzanne Lacy, *Exchange*, 1974, University of California, Irvine. Lacy with Susan Mogul. Courtesy of the artist.

or kidney worth? As part of the *Anatomy Lessons* series, Lacy prepared a "Body Contract" in 1974 with Lawyers for the Arts, a conceptual piece and a literal contract that provided for the sale of her own organs. This contract underscored the fact that people in economic need are driven to sell their organs and that organ transplantation has many ethical as well as scientific ramifications. Lacy exhibited "Body Contract" in the 2007 WACK! show at the Museum of Contemporary Art in Los Angeles, emphasizing the contin-

ued importance of these ideas to her art.[24] Lacy recognized that the female body had an especially complicated value to the body politic: "Our bodies are manipulated by the patriarchy as a battlefield for the diversion of attention away from economic systems which are themselves predicated on and preserved by violence."[25] This remarkable statement from 1978 affirmed Lacy's belief that patriarchy and capitalism are interdependent, with violence the predominant method of enforcing compliance with these structures that benefit only a few.

Other artists, many of them conceptualists, shared this interest in networks and exchanges, both literal and metaphorical.[26] Lacy's connection to conceptual art came in part from her time at CalArts and her relationships with Arlene Raven as well as Allan Kaprow. Jeff Kelley noted that between 1973 and early 1975, "the focus of [Kaprow's] works tightened on the experiences of human exchange."[27] Kaprow's *Rates of Exchange,* done in New York in 1975, involved a series of questions tape-recorded by each participant, who then played the tape back while contemplating himself or herself in a mirror. The questions considered the upper body: "is your hair dirty? is your brow creased with care?" and so forth. Then the tapes were exchanged with another participant. The recorded voice of someone else posing and answering questions was then played while looking in a mirror again. Other segments included a face-to-face dialogue that was recorded with "questions and answers which don't match," and private walking, handshaking, and dressing/undressing exercises accompanied by tape-recorded messages. The latter recordings were then replayed with a partner while watching each other dress and undress. Kelley's assessment of this piece was that Kaprow wanted to alter routine exchanges: a handshake, for example, by slowing it down, or walking, by linking it to a tape of unrelated questions, in order to examine "the difference between what we say and think and what we do. . . ."[28] By creating almost nonsensical embodied interactions between two people over time, ordinary, momentary interchanges are infused with awareness. While Lacy certainly shared with Kaprow a fascination with the quotidian, her concerns were with emotional and visceral dimensions of daily life rather than with routines and bodily excretions, which often engrossed her mentor.

The Creation of Monsters

Lacy's work remained centered on the body, in order to observe and respond to other bodies in performance settings. What did it mean to inhabit a particular body? What responsibilities attended upon that incarnation? The 1970s feminist interest in the life and writings of Mary Wollstonecraft (1759–97), such as her 1790 *The Vindication of the Rights of Women,* as well as in the work of Wollstonecraft's daughter, Mary Wollstonecraft Godwin Shelley (1797–1851), whose *Frankenstein; or the Modern Prometheus* was first

published in 1818, dovetailed with Lacy's premedical background and inter-
ests in the meanings and responsibilities of being human. Dr. Frankenstein's
creation of his monster certainly addressed the extreme consequences of
thoughtless experimentation and creation. Frankenstein ruminated:

> During my first experiment [the making of the monster], a
> kind of enthusiastic frenzy had blinded me to the horror of my
> employment. My mind was intently fixed on the consummation
> of my labor and my eyes were shut to the horror of my proceed-
> ings. But now I went to it in cold blood, and my heart often
> sickened at the work of my hands. . . . I shuddered to think that
> future ages might curse me as their pest. . . .[29]

Any scientist or artist has the responsibility to think about the long-
term implications of their experiments. This idea formed the focus of Lacy's
Monster Series: Construction of a Novel Frankenstein (1974), first performed
in collaboration with Sarah Macy at the Los Angeles Woman's Building.
In 1975 *Monster Series* was featured at Western Washington State College
up the coast in Bellingham, Washington. Projections of Mary Shelley's in-
troductory text to *Frankenstein* served to launch the narrative performance.
A silent black-and-white film showed Lacy and Macy sewing their clothes
together, as if becoming one, and then ripping the seams to separate them-
selves again (Figure 9). Projections of news articles and cartoons about
transplantation and organs accompanied a professor's academic analysis of
Frankenstein. (Lacy or Robbie Blalack performed the role of the professor.)
Lacy threw herself against a blank wall multiple times, leaving an imprint
from her clothed body, which she had soaked in black paint; she also drew
her own blood.

Lacy's early performances demonstrated what she has described as
"a direct relationship between the gendered, visceral body and the social
realm." In front of an audience, she pounded herself into a wall, she ex-
pounded on the creation of monsters, she stuck a needle into her vein to
withdraw blood, she metaphorically sewed herself to another and then
ripped the stitches, and she pondered organ transplants, among other top-
ics. In her recent collected writings, she tied her body art to the social
network of bodies:

> The body is flesh that can be penetrated, dismembered, and
> dissected clinically to its component biologies. The same space
> of infinite vulnerability also holds intersecting identities,
> shaped by the social corpus. . . . Underneath what appeared to
> be two distinct types of work—i.e., body-based art and large
> scale public performances—there was a single, though com-
> plex, exploration of violence and its permutations.[30]

Figure 9. Suzanne Lacy, *Monster Series: Construction of a Novel Frankenstein*, 1974, film still with Lacy and Sarah Macy. Courtesy of the artist.

Political theorist Silvia Federici "confirms the feminist insight which refuses to identify the body with the sphere of the private and, in this vein, speaks of the 'body politic.'"[31] "Construction of a Novel Frankenstein" grappled with the ways in which we are connected, as humans to each other, and as humans to our creations.[32]

One Woman Shows

The women's art community in Los Angeles in which Lacy was involved was crucial for her artistic exploration of relationships. In a typescript she prepared for her performance *One Woman Shows* in 1975, she wrote:

> I am interested in the creation of a new culture of becoming-by-acting, one in which the model of the aesthetic process will be extended as a way of being in the world. I feel it is my responsibility as a woman-making-art to make evident the process by which I participate in the creation of my own identity, and to provide structures which will allow for others to share in this activity. These structures should reflect my belief that the *right to name* and the *responsibility of naming* rests equally in everyone. It is precisely this act, the act of putting names to individual perception, which the artist claims, and which women are now beginning to demand.[33]

The 1975 piece *One Woman Shows* marked Lacy's shift to a larger scale of work and adoption of a "performance structure" that allowed her to explore formal, conceptual, and practical aspects of many women making art. Some approaches that Lacy introduced here were subsequently used over the next two decades in her other large-scale projects, refined formally or conceptually but linked to this early work. The nearly month-long piece (April 5–26, 1975) at Grandview Gallery in Los Angeles involved women choosing women who chose other women in a type of chain-letter event to produce individual, personal performances that allowed participants to join "in your own personal symbolic act of self-naming" (Figure 10). In *One Woman Shows,* Lacy wanted to include nonartists in the work, use an action or object to symbolize a woman's claiming her own power, and then, by combining the "self-namings" in a single work, make a statement about women's culture. A two-part approach—community formation and community expression—aimed at accomplishing these goals. The community formation, or recruitment, began in March with women whom Lacy had contacted calling her to tell her the names of women that they had invited to join them. Lacy viewed this "personal verbal communication from one participant to another" as a critical component of the piece.[34] (There was no e-mail at that time.) Participants attended one organizational meeting in late March at the gallery.

The performance started in the gallery with a group meditation. Then Lacy began, having selected three women "for whom I wanted to perform an act of self-naming. . . ." The three women watched, while the rest of the audience observed from a roped-off area, in a three-tiered arrangement of audience, participant-observers, and performer. The three women for whom

ONE WOMAN SHOWS ONE WOMAN SHOWS ONE WOMAN SH
Suzanne Arlene Mary Laurel Ruth
SHOWS ONE WOMAN SHOWS ONE WOMAN SHOWS ONE WON
E. K. Michele Susan Rita Joan Pat
WOMAN SHOWS ONE WOMAN SHOWS ONE WOMAN SHOWS
Signe Barbara Theo Susan Sheila
ONE WOMAN SHOWS ONE WOMAN SHOWS ONE WOMAN SHC
Eleanor Sarah Susan Helen Mary
SHOWS ONE WOMAN SHOWS ONE WOMAN SHOWS ONE WC
Betty Ellen Deena Condonee
WOMAN SHOWS ONE WOMAN SHOWS ONE WOMAN SHOWS
Aurelia Evelyn Judy Melissa
ONE WOMAN SHOWS ONE WOMAN SHOWS ONE WOMAN SHC
Edie Jane Roxanne Bobbie Ann
WOMAN SHOWS ONE WOMAN SHOWS ONE WOMAN SHOWS

Lacy performed responded to her, and then Lacy left, and each of the three performed for women they had chosen. "Their audience in turn became performers for still other women. . . . What starts as a single performance will soon become a series of simultaneous personal rituals all taking place in a public space. . . . As the loss of boundaries between individual works intensified, the watching audience traveled from witness to a performance to witness to a community in process." Participants were instructed to do their performance and leave their trace, "some form of artifact and explanation of the act" that could stay in the gallery. The performance continued throughout the month as the chain grew, but began on opening night. That first night Lacy performed for art historian Arlene Raven, librarian Mary Holden, and artist Laurel Klick; Arlene performed for Ruth Iskin and Susan King; Mary performed for Rita, Joan, and Eileen; Laurel performed for Barbara, Susan Mogul, and Signe Dowse; Ruth performed for E. K. Waller, Vanalyne Green, and Michele Kort; and so on. (Nearly fifty women were involved over the three-week period.)[35]

In Lacy's performance for "one woman show" she enacted "the woman who is raped," "the woman who is a whore," and "the woman who loves women." Philosopher Ti-Grace Atkinson in *Amazon Odyssey* (1974) theorized that the roles of rape victim, prostitute, and lesbian were symbolic restraints that circumscribed women's behaviors.[36] This analysis was compelling to Lacy, who explored these ideas not only in *One Woman Shows* but

Figure 10. Postcard for *One Woman Shows*, April 5–26, 1975, Grandview Gallery, Los Angeles. Pink cardstock, 5 × 8 inches. Courtesy of Suzanne Lacy.

also in subsequent works. Lacy paired the rape victim, the prostitute, and the lesbian with an action: reading the day's rape reports from the Los Angeles Police Department; drawing blood from her arm and injecting it into a grapefruit that she imprinted on the wall; and slamming her clothed body, soaked in black paint, into the white gallery wall (Figure 11).[37] Lacy then departed, leaving behind a crowded Grandview Gallery, with the audience standing eight people deep.[38]

One Woman Shows was also profoundly influenced by Arlene Raven, who had returned from Boston and a meeting with theologian Mary Daly to insist that Lacy read Daly's *Beyond God the Father*. Daly's 1973 book challenged patriarchal Christianity and helped shape Lacy's own embodied art, "the awakening of women to our human potentiality through creative action."[39] In addition to the expression of women in community, Lacy was also providing a structure in this piece for any woman to be a performance artist. By the mid-1970s then, Lacy was exploring collective processes as well as questions about who an artist is and what defines her as an artist, putting into practice emerging feminist theories from books and conversations.

Figure 11. Suzanne Lacy throwing her paint-soaked body against the wall in *One Woman Shows,* April 5, 1975, Grandview Gallery, Los Angeles. Courtesy of the artist.

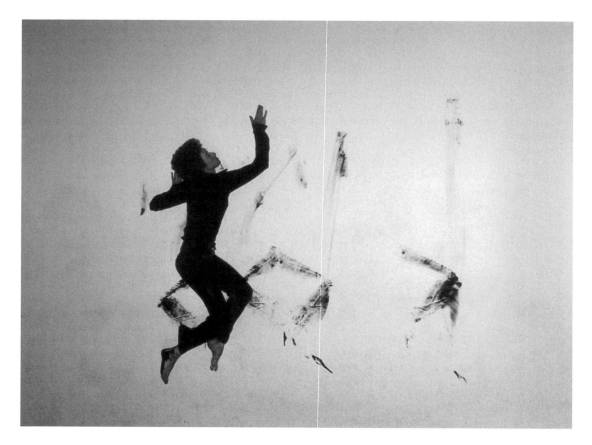

Writing about *One Woman Shows,* Lacy reflected that initially she had intended to remain anonymous as the event's organizer ("my act would be one act among many"), but that that decision ultimately seemed "artificial." "The decision to author the piece heightened my feelings of vulnerability: the success of the performance depended upon the meaning of this act for other women and their responses to it." In *One Woman Shows,* the collaborations defined Lacy's "success" to an extent and shaped the work, which would have been conceptually small without others' contributions. Lacy noted, "[The acts of self-naming] appeared simple, but the entire process depended upon the willingness and the seriousness and the spirituality with which the activity as a whole was approached."[40]

The form that Lacy created, a sequential set of pieces over time in a space, modeled the dynamism that she felt defined the essence of being human. "I believe identity is a dynamic rather than static concept; it is activity (the verb), existing in the *spaces between* bodies, and in the bodies which are themselves dynamic energy relationships. I do not accept the definition of woman as WOMAN (the noun), a person contained in an identity she 'was born with,' nor do I accept the definition of ARTIST as a person who was born into or adopts a role by virtue of certain unique and static characteristics which center around the notions of talent and creativity. . . . I am trying to find my identity in my acting."[41] Already in 1975 Lacy was keenly aware of positionality and its relation to performance.

Considering Lacy's oeuvre as a whole, I find *One Woman Shows* particularly important in her career: first, the scale of the piece was larger than anything she had yet done and involved a network of women; second, her writing about the piece articulated so many key ideas in her practice, from embodying the dynamism of relationships to the "spaces between," that provide the focus for this book; and third, the themes of violence against women and loving women have remained significant throughout her career.

Degrees of Separation

Even though 1976 was just over thirty years ago, it is challenging to keep in mind how socially segregated most people were then, despite telephones, televisions, and other media that were readily available to many. Of course, many of us still remain well within our social comfort zones most of the time, although headlines intrude online and messages beep continually. Lacy, however, wanted social connections, connections that would address injustices. She often positioned herself as an investigator in order to travel to places "where one becomes most fully aware of one's multiplicity," as María Lugones put it.[42] Lacy sought to understand the degrees of separation between herself and others, on both philosophical and practical levels.

Lacy's *Prostitution Notes* (1974) was a performance that came about because she wanted to know beyond superficial stereotypes what prostitutes experienced. Popular imagery included made-up madams who ran brothels in the "wild West," or seamy urban scenes of scantily clad women and their potential clients on dark streets; "prostitution" was barely mentioned as a real-life activity. Just as feminists in the 1970s were uncovering instances of rape and domestic abuse in their own circles and beginning to name these violent acts out loud as political acts against women as a group, so too were activists coming to terms with prostitution as it existed in contemporary life.[43] Prostitution embodies a range of exchanges—bodily and monetary—as well as networks of pimps, johns, police, court officials, and sex workers.

Prostitution Notes reported on the psychosocial spaces Lacy encountered during her four-month-long investigation of prostitution in 1974; this and other data were keyed to ten crudely drawn sections of Los Angeles.[44] To begin this performance, Lacy drew circles within circles on large pieces of brown craft paper, representing her friendships, acquaintances, and contacts. Lacy's piece queried the extent to which her own life was linked to that of prostitutes. "[I]t started with looking at my friendship network to see how far out I had to go. . . . [A]t what ring did prostitution occur? . . . I discovered that prostitution was within my first ring. . . . I found that one of my men friends was a male prostitute and he would take me up to Hollywood Boulevard."[45] She contacted people, met with them and their contacts in their social spaces, such as bars or coffee shops, itemized what they ate during their conversations, and also began collecting items from those locations to affix to the maps, such as restaurant matchbook covers (Figure 12). The documentation included photographs and annotations of her "tracking" prostitutes around Los Angeles, including an image of Lacy and Margo St. James (founder of COYOTE [Call Off Your Old Tired Ethics] prostitutes' union in 1973), whom Lacy subsequently accompanied to "see a hooker that was busted on a set-up by the cops, one of whom gave her VD [venereal disease] in the process."[46]

For Lacy, *Prostitution Notes* was a way to explore the spaces between her life and "these women whose lives were such powerful icons for my gender." As she wrote on the map illustrated in Figure 12, "Movement is the Form of 'The Life.' Place is the information, the language." The networks that interested her became clearer when transferred to a map in order to visualize them, and yet they were fluid as contacts shifted or disappeared. She intentionally avoided walking "the streets as an art performance, or dress[ing] up like a prostitute in order to flirt with their reality."[47] The "spaces between," while metaphorical, were also literal. "The street corners, restaurants, and bars of Los Angeles took on a new appearance. . . . Sunset at Highland is a very hot spot for hooking. I'm amazed, since I've passed it

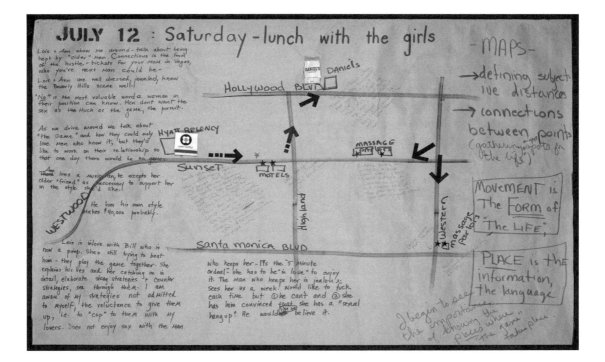

Figure 12. Suzanne Lacy, drawing from *Prostitution Notes: Saturday-lunch with the Girls, July 12, 1974*, 1974. Ink and collage on craft paper, 30 × 48 inches. Courtesy of the artist.

hundreds of times" without seeing it in that way.[48] As geographer Steve Pile wrote, "Exploring the unknown city is a political act: a way of bringing to urban dwellers new resources for remapping the city."[49] When Lacy framed the ten large annotated diagrams (nearly three feet by four feet) on brown paper from *Prostitution Notes* for exhibit in the 2007 WACK! show in Los Angeles, it was a commentary on enduring power relationships. Whether in 1976 or 2007, networks of women, johns, and pimps still exchange money for sex in capitalist, patriarchal, urban systems.[50]

Anatomy Lessons

By the mid-1970s, Lacy was experimenting with many genres—photography, collage, artists' books and postcards, video and performance—and in many contexts. A series that she called *Anatomy Lessons* was done over several years (1974–77). The chronology at the back of this book lists all the work in this series. Lacy reworked the imagery, texts, and titles from *Anatomy Lessons,* and these showed up as well in performances and handmade books during the same years. As confusing as the titling is, these pieces are among Lacy's best from her early career and demonstrate how she pursued an idea in terms of medium, composition, and its depictions in text, image, and embodied performance. To explore *Anatomy Lessons* from the nodes of body art, gender, performance, and comparative art history, I will focus

on portions of *The Anatomy Lesson #2: Learn Where the Meat Comes From* (1976), *The Anatomy Lesson #3: Falling Apart* (1976), and *Anatomy Lessons: "Floating"* (1977).

Learn Where the Meat Comes From

Lacy's fourteen-minute color video *Learn Where the Meat Comes From* (1976, directed by artist Hildegard Duane), formed part of the *Anatomy Lessons* exploration. Lacy assembled her commentary using recontextualized words from nutritionist and cookbook author Adelle Davis and chef Julia Child. A set of twelve color photographs of Lacy's performance by Raúl Vega has the same title; Plate 1 reproduces one of them. In *Learn Where the Meat Comes From*, Lacy literally tackled meat in the process of preparing a lamb roast. Her performance was all found text from writings by Davis and cooking shows by Child, as well as exercise regimes by health guru Jack LaLanne.[51] An elegant kitchen provided the setting for Lacy, who stood behind a counter on which a skinned lamb carcass rested. Lacy explained the various cuts, repeating an actual cooking lesson by Child that "[i]nnumerable housewives buy lamb year after year, often spending hundreds of dollars. . . . Taking the time to learn where the meat comes from will ensure your constant success." Lacy then instructed her viewer to become the lamb, just as she proceeded to do on camera: she inserted false teeth so that her lips were pushed away, and she thus began to resemble the flayed head of the lamb. She got down on her hands and knees: "Try to imitate the movements a lamb would make and notice which muscles you use. Imagine you are a curious animal, often turning, lowering and raising your head," she said, quoting Child. Lacy then transformed herself into a sort of vampire, exchanging one set of teeth for the plastic pointed versions from costume shops, and began to embrace and wrestle with the carcass. The video concludes with Lacy eating (with her own teeth) slices of the roast at a properly set table.

In this video Lacy investigated gender roles, the interconnections between life and death, her own body and that of other animals as well as monsters.[52] While on one level this humorous tape mocked cooking shows and housewives who watched them, on another level Lacy was continuing her experiments with representations of death, vulnerability, violence, and the self by performing as a lamb and then eating it. Lambs, of course, call to mind animal sacrifice in various religions, in addition to the Christian apostle John's reference to Jesus as the "Lamb of God."[53] While *Learn Where the Meat Comes From* was a solo video performance, there are some themes that connect it to her large group projects of the 1980s: the use of video; the focus, however parodic, on a traditional women's sphere, in this case cooking; and the physical merger with an animal carcass and all it represents—death, nurture, the other.

Learn Where the Meat Comes From—and the still photographs made

at the same time—focused on Lacy's body in an interior space and shared some conceptual elements with work by artist Lucas Samaras. Another former student of Allan Kaprow's and a regular participant in early East Coast Happenings, Samaras acted in *Self*, in 1969, an "assisted autobiography" that was filmed and edited by critic Kim Levin. Lacy becoming a vampire/lamb, who then cooked and ate the lamb, paralleled Samaras in *Self* during a dining sequence, in which he ate the letters that spell "self," as well as pictures of his family members.[54] Although this particular piece was unknown to her, Lacy had been impressed with his published imagery and writing even prior to a 1975 exhibit of some of Samaras's photo-transformations at the art museum at California State University, Long Beach. Lacy commented, "He talked about this messy quality of being inside a body and being born, being inside of a birth canal, being of flesh, and how problematic that was. . . ."[55]

Many artists, and many feminist artists, in the early 1970s used video, a medium newly available to the layperson.[56] (Still, a Portapak camera was much more cumbersome than today's models, weighing about eighty pounds, and the editing equipment was far from simple.)[57] In 1975, then San Diego–based artist Martha Rosler created a different version of a "cooking" show in her seven-minute video *Semiotics of the Kitchen*. Also a solo performance, *Semiotics* used kitchen utensils to humorously communicate hostility and frustration as a kind of "antipodean Julia Child."[58] Rosler alphabetized the utensils that she "demonstrated," jabbing, stabbing, and whipping them into the air around her, all the while maintaining a deadpan demeanor.[59] While Rosler's video used her body and cooking tools to imply oppressive behaviors that confined women to kitchens, Lacy's video overtly expressed life-and-death struggles as played out in the home. *Learn Where the Meat Comes From* externalized mortality and difference by using the lamb carcass.

Fallen Woman, Falling Apart

Also in 1976, Lacy collaged photographs of herself for *Anatomy Lesson #3*, titled *Falling Apart*, and she created a related artist's book, initially called *Fallen Woman*. The five collaged photographs of *Falling Apart* show Lacy's nude body falling through space.[60] Each of the black-and-white photos of Lacy's body was ripped apart in different ways, with the rent filled with a torn color photograph of intestines. (Lacy had photographed the guts after tossing them into the air. There was no Photoshop in 1976.) Susan Mogul, who photographed Lacy for this set, angled the camera up so that Lacy appeared against a cloudless sky, with no features defining the space. Lacy's tumbling hair shades her expressionless face. Her arms are flung above her head, opening her chest and making her rib cage prominent under her light flesh. In the version illustrated in Plate 2, her legs have been wrenched apart

at the pelvis, with her pubic area, one hip, and leg separated from the other leg and the rest of her torso. The curved, boomerang shape torn from the image of guts parallels the angle of her right leg. Her left leg flails in the air below the dark irregularities of the viscera, which seem to spill out of her abdomen. That the guts are in color reinforces their prominence, making them seem more vivid than the external body (Plate 2).

Closely related to *Falling Apart,* and instructive in its relationship, is another staged photograph from *Anatomy Lessons* (Figure 13). In "Floating" (1977) Lacy is suspended nude in water instead of in air. She lies in a swimming pool "with guts on top of me so that it looks like I'm being eviscerated. . . ."[61] Despite the gory associations of this image, Lacy's face is calm, with just a hint of tension between her closed eyes. She appears to tenderly hold bulbous organs in place as the water ripples over her torso and legs. A shadow of half of her body on the floor of the pool stabilizes the bottom of the photo. Curved reflections of light on the water's surface fill the rest of the frame, with no deck or ledge in view. The textures and shapes of Lacy's intact body together with the viscera floating in a sunny pool focus atten-

Figure 13. Suzanne Lacy, *Anatomy Lessons*, "Floating," 1977. Photograph by Rob Blalack. Courtesy of the artist.

tion on the contrast between inside and outside. There is no narrative or action to displace the focus on the body parts, which seem simultaneously real and abstract.

Stan Brakhage's 1971 film *The Act of Seeing with One's Own Eyes* inspired Lacy, who had been intrigued with dissection and bodily interiors since her days as a premedical student. She herself had participated in more than one autopsy. In this particular film, according to film historian Bruce Elder, Brakhage used the daily routines of pathologists performing autopsies in the Pittsburgh morgue to set up a "tension between responding with horror at the images, and responding to the real beauty of the images (for they are astoundingly beautiful); that this is the character of the film's central tension suggests that beauty and horror lie close to one another, an idea that has long been a key to radical aspiration in the arts."[62] The Brakhage still of a female cadaver sliced open with half of the skin peeled away is echoed in Lacy's *Anatomy Lessons* (Figure 14). In both cases—Brakhage's and Lacy's—a female body was the instrument used to explore the tensions of inside/outside, horror/beauty, and self/other. In Lacy's case, however, she

Figure 14. Female torso during autopsy, film still from Stan Brakhage, *The Act of Seeing with One's Own Eyes,* 1971. Photograph by Sharon Irish.

used her *own* body. Meiling Cheng argued that "by deciphering her own body as a text, . . . [Lacy's] corporeal methodology tampers with essentialism" because Lacy made her body the "universal sample of human physiology."[63] Her "specifically sexed body" was her starting point for coalition building.

The mutilation of her body in *Anatomy Lessons* was pictorial, while *Fallen Woman,* a handmade book from 1976, considered this violence textually. Appearing in an edition of twenty and dedicated to Arlene Raven, *Fallen Woman* had forty-two nearly square pages ($7^3/_4$ inches by $8^1/_4$ inches) of brown craft paper that were hand-stitched. The book was wrapped with an ace bandage, signaling both injury and care for an injury (Figure 15). The typewritten text included accounts of dreams interspersed with memories dated between December 1970 and February 1974. Lacy was not only describing violence with words but also contemplating the ways in which words connoted violence. Definitions were freely associated with the evocative text: body, fall, vigil, hands, blood brother, bloodshot, eye, eyewitness. Both the book and a shortened version of it published in *Dreamworks* in 1980 began: "This is a tale of four bodies, or parts of bodies, or even single body pieces. Some may see it as fragmentation. Others will recognize dismemberment. It could also be understood as memory, the memory which resides in each cell, each vessel and bone of my body."[64] The vignettes were grouped under four different body "parts": I remember falling; falling from grace; a Fallen Woman; and to hang without falling. The graphic physical maiming described in the text also represented psychological states.[65]

Much of the book's material was also contained in two performances called *Under My Skin,* one in San Francisco in 1975 and one at the Chicago Institute of Contemporary Art in 1977 (Figure 1). "Where does the violence come from?" Lacy asked in *Fallen Woman.* How is memory embodied? At what point do we die? What does evil feel like? "Once upon a time a little dracula was born in the small town of Wasco," the text reads, mixing autobiography, fairy tale, and horror literature. Dreamlike stories of childhood traumatic memories, a tour of a slaughterhouse, and an image of her hanging like a cow surface in the book and performance text: "I hang with my belly cut open. Someone reaches into the opening. He tries to pierce my heart with a long knife. . . . I do not die finally, . . . I am thrown on my back, my arms over my head, waiting watching as if through a tunnel, the birds circling round in the sky, and at last all I see is their flying."[66] While the photographs from *Anatomy Lessons* did not directly illustrate Lacy's artist's book, they provide visual analogs to the book's references to slit bellies and other traumatic injuries, and birth as well.

Similar verbal imagery occurred in the writing of Lacy's mentor and colleague Deena Metzger. An excerpt of Metzger's prose from her *Skin: Shadows/Silence: A Love Letter in the Form of a Novel* (1976) reads: "I want

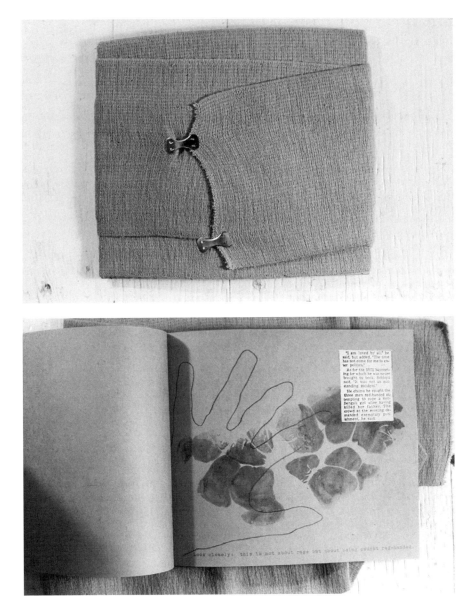

Figure 15. Suzanne Lacy, *Fallen Woman*, 1976. Brown craft paper, hand-stitched book, closed; forty-two pages, 7¾ × 8¼ inches. Courtesy of the artist.

to reach for a knife to carve myself into morsels, to divide into portions, to carve a slit downwards from my navel to my spine," a description of the humiliation of her rape.[67] Metzger sometimes told her students to "make a list of everything you must not write about." The goal was to begin the exploration of the self, "a vast, unexplored, and prohibited geography."[68] If this request were to be modified into a 1970s list of images that art must not depict, the list would include embodied motifs: menstruation, menopause, vaginas, blood, masturbation, rape, incest, prostitution, verbal and physical

abuse, self-mutilation, mental illness, rage, and cannibalism. While the first three words are unique to female bodies, vanguard artists of both genders and all media in the 1960s and 1970s were pushing art into taboo territory to examine relationships between horror and beauty.

Cinderella in a Dragster

In solo pieces, Lacy often took on characters who presented rich metaphorical possibilities: Cinderella and drag racer, among others. Her performance of *Cinderella in a Dragster* in 1976 extended in time and space, considering the art form of performance as well as the necessity of traveling up and down the state to earn her living teaching performance art. The piece began when Lacy flew from Los Angeles, where she lived, to San Francisco to teach, then flew back, drove to Irvine, and met the owners of a dragster when she arrived at California State College, Dominguez Hills (now CSUDH).[69] To prepare for this part of the performance, Lacy previously had paid by the lap to drive a formula car at the Grand Prix Racetracks. Then she had gotten acquainted with some (male) hot-rodders and arranged to borrow a dragster. Dressed in a yellow racing suit, she drove the dragster to the library on the campus of Dominguez Hills.[70] She then performed from the car for invited guests and an art class (Figure 16).

Figure 16. Suzanne Lacy performing *Cinderella in a Dragster*, 1976, California State College (now California State University), Dominguez Hills. Courtesy of the artist.

This semiautobiographical presentation concerned being an itinerant performance artist but also reflected on her circumscribed childhood in Wasco, California: "[I]f you've seen 'American Graffiti' you have a pretty good idea of what Wasco is like. It was very small, one mile square, and I calculated that I must have traveled fifty miles a week when I was ten, if you count vacations. . . . [W]ho, growing up in Wasco, could have imagined Los Angeles?"[71] In addition to using the Cinderella story to describe her peripatetic life, she used it as a way to describe this emerging art form:

> . . . I think one reason I like performance art is that you can
> work on the road, in cars or airplanes. . . . Cinderella is a fairy
> tale and that's a lot of what performance art is about, creating
> elaborate structures so that everything in your life seems to
> relate to the story at hand. . . . So whatever it is that I experi-
> ence in this lifestyle [of embracing acceleration] as it intersects
> with mine I synthesize into an image and that's this one which
> hangs in the air between us now, that's this fairy tale about how
> Cinderella became a metaphor for my life as a drag racer. . . .

Beyond the metaphor was Lacy's interest in the "point of contact between you and me . . . my life becomes . . . your own material out of which you will make your images and that may be art and it may be something else. . . ."[72] Lacy's rapid delivery in Dominguez Hills was "deeply indebted" to her friend the poet and critic David Antin (born 1932), whose talk poems featured "relentless, breathless" delivery in which the words seemed to have a "physical trajectory."[73]

The performance continued with Lacy tossing a slipper out of the dragster as she drove off. Then she drove south (in her own car) to teach her class in performance at the University of California at San Diego. There, she baked a pumpkin pie while wearing just one "glass" slipper, moving in an off-kilter fashion as she cooked.[74]

Lacy's *Cinderella in a Dragster* was featured on the cover of the very first issue of the quarterly *High Performance* in 1978, and as Moira Roth noted, this marked Lacy's arrival into national prominence.[75] Lacy's *Cinderella* wryly enacted the movement of labor up and down the California coast in order to earn a salary, drew parallels between a fairy-tale fantasy world and that of competitive car racing, humorously juxtaposed a male-identified car and a feminine high heel, and echoed other cooking performances, as when Lacy cooked and ate the lamb in *Learn Where the Meat Comes From*.

Allan Kaprow talked about the "extended space" of performance with Richard Schechner in 1968, specifically mentioning racing: "Some sports are not arena sports—such as Grand Prix racing, cross-country racing, surfing. These have an indeterminate locale. I think of theatre in broader terms than most theatre people."[76] Lacy herself broadened her "arena" by flying,

driving on freeways, using a dragster as a stage, and then moving from there into her classroom in San Diego. In the process of performing, she was also helping to define and enlarge performance art, "creating elaborate structures so that everything in your life seems to relate to the story at hand." *Cinderella in a Dragster* interacted with the geography of Los Angeles and Southern California—distinct areas separated by freeways. Into an industrialized, militarized landscape, Lacy inserted individual experiences that resisted any universalizing schema, and at the same time those embodied contacts traced connections among larger social forces.

3 THE URBAN STAGE

SOCIOLOGIST WINI BREINES DESCRIBED FEMINISM in the mid-1970s as "a tidal wave at its crest, evident locally and nationally in the thousands of activities and projects initiated by feminists." The International Women's Year Conference in Houston, Texas, in 1977 had twenty thousand women in attendance. Women were joining in analyses and protests of violence against women, feminist publications were expanding exponentially, and women were also challenging other women "to understand their racism and convert the movement into one in which women of all races and ethnicities were recognized, were affirmed, and could operate fully."[1] Converting that movement involved telling long-ignored stories. Susan Brownmiller, for example, noted in her examination of rape in 1975: "Rape in slavery was more than a chance tool of violence. It was an *institutional* crime, part and parcel of the white man's subjugation of a people for economic and psychological gain."[2] While social segregation among women, and particularly white racism, continued to challenge coalitional work, many feminists like Brownmiller and a few artists such as Suzanne Lacy were passionately committed to creating literal and figurative spaces in which women "were recognized, were affirmed, and could operate fully."[3]

At this juncture in time, Lacy scaled up her own activities, turning her considerable aesthetic and organizational skills to, first, creating performance structures (as she called them) where people could listen to each other; second, making these conversations as visible as possible; and third, keeping the dialogues focused on action. Her shift to larger work also coincided with the return to the United States from Europe of artist Leslie Labowitz in 1977.

Three Weeks in May

In 1977, rape victims and victims of violence in the home were largely invisible, with the media focused on them only when the violence or numbers were dramatic.[4] For example, the highly publicized trials of Inez Garcia for shooting two men in California in 1974 whom she accused of raping her received national attention. (One man, Miguel Jimenez, died of gunshot wounds.) Garcia was convicted in 1974, spent two years in prison, and then was acquitted in March 1977 in a second trial. A "docudrama" called *The People vs. Inez Garcia* was widely aired on public television in May 1977.[5] In general, however, safe houses, help hotlines, and crisis centers for rape victims were overextended and disconnected from major social services.

Against this background and with her own lengthy antirape involvement, Lacy organized an "expanded performance," *Three Weeks in May*, in Los Angeles in 1977.[6] Lacy wanted to address city dwellers who gave little thought to rape and its politics at the same time that she and her collaborators themselves took action. By May in Southern California, the winter rains have ended, and the temperature is mild, thus facilitating outside events. Lacy often works in threes; in this case, a three-week period was of sufficient length to garner attention across Los Angeles. She designed the project to be a "simultaneous juxtaposition of art and non-art activities within an extended time frame, taking place within the context of popular culture."[7] The city of Los Angeles was the spatial frame for this work, with distributed nodes (using my scheme) that allowed for private and collective expressions, small personal gestures, or "little frames of life," as Lacy called them, within a large urban network.[8]

Mapping Rape

Three Weeks in May opened on Mother's Day, May 8, 1977. Two maps by Lacy were the focus of the project. A map that revealed locations of rapes flanked a second one indicating where to find treatment centers, shelters, and organizations working for safe neighborhoods. In Lacy's daily performances over three weeks, she used a large stamp with the word "RAPE" and pounded the word in red ink onto the map to show the locations of reported rapes, which totaled ninety after three weeks. (Notoriously underreported, the rape count still averaged four to five rapes a day.)[9] Lacy had made these two twenty-five-foot maps by delineating the incorporated parts of Los Angeles city and county, an area for which rape statistics were available through the police. The map on which she marked rapes was bright yellow, backed with asphalt paper, and set off with yellow caution tape (Figure 17). Lacy's mentor graphic designer Sheila de Bretteville (who was then active at the Woman's Building) had encouraged Lacy to leave the gallery and speak to a broad audience: "'Make it look like a road. Make it look like something that people

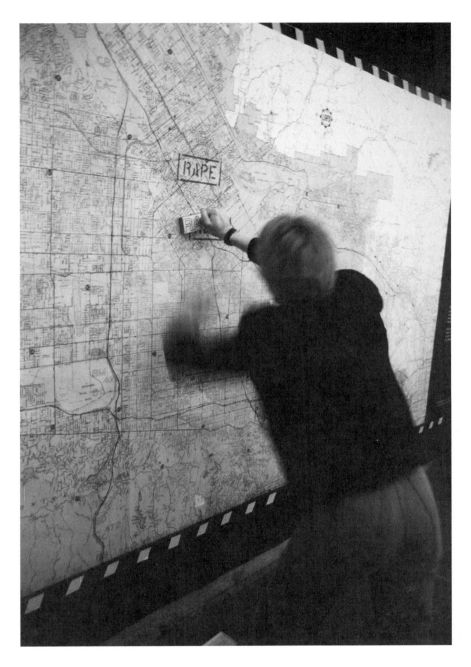

Figure 17. Suzanne
Lacy stamping
RAPE on map
of Los Angeles in
*Three Weeks in
May*, May 1977,
City Mall in City
Hall, Los Angeles.
Courtesy of the
artist.

travel through that's very much part of their experience.' This led to the no-
tion of locating things geographically on maps of Los Angeles."[10]

The maps were installed in City Mall, a public subterranean shopping
arcade in City Hall in downtown Los Angeles. While tourist maps of Los
Angeles feature locations for Universal Studios, Hollywood, Little Tokyo,

Chinatown, the Getty Center and so on, *Three Weeks in May* provided different maps, revealing locations of violent assaults and pinpointing organizations working to support rape victims. The City Mall, where many related events were held, was not the organizers' first choice, due to its relatively light pedestrian use and underground location, but in fact many city employees were drawn into the project who might not otherwise have been, and the project thus gained civic support and increased media access. As Jeff Kelley noted, "Ironically, the underground City Mall . . . positioned the artist and her project in the middle of a network of people, agencies, and funding sources that contributed to a greater degree of public visibility for the project—and for its subject—than otherwise could have been imagined."[11] Cosponsored by the Woman's Building and the Studio Watts Workshop, *Three Weeks in May* included other organizations as well: the City Attorney's Office, the Commission on Public Works, the Los Angeles Commission on the Status of Women, Women Against Violence Against Women, the East Los Angeles Hotline, the American Civil Liberties Union, the Los Angeles Police Department, the Sheriff's Department, and the Ocean Park Community Center Women's Shelter.

In addition to her own public performances with the map, Lacy curated the thirty other parts of *Three Weeks in May*. She invited women artists into her open structure, recognizing that they would take multiple approaches appropriate to different ways of being and different audiences. This was a deliberate, feminist strategy to acknowledge the specificity of practice: there was no universal observer, no neutral space, no single artistic gesture that would suit everyone. Private, women-only rituals as well as public art performances on the street occurred during the three weeks; symposia, radio programs, and workshops on rape and its prevention took place simultaneously with self-defense classes and speak-outs. Conceptually, Lacy was interested in contrasting experiences that occurred in the same spaces, much as she had pondered in *Prostitution Notes* how the same social spaces were altered depending on the people moving through them. Lacy and her collaborators chalked sidewalks near where rapes had occurred, for example (Figure 18).[12] The outline of a body on a sidewalk provided a graphic "you are here" marker of violence and activated new meanings in locations that may never before have been associated with violence in most people's minds.

The structure of *Three Weeks in May* allowed for a variety of experiences to be represented and enacted, not only to publicize the problem of rape for those oblivious to it but also to transform the organizers and participants themselves. The time frame of *Three Weeks in May* as well as Lacy's inclusion of many others also recalled her *One Woman Shows* from two years earlier. Lacy invited the artist Leslie Labowitz, among others, to make a contribution to the May project just after meeting her earlier in 1977.[13] Labowitz, who became an important collaborator with Lacy after *Three Weeks in May*,

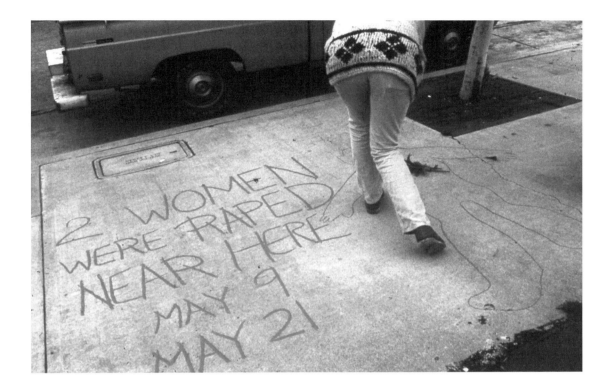

created a series of four public performances, "The Rape," "Myths of Rape," "All Men Are Potential Rapists," and "Women Fight Back"; these performances used Inquisition-like figures in pointed caps, others bandaged in gauze, and placards with hand-lettering.

A key role that artists played in *Three Weeks in May* was as communicators, public spokeswomen for the cause of female safety. Lacy designed *Three Weeks in May* to convey the ideas in a few images, with "a message that c[ould] be explained in thirty seconds by a reporter who may only invest a few minutes of her or his time at the event. . . ." The artists also used the media as an organizing tool in order to gather different people together around the issue of violence against women and as a generator of discussion.[14] "[T]he piece became an open structure for the dissemination of information beyond that possible for any one agency, individual, or artist," Lacy wrote.[15]

"When I developed *Three Weeks in May*, . . . it was Allan [Kaprow]'s theories that allowed me to move into the public, using the frame of the city to contain a variety of 'acts,' from reflective conversations to media interventions," Lacy recalled in *Artforum* just after Kaprow's death.[16] Kaprow had been one of Lacy's teachers at CalArts in the early 1970s and had used elements of urban Los Angeles—spatial dispersion in particular—in his Happenings of the previous decade.

Figure 18. Chalking sidewalks near sites of rape, *Three Weeks in May*, May 1977, Los Angeles. Courtesy of Suzanne Lacy.

In his 1966 book *Assemblage, Environments, and Happenings,* Kaprow had listed a number of rules of thumb, including:

> *The performance of a Happening should take place over several widely spaced, sometimes moving and changing locales . . .* by gradually widening the distances between the events within a Happening. . . . On the one hand this will increase the tension between the parts, . . . On the other, it permits the parts to exist more on their own, without necessity of intensive coordination.[17]

Both time and space were critical elements in the unfolding of *Three Weeks in May.* Spaces of rape, education, performance, and healing all spiraled through a three-week time frame. Moving among events around the city reinforced the idea that rape was widespread.

Three Weeks in May was Lacy's first large-scale public art project and included most of the strategies that have come to characterize her work, including using local and national media coverage in print and video to engage multiple audiences. Lacy remarked: The "appropriateness of message to medium is also part of the *aesthetic* integrity of the performance."[18] She admonished artists who were making art for billboards or television, for example, to incorporate critiques of those media in their art, to look critically at the social functions of what they produced. "Our goal is to change the very basis of our relationships with images so we can begin to make our environment rather than allowing it to make us," she wrote in 1981.[19] In 1982, Lacy published a limited edition book of ten copies to document *Three Weeks in May.* It was bound in yellow cloth.

"She Who Would Fly"

As a node in *Three Weeks in May,* Lacy created a personal, small-scale installation, "She Who Would Fly," in contrast to her public, gestural map marking. On May 20 and 21, 1977, at the Garage Gallery of Studio Watts Workshop in a hilly area of Los Angeles known as Highland Park, Lacy conducted a three-part performance. First, Lacy collected intimate, written testimonials of people's rapes; second, there was a private ritual with a few women, each of whom had experienced sexual violence; and finally, the tiny gallery was opened to members of the public, three or four visitors at a time.

When visitors entered, in addition to posted maps and writings, they would have seen enlarged on one wall a powerful text by writer Deena Metzger that described her own rape experience: "'Take off your clothes,' he says. My body is shaking. The dress peels from me like skin, a heap of feathers disordered, plucked live from the skin, a mound of fresh leather in a corner."[20] A flayed lamb's carcass with white-feathered wings was suspended from the ceiling, positioned to look as if it were taking flight. Above

the entrance, four nude women with their bodies covered in red greasepaint watched the visitors (Plate 3). The raw, winged carcass and the almost otherworldly women perched above the doorway were Lacy's images of the way consciousness wrests free from the body during a rape. Visitors became participants in the performance as they read about rapes and were observed by the painted women above them. Meiling Cheng wrote that "the work's most important aspect is the moment when the audience members suddenly discover that they are being watched by these bird-women. . . . This is the moment of theatrical reversal that the artist desires, one that symbolically transforms the performers from traumatized flesh/objects into accusatory subjects."[21] "She Who Would Fly" provided multisensory experiences to connect the abstract maps on display to real lives, just as the accounts of rapes heard during *Ablutions* accompanied the rituals under way. Further, these two expressions during *Three Weeks in May*—one in the Garage Gallery and one in the City Mall—addressed different audiences with different means: in the former, a small art audience; in the latter, a larger public.

The winged lamb carcass recurred the next year in Lacy's performance with Barbara Turner Smith, *The Vigil* (1978), and dancing, decorated versions of carcasses, lined up for show, were mounted for "There Are Voices in the Desert" (1978). These lambs seem to serve as mnemonics for embodied experiences. "My body is trying to remember" is a line from Lacy's *Under My Skin,* performed in 1975 and 1977. Thus, past times and places were collapsed into a liminal realm that held many trajectories.[22]

Entr'acte

Working so closely with women who had been raped, with daily reminders of the occurrence of more rapes, and with overtaxed groups trying to prevent sexual violence as well as to help those who were suffering from its aftereffects, Lacy was emotionally and physically drained by the end of May 1977. Taking advantage of some contacts in Europe and an opportunity to participate in an Italian exhibit, the Bologna Art Fair, she left Los Angeles for respite and self-reflection.

In keeping with this chapter's theme of "The Urban Stage," Lacy's summer travels can be seen as an entr'acte between *Three Weeks in May* and another large project in fall 1977, *In Mourning and in Rage.* In summer 1977, Lacy took two trips, which she grouped into a piece called *Travels with Mona.* Her traveling companion was an uncompleted paint-by-numbers version of Leonardo da Vinci's *Mona Lisa.*[23] This choice was at once a humorous response to the tiresome question put to Lacy the artist, "What do you paint?" *and* another means of exploring the emergent field of performance. Lacy documented herself coloring in this image at various landmark sites in Mexico, Central America, and Europe (Figure 19). In addition to the pop art

interest in the 1950s' paint-by-numbers craze, Lacy's public painting performances with an image of the *Mona Lisa* recalls the various adaptations and spoofs made on this painting by Dadaists, surrealists, and pop artists: *L.H.O.O.Q.* (1919) by Marcel Duchamp, for example, and Francis Picabia's takeoff on Duchamp in 1942, as well as Salvador Dali's 1954 *Self-Portrait as Mona Lisa* and Andy Warhol's 1963 serigraph of her.[24] Painting the same image of an art historical icon no matter what the setting placed Lacy in a long line of artists who both responded to this "masterwork" and questioned it at the same time.

This travel also allowed Lacy to strengthen connections to women performance and conceptual artists outside of the United States, such as German video artist Ulrike Rosenbach (born 1943) and Brazilian photographer, filmmaker, and sculptor Iole de Freitas (born 1945).[25] While in Europe, she participated in *Global Space Invasion* at the Bologna Art Fair by invitation from San Francisco's Floating Museum, organized by artist Lynn Hershman.[26] Upon her return to California, Lacy completed the *Mona Lisa* painting in a small booth in the gallery of the San Francisco Museum of Modern Art (Figure 20). As part of this culminating performance, she displayed a letter written to the museum offering the work as a gift to their collection; the letter went unanswered.

Lacy published a limited edition of *Travels with Mona* as a small accor-

Figure 19. Suzanne Lacy painting *Mona Lisa* in *Travels with Mona*, summer 1977, Chichén-Itzá, Yucatán, Mexico. Photograph by Rob Blalack. Courtesy of the artist.

dion postcard book in 1978;[27] in each postcard, Lacy is shown working on a paint-by-numbers image of the *Mona Lisa* in some far-off setting. The text, written by art historian Arlene Raven, cleverly comments on tourist attractions, as well as mocking staid historical studies. "Painting by numbers is like touring: the uninitiated traveler/artist can be assured of the route and the outcome—Education and Culture." In front of the real *Mona Lisa*, Lacy posed with an altered postcard of the painting, part of which she had erased, "a postcard of a work of art in a postcard artwork."[28]

 With *Travels with Mona* Lacy was in the forefront of artistic explorations about tourism, kitsch, social class, and feminist interpretations of the art canon, as well as the internationalization of feminism.[29] Along with a few other feminists, she celebrated creations by women who were not trained artists or who used consumer products like paint-by-numbers to express themselves. In 1976 Lacy curated a one-woman show at the Los Angeles Woman's Building of the bottle sculptures of self-taught Tressa "Grandma" Prisbrey (1896–1988).[30] After seeking out Prisbrey as a "performance artist of life," Lacy re-created in the gallery part of a room using collected bottles set in mortar, and then borrowed the artist's artifacts for the exhibit. With Prisbrey present at the opening of the exhibit, Lacy joined with her in expanding the definitions of art and its audiences.[31] Lacy previously had

Figure 20. Suzanne Lacy painting *Mona Lisa* in *Travels with Mona,* July 20, 1978, San Francisco Museum of Modern Art. Photograph by Cheri Gaulke. Courtesy of the artist.

collaborated in the mid-1970s with Evalina Newman of Watts, who quilted and crocheted. "The shared or published pattern forms the same kind of armature for painstaking handwork and for freedom of expression within a framework as the underlying grid does in contemporary painting," Lucy Lippard wrote.[32]

In Mourning and in Rage

In fall 1977, the strangled, naked bodies of several women were found in various locations around Los Angeles. Before the year was over, a dozen bodies of women and girls, some as young as twelve years old, had been discovered. Their killers, known initially as the Hillside Strangler, turned out to be two men.[33]

One morning in early December 1977, Lacy and Leslie Labowitz were having coffee together, reading the *Los Angeles Times*. Lacy, Labowitz, and others active in the Los Angeles women's community felt that the media were portraying the Hillside murders sensationally, obscuring real issues by salacious reporting about the pasts of some of the women and not addressing the larger issues of violence against women.[34] Labowitz recounted: "The images . . . were of women, spread legs, on a hillside. I'm thinking, 'This is a double form of exploitation,' and we both said, 'This is horrible. Let's do something.'"[35]

Lacy and Labowitz had met the previous spring. Labowitz (born 1946) had a graduate degree in fine arts from Otis College of Art and Design in Los Angeles and had studied, taught, and traveled in Germany and Spain from 1972 to 1977.[36] Labowitz had developed her work on violence against women in Europe, prior to meeting Lacy. Her contacts among European socialists, her familiarity with early-twentieth-century German and Russian art and literature (such as Bertolt Brecht and the Russian Constructivists), primed her to ask:

> How can I take the conceptual art world that I came from and the feminist consciousness and merge that into something that was not theater, 'cause I wasn't a theater person? [Something] more sculptural and that was in the public space. . . . I'd always used graphics and writing in my work anyway. I started using symbols of protest and activism to create pseudo-activist events. . . .[37]

Within two weeks of their morning conversation, on December 13, 1977, Lacy and Labowitz had organized a procession of twenty-two cars filled with seventy women dressed in black that left the Los Angeles Woman's Building, following a hearse, and drove downtown to City Hall as part of *In*

Mourning and in Rage.[38] Moving through the streets of central Los Angeles, these cars were on a time-bound journey through urban space, claiming the streets as a funeral procession would. (The Woman's Building at 1727 Spring Street was near the city center.) Upon arriving at City Hall, nine figures cloaked in black and one woman dressed in scarlet emerged from the caravan. Representing the strangler's ten victims up to that time, the women in black wore headdresses that made them seven feet tall and were shaped like the tops of coffins. The ominous tall figures, followed by those from the other cars, formed a procession from the street to the white steps of City Hall. They assembled in a line with the other women arrayed behind them as a kind of Greek chorus (Plate 4). A "ritualistic press conference" began with a banner as a backdrop that read, "In Memory of Our Sisters, We Fight Back."[39] The banner was designed to fit in the horizontal frame of a camera, so that one image—of the women gathered on City Hall's steps, with the banner raised—could carry a clear meaning via mass media (Figure 21). This performance was a tableau enacted for cameras, set on the stairs that served as a proscenium stage, witnessed by the media audience.

To give further depth to the imagery, for those in the know about avant-garde film, the tall black figures recalled the image of Death from Maya Deren's 1943 film, *Meshes of the Afternoon* (Figure 22). If one did not

Figure 21. Suzanne Lacy and Leslie Labowitz, *In Mourning and in Rage*, December 13, 1977, City Hall steps in Los Angeles. Photograph by Martin Karras. Courtesy of the artist.

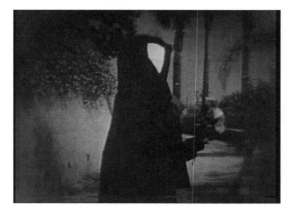

Figure 22. Film still
from Maya Deren,
*Meshes of the
Afternoon*, 1943.
Photograph by
Sharon Irish.

recognize this association, the image was still perfectly intelligible, but the reference to Deren was one way in which Lacy and Labowitz layered avant-garde ideas into their popularly accessible work.

This collective ritual produced a solemn ceremony in which the row of black figures stood out against the light gray stone and terra-cotta of City Hall, and the woman in scarlet was highlighted in her singularity. Each black-costumed figure came to a microphone to bear witness to the murders of the women and link their deaths to larger issues of women and violence. The figures were then draped in red, a color associated with rage. Thus unfolded what Lacy called "a modern tragedy," with the women behind the mourners chanting the slogan on the banner ("In Memory of Our Sisters, We Fight Back") after each mourner spoke.[40] At the conclusion of the event, singer and songwriter Holly Near sang "Fight Back," written specifically by her for this occasion. The bold colors, dramatic profiles, repetition, and single slogan fit the media conventions well, and the idea of a funeral procession connected to many people's experiences. *In Mourning and in Rage,* then, leveraged an increased willingness to focus on rape in broadcast and print media, at the same time the artists sought to reorient that coverage toward what they considered to be a woman-identified perspective.[41]

This performance claimed a public "stage," the steps of the skyscraper that served as the Los Angeles city headquarters.[42] The building faced an open green space that provided ample room for the press and onlookers. While City Hall had been featured in the television shows *Dragnet* and *Superman,* this staging was not intended to echo those fictional accounts but rather to associate official approbation with a challenge to news coverage.

In Mourning and in Rage was framed by urban space that was reinterpreted by the transient artwork in its midst. The angled headdresses of the women even echoed the top of the municipal skyscraper. As Edward Soja has pointed out about downtown Los Angeles,

[n]owhere else outside the federal citadel in Washington, D.C., is there a larger concentration of government offices, employees, and authority. . . . City Hall, with the City Hall East and City Hall South buildings just next door, is in many ways the capstone of the governmental citadel. Administering the country's second largest city, its all-American pastiche of Greek, Roman, Byzantine, and Italianate designs is symbolically LA Gotham, projecting the city's Dragnet-noir imagery televisually all over the world. Topped by a local interpretation of the Mausoleum of Halicarnassus, its 27 to 28 storeys was the only exception allowed to break the 13-storey height limit that was maintained by the city until 1957.[43]

By using a location known to television viewers, Lacy and Labowitz reclaimed City Hall from Superman and Joe Friday for real-time opposition to violence against women. With municipal architecture for the setting, the artists created a physical link, both live and in the media, between the resistance to violence and public policy (Figure 23).

The director of the Los Angeles Commission on Assaults against Women read a statement at *In Mourning and in Rage,* and three city council members—Pat Russell, Joy Picus, and Dave Cunningham—were present along with the deputy mayor, Grace Davis. The Rape Hotline Alliance presented demands to these elected officials for self-defense classes and the yellow-page listing of hotline numbers. Both in the organizing of the event and then in its staging at City Hall, Lacy, Labowitz, and their collaborators confirmed support of the authorities, drawing politicians into a cause that could have been seen as "radical." The event prompted the redirection of reward money for capture of the murderer(s) to self-defense classes for women, rape hotline numbers were finally listed in the yellow pages, and media conventions were made more visible to artists and activists who could employ similar methods on other projects.

Labowitz summarized the development of this media-savvy approach in a 1978 *Heresies* article written with Lacy:

> I started thinking about a model for its [performance's] use as a public political art form. . . . I saw the model as having five components: collaboration with a political organization; use of the skilled artist as director/organizer; a focus on issues of current concern; use of the language of the audience addressed and economic accessibility of the materials.[44]

Labowitz and Lacy proceeded to combine their talents in public events for the next several years as artist-collaborators and as organizers around issues of feminist concern that used language and materials that were widely

Figure 23. Exterior
of Los Angeles
City Hall, 1928;
designed by Austin,
Parkinson, and
Martin. Photograph
by Sharon Irish.

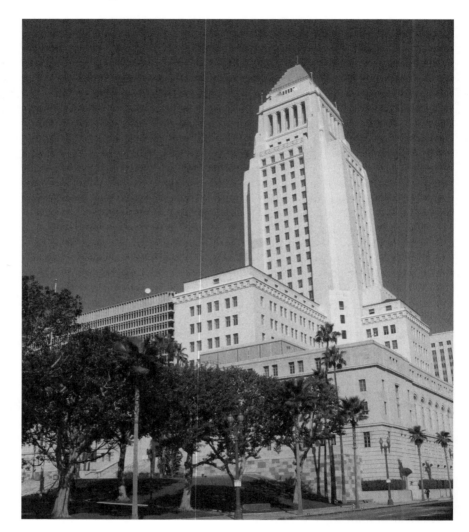

accessible. The writing and art-making collaborations of these two women
resulted in large performance structures as well as four publications.[45]

Ariadne: A Social Art Network

Lacy and Labowitz established Ariadne: A Social Art Network in 1978 in
true do-it-yourself fashion. Ariadne was a coalition of artists, activists, media
specialists, and politicians that facilitated funding and organizing for art-
related feminist actions and aimed particularly to undermine sexually vio-
lent imagery in cultural production. In addition to continuing an explora-
tion of "high" and "low" art through billboards and street performances, for
example, artists in Ariadne particularly supported mass media involvement

in feminist issues. Their intentions were not to bring members of the media in after they had decided on a plan of action but to make mass media techniques and strategies an integral part of their art.

On the East Coast, PAD/D (Political Art Documentation/Distribution) was one of several groups that started about the same time as Ariadne, in spring 1979; that group was meeting regularly by February 1980, with the idea that "social action can be incorporated into our art practices."[46] Another East Coast group, the Coalition for Women's Safety, formed to respond to the 1979 murders of twelve black women and one white woman during a five-month period in Boston. This remarkable interracial group publicized the violence against women and, similarly to Lacy and Labowitz, protested how police and media handled the crimes.

The social network of Ariadne was distinguished by its collaborative use of art to address issues of public concern. The Boston-based Combahee River Collective (founded in 1974), one of the key groups involved with the Coalition for Women's Safety, is another example of powerful collective responses to race- and gender-based violence.[47] Coalition building was integral to feminist efforts in both Boston and Los Angeles. Explaining how she drew on media sources and then used them to amplify her own agenda, Lacy wrote, "As artists we work with the issue of violence as source material, using feminist ideology to shape forms necessary for changing culture. These forms involve the collective action of many women artists and nonartists, working to 'break the silence' and create solutions to violence."[48] Two organizations that Ariadne partnered with in collective action were the Women Against Violence in Pornography and Media (WAVPM, founded 1976 in San Francisco) and Women Against Violence Against Women (WAVAW, founded 1976).

Ariadne is one instance of reciprocal interactions between theory and an arts-based practice. Philosopher María Lugones characterized coalitions as curdling, as unlike "substances" in suspension together.[49] Organizing from identity politics—from people's social positions—was like that. Female activists recognized that to make a broad-based movement across class, race, and sexual orientation would require building across differences, rather than subsuming those differences into some sort of "universal woman." As musician and activist Bernice Johnson Reagon (whom Lacy knew) wrote in 1982, "Today wherever women gather together, it is not necessarily nurturing. It is coalition building. And if you feel the strain, you may be doing some good work."[50] Lacy's performance structures, and Ariadne itself, were coalitions that put into practice the ideas emerging out of social movements of the 1960s and 1970s; they worked with media staffers to ensure that events took advantage of forms and settings that would enhance their effectiveness and visibility.

Lacy and Labowitz published their goals for Ariadne in *Heresies* in

1978: "to sponsor the creation of art work directed at ending all violence against women and to provide the context in the art community for a viable and effective political art."[51] While the membership was fluid and the administrative structure intentionally minimal, Ariadne had three conceptual goals: education, vision and theory, and projects. The media was implicated in perpetuating violence against women, both by the reportage of violent incidents and the depictions of women in movies and news. In response then, Ariadne "created a network of media representatives who would cover the event[s]" differently and in support of each other.[52] Ariadne also offered classes on performance and media at the Los Angeles Woman's Building, sponsored writings by members and forums related to political art and antiviolence activities, and continued antiviolence-related projects. Rather than continue to see rape as individual assaults against women, Ariadne sought to frame rape as a political act, an act of power symptomatic of patriarchy.[53]

Ariadne cosponsored an early screening and critique of the movie *Hardcore* in 1978.[54] Ariadne also helped organize the Incest Awareness Project at the Woman's Building (1979).[55] Lacy's own project on community organizing and violence in Ocean Park, California, *Making It Safe* (1979), at times merged with Ariadne. Lacy's student Mexican artist Mónica Mayer worked with Ariadne during her tenure at the Woman's Building and listed a number of activities associated with *Making It Safe*: "exhibitions, round-table [discussions], public speak outs, personal defense workshops and any other thing that raised the public's consciousness."[56] *Making It Safe* culminated in a potluck picnic at a public park for the participating women.

From Reverence to Rape to Respect

During her association with Ariadne, Lacy continued to create separate work, but the lines between them were not always distinct. Recently, Lacy stated that she and Labowitz decided to "give" authorship of one of their 1978 collaborations, *From Reverence to Rape to Respect*,[57] to Ariadne, signaling, to me anyway, that Lacy was experimenting with collective authorship and that Labowitz was ambivalent about authorship altogether.[58] According to Labowitz in 2005, she wanted to quit Ariadne almost from its inception, and slogged through the collaborations.[59]

Since I want to focus on the work rather than issues of authorship, and since the structure of *From Reverence to Rape to Respect* closely paralleled that of Lacy's *Three Weeks in May*, I will discuss this performance structure as Lacy's. Artist Claudia King approached Lacy in 1978 about creating a work in Las Vegas, and *From Reverence to Rape to Respect* was the result. The ten-day-long event, the hub of which was the University of Nevada, Las Vegas, was sponsored by the Nevada Committee for the Humanities. Lacy, Labowitz, and King, together with the Feminist Art Workers and Margo St. James of COYOTE (Call Off Your Old Tired Ethics), did media and educational events

as well as installations in the university art gallery. Other artists involved included Deborah Feldman, Kathy Kaufman and Nancy Buchanan.[60] As with *Three Weeks in May,* then, various artists contributed their unique expressions to a larger network of activities, which also included nonart content.

For a small-scale aesthetic expression within the larger *From Reverence to Rape to Respect,* Lacy created one of her most powerful installations, "There Are Voices in the Desert." Lacy constructed a diminutive room within the university gallery and painted it white. The entryway was only three feet high, so the visitor had to bend low to get inside the space (Figure 24). Sand covered the floor, and women had written personal accounts of rape or violence that had occurred in the desert on the exhibit's interior surfaces. Jeff Kelley described the actual performance as "one of the most powerful images I have ever seen in an art context" (Plate 5):

> One entered the room, encountering against the rear wall three
> lamb carcasses suspended as if dancing, embellished with pink
> and white Las Vegas showgirl plumage and beads draped over
> their fresh meat. Like horrible puppets, the carcasses were
> at once dancing and hanging by their necks wrenched in the
> moment just before death. Lacy sat above the entrance [on a
> ledge], naked, . . . She placed necklaces around the necks of the
> viewers, symbolically linking them with the adorned carcasses.
> A recorder hissed the sound of hot desert wind.[61]

By designing such a low door to her exhibit, Lacy required that the participants in the ritual literally crawl or squat to enter the room. In addition to creating compelling visuals, then, she also kinesthetically involved others. Reaching to encircle their necks with cheap jewelry, Lacy in her vulnerable nakedness was at once threatening and giving. The tensions of being clustered together in a small space with flayed lambs, accounts of assaults, and the unclothed artist would have had sensory and emotional power as well, similar to "She Who Would Fly" from the previous year. The lamb carcass, used by Lacy in seven other performances between 1973 and 1978, was a stand-in for human bodies that suffer.

After visitors left the little room, they sat within a circle of candles in the gallery for a facilitated discussion about their reactions. While Lacy remained within the installation, her collaborators extended her performance into conversation about "There Are Voices in the Desert."

Take Back the Night

Lucy Lippard reflected in 1984 that

> [s]ome of the most effective works were designed collectively
> and took place within the context of mass demonstrations. . . .

Figure 24. Exterior view of entrance to installation by Suzanne Lacy "There Are Voices in the Desert," part of Ariadne's *From Reverence to Rape to Respect,* May 1978, University of Nevada Art Gallery, Las Vegas. Courtesy of the artist.

This kind of action survived in left culture but was only revived in the context of art in the late '70s, primarily by Suzanne Lacy and Leslie Labowitz on the West Coast, with their float-performance in the "Women Take Back the Night" parade in 1978, and their large-scale, long-term outdoor "media strategies." Dealing with huge publics and the real world, their work might be seen as the ultimate in what used to be called "real-time art."[62]

The 1978 performance in San Francisco that Lippard referred to as a "float-performance" within a "parade" was another instance of Ariadne's insertion of artistic elements into mass actions on an urban stage. Lacy viewed the entire National Perspectives on Pornography conference (sponsored by Women Against Violence and Pornography in the Media) as a performance, featuring the two thousand women in attendance in San Francisco.[63] From the convention stage, Lacy announced that they would all participate in this performative event (what in other cities were called "Take Back the Night" (TBTN) marches).[64]

With Ariadne, Lacy's performance art class at the Woman's Building—Rosemarie Prins, Mónica Mayer, Betsy Irons, and Ann Klix—and Leslie Labowitz had made a float for this performance (Figures 25 and 26). Their float traveled through the district where most of the X-rated and neon-lit bookstores and strip joints were located. Lacy described the imagery:

> On the front, we built a virgin figure that was based on an image Leslie [Labowitz] had been very impressed with in Spain during the Santa Semana celebrations, where a virgin is carried with candles through the streets. On the backside of our virgin was the whore. And the whore was Hecate-inspired, a three-headed lamb carcass with pornography spewing out of its guts.[65]

Surrounded by thousands of women, the float upended traditional religious processions with the Virgin by creating a monstrous feminine twin linked to the Madonna figure.[66] This assemblage dominated the streetscape as it moved past other monstrosities, such as the sale of pornography. As Susan Griffin wrote so compellingly a few years later, "the pornographic mind is a mind in which we all participate. . . . It dominates our culture."[67]

While Lacy and Labowitz have remained close friends and began collaborating again in 2007, Ariadne ended in effect in 1981 and formally closed down in 1982. Both women separately continued what Lippard called "real time art." Lacy wrote about Labowitz's new directions in 1982, focusing on her performance *Sprouttime,* which was included in the 1981 exhibition LA/London Lab, at Franklin Furnace in New York City, cocurated

by Lacy and Susan Hiller of London. Lacy praised Labowitz's "trek from outer-directed activism to inner healing and then outward giving again."[68] By the time Ariadne folded, Lacy had benefited from Labowitz's aesthetic and political ideas and European sources.

Figure 25. Suzanne Lacy and Leslie Labowitz, with others in Ariadne, Take Back the Night float, Virgin, November 1978, National Perspectives on Pornography conference-as-performance, San Francisco. Courtesy of the artist.

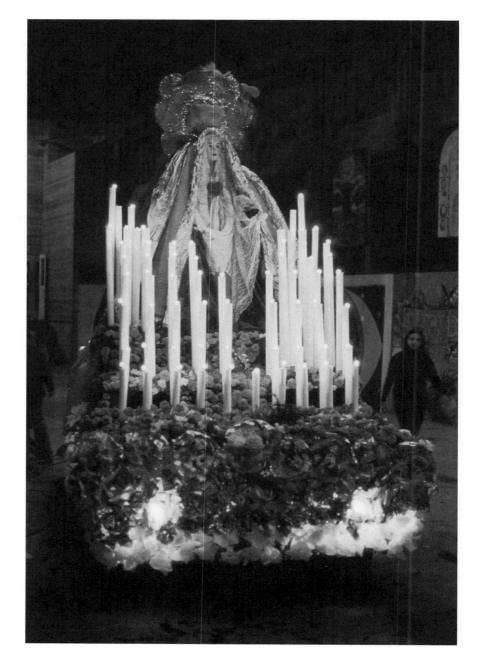

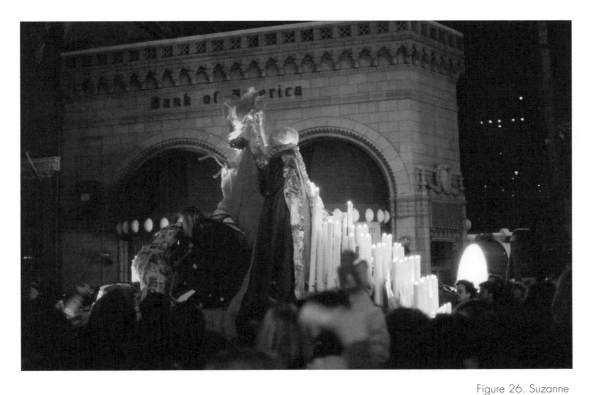

Figure 26. Suzanne Lacy and Leslie Labowitz, with others in Ariadne, Take Back the Night float, Whore, November 1978, National Perspectives on Pornography conference-as-performance, San Francisco. Courtesy of the artist.

4 CONVERGENCES

PREVIOUS CHAPTERS HAVE EXPLORED WAYS that Lacy extended herself in space, over time, and through collaborations. While the forms and strategies of Lacy's new genre public art are many, I have chosen to focus on embodiment and spatiality in Lacy's art because I find them to be among the most powerful modes for communicating socially and aesthetically.[1] This chapter is about Lacy's uses of converging bodies in spaces, both as an artistic as well as a social form. Knowledge about and critique of our embodied states are crucial to our life's work. Our somatic practices occur some*where,* and those spaces often reveal a lot about power structures.[2] By coproducing discursive spaces with others, Lacy kept bodies, power relationships, and spaces particular and avoided the distancing quality of "others" and "out there."

Art critic and curator Patricia Phillips suggested a model for thinking about public art in general that applies to many of Lacy's pieces: "a dynamic exchange of invention, production, delivery, reception, and action rather than a stable collection of formal characteristics."[3] Similarly, performance scholar Meiling Cheng examined Lacy's embodied art in Los Angeles as a challenge to static representations of gender because of her "multivalent approach" that was part of "coalition politics based on the commonality among similar selves." Cheng even labeled this coalitional approach "the Lacy school," distinguished by the artist's "commitment to connection."[4]

Before moving into a discussion of Lacy's works in the 1980s, I want to make use of Cheng's analysis of just how Lacy's "ethos of connection . . . collapses the supposed division between self and other and deliberately inverts the masculocentric value system. This politics of marginality is shared by many other *subjects,* all coming from what we might call the *multicultural*

contingency, including ethnic minority, gay and lesbian, and other socially marginalized artists." In Cheng's view, the "audience voluntarily become[s] . . . the artist's *participatory other/selves.*" This production and participation are reciprocal: Cheng also noted that "Lacy's self becomes reiterated, fragmented, multiplied, and transformed by these others, while these others both take over parts of her self and are temporarily subsumed under her nominal self, the cooperative project that has mobilized them all."[5]

Cheng thus affirms my designation "participatory reception," where the audience—often socially marginalized—shared with Lacy the responsibility for the creation as well as the reception of a performance.[6] Cheng posited that Lacy's pairing of genesis and responsibility in her model of the audience effectively "neutralizes the artist's privilege as the creative genius and compels the artist to maintain, or even to *earn,* her/his authorship by remaining responsive to vicissitudes."[7] This effortful earning of trust and leadership by a white female artist took place in the midst of a proliferation of cultural production and political activism by women of color. That Lacy was able to garner participation in her large-scale projects was due, in part, to her tenacity and her responsive-ability.[8] Lacy's own working-class background and her long-term involvement with African American women in Watts, for example, informed her responsiveness. While social divisions were sometimes *reproduced* in her work, they were also *exposed,* and the divisions were part of the creative process, present if not always resolved.

The "convergences" of this chapter's title refer not only to the gatherings for which Lacy was the catalyst in the 1980s but also to the ways in which her art projects converged with shifts in feminism and "turns" in the humanities and social sciences—dramaturgical and spatial—as well as with architectural and urban design paradigms.[9] Lacy's artworks about the body in space, the moving body, and moving through space theorized before the fact much of the "spatialization of social theory" and the increased use of spatial metaphors in the humanities in the 1980s.[10] One tether of the "dramaturgical turn" is tied to interest in Erving Goffman's work on ritual and everyday life among artists in the 1960s (mentioned in chapter 1); another tie to the dramaturgical is through the debates about "theatricality" in visual art that critic Michael Fried launched in 1967. Percolating through cultural criticism for two decades, by the mid-1980s, the theatrical in visual art became primarily a positive descriptor, with performance art and artists no longer disparaged (at least not for their dramatic form).[11] Lacy's infusion of everyday actions into her art was only incidentally part of an aesthetic critique, however. She was far more interested in "getting people to talk with each other, and perhaps as a result to think or act differently." The reason to "locate these art practices within the trajectory of art history," she wrote recently, "[is] to give real texture and meaning to the notion of artist citizen-

ship and in so doing accomplish the reconstruction of the civic relevance of art."[12]

Lacy had long pressed for new sorts of collaborations to further her artistic and political vision. Artist Peter Dunn labeled artists like Lacy "context providers" because of the structures they provide that enable participants to create their own meanings.[13] Critic Jeff Kelley remarked about her work: " . . . Lacy's art is an organizational strategy that extends metaphor into social process."[14] In conceptualizing her large-scale performances, she crossed artistic genres, and by her doing so, those genres were incorporated into people's lives in the process of enacting her pieces.

Coalitions that converged for her projects existed in uneasy tension, sometimes with heated exchanges. Further, as Anne Enke has pointed out, the spatial contexts of these coalitions at times exacerbated divisions by reflecting or reproducing social divisions. (For example, in preparation for Lacy's 1986 performance *The Dark Madonna* some white women refused to visit Watts for a dialogue, after black women had traveled to their predominantly upper-class white neighborhoods in Pasadena.)[15] As Lacy's projects grew in scale, the movements between production and reception became increasingly complex. This instability was an aesthetic and political choice that Lacy has called "imperfect art."[16]

Despite the challenges of geographic distance and social segregation, Lacy often chose architectural spaces to physically anchor social instabilities. While the architectural frame remained stable, each participant under her direction animated a space differently. Their movements were specific and unique to them, although they may have recalled other social, historical, or symbolic activities.[17] The "convergences" that Lacy organized and directed provided opportunities to articulate one's own positionalities, both verbally and visually, and begin to discuss them. This strategy was (and is) politically powerful in that there are few chances for face-to-face dialogue across differences. Built spaces also facilitated her work in three dimensions and in time, so that she could employ changes in direction, scale, depth, and massing; she added color. This chapter focuses on a number of her large, conversational projects: *Freeze Frame, Immigrants and Survivors, The Dark Madonna,* and *The Crystal Quilt,* as well as the contexts around them.

Freeze Frame: Room for Living Room

For an hour and a half on the evening of August 13, 1982, seventeen groups of women (most formed specifically for the piece) came together for *Freeze Frame* in the upscale San Francisco furniture showroom of Roche-Bobois and talked about survival.[18] Organized by Lacy with Julia London (cofounder of Women Against Violence against Women), musician Ngoh

Spencer, poet Natalia Rivas, choreographer Joya Cory, poet and sex worker Carol Leigh (also known as Scarlot Harlot), among others, and commissioned in spring 1982 by San Francisco's International Theater Festival with the San Francisco Museum of Modern Art, *Freeze Frame* emerged out of ten weeks of planning.[19] Various groups met before the August event not only to select the location and their preferred furniture setting within the final venue, but also to decide how they wanted to present themselves: "The lesbians in the Non-Traditional Workers group . . . decide[d] not to officially represent lesbians because they fear[ed] that the audience will equate these workers, such as carpenters, with lesbianism." Lacy reflected, "I know it is problematic and I'm running the risk of reinforcing rather than challenging social stereotypes, but I'm hoping that the *visual* convention of stereotyping will be broken down by *sound*—the voices of the women as they relate similar experiences."[20] Lacy used juxtaposition—sights mitigated by voices—to heighten the meaning of this gathering. Visual stereotypes were countered by conversations about lived realities that were audible to the audience. Lacy also reveled in the ironies of discussions about survival in the midst of such a luxurious commercial setting.

In the organizing phase, Lacy and her collaborators used a technique that recalled Allan Kaprow's 1969 *Pose (Carrying Chairs through the City . . .)*, in which people sat "here and there" in different parts of Berkeley during Kaprow's piece.[21] When the plans for *Freeze Frame* were being finalized, Lacy herself was in the midst of moving. She recalled that in late June 1982, she had purchased a used brocade-and-wicker couch for herself but had no place to put it. In a delightfully playful solution, she used the couch as recruiting tool for *Freeze Frame*, getting women to pose on it in the streets of San Francisco to attract participants and publicize the event.

For the performance, about one hundred women, including Lacy's mother and sister, arranged themselves in the furniture showroom. These groups named themselves, following animated discussions prior to the event: twelve elderly Jewish women on a long serpentine couch, pregnant women on a long pink sofa, elderly black women on a white duck couch, bridge players in upright red lacquer chairs, Filipinas around a wood-and-wicker dining room set, women in wheelchairs around a chrome-and-glass table (Figure 27). The women also chose their props: sex workers displayed a mask and an open black satin purse spilling three $100 bills; former mental patients sat near an overturned bottle of pills and a syringe that represented forced medication. Teenagers dressed in leotards and leg warmers, women from San Francisco's Mission District wore red and white dresses with gardenias in their hair, and nuns appeared in modernized habits.

Freeze Frame began with a fifteen-minute silent tableau. Lacy used green and red cards to cue the sequences, with the green card alerting groups to start talking. Clusters of audience members were let in gradu-

ally to move through space and listen in on the conversations; by the end of the performance, four hundred people had passed through.[22] Critic and historian Moira Roth noted that *Freeze Frame* drew "strongly upon feminist consciousness-raising for its formal structure."[23] Described by feminist scholar Maria Bevacqua, consciousness-raising was a "strategy credited with providing the critical context in which women talked about sensitive, even painful experiences openly."[24] In *Freeze Frame*, however, the intimate conversations among groups of women took place in public. This provided the listening audience with aural correctives to their initial visual impressions.

At the conclusion, all 120 of the participating women came together at the back of the store, spoke in unison, and then had the opportunity to speak individually.[25] The general sense during this wrap-up session was that *Freeze Frame* had provided a welcome forum for many of the women; the room felt electric with power. Many of the women participated in *Freeze Frame* because there were so few opportunities in the art world to confront and challenge social norms. Even so, when we in the United States were (and are) so steeped in racism and unskilled at cross-cultural conversations, it is not surprising that a number of women, despite volunteering, felt caught in a web of "whiteliness," that power and privilege differential (discussed in the introduction) that sometimes created tangles of misunderstandings and vulnerabilities in Lacy's projects. Those feelings surfaced again for

Figure 27. Elderly Jewish women on couch in *Freeze Frame: Room for Living Room,* by Suzanne Lacy and others, August 13, 1982, Roche-Bobois furniture showroom, San Francisco. Courtesy of the artist.

some after the performance ended; a few felt that the group with which they identified during the performance had been used for "display." Lacy confirmed that "the tensions between people of different races with a white woman directing were very real."[26] While *Freeze Frame* ended that August evening, Lacy's performance structures continued to provide support for public dialogues.

Of curated conversations like *Freeze Frame,* Lacy wrote, "In this performance we put a frame around everyday life by revealing real experiences, rather than made up or enacted ones, of real people. . . . You might also think of it as painting brought off a canvas or a sculpture brought to life."[27] Lacy acknowledged some of her inspirations in the early-twentieth-century civic theater movement with the mention of paintings off of canvases— living tableaux—as well as in Allan Kaprow's interests in the everyday.[28] In that same year, 1982, artist Faith Ringgold told autobiographical stories and invited the audience to share theirs as well in *No Name Performance #2.* Thus, Ringgold, too, was curating conversations as performances, fostering a "terrain for elaborating strategies of selfhood. . . ."[29]

Lacy and Ringgold were early practitioners of what Grant Kester has termed dialogical art and what Homi Bhabha called conversational art.[30] Conversational art, noted Bhabha, "cannot appropriately be defined within the current art-historical discussion. . . . When . . . [it] seeks to transform the distance between art and its audience, it does so by changing our sense of the 'space' of the artwork itself, by making us rethink fundamental questions concerned with the category of the aesthetic." That rethinking did indeed need to occur in art history, but in theater time-based and spatial aesthetics were well understood. The aesthetics of Lacy's conversational pieces emerge from animated, three-dimensional, durational, and unpredictable qualities as well as from the relationship of the people conversing to the audience members walking by. The space to which Bhabha referred is liminal, where the "articulation of cultural differences" occurs both in spoken and visual forms.[31]

While Bhabha never wrote about *Freeze Frame,* he noted aspects of this sort of art that challenged art historical analyses. The large scale of *Freeze Frame* and other conversational artworks, the way in which the audience entered into the same space as the performance, and the art's connections to contemporary issues of historical consequence certainly fell within "current art-historical discussion" but were sidelined, in part because of political subject matter, I believe. The non-gallery setting, the embodied exchanges that were integral to the form and meanings of Lacy's pieces, and the collapse of the distance between audience and art because of women's presence and discussions have become more common in the past two decades but still remain underrecognized for the formal and social innovations they offered. The merging of subjects through sound and space, as when the audi-

ence entered the artistic performance, for example, is a key characteristic of what Bhabha called "contextual contingency, . . . multilayered dialogues and unplanned directions . . . that come to be constructed through the working out of a particular practice, or in the performative act by which the work at once encounters its audience and constructs its community of interpretation."[32] Bhabha's "contextual contingency" of an art practice points to the simultaneity of encounter and meaning construction that I am calling participatory reception.

Conversations and Meals

Writing in a typed journal kept during the early 1980s, Lacy speculated about a lunch meeting with a woman who shared her own beliefs, passions, and levels of commitment: "[S]ome kind of connection takes place and I find it a very warm and spiritual and primarily aesthetic experience. What's happening is that the feeling of love that I have for women and in particular the struggle that women engage in, . . . I feel that on a very profound level. . . . It's the kind of excitement out of which I create images, it's an artistic experience." In the 1970s and 1980s, Lacy experimented with ways to "make visual that excitement about the connections between the women."[33] But the interracial, cross-class, multicultural connections that Lacy sought to foster were hardly easy, straightforward, or instant, as evident in the *Freeze Frame* interactions. Driven by the aesthetic and spiritual dimensions of her arts-related organizing, she often created events around food in order to assist in building relationships.

In 1980 in New Orleans, Lacy and cultural events producer Jeanne Nathan joined with Laverne Dunn, Betty Constant, Mary Ann Guerra, Marilee Snedeker, and Mary Helen Matlick to honor women of New Orleans, past and present, in *River Meetings: Lives of Women in the Delta*. This was a completely collaborative effort to protest the state of Louisiana's failure to ratify the Equal Rights Amendment (ERA, first introduced in 1972) and to support the pro-ERA locals using a conference-as-performance strategy, with *River Meetings* the key event. The organization staging this performance was the national Women's Caucus for Art (WCA), which in fact split over gathering in a non-ERA state. (WCA members who refused to go to Louisiana held an alternate conference that year in Washington, D.C.) The WCA women who did go to New Orleans stayed in private homes and ate meals with their hosts.[34]

The multifaceted conference structure in New Orleans resembled the National Perspectives on Pornography conference-as-performance in San Francisco that Ariadne had produced in 1978. To launch the New Orleans event, eight women held potluck gatherings in their homes throughout New Orleans, with guests encouraged to host their own potlucks. After this

recruiting phase and during the WCA conference-performance, five hundred women gathered for a potluck meal at the newly renovated U.S. Mint (built in 1835) (Figure 28). This evening was the first time in a long while that the then 145-year-old building had been open to the public. It had once housed Confederate soldiers and, later, a prison for Prohibition violators, in addition to service as a federal and Confederate mint. Women attending the reception and potluck performance on the evening of January 30 temporarily claimed this historically contested space.[35] The dinner honored twelve regional women from different ethnic and racial backgrounds who had made significant contributions to history, but organizers also asked that "each woman attending the dinner in the Mint . . . describe a woman important to her own life, adding to our lore the names of countless women left out of history."[36]

The New Orleans potluck at the Mint was one of a number of dinners that Lacy arranged with others, starting in 1979, to serve as a platform for social performance. In 1981, with Marilyn Rivchin, Nancy Bereano, and Carolyn Whitlow, Lacy organized an interracial potluck event for one hundred women, *Tree: A Performance with the Women of Ithaca [New York]*. This gathering, commissioned by the Johnson Museum at Cornell University, reenacted a substantial, historical conflict. Lacy wrote, "We were not trying

Figure 28. Site of dinner gathering at the U.S. Mint (now Louisiana State Museum) for *River Meetings,* by Suzanne Lacy and others, January 30, 1980, New Orleans. Courtesy of the artist.

to gloss over the [white] suffragist betrayal of black women, nor the distrust that exists now between races." In this college town, for example, there were many older, working-class black women who served the needs of the wealthier, often white students. The event acknowledged distrust as a part of some of the relationships in the room but framed the conversation around honoring two local women, Eleanor Washington, the great-grandniece of Harriet Tubman, and Helen Blauvelt, a historian and daughter of a suffragist. Each woman in attendance was asked to add the name of a woman she wished to honor to a large mural of a tree. Lacy performed the role of "suffragist 'stumper' who traveled from town to town raising the vote—a person-to-person consciousness-raising and community building process. . . ."[37] Convergences such as these, in potluck settings, took shape due to Lacy's role as an itinerant artist-organizer.

Lacy launched another series of potlucks in 1983 in Los Angeles, initially with twelve women consciously chosen because they represented different ethnicities. During a time of heightened xenophobia in California, they brainstormed a large-scale artwork that became *Immigrants and Survivors*.[38] Lacy drew on her long-term contacts in Watts—she had worked there in a federally funded position in the mid- to late 1970s—and the mostly white feminist art community to build "a progressively broader audience."[39] The promotional material suggested that all women could be viewed as immigrants, as they "left behind familiar areas and ventured into new activities."[40] Betty Ann Brown recalled, "We decided that we wanted to gather as many diverse women as we could, and bring them together for one night, for one immense potluck. . . . Then one night hundreds of us sat around big tables in the dining room of the American Film Institute [in Hollywood]. . . . We shared our food and we told our stories."[41] The press release mentioned "collective paintings" made on canvas tablecloths and post-dinner entertainment including poetry recitation and gospel singing. Cheng reported that about two hundred women participated in this dinner and "tested the possibility of multiethnic and multicultural cooperation among women of diverse colors, creeds, and backgrounds long before the term 'multiculturalism' gained widespread cultural currency in L.A."[42] All these dinner events served to bring people into discussion from various urban areas and from around the globe. They were linked conceptually and aesthetically as bodies-in-space, together for a period of time in the real world, with relationship building as the focus.[43]

The Dark Madonna

The Dark Madonna of 1986 was an attempt by Lacy and her collaborators Anne Bray, Carol Heepke, Yolanda Chambers Adelson, and Willow Young to again tackle "the relationship of women of different races" and to do so

on their home turf, in Los Angeles.[44] *The Dark Madonna* was a performance staged at dusk in the sculpture garden of the University of California, Los Angeles (UCLA) (Plate 6). This culminating event had been preceded by months of facilitated discussions around Los Angeles.[45] Lacy's commitment to nurturing cross-racial relationships was unwavering, and *The Dark Madonna* was another instance of that engagement. The challenging topic of experiences of racism inspired an aesthetically beautiful vision, fleeting and utopian, in two parts, the Light and Dark Tableaux. Lacy took full advantage of the setting by making use of the twilight. She wrote,

> Intentional inversion of the viewer's presumed associations
> with light and dark is an aspect of the fundamental "language"
> of this performance. Day (white) is not "light," but static, iso-
> lated, filled with painful revelations. Night (black) is not "dark,"
> but active, seeking, and filled with healing. . . .[46]

At 7:45 on an evening in late May, forty women of various ages, racial, and ethnic identities and body types formed the Light Tableau; they posed as living statues in the garden while a soundtrack by composer Susan Stone provided an aural accompaniment. The women were dressed in all-white costumes; over one thousand audience members around the edges surveyed the tranquil scene for forty-five minutes. As the light dwindled at 8:30, ten "shadows" (women in black, cued by Lacy) raced from the edges of the garden and cloaked some of the women in black. Others removed their white clothing to reveal black underneath. One pivotal point was that half of a minute when the scene went dark; the light fell off the lavender flowers on the jacaranda trees, and the women, now all in black, merged with the night. Following this quick, spectacular snuffing of color in the garden, 120 other women in black emerged on cue from the perimeter in groups of four to six. They held flashlights and slowly wandered to their places on the lawn. They roamed through the dark with thin columns of light marking their movements. When they sat to form discussion circles on the grass, the women illuminated each other's faces with the flashlights, the effect being of glowing campfires among the scattered groups. The women who had been statues left their pedestals and joined in the conversations about race and racism in Los Angeles.[47] By 9 p.m. the audiotrack ended, the dark purple ribbons separating the audience from the performers were dropped, and the audience members were handed flashlights to move into the garden and watch or join the discussions.

The UCLA Franklin D. Murphy Sculpture Garden was determinative in the creation of *The Dark Madonna*. Designed between 1963 and 1965 by Ralph D. Cornell, the sculpture garden is an expansive outdoor room, over five acres in size, defined on all sides by buildings or plantings. Abstract and figurative metal and stone sculptures are arranged as if in a large gallery,

set apart from each other but visible from many vantage points. Breezes and natural light, ambient sounds, and an array of odors contribute to multi-sensory experiences. Of the sixty-three sculptures on display in 1986, about a quarter of them had women's bodies as their subject.[48] Lacy commented to Moira Roth, "'The Dark Madonna' was also conceived of as an ironic work. The Franklin Murphy Sculpture Garden is, above all else, a display case for European white male artists. . . ."[49] The controlled nature of the garden and its carefully placed sculptures provided a manifold setting for participating women to represent themselves in a manner significant to them: mothers, sisters, professionals, elders.

When Lacy explicitly introduced race and gender into the UCLA garden, the setting was a critical component in the performance. It was a counterpoint to the living, breathing bodies of the women in the tableau (Figure 29). Stone and bronze were necessary ballast to flesh and hair, the latter refusing to be fixed in time and place. As the shadows lengthened through the evening, they provided a parallel to the "shadows" of racism that were the subject of Lacy's piece. This transience of the performance—of lighting, movements, sounds—evoked the embodied efforts to work through racial identity and racism, a kind of groping in the dark.

Lacy reflected in 1990: "'The Dark Madonna' in Jungian terminology

Figure 29. Close-up of living statue in *The Dark Madonna,* by Suzanne Lacy and others, May 31, 1986, Franklin D. Murphy Sculpture Garden, Los Angeles. Photograph by Susan Mogul. Courtesy of the artist.

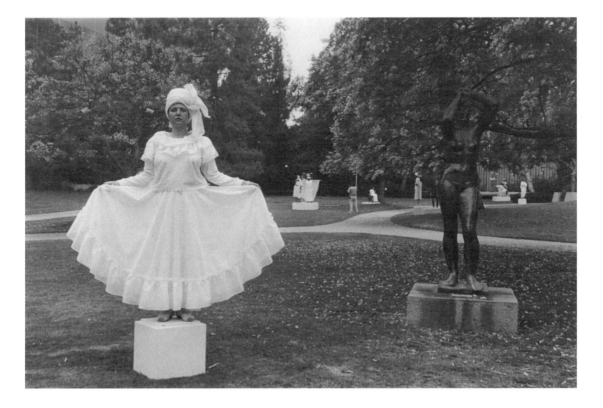

represents the shadow—the unclaimed characteristics of the self needed to form the integrated self. Extending the metaphor, the projections of negative characteristics on another race, known as racism, is a collective rejection of the dominant society's 'shadow.'"[50] Racism, as Lacy presented it in her writing about this piece, was metaphorically captured by the notion of shadow. While Lacy would be the first to state unequivocally that racism is far more tangible, vicious, and damaging than a shadow, in terms of the imagery of *The Dark Madonna,* it represented one way in which white society collected its negative characteristics, transferred those onto nonwhite people, and then rejected those enshadowed people, denying whites' own unclaimed characteristics and unjustly oppressing other groups.

In 1978, white writer Adrienne Rich published an essay called "Disloyal to Civilization: Feminism, Racism, Gynephobia." This powerful reflection was a major inspiration for Lacy's interracial work in the 1980s, particularly for *The Dark Madonna.* Rich noted that "black women and white women in this country have a special history of polarization, as well as of shared oppression and shared activism. . . . It is time," Rich declared, "that . . . [we] look with fresh eyes at the concept of female racism. For true accountability is a serious question for the feminist ethic—and indeed for any lasting and meaningful feminist action."[51]

Significantly for Lacy, Rich quoted extensively from Barbara Berg's then just-published history *The Remembered Gate: Origins of American Feminism,* which linked nineteenth-century white women activists to interracial and cross-class organizing.[52] In 1984, Lacy had commented, "Arlene Raven and I have begun to think about contextualizing my work with early feminist pageants, pointing to them as precedents for my explorations. In a sense it's a manufactured history that will encapsulate the work and give it a history, a sense of its existence in time, which is important when you are dealing with a mass audience who doesn't have the faintest idea what performance art is."[53] Lacy was searching not only for some historical foundation for her own work but also for theoretical grounding that would support her very challenging goals. Rich explained, "Identification with women *as women,* not as persons similar in class or race or cultural behavior, is still profoundly problematic."[54] In Rich's essay, Lacy found part of the history and theory that she sought in order to address stereotypical imagery and how that imagery forever limits us.

The Dark Madonna began, according to Lacy, with Rich's essay. In conversations with feminists such as Judy Mitoma, however, Lacy's initial idea to explore relationships between black and white women was pushed further.[55] At the time a founding faculty member in World Arts and Culture at the University of California, Los Angeles, Mitoma insisted that more women needed to be included in Lacy's project, and it was she who suggested the image of the Dark Madonna as one means to do so. As Susan Stanford

Friedman iterated, "binary categories of race should be supplemented with a more complicated discourse, one that acknowledges the ongoing impact of white racism but also goes beyond an analysis of white strategies that divide and conquer people of color."[56]

Lacy described *The Dark Madonna* as "one of the most painful pieces I have ever done."[57] Lacy's deeply held belief in social equity manifested by this "conversational art" piece around racism made this Los Angeles performance a wrenching experience for her. Rich's essay pressed for the vital emotional work of understanding racism, which paralleled Lacy's goals. Intellectual analysis, in addition to distancing women from each other, Rich claimed, also reduced "to formula the still unexplored movements and gestures, silences and dialogues, between women. . . ."[58] One participant's letter reflected the healing potential of the aesthetic experience that *The Dark Madonna* provided:

> I wore a white clerical robe over black clothing. The white robe was like the longing for acceptance and equality that in my youth had translated into wanting to be white. It became heavy and oppressive; a dead carcass on my back; the weight of forced assimilation. Arms limp at my side and head lowered was the posture of apology for the wrongness of my color. . . . As I took off the robe to reveal only black, I felt strength, pride and healing. I straightened my back, placed my hands on my hips, and held my head high: gone was the ingrained shame.[59]

Accessibility and the Avant-Garde

Lacy's coalitional strategies included adapting popular imagery (dark Madonna) and focusing on intractable social topics (racism) to draw people together, but she also addressed the art world by making reference to earlier artistic sources. *The Dark Madonna* recalled a cinematic vignette in the 1946 Maya Deren film *Ritual in Transfigured Time*.[60] Sequences of this avant-garde film depict dancers playing the "statue game" as well as becoming or posing with actual statues on pedestals. Different aspects of the self are performed by different bodies. Rita Christiani, a mixed-race dancer from Trinidad, "play[ed] Deren's alter ego,"[61] in much the same way that the women performing in *The Dark Madonna* were part of Lacy's metaphorical expanded self. (A large percentage of the women in that performance were from Lacy's own friendship circles.) In Deren's film, white dancer Frank Westbrook posed on top of a pedestal and then leapt after Christiani (Figure 30). In both Lacy's and Deren's works, the movements were staged out of doors in an accessible, landscaped garden, essentially inserting multiracial interactions (among other ideas) into a public space, making gesture and posture ways of performing hybrid identities.[62] As Cheng noted about

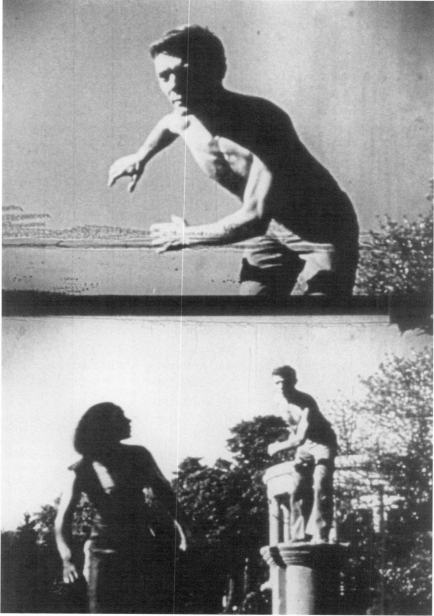

Figure 30. Film
still from Maya
Deren, *Ritual in
Transfigured Time,*
1946. Dancers
Frank Westbrook
and Rita Christiani
in sculpture
garden. Courtesy
of Anthology Film
Archives, New York.

The Dark Madonna, "the participants are joined in an environment condu-
cive to fostering their affinities, for their bodies are literally, emotionally,
and physically engaged by the common task at hand: to carry on dialogue
for an ongoing performance."[63]

 The references to Deren's films (which occurred also with *In Mourning*

and in Rage, as discussed in chapter 3) are one means to locate Lacy's work in the realm of avant-garde, experimental art, at the same time that these echoes of past art are translated by Lacy into forms that also have popular resonances. While some critics and historians may have recognized in *The Dark Madonna* a nod to *Ritual in Transfigured Time,* the aesthetic impact of performers in a garden in the gloaming, with jacaranda trees perfuming the air, was not diminished if an observer had never heard of Deren. Other viewers of *The Dark Madonna* may have thought of religious processions in honor of the Virgin Mary, or goddess worship from pre-Christian times. Lacy's challenge was to appeal as broadly as possible to various publics with a tableau that represented what she hoped would come to pass: leadership by women of color, healing the effects of white racism.

Whisper Minnesota

During the time that *The Dark Madonna* was in development, Lacy was a visiting artist at the Minneapolis College of Art and Design for six months, starting in September 1984. For over two and a half years she collaborated with numerous organizations around the state of Minnesota to increase the visibility of and leadership by older women.[64] "The idea," Lacy explained, "is to create mythic or celebratory events around the process of aging, because we don't have those rituals to distinguish our passage into old age. . . . I'm interested in aging because I feel in a certain sense we've been robbed [as women] of dignified, competent and beautiful models or images of aging."[65] *Whisper Minnesota* (September 1984–May 1987) and its culminating performance, *The Crystal Quilt,* shifted between an overview and a detailed look at the roles of older women in public life in Minnesota and considered the spaces of leadership that they occupied.

Standing on the mezzanine level of the IDS Center in downtown Minneapolis on Mother's Day of 1987, an observer would have been part of a crowd looking down on a tableau called *The Crystal Quilt* created by 430 older women in the faceted atrium of an iconic skyscraper (Plate 7). Seated in groups of four at tables arranged in a red, yellow, and black quilt pattern designed by artist Miriam Schapiro, the women animated the "quilt" by moving their hands and arms in synchrony.[66] Dancer Sage Cowles had choreographed the shifting shapes that they made—sunbursts, stars, triangles, and crosses. A soundtrack composed by Susan Stone wove multilingual stories and songs voiced by the performers together with sounds of rural Minnesota life. Lacy directed the women in this living quilt for an hour's performance tableau, giving visual form to their contributions to public life.

Stone's soundtrack launched the performance and cued the participants' movements through four phases. Rhythmic movement and changes in tempo paced *The Crystal Quilt* as women entered via escalator, stepped

onto the carpet, moved their hands choreographically, and raised clapping hands. As women dressed all in black moved into the atrium, they took their places at tables and unfolded black layers to reveal yellow and red tablecloths arranged to match Schapiro's quilt design.[67] "This slow unfolding echoed the painstaking piecework of quilt-making," according to Patrice Koelsch.[68] Thus, this monumental space downtown became intimate through movement, conversation, music, fabric, and color. An audience of about three thousand people watched the hour-long living tableau from the mezzanine and main-floor levels (Figure 31).[69] At the conclusion of the performance, audience members entered the quilt and presented the performers with hand-painted scarves by California artist Julie Arnoff (Figure 32).

By the early 1980s Lacy was thinking about the aesthetic impacts of a dense cluster of bodies. A distant view from above organized the seated women into an almost modernist, abstract, gridded pattern. In Lacy's performance tableaux such as *The Crystal Quilt*, the massing of bodies and movement were formal strategies to place previously marginalized people front and center. Hundreds of older women, included in a coalition of "othered" people, performed together but also had individual and rich identities, evident aurally on the soundtrack.[70]

Lacy had been exploring the lives of older women since 1975, using her own body in six performances and also including others in conversa-

Figure 31. Close-up of performers directed by Suzanne Lacy, *The Crystal Quilt*, May 10, 1987, Minneapolis, Minnesota. Photograph by Anne Marsden. Courtesy of the artist.

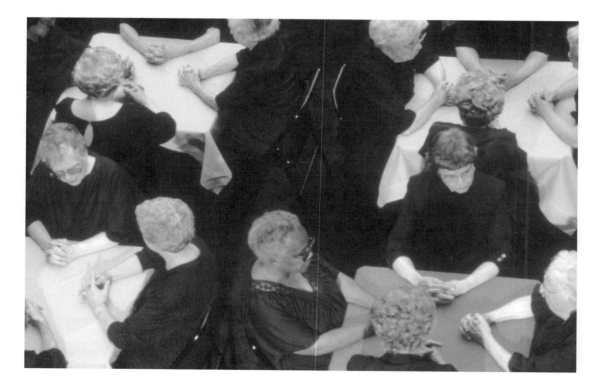

tions.[71] In *The Crystal Quilt,* the folk art form of a quilt was greatly enlarged and made three-dimensional by the women on the floor of the atrium; the patterns of the quilt "pieces" were created by women at tables. Recall Lacy's work with Evalina Newman in the mid-1970s in Watts when Ms. Newman and her companions gathered to sew. These women exhibited their quilts and other artwork alongside Lacy's photo collages, as shown in Figure 3.

Besides the vernacular form of a quilt, *The Crystal Quilt* had parallels in other popular imagery, such as televised sporting events and bridge tournaments. It, too, was broadcast live, on public television.[72] This use of mass media was both instrumental and symbolic, in that video and still photography documented the event but additionally shaped perceptions of the event.[73] Throughout her career, Lacy considered ways in which the repetition of images, in advertising or news, for example, increased public awareness. Building on Lacy's earlier work, *Whisper Minnesota* kept the leadership of older women in the public consciousness for several years.

The organizing process for this statewide gathering of women was both broad and deep. Collaborating with dozens of organizations, *The Crystal Quilt* was one part of the *Whisper Minnesota* project, which included a media campaign, a leadership seminar, a conference and film screening, several college-level classes, and a play, all focused on roles of women elders.[74] *Whisper Minnesota* required substantial fund-raising, sustained coordination

Figure 32. Audience joining performers in the atrium of the IDS Center, *The Crystal Quilt.* Photograph by Anne Marsden. Courtesy of the artist.

of many people, and phenomenal volunteer time and energy for over two years. A quiltlike chart from Lacy's archives shows the network of people and organizations that shaped the Minnesota project and contributed to the culminating performance (Figure 33).

Lacy's Minnesota activities produced a tangible, visible, audible result in May 1987 but also many intangible effects among organizers, performers, and audience members. Involving a number of leading Minnesotans, the quilt literally envisioned diverse individuals together in a single image. While each woman was distinct, this "unity across difference" has long been a central theme in Lacy's work. Video interviews with key participants contributed a level of detail and specificity to a project that also aimed for a larger perspective on the lives of older women.

Whisper Minnesota was built on an earlier project of Lacy's created in 1984 in San Diego (La Jolla), California, *Whisper, the Waves, the Wind*

Figure 33. Organizational chart for *Whisper Minnesota* projects, 1986–87. Illustration by Martin J. Holland after photocopy from personal collection of Suzanne Lacy. Courtesy of Suzanne Lacy.

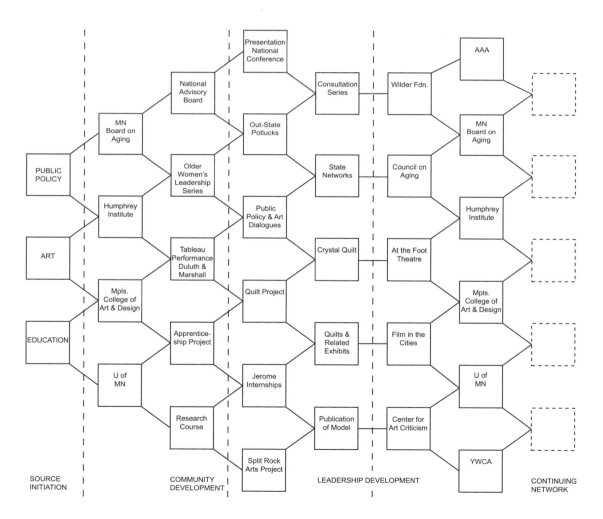

(Plate 8).[75] The La Jolla tableau had a similar concept as *The Crystal Quilt*—older women in conversation, seated around tables—although the California work was staged on a beach, with the women in white. Of that piece, Lacy noted, "The power of the performance will come if I can evoke whatever is going on in me as part of a universal experience of aging. That will be part of my female condition, but it will also be above and beyond being a woman. It's about being in a body that's part of a life process, a cycle, like the wash of waves on the beach."[76] *Whisper, the Waves, the Wind* was at once smaller in scale in terms of the number of women who participated, and more cosmic because of its outdoor setting in a gorgeous cove on the California coast (now claimed by seals).[77]

While *Whisper Minnesota* was a more ambitious version of *Whisper, the Waves, the Wind,* sharing the theme, some of the imagery, and structure with the earlier piece, it also contrasted with the California version. Lacy wanted to increase the impact of her art on social change and recognized that to sustain shifts in awareness there had to be policy shifts as well. In Minnesota, local and state organizations and many more local collaborators were involved early in the process. Sharon Roe Anderson at the Humphrey Institute for Public Affairs at the University of Minnesota, for example, was central to Lacy's increased emphasis on changing social policy. Anderson ran an eight-month seminar at the Humphrey Institute for thirty-five older women from various regions of Minnesota, the Older Women Leadership Seminar (OWLS).[78] While *Whisper, the Waves, the Wind* had had some involvement with the San Diego mayor's office and other municipal structures, *Whisper Minnesota* had far greater involvement over a longer term with political and social service leaders.

Critical Receptions

One of Lacy's most successful works, *The Crystal Quilt* received substantial scholarly attention as well as ample coverage in the popular press, thus also making it one of her best-known projects. Three articles on Lacy comprised a section of *The Drama Review* in spring 1988. Given that *The Crystal Quilt* had just taken place the previous spring, the essays by Lucy Lippard, Moira Roth, and Diane Rothenberg considered that piece in depth. Lippard critiqued *The Crystal Quilt* in relation to Lacy's other ritualized performances around tables, which had often evoked potluck dinners as well as political meetings or quilting parties. Acknowledging the difficulty of moving from symbolic, abstracted forms to political effectiveness, Lippard asserted that at the least "Lacy herself is recipient of the power generated as much as her participants and audiences." This group energy allowed her to transform into a "new hybrid: a multiple self."[79] Roth took an even broader view of Lacy's career up to that point, compiling a chronology of her projects from 1972 on and linking her earlier, smaller-scale pieces to the social reform themes of

the large pageantlike performances. But Roth also suggested a parallel view of Lacy as a "witch," "a carrier of much that could not be spoken. . . ." Lacy's art addressed issues that others often avoid: Roth noted that "images— unruly, often coarse, violent, and initially uncensored—have always pressed upon Lacy's imagination."[80] In *The Crystal Quilt* performance, the taboo topics that surfaced included racism, sexism, sex, and dying. Anthropologist Rothenberg focused on "the structure of the organization being formed to facilitate the performance." Rothenberg viewed the *Whisper* project as an example of "feminist experiments in manipulating the social world. . . . The image which carries the message is culturally loaded and multivocal."[81]

More recent examinations of *The Crystal Quilt* have considered it in relation to works by other artists. Jennifer Fisher compared Lacy's tableaux to those of Janine Antoni and Marina Abramović and asserted that they all "constitute[d] zones of interperformance by which the terrain of fixed representation is transformed," meaning that reciprocity between artist and participant(s) was a crucial aspect of each piece. Haptic and visual ways of knowing were integral to these complex collaborations, which, in Lacy's case, took place in a commercial office building, not a museum (Antoni) or gallery (Abramović).[82] Further, the scale of social complexity in Lacy's work is more appropriately compared to that of Christo and Jeanne-Claude rather than that of either Antoni or Abramović.[83]

Anne Basting compared *Whisper Minnesota* to the Grandparents Living Theater, which similarly blurred "distinctions between on- and off-stage, between theater and everyday life, and . . . between public and private spheres."[84] Basting noted that Lacy took the "blurring of distinctions . . . to much greater lengths . . . in order to create a sense of authenticity, a sense that the performers are real people. . . ." Basting also aptly pointed out that the atrium space "dictated the performance style in some respects, [but] the exposure of the theatrical apparatus was also a choice."[85] There was no backstage, no dressing room, no lighting booth; the performers and the performance, then, were defined by simply moving onto the carpeted area and gathering around tables. The movement of the observers into the performance area enacted the shift from "art into life as the stunning image was broken by the audience, which was invited to intrude, and as the performers were reabsorbed from their liminal condition of isolation and elevation into real life, embodied by the audience."[86]

Lacy's artistic explorations of the lives of older women acknowledged that each of our life paths is marked by the past, present, and future; she attempted to learn from the girl/woman she had been as well as from whom she might become as she aged.[87] Longtime feminist Gloria Steinem's 1992 book *A Revolution from Within: A Book of Self-Esteem* provided a description for a similar personal journey. Going deep into herself, Steinem imagined "someone walking where I had yet to travel. It was my future self, the

person I wanted to become, an optimal self who was leading me."[88] Lacy's performances similarly provided lessons for her to move forward; they were instrumental in her development as an artist and as a political being.

Spatial Convergences

The physical structures that frame Lacy's performances, such as in a building atrium or a sculpture garden, shape her imagery and determine many aspects of her projects even as they are transformed during a performance.[89] The donated space in the IDS Center for *The Crystal Quilt* was no exception: the geometry and the glass of the atrium roof as well as the complex as a whole were fundamental in the development of the piece. Completed in 1973 and designed by the internationally known team of Philip Johnson and John Burgee with the local architect Edward F. Baker, the IDS Center is an urban hub and a landmark of architecture and engineering (Figure 34). It was remarkable in the 1970s for its mixed-use design as well as its singular height. The fifty-seven-story office and shopping complex of the IDS has four discrete structures that converge at the eight-story, skylit atrium (Figure 35). "The Crystal Court," was an early instance of interior "quasi-public space" in a corporate headquarters, leading to the appellation for the IDS Center of a "social skyscraper."[90] Lacy in turn redefined "social."

Ed Baker, the architect who as part of a joint venture hired Johnson and Burgee for the IDS Center design, pioneered the use of skyways in downtown Minneapolis that bridged commercial centers with public walkways. The glassed-in connectors—skyways that architect Johnson noted allowed for "the Piranesian movement of people"—create climatically controlled, elevated streets that introduce another layer of movement and mixing in the urban realm, a technical solution to pedestrian circulation in a cold climate and an opportunity for surveillance, interaction, and profit. People enter the IDS complex either via skyway or from the street level, moving past the angular reflective walls of glass as the space narrows toward the entrance—architect Johnson dubbed these areas "funnels."[91] According to Johnson, the designers tried to animate the spaces "by having people come down the escalators and still be going out the door; we tried to give a feeling of being surrounded with active people."[92] For quite different reasons, Lacy, too, wanted to activate the interior space of the IDS Center. The centrality of the atrium in the building and its role as an urban node were instrumental to Lacy's aesthetic and social engagements through organizing and performance.

The large temporary "Crystal Quilt" in the atrium—made up of tables, chairs, and women who engaged in small-scale conversations within the larger piece—implicitly posed the questions: Who went to the atrium? Why? Who benefited from these large commercial developments?[93] *The Crystal Quilt* thus operated on the level of the downtown cityscape, the level of the

Figure 34. Exterior of IDS Center, Minneapolis, Minnesota, 1973; designed by Philip Johnson and John Burgee with Edward F. Baker. Photograph by Sharon Irish.

building as a setting for bodies enacting a quilted form, and on the individual level as women shared their thoughts on leadership and the future.[94] The meanings of *The Crystal Quilt* were carried by the physical form of the quilt and its architectural setting—the context—as well as the conversations and interactions among the women who were integral to its creation. The architectural context of angled glass surfaces and varied colors were integrated into the forms of Lacy's piece.

The human intimacy of *The Crystal Quilt* contrasted with architectural links among downtown buildings that encourage rapidly moving foot traffic, shopping, and fleeting contacts and increase corporate commerce that is faceless and placeless. In addition to "creat[ing] in contemporary terms with media, celebration and spectacle, the spirit of a Midwestern quilt-

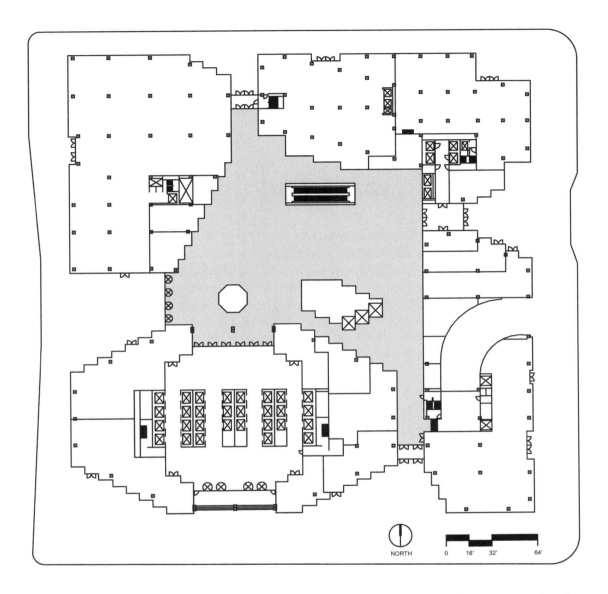

NORTH 0 16' 32' 64'

ing party on a long summer afternoon," Lacy and her cocreators attempted "to situate a work of performance art within a complex social setting, so that it had an ordinary dailiness to its multiple mini-performances of preparation (meetings, events, publicity and planning)."[95] *The Crystal Quilt* provided a gloss on architect Johnson's interest in "active people" in the IDS Center: by claiming a prominent commercial space for older women, they, too, were seen as activating agents.

In this chapter I have raised some issues about bodies in spaces in order to highlight Lacy's significant contributions to public art through her use of

Figure 35. Plan of IDS Center, atrium level. Drawing by Martin J. Holland.

social formations in urban places. Further, I suggested that the processes of convergence animated these places with new meanings, which in turn enriched the performance and its receptions. Ways in which performances have activated twentieth-century architecture like the IDS Center provide insights about movement within and reception of large buildings in their urban settings. The social skyscraper, in this case, was reinterpreted by Lacy's coalitional art making. With geographer Doreen Massey's recent distillation of spatial theory, the *body in space* seems more critical than ever to assessing Lacy's art and broadening aesthetic possibilities. Massey's propositions for space dovetail with my own generalizations about the "betweenness" of Lacy's work.

> *First,* that we recognize space as the product of interrelations; as constituted through interactions. . . . *Second,* that we understand space as the sphere . . . in which distinct trajectories coexist; as the sphere therefore of coexisting heterogeneity. . . . *Third,* that we recognize space as always under construction. Precisely because space on this reading is a product of relations-between, relations which are necessarily embedded material practices which have to be carried out, it is always in the process of being made. . . . Perhaps we could imagine space as a simultaneity of stories-so-far.[96]

These "stories-so-far," lived and remembered by bodies, created tension, anguish, joy, and solace. Lacy has provided in literal spaces figurative structures for people to converge and tell their stories, amplified in public.

5 WE MAKE THE CITY, THE CITY MAKES US

S U Z A N N E L A C Y B E G A N W O R K I N G at the California College of
Arts and Crafts (CCAC, now the California College of Art) in 1987 in
Oakland and continued at that institution in one capacity or another until
2002. Following her deepened engagement with public policy issues during
Whisper Minnesota, she wanted to further explore the strategies and implica-
tions of her work in public. She recounted to Moira Roth that a 1989 series
of events that she curated in Oakland, *City Sites,* was similar to Ariadne, the
social art network she had cofounded with Leslie Labowitz in the previous
decade: "It's a way to create a context which generates theory and practice."[1]

City Sites, cosponsored with the Oakland Arts Council, was intended
"to provoke dialogue by presenting nine artists [or artist-pairs] and their work
to different constituencies. . . ."[2] The artists were well-established, experi-
enced professionals with a wide range of skills in community-based arts:
Judy Baca, Newton and Helen Harrison, Lynn Hershman, Marie Johnson-
Calloway, Allan Kaprow, John Malpede, Adrian Piper, Suzanne Lacy/Arthur
Strimling, and Mierle Laderman Ukeles. These "visual, strategic, and ana-
lytic" thinkers participated in public lectures, private meetings with inter-
ested groups (dubbed "pressure point activities"), a critics' project, and a
class at the CCAC. The artists explained their working models to a public
audience at a different site that was linked to the subject matter of their
work.[3] Piper chose a blues nightclub as a result of *Funk Lessons* (1983–85),
Lacy and Strimling spoke about *The Crystal Quilt* at a nursing home, and
Ukeles presented her work with New York City's Sanitation Department
(1970 on) at a city garage. Implicit in the design of this series was the recogni-
tion that the sometimes isolated, often layered nonart spaces in urban areas
were being claimed temporarily for artists to interact with nontraditional

audiences. Lacy aimed to focus on "how to gather and assess information, how to develop a layered language that is accessible to defined audiences, and how to understand responses evoked by one's work."[4]

The questions posed by Lacy as she reflected on *City Sites*—"What is the nature of art in a complex urban setting? Who sees this art? In whose interest is it made?"—evolved out of her involvement in conceptual art at the beginning of her career. While the art object for many of the participating artists was not irrelevant, still for conceptualists it was "reimagined . . . vis-à-vis the social, political, and economic realities within which it was being made."[5] And these "realities" were generally dispersed throughout cities. With this reimagining, then, possibilities burgeoned for artists seeking new ways to interpret the myriad, fast-paced changes in the metropolis. Bell hooks described this physical and metaphorical movement: "'[T]he politics of location' necessarily calls those of us who would participate in the formation of counter-hegemonic cultural practices to identify the spaces where we begin the process of re-vision. . . . For me this space of radical openness is a margin—a profound edge."[6] Literally occupying spaces that were physically marginal to the art world allowed Lacy and the other artists to connect with people who were on the social margins.

Geographer Barbara Hooper, writing about "new" critical urban theory, asserted that "[a]t issue here is not the 'physical' city alone but the entirety of its social space—the many layers of physical, social, historical, geographical, cultural, symbolic, and embodied/lived associations and relations. . . ."[7] Hooper centered her analysis in the body, "bodies in social space—discursive, physical, and lived. . . ."[8] This multicentric, multilayered approach certainly characterizes Lacy's work; her 1993 piece *Full Circle: Monuments to Women* in Chicago is the focus of this chapter. Urban and architectural spaces were defining elements of Lacy's art in part because she redefined them as racialized and gendered spaces.

The embodied practices of the inhabitants of cities affect the streets, parks, buildings, and air of their environments, just as the cities act on the people in them. Political scientist Margaret Kohn made this point by quoting theorist Henri Lefebvre: "Architecture [or space more generally] produces bodily practices in a way that is not always visible or legible 'for it reproduces itself within those who *use* the space in question, within their lived experience.'"[9] Lefebvre's assertion helps explain how invisible aspects of cities—including memories, demolished buildings, and even abandoned cars—multiply meanings of urban events, both mundane and dire. Lacy inserted her projects into urban spaces—the steps of the Los Angeles City Hall; the Franklin Murphy Sculpture Garden; hotel lobbies, city streets, stores, and parks in Los Angeles and San Francisco; the U.S. Mint in New Orleans; the IDS Center in Minneapolis—altering the cities a bit at the same time the cities shaped her own works.

By attending to the specific histories of particular sites where Lacy's projects occurred, we gain another critical strategy with which to evaluate new genre public art. Architectural theorist Jane Rendell has contributed significantly to integrating art in public with architecture and urbanism. In 2001, she noted:

> Recent work in feminism, cultural studies and human geography, is highly spatialised, with words such as "mapping," "locating," "situating," "positioning" and "boundaries" appearing frequently. Positionality in these cases provides a way of understanding knowledge and essence as contingent and strategic—*where* I am makes a difference to what I can know and who I can be. . . . From feminist theory, we can understand the "internal" space of individual subjectivity and the "external" space of the urban realm to be a series of overlapping and intersecting boundaries and thresholds between private and public, inner and outer, subject and object, the personal and the social.[10]

Lacy's works and the spaces in which they were enacted had reciprocal relationships that indeed overlapped and intersected: both the art project and its spatial setting, then, merit examination. As historian Robert Self wrote, "It is crucial that historians ground understandings of 'space' in concrete social formations, places, and politics and that we clarify specifically what spatial analysis can offer to historical studies of politics, institutions, and race. Historians must avoid the fetishizing of space as an academic bon mot that elevates our work rhetorically but adds little analytically."[11] While Self's challenge is an ambitious one, I hope to "ground" a portion of Lacy's *Full Circle* at the close of this chapter by analyzing one location, Daley Plaza, where seven "Monuments to Women" were concentrated. "[W]hat exists in the space between the words public and art," Lacy wrote, "is an unknown relationship between artist and audience, a relationship that may *itself* become the artwork."[12] Interwoven with the relations of public artist and her audience is another relationship: between the urban space(s) and those artworks and observers who move through and around them.

Chicago, 1993

Imagine a seemingly spontaneous appearance, overnight, of large boulders in downtown Chicago. In May 1993, these installations marked the first phase of *Full Circle: Monuments to Women,* created by Lacy with a coalition of Chicago women. The "instant monuments," as Lacy called them, were one hundred limestone boulders carefully sited throughout the Loop (as downtown Chicago is known) on sidewalks and plazas, near parks and sculptures,

to honor one hundred Chicago-area women (Figure 36).[13] The half-ton boulders were intended to acknowledge the contributions of Chicago women, many of whom came full circle, "women who first came to service when they needed the support and stayed to assist others."[14] Donated by the woman-owned Wapanucka Oolitic Limestone Quarry in Oklahoma, each boulder had a brass plaque engraved with the name and a short quote of the honoree, but the boulders themselves were uncarved and thus also anti-monuments. I will focus on the installation of boulders, what artist Gordon Matta-Clark might have called "nonuments," around Chicago's downtown.[15] The second phase of Lacy's Chicago work never occurred (she ran out of time); it was to be a performance by Lacy related to personal service, such as volunteering at a shelter for homeless people.[16] The final part was a private, international dinner party called "Dinner at Jane's," held at Hull-House Museum, the historic site of Jane Addams's settlement house, just west of downtown.[17]

Lacy's Chicago project was one of eight that comprised "Culture in Action," a series of art events in 1993 instigated by curator Mary Jane Jacob, who had teamed up with the then ten-year-old organization Sculpture Chicago as the sponsor. Jacob had previously organized a citywide installation of artwork in 1991 in Charleston, South Carolina, called "Places with a Past."[18] The commissions for art in Chicago and Charleston for the most part were created outside of institutional art settings, with artists working over a number of months in particular areas of each city.[19] Lacy's 1989 *City Sites* and *Three Weeks in May* of 1977, for instance, prefigured this curatorial approach, which in turn drew on Allan Kaprow's *Fluids*. *Fluids* involved the building of ice structures around Pasadena and Los Angeles in 1967.[20] Embedded in the process-oriented "Culture in Action" artworks, as well as in *Fluids, City Sites,* and "Places with a Past," were relationships not only among people but also to the physical environments in which the works occurred. The setting, often implicitly, helped shape the meaning(s) of each of the artworks.

While corresponding with curator Jacob about the Chicago commission, Lacy was a visiting artist in Ireland. Observing the Irish landscape strewn with rocks and researching "Catholic church power structure, . . . media, women's bodies, representation, [and] a culture in transition" had Lacy thinking about generations of immigrant Irish women and how they might be depicted in Chicago.[21] When Lacy began to conceptualize her piece for "Culture in Action," then, she wanted to address the ideas of "monuments," "service," and "women." She also characterized it as an "abstract 'tribute' to Jane Addams."[22] After initially exploring some sites in Chicago relevant to Irish immigrant history, Lacy broadened the project to include all women, not just Irish women. Shortly after the May opening of *Full Circle,* an article in the *New York Times* confirmed the dearth of monuments of and to women at that time: "We know of only 40 public outdoor statues of American women nationwide." Of those, five were of Sacagawea.[23]

Figure 36. Diagram of placement of "Monuments to Women," part I of *Full Circle*, 1993, Chicago. Drawn by Martin J. Holland after a map by Michael Piper.

The monuments of *Full Circle* were rough-hewn ironic reminders of Chicago's past and current female leaders, particularly those whose public service was similar to that of Jane Addams (1860–1935), who was one of the ten honorees from history.[24] They allowed for temporary customization by each woman; they were intimately scaled yet unmovable, by virtue of their weight. Each honored woman had an individual boulder dedicated to her, but the unsculpted rawness of the monuments playfully underscored the general lack of resources for most of their causes. About fifteen men from the World Trade Granite and Marble Co. and others worked with Lacy most of one night installing the rocks to achieve Lacy's goal that the monuments appear suddenly. The impact of *Full Circle* derived, in part, from this almost surreal and humorous juxtaposition of familiar urban spaces with boulders. "Surprise was a key element," according to Lacy.[25] Happening upon one boulder in an unexpected place, then another, and another insistently reminded the viewer of the numbers of women active in public life. The boulders altered the familiar topography of the Loop, modifying everyday predictability. Just as in previous work by Lacy, the urban context was a key aspect of this project.

The "urban context" for Lacy in Chicago was not just the architectural history of the Loop, which has been a focus of many scholarly and popular publications, boosterish and critical.[26] But because Chicago's architecture has long been famous—starting with late-nineteenth-century commercial and monumental buildings by designers and theorists such as John Wellborn Root and Louis Henri Sullivan, and then the "White City" of the World's Columbian Exposition of 1893, masterminded by Daniel H. Burnham—the historic constructions of the 1890s were one of Lacy's reference points. Further, the 1893 Chicago exposition included the Woman's Building (designed by Sophia Hayden, 1868–1953), which had served as the inspiration for the Los Angeles Woman's Building when it was established in 1973.[27] *Full Circle* also occurred near the centennial of the 1889 founding of Hull-House by Jane Addams and Ellen Gates Starr. "[S]ocial settlement houses [like Hull-House]," architect and historian Dolores Hayden wrote, "represented the great success of urban cooperative housekeeping in the late nineteenth and early twentieth centuries."[28] Finally, the limestone quarry that contributed the boulders was also about a hundred years old in 1993.

When Jane Addams and her colleagues moved into the immigrant community on the near west side of Chicago in the 1880s, they were pioneering advocates for public housing, health, and education, with many strategies. What Lacy intended to underscore with *Full Circle* was the ways in which women's leadership had been so important in the previous century's civic reform movement and how women's contributions to public life could be honored, altered, and strengthened in late-twentieth-century

Chicago. "Hull House founder Jane Addams was well aware of the liminal nature of social settlements. She referred to her work as occupying that 'borderland between charitable effort and legislation.'"[29] Historian Gerda Lerner noted in 1975 that "'Jane Addams' enormous contribution in creating a supporting female network and new structures for living' has often been ignored by historians, who have concentrated on her role as a Progressive reformer. . . ."[30] Lacy's project highlighted this past and ongoing "supporting female network."

The monuments of *Full Circle* occupied powerful spaces; their physical locations were carefully chosen to relate to the contributions being honored. Their squat proportions provided an ironic and funny contrast to the Loop's tall buildings.[31] At the opening of *Full Circle: Monuments to Women* on a Sunday afternoon in May, small parties gathered around the various boulders to celebrate "private acts in a public setting" that fleetingly personalized the monuments (Figure 37).[32] Some groups had balloons or flowers,

Figure 37. A group gathers around the "Monument" honoring Gladys Arana Nelson. Suzanne Lacy and a coalition of Chicago women, *Full Circle*, May 22, 1993, Chicago. Courtesy of Suzanne Lacy.

some hosted musicians. But because the Loop on Sunday is not crowded with daily business, one could look up or down or across the grid of the business district and see many of these small groups gathering. The public spaces were "feminized" as reminders of the unceasing efforts by women to impact public policy and contribute to the common good. The boulders remained in place from May to September.

The temporary, individual events that occurred at many of the monuments paralleled Lacy's *One Woman Shows* of 1975, in which different women sequentially created performances for each other in a chain that lasted for three weeks. To an extent, this offer to "fill in the blank" was also available to the project's volunteers, the critics, and the uninitiated observers on the streets in Chicago. Calling the unworked stones "monuments" created mental friction. The boulders could "mean" contradictory things, "clunky obstacles on busy streets," or "rugged" and "inspiring."[33] As temporary installations, the boulders were not permanent monuments; as straight-from-the-quarry stones, they were not sculptures; as occupiers of downtown sidewalks, they were not museum or gallery objects; and as abstract placeholders, they represented real people, past and present, many of whom worked with marginal populations outside of the central city.

Challenges of Recognition

Full Circle: Monuments to Women sought to represent women from communities in Chicago in proportion to their real numbers in the city. By the beginning of 1993, a steering committee of about twenty members was at work formulating the selection process for the honorees, with subcommittees of additional people from local academic, cultural, service, and philanthropic organizations.[34] These women were crucial partners in the development of Lacy's project, although the aesthetic execution of it remained Lacy's. Over a two-year period project volunteers came and went, but some of the organizations that cooperated included the Chicago Historical Society, the Hull-House Museum, the Chicago Foundation for Women, and the School of the Art Institute of Chicago. Lacy communicated by phone, fax, and in person, flying in periodically to meet with various committee and Sculpture Chicago staff members.

Criteria for selection of living honorees included current residency in the Chicago area; significant impact on a specific community or on a state, national, or international level; and serving as a positive role model for other women.[35] The procedure to select a group of ethnically and racially representative women to be honored by "monuments" involved proactive solicitation of nominations, many follow-up phone calls, and several lists, checked and rechecked for demographic balance. Eventually there were 350 nominations, and fifteen women sorted through them. Ninety living and

ten historical women were selected. The women from history were selected at the March 1993 Chicago Area Women's History conference.[36]

Integral to Lacy's art projects were the many negotiations among sponsors, local communities and organizations, city government, and other artists. Installing boulders around the Loop meant Lacy and the *Full Circle* coalition had to maneuver through municipal bureaucracy, including obtaining permission from the city council. The ordinance proposed to the council's Committee on Transportation and Public Ways to permit placement of the boulders around the Loop was opposed by some officials, including sixth-ward alderman John Steele. The *Chicago Tribune* quoted him: "I don't want white people deciding who the heroes of the African-American community are." The *Tribune* reported that Steele asserted that "several organizations prominent in the black community were not involved in the selection process."[37] Two African American women on the *Full Circle* steering committee, Ronnie Hartfield, then executive director of Museum Education at the Art Institute of Chicago, and Amina Dickerson, then vice president of Education and Public Programs at the Chicago Historical Society, promptly called and wrote to Steele, informing him about the actual process. The committee eventually did approve the resolution.

In early May 1993, Dickerson compellingly wrote to Steele:

> I want you to know that I have been closely associated with the project since its earliest stages and am familiar with the many women's groups, individuals and organizations that have been contacted or otherwise consulted in the development of the project. The list of women *that were nominated by these women* to be recognized as part of this collective, public art project is, I believe, a comprehensive, representative and highly appropriate group of women of achievement in this city. . . .
>
> This effort is one that seeks to bind women throughout the city at a time when the divisions among us have the potential of devastating impact on our respective communities. . . . Further, the caliber of individuals that have lent their time and talent to this project, including Gwendolyn Brooks who will preside at the opening, suggests that the project has tremendous merit and may, in fact, yield greater support for the many issues in which these women are involved: education, social services, community activism, rights for battered women, children's activists, religion and values, world peace, cross-cultural communication and, of course, the range of performing, visual and literary arts.[38]

Dickerson's letter underscores the teamwork and vigorous organizing efforts of the *Full Circle* steering committee.

When the rocks "surprised" Chicagoans with their sudden appearance, they received a lot of formal and informal attention.[39] There were diverse opinions about who was chosen, who was left out, and the balance between honorees who were well known (like the mayor's wife, Maggie Daley, and cultural commissioner Lois Weisberg, for example) and those who faithfully had served their causes in obscurity.[40] Some who complained did not know about the selection process, explained above, and thought that Lacy as an outsider had made the choices, which was not the case. Lacy teamed with local individuals and organizations already at work on issues that dovetailed with her interests.

Implicit in the boulders were questions about who counts, what counts as service, and who is really served. One steering committee member felt that the group was "too elitist . . . in the selection and even in the operation of the whole program."[41] While the specific objections may never be answered satisfactorily, I would argue that the project's goal of engagement was at least partially met: whether they agreed with the final list of honorees or not, Chicagoans were compiling their own lists and thinking about particular women they themselves would recognize. In that sense, the boulders became placeholders for honoring *all* women committed to public service, which encompassed a wide range of activities.

Philosopher Charles Taylor's essay on "The Politics of Recognition" delved into what it has meant to a person's individual and collective identity(ies) to be recognized as valuable in and to society.[42] We actively create our identities in relation to others or, as Taylor put it, dialogically. We also construct embodied relationships with physical spaces, as Barbara Hooper noted. By creating monuments to individuals in urban places, Lacy "grounded" social formations in specific places (recalling historian Robert Self's strategy quoted above). In establishing reciprocal relationships between people and places, she inserted unacknowledged services into the public realm. I expand on this reciprocity in my discussion of Daley Plaza below.

Taylor recognized Frantz Fanon's influential argument that "in order to be free [subjugated people] must first of all purge themselves of these demeaning self-images." Feminism, Taylor continued, has taken up this "struggle for a changed self-image."[43] Certainly Lacy's *Full Circle* did more than honor "women's contributions" in general; they marked particular, though diverse, services to various publics and brought them attention in places where many of these women were not known. The actual gaps between the boulders allowed people moving between them to ponder: service to whom? whose downtown is it? which public(s) does the art address? Each of these questions prompted dialogues (internal and/or external) about human commonalities and differences.

"Culture in Action," which included Lacy's *Full Circle*, was controversial for a variety of reasons. Art critics asked who the "public" was and

whether some "Culture in Action" artists exploited the communities with which they engaged; they questioned the quality and meaning of the individual projects and the temporary nature of the pieces.[44] In her book on site-specific art, art historian Miwon Kwon devoted a whole chapter to it. Within that chapter, she wrote a section on *Full Circle*. According to Kwon, while

> Lacy emphasized the distinctness of individual identities . . .
> over the importance of a single collective image . . . [,] whatever
> the individual differences, all were subsumed in the end by the
> artist's search for a common denominator that celebrated an
> abstract gender unity, delimited in this case by a set of service-
> oriented characteristics that were in effect naturalized as innate
> attributes of women in general.[45]

Informed by Taylor, I think that Kwon misunderstood Lacy's work in Chicago. Lacy and her collaborators aimed to recognize different and multiple identities in relation to the city and to each other, strategically focusing on women due to their historic and actual oppressions.[46]

Kwon focused on the "service" aspect of *Full Circle* and dismissed Lacy's work for naturalizing the capacity for service by women. Lacy herself recognized the pitfalls of her focus. In the catalog that was published two years after the events, she wrote:

> "Service," an inadequate word, . . . still seems the best way to
> describe a quality of supporting, nurturing, correcting injus-
> tice, promoting equality. . . . Often service smacks of essential-
> ism. . . . That is dangerous territory, for theoretical reasons
> as well as because it suggests that women can and, therefore
> must, serve. Nevertheless, it still seems the best word to de-
> scribe a sense of freely embraced responsibility for nurturing
> life . . . and the activism that goes with that responsibility.[47]

In her just-quoted reflections on *Full Circle*, Lacy was articulating a struggle in which she has engaged since the 1970s. She noted in 2004: "Social engagement in the arts is rooted in the exploration of an art practice connected with everyday life."[48] In *Whisper Minnesota* in the 1980s, for example, Lacy explored ways to embed new policies in institutions so that improvements would endure in daily life. Her efforts to use art to affect social policy continued in Chicago and elsewhere.

Lacy's project in Chicago indeed raised knotty problems of public service, both in Jane Addams's era and our own. While the particulars of Addams's approaches to service were not appropriate one hundred years later, it certainly *was* appropriate in *Full Circle* to acknowledge foremothers and their contributions. In addition to the white Addams, African American Ida B. Wells (1862–1931), a journalist who campaigned against lynching

and became president of the Black Alpha Suffrage Club of Chicago, was an honoree from history. How might have these two women from the same generation supported each other? The challenges of working across race, ethnicities, class, and other differences have not diminished. As Dickerson wrote in her letter to Alderman Steele, *Full Circle* sought "to bind women throughout the city at a time when the divisions among us have the potential of devastating impact on our respective communities." The crux of *Full Circle* conceptually was the (re)emplacement of a "supporting female network and new structures for living" in the spirit of Jane Addams. The physical presence of one hundred boulders in the Loop gave tangible, aesthetic expression of the numerous networks that were active in Chicago, yet also in need of support and strengthening.

Participatory reception allows for a wealth of responses to works such as *Full Circle*. Surely, some people like Kwon found that the individual honorees were "subsumed in the end by . . . a common denominator," but others saw openings, spaces between, where new meanings could develop in previously unseen juxtapositions. Art historian Irit Rogoff pointed to "that mighty critical apparatus which was evolved throughout the 1970s and in which an unraveling of the relations between subjects and objects took place through radical critiques of authorial authorities."[49] Once the "author" expanded to include more people, the receptions of cultural productions became more varied. Lacy's art, shaped by antiracist activism and feminism, contributed to the unraveling that Rogoff described. The boulders of *Full Circle* provided forms that were similar but spatially distinct, thus reinforcing the message of what geographer Massey labeled "coexisting heterogeneity."

Lacy aimed to communicate with many publics on several levels. In an unpublished paper, she wrote:

> In *Full Circle* I was interested in questions about the "reach" of the work. How could the piece function in layers, on the one hand embody a more complex set of questions about women's culture, and on the other present a simplified representation of these concerns to a broad constituency?
>
> So the exploration had to do, as it often does nowadays, with the presentation of complexity in systems [on the streets for example, systems that were] designed for reductivist information. This is where the intuitive responses . . . had to come in. Since the one-liner was the ultimate that could be hoped for within mass culture, I was relying upon the consciousness of the perceiver to enrich and expand the piece. As in a work by Allan Kaprow, the performance would take place within the experience of the viewer/participant. In some it did, in some it did not, and a lively dialogue ensued within the media.[50]

As Lacy noted, the artist had to grab the viewer with a "one-liner"—
"contributions of women to Chicago"—and then some viewers might choose
to grapple with problems posed in the work beyond the immediately obvi-
ous, thus expanding their experience. During summer 1993, there were
interviews on radio and television and in print media with the women hon-
orees. Lacy wrote, "If a work can speak in different ways to different people,
then it has a chance to say one thing to the art world . . . and another thing
to the mass audience."[51] The boulders of *Full Circle* prolonged the experience
of them because they were spatially dispersed, subtly varied in shape, size,
and identity (of the honoree), and in place for four months, a time span that
allowed repeated encounters.

Movement Through

From Lacy's student days onward, many of her projects involved driving
or other forms of travel (reflective of California's car culture). She had ob-
served movements of sex workers in Los Angeles in *Prostitution Notes* in the
mid-1970s, and in 1978 she framed her frequent travel along the California
coast by plane and car as the performance *Cinderella in a Dragster*. Urban
landscapes, with their density of people and variety of architectural sites, re-
quire physically moving through the city to gain any sort of understanding
of the complexity of the lives there. The spaces in which these lives occur
shape and are shaped by the activities in them.[52]

Full Circle: Monuments to Women required movements through space
to grasp the entire piece. The monuments did not form a path but rather
emerged in one's path as one moved around downtown, dodging people,
planters, lampposts. All boulders rested on the sidewalks, but some sat
firmly under a building relief or against a balustrade, and others were at
the curb's edge. The *Full Circle* monuments occupied public rights-of-way
whether people wanted to see them or not. Those who were intrigued by
the opening events in May or who stopped to examine a rock near another
public sculpture and wondered at the contrast had opportunities to con-
tinue the interaction with the artwork.

Lacy's artwork was a mediating structure in the spaces between vari-
ous publics and art, block by city block, and in time. Jane Rendell has writ-
ten, "Walking exposes the audience to series of encounters with differing
aspects of place, focusing on the journey between particular sites as much
as the places themselves."[53] Further, each person moves into and through a
place with a unique rhythm and posture, occupying space differently from
the next person and responding to the designed environment in varied, un-
predictable ways. While social practices are spatial, they are also particular
to one's identity(ies). Bodies of varied genders, abilities, ancestries, ages,
and sizes were the means by which people experienced the monuments. As

people passed the boulders, sat on them, leaned over to read the plaques, and conversed about them, the boulders and the passersby merged a bit. In this sense, the abstract boulders became figural, especially when an honoree stood or sat in a wheelchair next to one of them, of course.

The "spontaneous" appearance of boulders created a ritual of moving from one to the next. Lacy intended that *Full Circle: Monuments to Women* seem to arise spontaneously, but in fact their placement was carefully negotiated and renegotiated over several months. The same could be said of the mini-gatherings at each rock, many of which were orchestrated by the honorees and documented by photographers. *Full Circle* thus connected spaces between abstractions and bodies, spontaneous events and rituals.

Jane Rendell's hybrid writing noted, "[T]he ways in which relationships between makers and users are constructed can constitute a major part of the conceptualisation and realisation of a project, affecting aesthetic and formal decisions. This may tend towards the choreographic, where the work manifests less as an object and more as an event, a series of exchanges people make with one another."[54] This thoughtful essay stresses the importance of embodied relationships in cocreation, as well as the importance of exchange and movement in projects like Lacy's. Rendell's choreographic aspect was evident in *Full Circle* as people traveled between rocks across the Loop, experiencing the city with their bodies and in interactions with other exploring bodies. Moving through space, even given people's varied awareness of their own movements, added a kinetic dimension to their daily experiences. Movement affirms our presence on life's continuum, allowing for new conjunctures, shifts between points of view, and transcendence of immediate contexts. The literal spaces in which social performances take place not only represent human presences in the city but also actually help constitute our experiences. It matters *where* we are; our interactions take *place*.

Rock Women at the Daley Center and Plaza

The map in Figure 36 shows the locations of the boulders placed around the Loop. A group of seven monuments on or near the Richard J. Daley Center and Plaza, numbered in the inset, provides a sample with which to explore *Full Circle* itself and the relation of some of its monuments to the surrounding built environment (Figure 38). The Daley Center skyscraper fronting on the granite plaza, Pablo Picasso's untitled steel sculpture from 1967, a minimalist fountain, and an eternal flame memorial shared the site with four monuments, comparatively small boulders honoring three women categorized as white and one African American: Rose Farina (1), Rev. Dr. Johnnie R. Colemon (2), Lois Weisberg (3), and Maggie Daley (4).[55] Farina was an arts organizer, producing large events in the city, such as the *Under the Picasso* series. Farina's rock was appropriately near the Picasso. Rever-

Figure 38.
"Monuments to
Women," part
of *Full Circle*,
May–September
1993, Daley
Plaza, Chicago.
Photograph by
George Philosophus.
Courtesy of Suzanne
Lacy.

end Colemon was a religious leader, having organized the New Thought Movement as well as the Christ Universal Temple. Colemon's ministerial leadership connects her to the eternal flame, next to which her rock was located. Weisberg was the city's cultural affairs commissioner. Daley was the wife of Chicago mayor Richard M. Daley and had long been active in promoting arts activities for Chicago's youth. Weisberg's rock was placed near the fountain, while Daley's rock was near the southwest column of the Daley Center. Honorees were dubbed "rock women."

Across the street from the civic center, by the 1965 Brunswick Building, near Joan Miró's *Miss Chicago* sculpture (installed 1981), was another rock, dedicated to Kanta Khipple, who was originally from India (Figure 39). Khipple founded Apna Ghar in 1989, the first shelter for Asian women and children who are victims of domestic violence. The rough, jagged stone dedicated to Khipple sat insistently in front of the elegant travertine-faced concrete of the Brunswick Building. Beneath the carved limestone reliefs of the City Hall-County Building (1911) and facing the Daley Center were two more boulders, in recognition of Aurelia Pucinski of Polish descent and

Figure 39.
"Monument" to
Kanta Khipple
in front of the
Brunswick Building,
Full Circle,
May–September
1993, Chicago.
Photograph by
George Philosophus.
Courtesy of Suzanne
Lacy.

Ruth M. Rothstein, who valued her Jewish heritage (Figure 40). Attorney Pucinski, honored for her longtime commitment to fairness in the judicial system, was Clerk of the Court of Cook County (Illinois) in 1993. Rothstein was a labor organizer and an advocate for women's rights, mainly in the community health arena, as a leader in the Cook County Bureau of Health Services. Other boulders could be seen up and down the streets, but these seven marked the open space in front of a landmark of Chicago modernist architecture, marking this space as gendered and racialized, among other positionalities.

The *Full Circle* monuments were ambiguous in relation to the Daley

Plaza site. On the one hand, there was nothing particularly distinctive about them compared to the boulders placed elsewhere in the Loop. On the other hand, since there were a number of them clustered together in a location of governmental power, they addressed both the content (twentieth-century governmental headquarters) and the forms (open plaza surrounded by contrasting buildings) of that particular setting. Lacy implicitly queried what "site-specific" art might mean, as art and in relation to the site. Miwon Kwon suggested that "many artists and critics now register their desire to better serve and engage the public, to further close the gap between art and life, by expressing a deep dissatisfaction with site specificity."[56] Kwon continued with her critique of new genre public art by claiming that it represented "a crucial shift in which the 'site' is displaced by notions of an 'audience,' a particular social 'issue,' and, most commonly, a 'community.'"[57] Instead of Kwon's either "site" or "audience" opposition, I believe that new genre public art provides, in fact, encourages, multiple approaches: one participant may choose to focus on an issue, another on the site. Lacy's contributions

Figure 40. "Monuments" to Aurelia Pucinski and Ruth Rothstein on the east side of City Hall, *Full Circle*, May–September 1993, Chicago. Photograph by George Philosophus. Courtesy of Suzanne Lacy.

included practicing and theorizing a "both [site]/and [audience]" notion of public art, particularly in order to address the art world as well as varied publics. Placing art in public spaces supported her multiple goals.

The Daley Center plaza is a void, a space between, although it was not "blank" until midcentury downtown redevelopment made it so. The placements of *Full Circle* monuments acknowledged the significance of the 1965 civic center and its plaza (renamed Daley Center and Plaza in 1976 to honor the mayor, Richard J. Daley, who had just died). Designed as a joint venture among three large Chicago architectural firms, the chief designer, Jacques Brownson (born 1923) from C. F. Murphy Associates, commented, "One of the things at the Civic Center . . . rather than to clutter it up was to leave your space and make those elements that go into it not permanent but changing, almost like a curator would set up an exhibit in a museum."[58] As part of that uncluttered, modernist aesthetic, then, the 648-foot-tall Daley Center is an abstract composition, variations in brown and red, with no specific reference to human scale. The skyscraper rises with complete assurance to the north of the plaza (Figure 41). Lacy's temporary installations in the open space took advantage of the marvelous forecourt excavated from the city for the civic center, just as its architects had intended. "We have to have [open space]," Brownson said. "If it's a courts building, it has to have a forecourt. It has to be full of sunlight because Chicago is dark and cloudy and gloomy and dismal enough."[59] Bounded by Randolph, Dearborn, Washington, and Clark streets, the civic center with its two-and-a-half-acre plaza, a centerpiece in the mid-twentieth-century reconstruction of Chicago's Loop, has been a locus of activity since its creation. Buildings around the perimeter define the plaza as an urban room.

In speaking about Daley Plaza, the architect Brownson articulated the importance of flexible and open public spaces within the center of Chicago:

> [T]here is a plane, the floor plane of the surface, on which you can do almost anything. You can have any kind of activity. I've seen certain times where they had a demonstration in the plaza. The police department had a guard dog demonstration on it. The next time the farmers' market is going on. All of these kinds of activities are what makes a real plaza. . . . It's the agora of the city. . . . I wanted less things on it, and that was the hardest thing. . . . It's the void that has become so important—the emptiness, the lack.[60]

By locating boulders for four months in or near Daley Plaza, Lacy activated the "emptiness" with particular markers of an idea, extending women's engagements with public processes into public space with oddly unsculpted rocks placed next to familiar buildings. The then-minimalist composition of the Daley Plaza and Center aided the temporary urban interventions of

Lacy. In turn, by installing "nonuments," Lacy heightened the civic center's monumentality by contrast.

In a 2005 article, Dennis Frenchman assembled lessons from "Event-Places," where urban form and public activities are interwoven to create a "dialog between people and physical setting . . . reaffirming the value of shared experiences and spaces in the city. . . ." Drawing on a joint study conducted by Spain's Universitat Polytechnica de Catalunya and the Massachusetts Institute of Technology, he suggested guidelines for successful event-places that confirm many of the approaches already in use by community and public artists like Lacy. Among his suggestions are to stage an

event in a territory with strong edges, create intimacy with emotional bonds between the event and the participants, design multiple nodes of activity ("granularity"), provide for triangulation (a William Whyte term describing how interaction between two strangers is eased in the presence of a third, shared object), promote movement, and engage all the senses.[61] Compared to his list, the *Full Circle* monuments were set in the well-defined Loop as sites for casual observations, expressions of curiosity, intimate gatherings, and public ceremonies. The boulders provided for granularity and triangulation as people moved among them.

Lacy's work can inform and transform other disciplinary projects, as architect and theorist Jane Rendell has remarked: " . . . [A]rchitecture takes inspiration from other spatial arts. Architects can learn possible tactics and strategies from the work of feminists in dance, film, art and writing, as well as those artists operating in the public spaces of the city, for example, Niki de Saint Phalle, Maya Lin and Suzanne Lacy."[62] Marking Daley Plaza with boulders honoring an African American pastor, a South Asian activist against domestic violence, and the Irish Catholic mayor's wife, for example, inserted racial categories and gender into public space and also called attention to a modernist skyscraper that itself has provoked admiration and hostility to both its governmental functions and its minimalist aesthetics. In an earlier essay Rendell wrote with Iain Borden, they noted, "architecture is not just the product of architects, planners and built environment professionals, but is also the product of users, subjects and metropolitan dwellers of all kinds. The same is true for public art. Art is not just produced by artists, but is reproduced by viewers and audiences."[63] The intertwining of architecture and art, of artist and city dwellers in *Full Circle* enriched the relationships among the objects and the subjects; in addition to conversations among people, *Full Circle* connected physical spaces to women engaged in public service.[64]

Lacy's "conversational art" work in Chicago promoted dialogues among people, allowing for indeterminacy and contentiousness when different constituencies came together to communicate. For generations of meanings to occur within people, though, there must be openings for ideas and feelings to take shape. Lacy's "spaces between" provided room for people to reposition themselves in relation to others, whether in conversations at a monument or in learning about an honoree's contributions, deepening cultural memory. When critic Homi Bhabha examined conversational art, he highlighted new aesthetic possibilities in this approach:

> [C]onversation shrinks the distance between subject and object. . . . This results in an aesthetic strategy that articulates hitherto unconnected moments between memory and history, revises the traditional divisions between private and public,

rearticulates the past and the present, and, through the perfor-
mance of the artwork, fosters unexplored relationships between
historical or biographical events, artistic innovations, and an
enlarged sense of cultural community.[65]

Lacy took elements of the city—urban plazas, sidewalks, parks, sculpture,
and niches—and represented caring human relationships within or upon
them.[66] Doreen Massey concisely stressed the generative importance of
space: "Without space, no multiplicity; without multiplicity, no space. If
space is indeed the product of interrelations, then it must be predicated
upon the existence of plurality. Multiplicity and space as co-constitutive."[67]
Conversations out of doors, people moving through space, sidewalk cook-
outs, speak-outs on rape on an urban plaza, gospel singers on a balcony
overlooking a market, marking maps in a public mall, and driving around:
bodies interacting with cities; cities interacting with bodies. For over twenty
years, Lacy's urban projects brought diverse people into relationship with
each other in physical spaces.

6 TURNING POINT

In 1988, critic Lucy Lippard reflected on the transition in Lacy's art from her early pieces where "she symbolically and literally gave away parts of herself and collected parts of others (sometimes in vampire guise) . . . [to] her large-scale participatory organizational pieces . . . [when] [s]he turned . . . to the beneficent and outreaching aspect of her collective persona."[1] In early performances such as *Net Construction* (1973), Lacy exchanged literal body parts; in *Learn Where the Meat Comes From* (1976), she enacted chef, lamb, and vampire. By the 1980s, Lacy's time was increasingly consumed by participatory performances that fostered reciprocal relationships with women of color, older women, incarcerated women, and survivors of domestic violence, for example. Further, feminisms in the 1990s had multiplied. Many feminists recognized that the binary divisions that characterized much of 1970s feminism were not sufficient to address multiple oppressions and complicated, globalizing lives. Lacy was forty-eight years old in 1993, working on projects in Chicago, Pittsburgh, and upstate New York, as well as in the Bay Area of California, where she was living. While in the 1970s and 1980s Lacy had investigated aspects of her present and future selves, as a mortal being, for example, or as an older woman, in the 1990s she became intrigued by the lives of teenagers.

The next two chapters will consider Lacy's work with teens, first in Vancouver, British Columbia, and then in Oakland, California. The social locations, racializations, sexual identifications, and developing bodies of young people made for especially charged situations related to multisensory performances with teenaged participants. Several of these performances pointed to the generational distance between Lacy and the young people with whom she worked, as well as changes in feminist practices

and theories in the 1990s. Examining these issues in the context of particular works, in specific places and times, helps to pinpoint the aesthetic forms and the social content, rather than gloss over the processes with generalizations.

At the same time that I want to retain specificity, however, I hope to suggest some ways in which embodied movement, touch, face-to-face conversation, and written and visual communication coproduce spaces in general. A recent article by a trio of British geographers recognized the importance of "placing [visual experience] in relation to an expanded field of bodily and social experience. . . . Visual perception is not a singular sense: it is always gained through other sensory stimuli and mediated by intersubjective relations between people and objects—perhaps more so in an urban setting than in any other."[2] These scholars essentially describe the importance of performance to Lacy; assessing Lacy's work in theatrical terms has been easier than as visual art, but the "spatial" turn in art criticism since the 1990s (see chapter 4) has lessened this challenge somewhat.[3] Still, some of the tensions in Vancouver and Oakland arose because of Lacy's assumption of the role of theatrical director, when others assumed they were collaborating with a visual artist.

Turning Point **in Vancouver**

In June 1993, the Vancouver (British Columbia) Parks Board invited Lacy to a workshop along with Australian artist Marla Guppy. Increasingly a node of artistic activity, Vancouver in the early 1990s wanted to formulate an arts policy and attract not just financial but social and cultural capital to the city as well. Lacy's work in Minneapolis as well as Oakland (described in chapter 7) had caught the attention of the Canadians. She was then brought back in 1995 for the Women in View Festival. What came to be called *Turning Point* emerged out of that invitation.[4] Lacy had been working with teens in Oakland, where youth culture was increasingly evident. The rapidly changing city of Vancouver was similarly alert to youth, and the planning team that had contacted Lacy was particularly keen to focus on young women.

Turning Point had three components but two phases. Two components—a mass media intervention campaign, and networking among and mentorship for teenage girls—essentially comprised the first phase and lasted about a year. The third component, a culminating art performance, was developed in the second phase. (Lacy conceptualized both phases as part of the performance, but others did not view it that way.) The *Turning Point* mission statement declared:

> For us, the process of coalition and community building is an
> integral part of the artwork. Similarly, the mass media aspects

are designed as a public face for the art. Pulling the whole process together, a final performance serves as a celebratory ritual that brings the diverse themes and people together in a public site. But it is this networking and community building, the support of gender-aware policies and sensitivities, the mentoring and relationships formed, that will form the lasting legacy of this project.[5]

Like most of Lacy's large-scale projects, this piece involved about two years of preparation prior to the performance, with small events occurring in varied venues to publicize the project and provide opportunities for girls to organize and interact. The final performance, *Under Construction*, took place in 1997 at an upscale residential development, then still being built: The Residences on Georgia, designed by architect James K. M. Cheng, was located near downtown Vancouver (Figure 42). The producer, Barb Clausen, said that Lacy watched the construction of this nearby building from her hotel room (under way in April 1996) and was drawn to this location.[6] While my focus will be on Lacy's use of the high-rise site, I will start by sketching out the larger project, its development, and reception.

Figure 42. Suzanne Lacy and others, *Under Construction*, June 15, 1997, Vancouver, British Columbia. Bird's-eye view of performers in court of The Residences on Georgia, designed by James K. M. Cheng. Courtesy of the artist.

Turning Point Process

Susan Gordon, a representative of the Vancouver Parks Board and a key organizer of *Turning Point*, found Lacy's step-by-step approach, which she articulated in an early meeting, to be useful as a guide in community development work: name the issue, develop a vision, lay out the objectives, find the resources, and build the networks.[7] At this level of generality, of course, the steps seem straightforward. But in any complex, cross-cultural, intergenerational, international work, this is hardly the case, and *Turning Point* was no exception.

A steering committee of eleven adults formed in 1995, guided by a group of four Anglo-Canadian women: Barb Clausen, Susan Gordon, Joslin Kobylka, and Alix Sales.[8] Clausen, whose background was in dance, had just formed the New Performance Works Society in 1993, which became the producing body of *Turning Point*. This was the first community project of Clausen's organization.[9] She was the producer, the point person on the ground in Vancouver for the whole time; her knowledge and contacts in the community were crucial. (She was supposedly half-time, although she worked far beyond twenty hours a week.) Heather Howe, Clausen's ten-hour-a-week assistant, did the bulk of the teen recruiting. Alix Sales worked for the Office of Cultural Affairs and headed up *Turning Point*'s Research Group, which was in charge of assembling demographic information for recruiting needs and generating questions for interviews to be edited for the sound track. Gordon and Kobylka worked for the Parks Board.

The issue for many of these women was the status of girls in the greater metropolitan area. Several of the core women had teenage daughters, and Lacy herself was a mentor for an Oakland teen, Unique Holland, then eighteen, whom she had met through her work in Oakland. In the narrative of the work plan from December 1996, Lacy mentioned the group's interest in two recent books in particular: Peggy Orenstein's *School Girls: Young Women, Self-Esteem, and the Confidence Gap,* and Mary Pipher's *Reviving Ophelia: Saving the Selves of Adolescent Girls,* both from 1995.[10] This interest was aligned with an upsurge in youth development research and funding in the mid-1990s.[11]

Turning Point's vision, then, was to strengthen support systems for young women through educational, cultural, and media strategies. In Oakland, where Lacy had moved in 1987, she had been able to observe and participate in excellent practice in terms of youth development, with many diverse adults involved with young people not only in schools but in the courts, jails, and on the streets. To begin *Turning Point*, then, Lacy and the steering committee focused on bringing girls together who would help set the agenda. Lacy flew back and forth to Vancouver every month during the initial year-long phase. Making a concerted effort to bring youth to the table,

so to speak, was also consistent with a focus in the United States on "giving voice" to youth. But from the start, it was difficult to get enough participation by girls.

Early in January 1996, the adults organized a weekend retreat for interested girls to begin peer leadership and media literacy training.[12] After the January workshop, between February and May 1996 at the Vancouver Art Gallery the adults conducted ten sessions on art and media literacy.[13] Then a two-week intensive workshop took place in August 1996 with thirty girls who had been nominated and were then paid to take the workshop. This featured a college-level class on public art and facilitated discussions on racialization and gender, focused on the culminating performance.

The girl-centered organizing highlighted the isolation that many of the girls felt from each other. In casual public mini-performances held during fall 1996, the girls had the opportunity to share one-on-one with each other and new recruits, thus addressing to some extent the social divisions that they felt. A further issue was the way young women's bodies were represented in the media; the girls did not like the depictions on billboards and commercial postcards, for example, that they saw all over their city. In media literacy exercises, they dissected ways that advertising, movies, and other popular culture limited their possibilities, then created their own imagery, in zines, conversations, and posters. The three zines, small photocopied booklets, included drawings, brief texts, and information about *Turning Point*.[14]

During the months the girls were involved with media interventions, there were also mini-performances taking place, usually in the form of hand painting with henna paste *(mehndi)* in public places (Figure 43). *Mehndi* is a traditional practice from India and parts of the Arab world of decorating hands (and feet) with a thick paste made from powdered henna, oil, and a liquid such as water, tea, or lemon juice. The paste is applied in intricate designs, allowed to dry on the skin for several hours, then washed off. The reddish stained patterns remain for one to three weeks. According to Lorrie Miller, who used *Turning Point* as a case study for her dissertation in art education,

> The hand painting logo came from one of the girls' sketchbook pages, but the idea of doing henna on their hands came from [Lacy] as she noticed some girls doodling on their hands. One of the participants reflected on the hand painting: "What I really liked [about *mehndi*] was that only women did it. . . . [A] few of us were using these pens that we were given and . . . we were drawing on our hands. Suzanne came over and was just so amazed. . . . That is how we got on that [idea of hand painting.]"[15] (Figure 44)

Figure 43. Hand painting with henna during *Under Construction*. Courtesy of Suzanne Lacy.

The *Turning Point* participants would invite other girls and adults to have their hands painted as they conversed; they were actors, and thus intimacy was easier to establish in this performative context. The first hand-painting event was held in October 1996 at the Community Cultural Development

conference of the Assembly of British Columbia Arts Councils. "For that event, pairs of girls in black *Turning Point* logo T-shirts [sat] at small tables handpainting and chatting. . . . The girls ignored the conference delegates as they watched them and listened in on their conversations."[16] A second event, in December 1996, was at Dr. Sun Yat-Sen Classical Chinese Garden; the audience was again invited to walk among the girls and "eavesdrop" on their conversations. For the Women in View Festival on February 23, 1997, another hand-painting event was organized at eleven cafés along Commercial Drive, following a girl-directed workshop at Britannia Community Centre. Girls provided handbills that read: "Turning Point is art and social action whose goal is to use public spaces and connections to make the voices of young women heard."[17] Miller quoted Clausen: "I insisted [the performance on The Drive] should be more of the girls' own engagement. That is one of the things I felt was missing was the girls getting engaged in how it should be organized."[18] Another location for girl-related activity was an opening at the Roundhouse, a community center near downtown Vancouver. Joyce Rosario (a core participant) organized a coffeehouse and poetry reading on May 3, 1997, for Vancouver Youth Week. At least twenty girls, like Rosario, were fully committed to long-term involvement toward the performance.

Using the site selection as part of the teaching process during the

Figure 44. Logo for *Turning Point*, 1996–97, Vancouver, British Columbia. Hand design by Christina McLeod. Courtesy of Suzanne Lacy.

two-week workshop, Lacy talked with the girls about where they might want to do a performance that would call attention to their stories and their potential for positive development.[19] Lacy sketched ideas for three sites in a work plan from mid-December 1996. For the then-new Vancouver Central Library (Moshe Safdie and Associates and Downs/Archambault and Partners, 1993–97), she envisioned an illustrated book as metaphor, using the library's windows as frames. For the Georgia Street construction site, which was eventually selected, although accessibility was a problem, themes would involve Vancouver's changing demographics, forming a foundation, building the future, and developing a physical sense of capability, in a setting in which young women are not usually found. For the David Lam Park/Roundhouse, which would allow much larger participation (about a thousand girls), Lacy's image harked back to early-twentieth-century pageantry. For this last location, she imagined one thousand young women coming across False Creek in barges and disembarking at the water's edge just before dusk. The girls would go to small, low tables lit by flickering candles, which would become more prominent as night fell. A sense of mystery at dusk would help suppress the "ambient energy that might transform this into a festival-type activity, rather than a theater event." Girls would paint each other's hands and talk. The audience would experience the tableaux and then move in to listen.[20]

According to Lacy, the final "image" for the performance was not settled for the first year. The twenty girls on the production team considered the images together with her.[21] As Lacy learned more about Vancouver, the real estate shifts, the ethnic conflicts, and the young women themselves, a site under construction seemed increasingly apt to her. While she was eager to move ahead with the construction site, she let the images "float" for a few months to ensure that the girls were on board.[22] Once there was agreement on the site, the planning for what became *Under Construction* moved ahead. Aligned with the steering committee, Lacy wanted to target girls ages twelve to nineteen and hoped for an ethnically balanced representation of five hundred to seven hundred girls for the final event. She specifically recommended recruiting from the Indo-Canadian and First Nations communities; her list also included European, African, Latina, Chinese, Southeast Asian, Japanese, and social services youth, teen moms, and disabled young women.[23]

Under Construction

The partially completed condominium complex Residences on Georgia provided the setting for the performance *Under Construction* on June 15, 1997, with 130 teens ages thirteen to nineteen, from Vancouver and the lower mainland of British Columbia. (The Residences were completed in 1998.)

When Lacy came to Vancouver, she stayed in the Pacific Palisades Hotel a block north, up the hill from the construction site, thus overlooking the rising residential towers. In a planning document, Georgia Street was described as "Vancouver's premier downtown ceremonial route."[24]

To arrange the use of the construction site, Lacy connected with Bob Rennie of Rennie and Associates Real Estate and through him to Ledcor Inc. With Clausen, she pitched the idea to Mike Fisher, the construction liaison for Ledcor Inc. They realized that Clausen had served as the producer of a dance performance that Fisher had been in fifteen years before, so while he might have said yes anyway, he was even more receptive to Lacy's scheme.[25] According to Lacy, "[T]he difficulty inherent in securing and using [this site] will be part of the image; that is, the spectacle quality will be part of the feat of obtaining such a site."[26] For the afternoon performance, the young women gathered in a two-hundred-foot space separating the two towers, prior to any landscaping. This contained space provided possibilities similar to those of the atrium of the IDS Center, where *The Crystal Quilt* had been performed ten years before. While this garden area was removed from public access after completion of the condominiums, during Lacy's performance project, the public moved into and through this soon-to-be private realm.

One participant from the core group reflected on the construction site:

> I hope people picked up that it is straight out construction or, young women under construction, or we are deconstructing things and reconstructing things and reconstructing them in a construction site. Constructing-construction, playing on the word. And then that the actual site itself looks from a distance, almost finished. It's very nice, you can see the windows, it's all shiny and when you approach it, or you come up close, you see that under the surface it is still being built. Which is sort of a metaphor for a young woman.[27]

The performance began when the girls on the production team marched on the sidewalk along Georgia Street toward the Residences carrying traffic-sign-shaped posters with paired phrases on them—Soft Shoulders/Sharp Mind; Stop/And Listen—that could be rotated to allow viewers to read both sides.[28] Arriving at the building, they came to the hoarding that they had previously painted pink and entered the construction site (Figure 45).[29]

The performance had, in a sense, three scenes. Scene one recalled something akin to a word-picture by the painter Stuart Davis (1894–1964) in its use of text, color, and visual energy, with a display of liberal amounts of blue tarps and yellow caution tape.[30] The cross street with Georgia, Alberni Street, was blocked off, although it was filled with construction trucks (two concrete trucks, a forklift, a flatbed trailer, a dumpster, and a dump truck),

Figure 45.
Approach to site of
Under Construction,
Vancouver, 1997.
Photograph by
Fowler. Courtesy
of Suzanne Lacy.

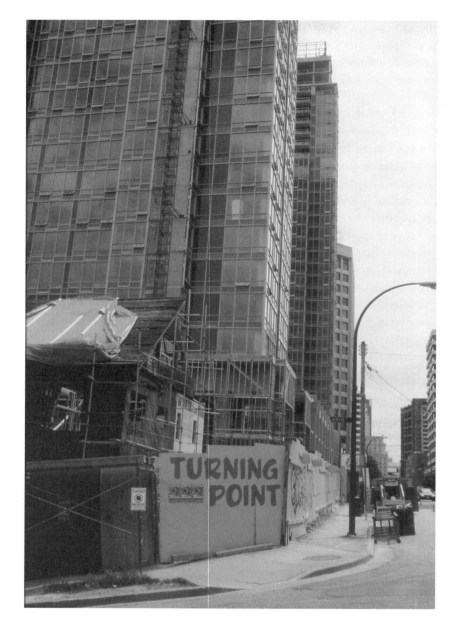

portable toilets, barrels, stacks of wood, an ambulance, a food truck, as well
as people selling T-shirts and handing out programs (Plate 9). Twenty teen-
age girls in yellow and white hard hats and orange vests flashed handheld
signs, using walkie-talkies as they moved around the block (Figure 46).
Lacy described the intended effect: "Traffic paraphernalia, including street
signs, flashing construction warnings, cones, stanchions, etc. create a vi-

sual look of roadwork and potential hazard."[31] The audience lined up outside the pink hoarding and, while waiting, watched twelve video monitors visible through peepholes. These video vignettes included interviews with girls, two girls decorating their hands with henna, a girl painting a wall, a girl taking photographs.[32] Speakers blared a sound score by Vancouver composer Jan Berman, a cacophony of construction sounds spliced with music.[33]

For scene two, the first sound track faded and another began: interviews with thirty-two young women, "layered to give impression of several voices in conversation at once."[34] The audience members heard this "conversation" as they entered a "hallway" into the central courtyard, where they could view the tableau.[35] This "hall" was constructed of plywood, to keep people away from protruding rebar and other hazards.[36] Alix Sales was the site manager, and she reported that at least two thousand people lined up for the performance, including the girls' family members. (The organizers had anticipated one thousand people.) Originally everyone was to enter the site, but the liability insurance forbade access for that many; thus, there were many frustrated and disappointed viewers.[37] The tableau was composed of girls in bright red T-shirts, with labels they chose for themselves pinned to the shirt (e.g., shy, artist, outspoken, crazy). In the 50-by-200-foot space

Figure 46. Performers with signs in *Under Construction,* June 15, 1997, Vancouver. Courtesy of Suzanne Lacy.

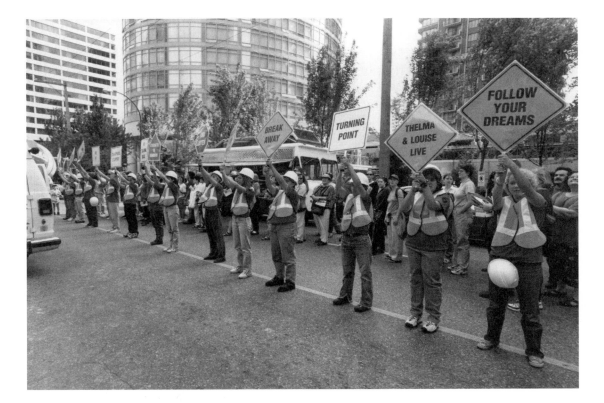

between the towers, some girls were seated on overturned white buckets in groups of four, discussing topics that included families, sex, the media portrayal of young women, and who listens to whom (Plate 10).[38]

Up above the courtyard, on top of one townhouse, Lacy was out of sight giving instructions via cell phone and walkie-talkie to "director girls" down below. She cued the movements of girls in the court as well as entry for audience members. Girls sat on concrete blocks and decorated each other's hands with henna. Then they switched positions, rotating from hand painting to bucket talking, while others in overalls and hard hats poured concrete into four-by-eight-foot wooden frames and then raked and troweled it level.[39]

In the final, third scene, the audience entered the courtyard "stage" to listen to conversations directed by the core girls, who had developed a set of questions about provocative issues. As girls left the stage area, they put their handprints in the wet cement and headed off to a post-performance party.

New Genre Public Art versus Community Cultural Development

By 1997, Lacy had had twenty years' experience producing large-scale events that used spectacle—massing of bodies, color, rhythm, movement, sound, and space—to raise public awareness and perhaps affect policies regarding issues of oppression and equity. The Vancouver committee had invited her to create such an event that would have a high profile in their community about an issue important to them. However, people unfamiliar with the process that leads up to such an event could easily make some incorrect assumptions, first about the process itself and then about the final production.

While frictions are normal and expected among participants in this sort of project, misunderstandings in Vancouver led to some failures. First, people in Vancouver expected that in creating a performance with the transformational potential of *The Crystal Quilt,* many local artists would be involved with its creation from its inception. Lacy's understanding, by contrast, was that she was collaborating with girls, not local artists. Some girls and adults also expressed dissatisfaction with Lacy's work with the girls.

Second, the efforts to recruit enough young women to participate in the performance did not result in nearly sufficient numbers for the aesthetic effect that the piece required to succeed visually.[40] Too few participants meant that bodies in red lacked density; the impact of red against gray concrete was diluted because there were too many open spaces among the girls. Instead of an intake of breath and an exclamation (i.e., "Why haven't we seen this many girls together in public space before?"), the response was to notice first the girls sitting on buckets instead of being struck by a mass of red. The girls were individualized too soon as people viewed the tableau, and the sound was too dispersed.[41] Formally, a large crowd of brilliant bod-

ies would have been an effective contrast in texture, shape, and color to the concrete court and the glass towers that rose to each side of the court.

Third, the audience management during the performance did not accommodate the large numbers of people who wanted to see the event and left many waiting for a long time without ever getting in to view the performance. These stage management errors also affected the aesthetic impact of the piece. And finally, the adults in Vancouver who were central to *Turning Point* had a gender analysis but not an intersectional view of social relations that adequately acknowledged white racism. These expectations and letdowns are much more evident in hindsight. Further, *Turning Point* coincided with the cancer treatment and subsequent death of Lacy's younger brother Philip Lacy.[42] For the remainder of this chapter, I want to focus on (1) community cultural development, and (2) the ways in which racism was and was not addressed.

Producer Barb Clausen reflected that it "took quite a while for those in Vancouver to figure out that new genre public art did not equal community organizing."[43] In her final report, Clausen wrote, "There was no real possibility for local artists to use their skills until the production was clearly defined and artistic collaborators (such as a composer, a stage designer, and a video director) were chosen by Suzanne and hired as part of the professional production team." When these individuals were hired, however, they *were* local professionals.

Clausen also noted the issue of "an aesthetic being imposed by someone living and working outside our community."[44] That aesthetic, Lacy's aesthetic, was what she had been invited to create, but a diversity of expectations among the members of the steering committee meant that those in Vancouver were not necessarily in agreement about what they wanted. According to Lacy, she repeatedly checked with the local committee as to whether they wanted a spectacular culmination like *The Crystal Quilt*, or whether they wanted a youth-driven production; she understood that they wanted the former, and she never indicated that she would do otherwise.

Lacy has always controlled the performance structure (to the extent possible) and persisted in realizing her artistic vision, while welcoming contributions of content, strategies, networks, and funds. She recently identified the problem as occurring when the development process shifted into production mode and left many feeling excluded. Further, she has come to realize that the current culture of visual art assumes parity among the participants, whereas theater is more hierarchical, with a director hiring people to get a job done. When Lacy moved into production for *Under Construction*, she confused and/or angered a number of people in the local community by demanding a level of expertise and efficiency that was markedly different from the earlier, informal process.[45]

The funding community was primed to look closely at Lacy's approach

to art. *Turning Point* was to be a pilot project, so a relatively large amount of money was allocated as it unfolded.[46] According to Clausen, a community of funders came together around the project:

> Many of the funders and bureaucrats who took a direct and personal interest in the outcome of this project formed a kind of community of advisers and supporters who helped not only in the development of this project but also in the development of a pilot funding program (Artists in Communities) designed to support projects in community cultural development both in this province and nationally.[47]

By 2004, the Canada Council and the Provincial Government were supporting community arts with a special funding source. Thus, "*Turning Point* happened at a critical point in Vancouver's development as a culturally diverse city proactive in supporting artists working with community."[48]

Turning Point and Intersectionality

During repeated visits to Vancouver, Lacy learned about the anti-Chinese sentiment in the city. Clausen maintained that this was not an issue among the girls; the city was changing demographically, but that was not paramount for the young participants. On the other hand, Miller interviewed one Chinese Canadian young woman who participated for a year and a half in preparations for *Under Construction,* first as a volunteer and then as a production assistant in the final weeks prior to the performance. Miller reported that the woman

> described herself as not in either dominant group in her school because she found that the students from Hong Kong were a little hostile towards Canadians and wouldn't respond to her unless she spoke Chinese. Whereas the Caucasian students tended to be more outgoing and athletic than she was. . . . "[M]any times I don't converse with white groups, or other groups because . . . well one reason is that my school must be 80% Chinese now, I swear. It's really funny but it's just that you stick with an ethnic group and your school becomes a certain ethnic group and you can't get out of that."[49]

One of the girls that Miller interviewed for her thesis reflected a common sentiment among both her peers and the local adults: "Our issues *were* represented, but the ownership was outside of us. *Now,* I think or am capable of seeing we did not *own* the direction or aesthetic design. We appeared, informed the designer of the actual material (ourselves) but obviously were not the ultimate directors. We were learning just as much as teaching. It was ours

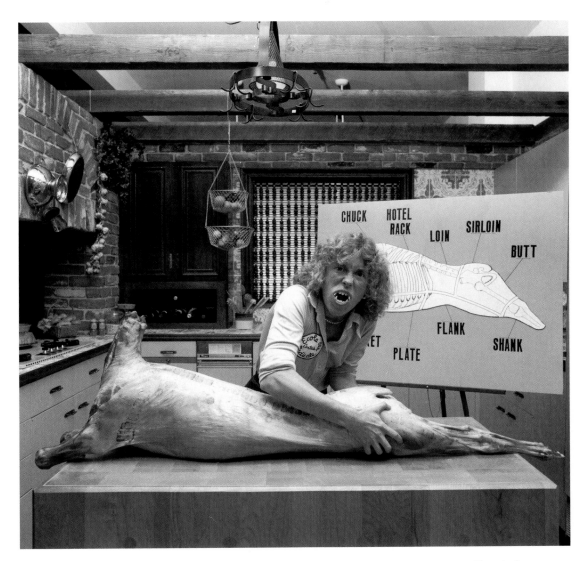

Plate 1. Suzanne Lacy, *Learn Where the Meat Comes From*, 1976. Photograph by Raúl Vega. Courtesy of the artist.

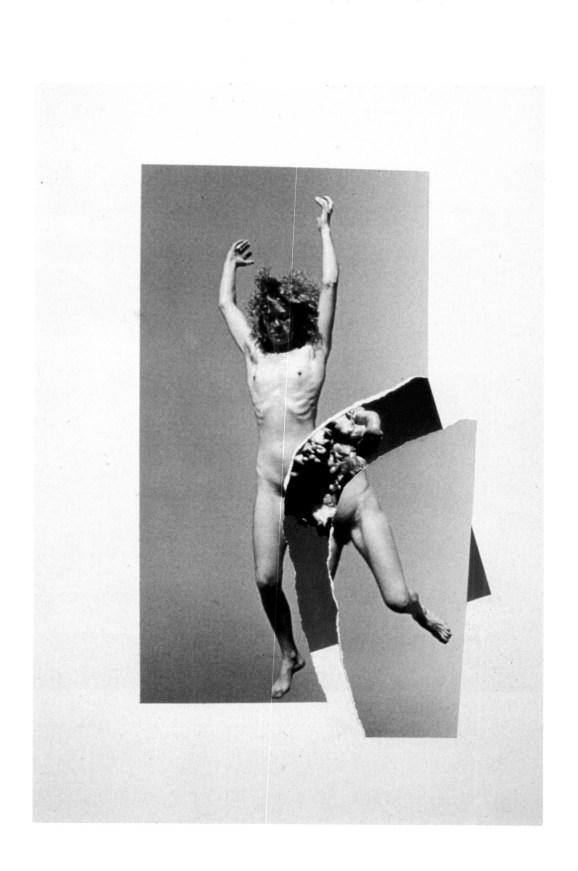

Plate 2. Suzanne Lacy, *Falling Apart,*
1976. Collage. Photograph of
Lacy by Susan Mogul. Courtesy
of the artist.

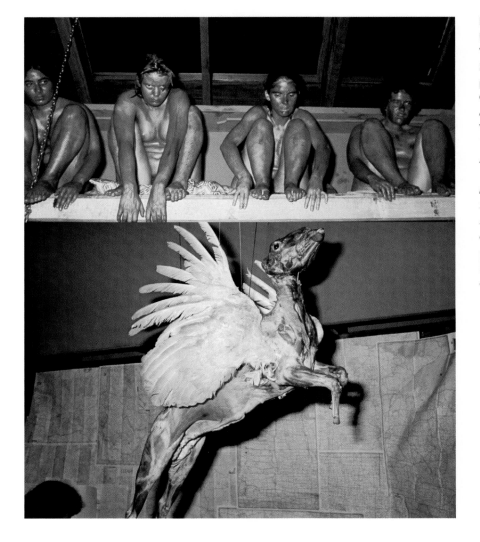

Plate 3. Suzanne
Lacy, "She
Who Would
Fly," installation-
performance at
Garage Gallery
of Studio Watts
Workshop during
*Three Weeks in
May,* May 20–21,
1977, Los Angeles.
Montage by
Suzanne Lacy
showing lamb
and women, using
photographs by
Raúl Vega. Courtesy
of the artist.

Plate 4. Suzanne Lacy and Leslie Labowitz, close-up of performers during *In Mourning and in Rage,* December 13, 1977, City Hall, Los Angeles. Photograph by Martin Karras. Courtesy of Suzanne Lacy.

Plate 5. Suzanne Lacy, interior view of "There Are Voices in the Desert" installation, part of *From Reverence to Rape to Respect,* May 1978, University of Nevada Art Gallery, Las Vegas. Courtesy of the artist.

Plate 6. Suzanne Lacy and others, overview of *The Dark Madonna*, May 31, 1986, Franklin D. Murphy Sculpture Garden, University of California, Los Angeles. Courtesy of the artist.

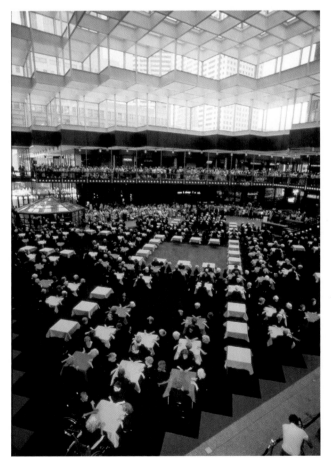

Plate 7. *The Crystal Quilt*, directed by Suzanne Lacy, May 10, 1987, IDS Center, Minneapolis, Minnesota. Photograph by Anne Marsden. Courtesy of the artist.

Plate 8. Portion of beach during
Whisper, the Waves, the Wind,
by Suzanne Lacy and others, May 19,
1984, La Jolla, California. Photograph
by G. Pasha Turley. Courtesy of
the artist.

Plate 9. Performers on Alberni Street in *Under Construction*, by Suzanne Lacy and others, June 15, 1997, Vancouver, British Columbia. Courtesy of the artist.

Plate 10. Performers in court of The Residences on Georgia during *Under Construction*, by Suzanne Lacy and others, June 15, 1997, Vancouver, British Columbia. Courtesy of the artist.

Plate 11. Interior
of bus-museum
in *La Piel de la
Memoria/The Skin
of Memory,* by
Suzanne Lacy with
Pilar Riaño-Alcalá,
Raúl Cabra, Vicky
Ramirez, Mauricio
Hoyos and others,
July 1999, Barrio
Antioquia, Medellín,
Colombia. Photo-
graph by Carlos
Sanchez/Pregón
Ltda. Courtesy of
the artist.

because we were the art, but individually we had no scope on the whole project."[50] Further, in her interactions with the girls, Lacy did not shy away from difficult topics, such as rape, abuse, racism, sexual orientation, identity, and violence. When the girls' comments were included in the sound track, some organizers viewed this approach as exploiting girls' misfortunes.[51] Alternatively, other adults pointed out that most of the participating girls were already very powerful; most of their stories were not representative of those in need.

Lacy's interests were in the edgy construction zone that spatially expressed social and racialized positions in the city. Her reciprocal relationships with the teens, while not as equal as some girls anticipated, provided a framework for their own creations within the larger structure: the zines, the henna painting, the lively interactions around urban sites. Clausen was heartened by the frequency with which she heard, "I never would have met you. . . . " She felt young women's lives *were* changed by the project. Clausen noted: "[M]any of the young women became involved in community development for the first time through this project, and many have stayed active in community activities since the project concluded."[52]

Lacy and Unique Holland, an African American teen from Oakland who worked closely with Lacy during the two-week workshop in Vancouver, heard accounts of intersectional oppressions from Afro-Canadian, First Nation, and Indo-Canadian young women, as well as those of Chinese descent. In hip-hop feminist Ruth Nicole Brown's recent book *Black Girlhood Celebration,* she eloquently explains the problems of "girl empowerment" and addresses those "well-meaning adults and state directives that attempt to 'empower' girls without an understanding of what it means to be a Black girl [in the case that Brown makes] and to participate in a Black girlhood that is mediated by race, class, gender, sexuality, and hip-hop." She continues with Marnina Gonick's critique that *Reviving Ophelia* is one of the "contemporary organizing discourses of girlhood that produce and reproduce the neoliberal girl subject." I do not mean to denigrate the admirable goals of the steering committee in Vancouver to improve girls' lives, but when that effort is not particularized by the awareness of racism and other oppressions, it may have bad results. About African American girls, Brown claims, for example, that "the organizing nonprofit [group] profits most from changing speaking Black girls into 'empowered' Black girls, meaning silencing their speech and actions."[53] Lacy recognized that including Holland and Colombian anthropologist Pilar Riaño-Alcalá in discussing multiple oppressions with the girls was crucial for amplifying conversations about racism, particularly since the Canadians with whom she worked did not reflect the diversity that they aimed to foster.

Chinese Canadian girls faced a specifically spatial sort of dislike from some Canadians. Certainly young women's bodies in public spaces—in advertising or along streets where drugs were available—were not limited to

those of young Chinese women. But they were targets of resentment due to their role in property redevelopment. As Lacy reported,

> The fact that Hong Kong [was] about to revert to China—and because of that everybody that had money in Hong Kong was sending their kids to Vancouver because as British citizens they had free access. . . . And in the core of downtown, all these Chinese people were moving in, dumping their money into highrises, buying condos for their kids, for their teenage kids to come there, live on their own and go to school. . . .[54]

Thus, the Chinese young people who were living in condominiums in Vancouver were the focus for some of their compatriots who were angered by the rapid construction of high-end real estate and blamed it on Chinese immigrants.

Racialized Real Estate

The spectacle of *Under Construction* derived in part from the difficulty of securing and using the site, as Lacy stated. The influx of Chinese immigrants into British Columbia certainly heightened Lacy's interest in the complex meanings attached to the high-rise under construction on Georgia Street. In a 2001 interview, Lacy sketched some of the tensions related to *Under Construction*:

> The owners, who were from China, found out two days before that the construction company that we had made our deal with, to be in the space, they found out that we were going in there and they tried to pull the rug out from it, two days before the performance. I was behind the scenes trying to deal with people. . . . It was tremendously circumscribed the way the performance took place. The owners of the building were up on the tenth floor watching the whole thing with binoculars. They were freaked out that they were going to get sued, that someone was going to get hurt. Somebody almost got hit [by a car] actually, because there were so many people in the audience outside.[55]

Further, in addition to meanings about spaces between adolescence and adulthood, between girls of different backgrounds, and, literally, between the two condominium towers, the performance had another layer of significance linked to the building's place in Vancouver real estate development. Planner John Punter noted that "The Residences on Georgia is *the* exemplary piece of urban design in [the neighborhood of] Triangle West."[56] In

situating *Under Construction* there, Lacy pointed to some very knotty racialized real estate issues in an understated way.

The Residences on Georgia was evidence of a trend in Vancouver that had many Canadians concerned: the influx of Hong Kong money, which was changing the face of the city. Developed by Westbank Projects for the pan-Asian Kuok Group, this aesthetically successful design displayed the connections of Vancouver-based James K. M. Cheng, a Hong Kong–born, Harvard-trained architect with a global clientele.[57] The design included two thirty-five-story glass towers separated by a "green oasis" (where the performance occurred before landscaping) and a series of three-story townhouses along Alberni Street creating a link between the two towers.[58]

The project increased the density and scale of the area, particularly because the towers were sited at a point where the land sloped down sharply northward and thus appeared even taller from Georgia Street. Two years after *Under Construction,* in 1999, *Canadian Architect* remarked on this trend: "Vancouver's West End is famous for its dense forest of residential point towers, all vying for their share of spectacular mountain and ocean views. This unique visual resource, combined with a large influx of foreign capital, has driven up land values, thereby encouraging the production of luxury condominiums."[59] As the young production team paraded down the Georgia Street corridor from the direction of downtown Vancouver to the *Under Construction* site in 1997, their movement had a parallel in the "march" of property development during that decade.

Sociologist Peter S. Li reported on the *perception* of this "influx of foreign capital":

> By the end of the 1980s, there was a general perception that the overheated real estate market in Vancouver was largely caused by wealthy Hong Kong immigrants and offshore Asian investors buying into the housing market, . . . Few residents would openly criticize Hong Kong immigrants and their perceived impact on the housing market for fear of being accused of "racism". . . .[60]

Lacy understood that there was a long tradition among (not just) Anglo-Canadians of anti-Asian sentiment. As Li reported, "Throughout the latter half of the nineteenth century and early twentieth century, . . . [a]nti-Orientalism was particularly strong in British Columbia where the Chinese tended to congregate." Li noted a shift in attitudes by the later twentieth century:

> With further changes in immigration regulations in 1985 to expand the recruitment of business immigrants, many immigrants with substantial assets from Hong Kong, and also

Taiwan, began to establish themselves in Canada. . . . [D]espite
the economic accomplishments of the Chinese and their occu-
pational mobility, a segment of the Canadian public . . . has suc-
cessfully depicted an image of Chinese immigrants as socially
undesirable without explicitly resorting to the notion of "race."[61]

During the time that Lacy was working in Vancouver, the real estate
market was one incubator for racializing social conflict. Housing prices
doubled in the 1980s in Vancouver and in some locations increased signifi-
cantly more than that. Into this charged atmosphere, then, came the plan
to build high-rise apartments designed by architect Cheng and financed by
a pan-Asian conglomerate. Real estate investments by multinational corpo-
rations were fueled also by "insecurities in Hong Kong in the late 1980s,
and the citizen unrest in China in 1989 [which] collectively stimulated in-
migration and the high-rise condominium market in particular."[62] These
tensions were never addressed directly by those Anglo-Canadians involved
with *Turning Point*. Lacy talked about it, some of the girls talked about it, but
few locals picked up on the issue in order to have public conversations about
it in an art context.

The construction site in Vancouver, where teenagers conversed about
how society viewed them as well as how they viewed a culture buffeted by
changing racial and gender relations, provided a rough, unfinished context
for new social understandings in *Under Construction*. As the young women
moved through the city and into the concrete, steel, and glass environment
of the incomplete Residences, they accomplished more than a group per-
formance: they temporarily made the space their own, putting their bodies
into an unlikely location, and also revealed ways in which they were *not*
uniform, *not* coherent. In turn, the residential tower complex itself acquired
broader meanings since everyone involved in *Turning Point* became aware
of its construction in the midst of their city's changing population and
land use. The architectural settings for her work, then, helped shape Lacy's
multimodal new genre public art at the same time the sites were redefined
by the visual, kinetic, and emotional content in the art. While Lacy struc-
tured dialogues in public, their content was open-ended, as in the questions
"Under construction? In what ways?" The answers differed depending on
one's vantage point.

7 TEENS AND VIOLENCE

With Lacy's move to the Bay Area (San Francisco, Oakland, and Berkeley, among other cities) in 1987, she found her *place*: activist, working-class, edgy. She was hired by the California College of Arts and Crafts (CCAC, now the California College of Arts) to be dean of the school of fine arts, and then founded the Center for Art in Public Life in 1998, prior to her departure in 2002. From the late 1980s until 2002, though she continued to travel, of course, Lacy was no longer commuting to teach at various institutions: she was at home in Oakland.

Lacy's new home, Oakland, had no shortage of tension and differences, but the Bay Area was also rich with intellectual activities and social change advocacy. The bloodletting from gun violence was all too real. According to the Office of Juvenile Justice and Delinquency Prevention, "Oakland's rates of overall violent crime and gun homicides involving youth were among the highest in the state and the nation between 1986 and 1996. Young people between the ages of ten and nineteen made up the second largest number of the city's homicide victims each year."[1] In 1993 alone, there were 154 homicides. Lacy continued her boundary-crossing practices there, with her artistic explorations marked by a strong commitment to the city of Oakland for over a decade and a deep empathy with its young, often troubled population.[2]

Oakland is and has been known for its cultural and racial diversity, its high crime and unemployment rates, and its celebrity politics, with former governor Jerry Brown as mayor from 1998 to 2006. The East Bay city also has a very high percentage of artists who live there, ranging from dancers to glass artisans to visual art collectives.[3] As dean of an art college, Lacy had a high level of visibility that brought with it some political clout. She joined a

complicated, stimulating community, then, serving as a consultant on others' projects as well as a city arts commissioner.

I want to describe Oakland's layout because, as historian Robert Self underscored, "[c]lass and race are lived through the fabric of urban life and space."[4] Oakland is on the eastern edge of San Francisco Bay, a rectangular wedge between the bay on the west, the foothills of the Diablo Mountains to the east, the predominantly white suburb of San Leandro to the south, and Berkeley to the north. The level portions of Oakland are former tidal flats and include East and West Oakland. There had been phenomenal increases in property taxes during the 1970s across California, with a disproportionate share of the taxes carried by small property owners because, as a development incentive, urban centers eager for business investment gave corporations tax breaks. This uneven economic and spatial development played itself out in many arenas, including Lacy's Oakland projects.

East Oakland, which runs on a diagonal for seven miles south of downtown, is defined by the two freeways (580 and 880), which mark either side, with Eastmont Mall (now Eastmont Town Center) as a landmark of sorts. Eastmont Mall was in the heart of one of Oakland's poorest neighborhoods and by the early 1990s had lost all four of its anchor businesses.[5] The population had diversified by then so that communities of Asian descent were closest to downtown, the Latino/a people lived in the neighborhood of Fruitvale, and long-term African American residents were in West Oakland and the Deep East Side, now famous for contributions to West Coast hip-hop culture as well as sydeshows, the illegal street demonstrations of driving skills that included doughnutting (spinning the car in a circle) at intersections.[6] As the city rises above the MacArthur Freeway (Highway 13), the residents there are predominantly white and well-to-do. Self noted that class was literally evident in the terrain, with income related to elevation: the flatlands were poor and working-class, the neighborhoods in the foothills were better off, and the Oakland Hills, with their sweeping bay views, were rich.[7]

West Oakland is also flat, sandwiched between the port and downtown. Following World War II and into the 1960s, the neighborhoods of West Oakland formed the core of African American life in the East Bay and indeed on the West Coast, dense with black-owned businesses and varied housing for unionized workers, among others. But the real economic power was held by white merchants and real estate owners downtown, who "encouraged a regional pattern of industrial investment and development" that meant that industrial jobs and investment in the central city moved away.[8] And then BART (Bay Area Rapid Transit) was built along Seventh Street, and three federally subsidized freeways (580, 880, 980) went in through West Oakland. Quite rapidly, then, West Oakland became a place to move through from San Francisco to downtown Oakland or the nearby suburbs, "a postindustrial transportation crossroads."[9] West Oakland be-

came increasingly isolated from municipal politics, had deteriorating housing stock, a high percentage of young people who could not get jobs, and was aggressively policed.[10]

Teenage Living Room and T.E.A.M.

In fall 1991, Lacy together with Chris Johnson, an African American photographer also from the CCAC, began volunteering at nearby Oakland Technical High School. Lacy and Johnson realized that their institution generally vilified these young people, many of whom waited for the bus in front of the CCAC campus. Johnson worked with teachers in the public high school on a media literacy curriculum.[11] Since the Bay Area already had an activist intellectual community, this curriculum drew on the expertise of Berkeley academics Todd Gitlin, Herb Kohl, and Troy Duster, for example.[12] Johnson and Lacy then taught a class on media literacy, which was duplicated by teacher-leaders in eight other public high schools and a court school. As a celebration in spring 1992, the two CCAC artists worked with teachers on a performance sketch, *Teenage Living Room*.

Teenage Living Room, presented in May 1992 in the Broadway parking lot of the CCAC, included nearly fifty ninth-graders and eighteen cars and trucks lent by faculty members (Figure 47).[13] The college campus rises above Broadway Boulevard, a major thoroughfare of used-car lots, auto showrooms, and outsized billboards. The vehicles were parked oriented toward each other; the teens, prior to taking their places, posed for cameras. They then got into the cars and trucks to carry on conversations on topics that they had selected. An invited audience of CCAC students, Oakland Tech faculty, and media representatives came onto the gritty lot to "overhear" the teens' discussions.[14] Conversations considered power, sex, friends, family, violence, and money. Excerpts of these interactions were broadcast on the local NBC affiliate, KRON-TV. *Teenage Living Room* thus captured public attention through mass media and refocused it on representations that were richer and fuller than standard ones: "The images of a few, shown on the media to represent many, become stereotypes that simplify lives which in reality are much more complex."[15]

Based on their initial experiences with the youth at Oakland Tech, in 1993 Lacy and Johnson expanded their efforts together with theater director and media specialist Annice Jacoby. They created an "arts-in-community organization" called Teens + Educators + Artists + Media Makers (T.E.A.M.). T.E.A.M. allied itself when feasible with city and county entities to increase positive outcomes for young people in city and county government, the legal system, health care institutions, and schools. Additionally, the teens (the "T") initiated many of T.E.A.M.'s activities, building off of previous collaborations. Active between 1993 and 2000, this visionary, ambitious,

Figure 47.
Suzanne Lacy
and Chris Johnson,
with teens from
Oakland Technical
High School,
*Teenage Living
Room*, May 20,
1992, Oakland,
California. Courtesy
of the artist.

and multitiered group had the goal of "demonstrating how art can effectively participate in civic policy."[16] Students were encouraged to use audio and video to create their own images of themselves, and they organized speak-outs as well as speaking at city hall meetings. T.E.A.M. produced *The Roof Is on Fire* (1994), *Youth, Cops and Videotape* (1994), *Signs of Violence* (1994), *No Blood/No Foul* (1996), *Expectations* (1997), *Code 33* (1998–99), and *Eye 2 Eye* (2000).[17] In addition to producing performances, T.E.A.M. offered classes, training workshops, and video screenings of thirteen youth-produced videos and five video documentaries.

Ann Wettrich and Lacy described the processes at work in this umbrella organization:

> The continuum of engagement by youth in this work encompasses youth as learners, as co-makers and co-conceptualizers and as independent creators. Artists adopt different positions such as teacher, collaborator, instigator, coach and advocate. . . . The discursive relationship within the work—whether between artist and community, artist and collaborators or, in this case, artist and youth—organically influences the direction of the work.[18]

This description of a continuum in which artists "adopt different positions" and enter in relationships with each other, youth, and/or residents underscores the necessity for an approach in which the contributions and responses of various actors are centered at different stages. Further, T.E.A.M. was fluid: people moved in and out of project-based initiatives over the years.

Networking by Lacy, Jacoby, and Johnson among Bay Area schools, municipal agencies, nonprofit groups, and universities resembled the approaches Lacy had used in her years in Los Angeles, as well as in projects she developed outside of California in the 1980s. Ariadne, a "social art network" from the late 1970s that Lacy and Labowitz had cofounded in Los Angeles, had a parallel in T.E.A.M., which also was a coalition of artists, activists, media specialists, and politicians, this time working together with youth. Similar to *Whisper Minnesota* and *Full Circle,* too, T.E.A.M. projects "attract[ed] and exploit[ed] the technological apparatus of the mass media to challenge its negative stereotyping with images that shed a positive light on a community's identity," as art educator Charles Garoian noted.[19]

In discussing artistic projects that encompass many parts of a city, we must acknowledge the nonartistic events that impact many residents. These events either become counterpoints within the artistic work or are incorporated into it somehow. For example, since Lacy and her colleagues worked with youth in Oakland, the conditions of the public schools in the 1990s were critical to young people's well-being or lack thereof. Oakland's Unified School District had been in severe financial and administrative straits for a considerable time.[20] The district had a student population of nearly fifty thousand; in the mid-1990s, according to Lacy, 55 percent of the students were African American, 20 percent were Latino/a, 20 percent were Asian American, and 5 percent were Euro-American. While the Loma Prieta earthquake of 1989 and the October fires of 1991 were traumatic devastations that literalized some of the rifts that Lacy addressed in her work, the sorry state of Oakland's school system was central to Lacy's arts education praxis.[21] In 1990, Elihu Harris won the mayoral election, and three new members of the city council joined the efforts to address the educational fault lines. Sheila Jordan, former school board member and city council representative from Lacy's district of Montclair and Rockridge, became a key partner in many of Lacy's projects.

Garoian claimed that Lacy's community-based performance art was "a place for exploration and creation. It serves as a liminal space, a neutral zone within which to engage a discourse between binaries, to entertain differing points of view. . . ." He further asserted that "for Lacy, communities are contested sites, and performance art is a function of community development." Given her long tenure in Oakland, Lacy was able to collaborate with city officials, school leaders, and community organizations over

an extended time. Oakland mayor Elihu Harris (1991–99) "argued for a city policy that involved youth in collaborative productions of art and culture," demonstrating his support for T.E.A.M.'s performances with youth and other community development efforts.[22]

In a 1990 article, "Wrestling the Beast," Lacy wrote about the "growing interest in art rooted in the facts, experiences, and problems of social life" in the 1980s, compared to another trend toward "'re-presenting' mass media imagery in accord with inaccessible theory and emulating the fantasy and mythology brought into vogue by science fiction film genres."[23] In 2002, Lacy and Wettrich championed the pioneering arts-in-community work by Ruth Asawa in the mid-1960s in San Francisco and Judith Baca's initiative in creating the Citywide Mural Program in the 1970s in Los Angeles. "They helped set the stage for two forms of contemporary practice: youth development through art in communities and education through art in the schools."[24] Lacy and Wettrich also noted how the artist was often caught "between": "Artists occupy a dual position in many youth-serving institutions, one that seeks to become embedded in the practice of education even while standing in opposition to the inadequacies of the system."[25]

The Roof Is on Fire

Two years of organizing ended with another performance in June 1994, *The Roof Is on Fire* (Figure 48).[26] This performance was staged in conjunction with the All American Cities Conference in the newly built City Center West Garage of downtown Oakland's City Center and was timed for maximum impact on urban policies related to youth. Workshops, facilitated discussions, neighborhood mapping exercises, media and leadership classes, and small-scale performances led up to *The Roof Is on Fire*. Key members of the interracial T.E.A.M. at this juncture included Chris Johnson (Lacy's colleague at CCAC), Eric Tam, Stephanie Johnson, and Jacques Bronson. The large performance event emerged out of weekly meetings with teens and teachers (twenty to forty people) for five months; about fifteen individuals identified by teachers and students comprised a youth leadership team.

Lacy and Unique Holland met in 1994 when working on *The Roof Is on Fire*. Holland was fifteen years old, a sophomore at Oakland Technical High School right down the street from the CCAC and a member of the leadership team. Holland also worked with Lacy on *Signs of Violence* (1994),[27] *Youth Cops and Videotape* (1995),[28] *No Blood/No Foul* (1996), *Expectations* (1997),[29] *Turning Point* (1997; see chapter 6), *Code 33* (1999), and *Eye 2 Eye* (2000).[30] Holland visited Japan with the *No Blood/No Foul* installation in 1996 and Elkhorn City, Kentucky, with Lacy, for work on *Beneath Land and Water*, beginning in 2000.[31]

For *The Roof Is on Fire*, 220 students took their places in ninety rented

Figure 48. City Center West Parking Garage in downtown Oakland, the location of *The Roof Is on Fire*, June 1994. Courtesy of Suzanne Lacy.

cars on the garage roof to discuss topics that they had chosen in advance—music, sexuality, family, neighborhoods, the future, and drugs.[32] Twenty percent of the youth were drawn from the Community Probation Program (males) and the Reaffirming Young Sisters' Excellence (RYSE, a probation program for females). A diverse audience of about a thousand people, including the youths' families, had to bend over and lean in to listen to the teens, all while standing silently outside the parked cars (Figure 49).[33] The

Figure 49. Suzanne Lacy and T.E.A.M., *The Roof Is on Fire*, June 1994, City Center West Parking Garage, Oakland, California. Courtesy of the artist.

roof of the parking deck was lined with highway signs borrowed from the state transportation division, CalTrans. The local NBC television station documented the event in a one-hour program.

Youth Policy Initiative

The powerful youth culture in Oakland generated new forms of music, spoken word, and multimedia at the same time the city was beleaguered by poverty and racism.[34] City council member Sheila Jordan and parks and recreation director Cleve Williams started the Oakland Youth Policy Initiative (OYPI) in 1995 and brought T.E.A.M. together with other organizational partners, including Oakland Parks and Recreation, Oakland Sharing the Vision, Urban Strategies Council, youthAction, Friday Night Live, and the mayor's office, to draft a policy to present to the city council for adoption. Producing *The Roof Is on Fire* solidified T.E.A.M.'s connections among youth and civic leaders, thus positioning this group to have an impact on policy. When the city council approved and funded the Oakland youth policy in 1996, creating the Oakland Youth Advisory Commission, T.E.A.M.'s efforts contributed to its adoption. The policy was "an official statement of priorities . . . a collectively derived statement . . . that says we recognize youth are our most important resource and that we will put time, energy, and resources into their development."[35] Recall that Lacy was be-

ginning work in Vancouver during this time as well; Vancouver had a very progressive youth development agenda. Further, Lacy's work in Minnesota in the 1980s had been exploring this same intersection between the arts and policy formation.

As stressed in an unpublished document called "Hearing Us Out: A Future for Oakland Youth," "[a]n important innovation of this civic process includes the integral participation of artists in all phases of planning."[36] Another document stated, "[R]ecognizing the need for inventive organizational forms that will attract a broad youth participation, we suggest the inclusion of public art processes, particularly in the representation of youth concerns to the entire community."[37] *No Blood/No Foul* (1996) was organized by T.E.A.M. to encourage the passage of the youth policy, but subsequent productions were related to expressed community concerns: Unique Holland, who was about to graduate from high school in 1996 and served as one of the student leaders in T.E.A.M., indicated that OYPI had five areas that they wanted to address using "performance hearings, real conversations in staged settings . . . [1] family, [2] safe communities, [3] healthy neighborhoods, [4] education and employment, and [5] youth training."[38] Holland represented T.E.A.M. on the OYPI steering committee; she noted that the coordinators, Marcelle Moran and Kaila Price, were very supportive of youth input.[39] Moran commented, "What excites me about this initiative is that it involves youth at the core of both the process and the product!"[40] Broad community input also was invited either through attendance at hearings or by calling a toll-free number.

No Blood/No Foul

No Blood/No Foul was held in June 1996 at a tony health club in downtown Oakland, Club One Fitness Center at City Center, and featured "basketball as performance" between youth and police officers; the rules changed every quarter (Figure 50). The title came from the rough rules of street ball: "If there's no blood, then there's no foul." The event was held to support passage of Oakland's Youth Policy Initiative, which indeed was passed later that summer by the city council and provided funding for youth programming.[41] A lot of informal lobbying was going on at the event, since city council members were in attendance.

At Club One, the second-floor basketball court is surrounded by a balcony that ordinarily provides space for a running track and exercise machines. For the performance, the balcony was converted to a viewing area for the audience. From there, one could watch the game unfold as well as see video clips on twenty monitors of interviews with participating players (Figure 51). In addition to these clips, an opening sound track and sports commentary were audible from the balcony area. Frank Williams, a professional color commentator, literally called the shots. During one quarter,

Figure 50. Suzanne Lacy and T.E.A.M., action view of *No Blood/No Foul,* June 5, 1996, Club One Fitness Center at City Center, Oakland, California. Courtesy of the artist.

the audience participated as referee, once again blurring the distinction between observer and actor. Posted on the walls of the balcony was black asphalt paper that invited graphic responses to the game or the youth policy. At halftime, in the mural-lined space of the court, there was a step-dance routine. A 180-foot mural on paper was created in graffiti style. Family members sat on bleachers, courtside.

In terms of strategies and physical layout, *No Blood/No Foul* shared a number of aspects with *The Crystal Quilt* (1987) and foreshadowed *Under Construction* (1997): an extended preparation in the local community with workshops and conversations, collaboration with other community leaders, a prerecorded sound track, an elevated viewing area for spectators to gain a broad overview of the action, rhythmically moving bodies, an invitation to interact with the performers (giving hand-painted scarves to the women, refereeing a quarter of the game, listening to girls' conversations), staging of the event in a centrally located downtown space normally given over to for-profit functions, a "both/and" quality of up-close clips of individuals as well as panoramic view from above, live video and documentation that continued the performance in "media space."[42]

Of course, *No Blood* took place nearly ten years after *The Crystal Quilt,* in a different city, with conflict and disagreement between youths and cops

as the focus; *Under Construction* was still in development. In contrast to the measured movements of the women in *The Crystal Quilt*, there were fast-paced interventions based on game play. Spaces at the club shaped the performance and contributed to its success. Telephones in the first-floor lobby connected to an answering machine that departing people could use to call and record their reactions to the youth policy and/or the event. The entry introduced visitors to youth-related issues and encouraged feedback; the next two levels of the facility provided performance space for *No Blood*. Using the balcony as an observation area for the games on the court spatially separated the audience from the action; this separation was then blurred on that level by video and surfaces for chalking. The act of marking a civic milestone—creating and discussing the youth policy—points to the promise of artistic contribution to public action.

Figure 51. Interior of gym at Club One Fitness Center at City Center, Oakland, setting for *No Blood/ No Foul*, June 5, 1996. Courtesy of Suzanne Lacy.

Code 33: Clear the Air

Code 33: Clear the Air was the most ambitious of Lacy's collaborative projects in Oakland and, as it turned out, the last citywide project she organized there.[43] The development phase of *Code 33* was structured to strengthen media literacy, public speaking, writing, and art production skills for youth.

Leadership and media workshops were held in widely distributed locations throughout Oakland. For a year and a half (1998–99), young participants spoke before neighborhood crime prevention councils, city council, and police gatherings, among other groups. Leading up to the final production, Unique Holland and Greg Hodge (a community activist and attorney) facilitated five workshops between youth and police officers; these discussions were heartfelt, heated, and televised.[44]

The culminating event of *Code 33* on October 7, 1999, was to utilize the street, the garage elevators, and the various levels of a parking structure in a sequence of three "acts."[45] Before describing how these acts unfolded, I want to highlight Holland's commentary on the selection of the downtown Oakland parking garage, because it underscores the political nature of space and the spatial nature of politics. In 2002, she reported:

> I really wanted *[Code 33]* to take place in East Oakland at Eastmont Mall, which is an area that has been pretty much abandoned by a lot of folks. It's got a bad reputation; it's a place where the sydeshows would happen, people would come in from as far away as Hayward to drive their cars around, what they call reckless driving. . . . Eastmont used to be the place to go to do the mall thing and now it's been all but abandoned. I felt that it was a really powerful metaphor for what was happening in the city, what's happening to young people of color. I was really invested in its happening there. . . . Suzanne said she talked to a bunch of people and certain people were really uncomfortable about going to East Oakland. . . . It got to this really sticky place. To be fair there were some people who Suzanne said she spoke with in the Eastmont area and they didn't want it to be there because it was like showing your dirty laundry to the community. . . . There were people who had safety concerns about being there; there were people who lived in the poor West Oakland community that wouldn't travel to East Oakland because people from West Oakland don't go to East Oakland, and people from East Oakland don't go to West Oakland. . . . It ended up being [in downtown Oakland] and placed in the context of this is where the entire community, the entire city can come together and participate.[46]

The setting, then, was downtown at the City Center West Parking Garage (where *The Roof Is on Fire* had been held). The garage ground-floor windows were filled with posters created by students from Johanna Poethig's class at California State University at Monterey Bay in tandem with prisoners in the Salinas Valley State Prison, Soledad. The event's graphic designer, Raúl

Cabra, produced bold black and red *Code 33* imagery as well as designed the stage setting with Patrick Toebe (Figure 52).[47]

 Code 33 was supposed to begin with act one, a street-level procession of thirteen lowrider cars (from the Street Inspiration Club) circling the garage in one direction, with a cortege of police cars moving past them in the opposite direction. All cars were to use their sound systems to accompany the drive-by.[48] David Goldberg created a sound montage to be played on the cars' audio, consisting of music, excerpts from teen–police conversations, and found noises. The first act never took place, though, due to a "Free Mumia"

Figure 52. Poster for *Code 33: Clear the Air* by Raúl Cabra, 1999. Courtesy of Suzanne Lacy.

demonstration that apparently coincided with the opening of *Code 33*.[49] The car procession was canceled after about half an hour of demonstrators and audience members intermingling in the street, with considerable confusion between the "art" event and the "live" protest, both with leaflets and signs and people concerned about issues of police, violence, prisons, and racism.

The second act, evocative of urban streets, unfolded at dusk on the rooftop of the garage with 100 police officers and 150 teens conversing, in groups of 6 to 8 on twenty-nine platforms. The youth wore Code 33 T-shirts, and the police officers were in uniform, illuminated by headlights from almost fifty cars (Figure 53). The audience members who had been able to get into the garage despite the "Free Mumia" protest listened in on the conversations. Moira Roth described the setting: "In the distance are the lights along the suspension curves of the illuminated Bay Bridge that connects San Francisco to the East Bay. . . . On two sides are large vacant lots, and across the street are the two towers of the Federal Building linked, high up, by a delicate bridge walkway."[50] About thirty video monitors were arrayed on this level, displaying eight neighborhood portraits of youth made by youth.[51] At the end of about an hour of conversations about crime, authority, power, and safety, a police helicopter chopped the air overhead, shone a spotlight on the crowd, and then landed on the garage.[52] This spectacle marked a transition into the third act.

Figure 53. Suzanne Lacy and T.E.A.M., *Code 33: Clear the Air,* October 7, 1999, City Center West Parking Garage, Oakland, California. Courtesy of the artist.

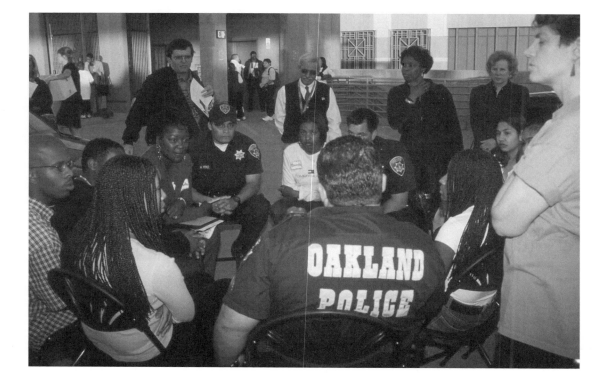

As part of this transition to another level, about thirty youth left the discussion groups and joined Kim Battiste's adult company Culture Shock on a lower floor. Headlights of one hundred red, black, and white cars pointed toward the performers, illuminating the movements of the fifty or so dancers. Joining the dancers were the lowriders and their cars, pleased to be able to display their artwork despite the cancellation of the earlier procession.

The third act unfolded on this level, which had no roof and projected like a terrace. This final act featured community responses with eighty Oakland residents, representing eight neighborhoods and also wearing Code 33 T-shirts (Figure 54).[53] The block party–like conversation spaces were defined by white picket fences and imitation grass on mini-stages. Together with these "performance hearings," a big *X* marked the location to sign up for mentoring with representatives of local organizations that served youth, and computer and video equipment for young people to use to document responses. Projected on a tall concrete wall was a video of Oakland made as a car drove through the city. Roth assessed this final part: "This 'loosening' is characteristic of many of Lacy's performances as they are deliberately designed to move from a stylized and focused image into 'real life' with its more chaotic shapes."[54] Critic Megan Wilson noted that the performance reminded her of a music video crossed with a reality television show.[55]

While *Code 33* focused on content of concern to youth and police,

Figure 54. Suzanne Lacy and T.E.A.M., *Code 33: Clear the Air*, October 7, 1999, City Center West Parking Garage, Oakland, California. Courtesy of the artist.

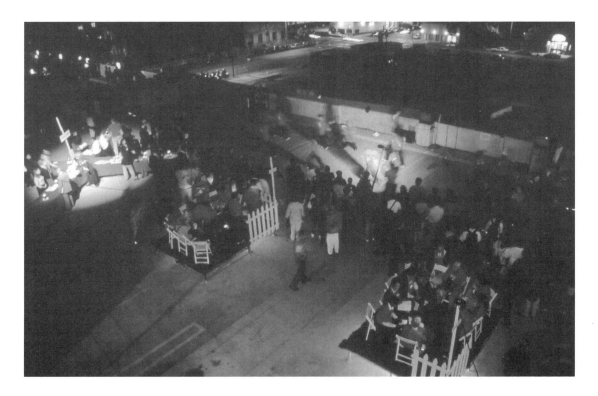

its structure recalled earlier experimental art, such as Claes Oldenburg's *Autobodys* set in Los Angeles during two December evenings in 1963. The script for *Autobodys* was divided into five poems that directed performers in detailed choreography in a parking lot behind the American Institute of Aeronautics and Astronautics. About twenty people moved in and out of predominantly black and white cars, a cement mixer, a motorbike, a sound truck, a wagon, a wheelchair, and a minibus, sometimes becoming pedestrians. The headlights from the cars illuminated a central area of the lot through which cars drove, and white paint (imitating milk), ice cubes, and soapy water were spilled. Flares and flashlights provided other illumination, while the turning concrete drum, engines, horns, recorded music, and radios provided the "sound track."[56] The screen of a drive-in theater across a field next to the parking lot was situated such that the projected movie could be seen from the site of Oldenburg's Happening. Thirty-six years later, *Code 33*, too, had a choreographed procession of cars (the police cars were black and white), a moving image projected outdoors on a wall, and headlights used dramatically. Like Oldenburg, Lacy featured engines and recorded music, among other noises, in the sound track; the police helicopter in *Code 33*, with its searchlight beaming down on the garage, literally took urban performance to a new height.

Code 33 was vigorously attacked by some media and community groups because it was seen as selling out: serving as an apologist for police brutality.[57] A subsequent statewide referendum might be seen as a tragic fourth act of *Code 33*. In March 2000 California voters approved Proposition 21, the Gang Violence and Juvenile Crime Prevention Act, by a large margin (62 to 38 percent). This act toughened laws for violent youth, requiring more of them to be tried as adults and incarcerated with adults, and increased the penalties for gang activities. As a local counterpoint, though, police chief Richard Word started the Chief's Youth Advisory Team following *Code 33*. A new truancy prevention program was launched in fall 2002: Police and Students for Learning (a partnership among the Alameda County Office of Education, the Oakland Police Department, and the Oakland Unified School District).[58]

The last project I want to consider in this chapter placed Lacy in a team role in which she worked alongside international collaborators. The result was a powerful and mobile installation, truly a collective response to violence and loss. In contrast to the Oakland projects, for which Lacy filled many directive roles in various networks, her work in Colombia supported the community-based work of her colleague Pilar Riaño-Alcalá.

La Piel de la Memoria/The Skin of Memory

In 1998, Lacy joined other activists to develop a project, *La Piel de la Memoria/The Skin of Memory*, in Medellín, Colombia, which occurred in

July 1999 as part of the Calles de Cultura/Streets of Culture festival.[59] *The Skin of Memory* emerged out of the 1997 action research of Pilar Riaño-Alcalá, whom Lacy had met in 1996 during the production of *Turning Point: Under Construction* (1997) in Vancouver, British Columbia (see chapter 6). With Riaño-Alcalá as the galvanizer, Lacy collaborated on *The Skin of Memory* with her, youth workers, residents of the Medellín neighborhood of Antioquia, and several governmental and nongovernmental organizations, especially the Corporación Región (CR).[60] The coordinating team also included William Alvarez, Jorge García, Juan Vélez, and Angela Velásquez; historian Mauricio Hoyos was the producer. The funding was all Colombian, although Lacy donated her time. A professionally made video was produced in Spanish. For Riaño-Alcalá, the title of the piece, *The Skin of Memory*, reflected the concept of this work: "You press [skin] at one point, it will impact all the other points."[61]

Medellín, Colombia

Medellín, a city that had thrived industrially and commercially through much of the twentieth century, is located in a valley of a mountainous region northwest of the capital of Bogotá. The department in which Medellín is located is called Antioquia, as is the neighborhood, or barrio, in Medellín where *La Piel de la Memoria* took place. Already settled by 1910, Antioquia was a flat, swampy area of southwestern Medellín, while much of the city is built on the hills that lead up to the surrounding mountains. Medellín has long been sharply divided along social and class lines. Anthropologist Riaño-Alcalá has written that the barrio has "a distinct history marked by exclusion, social tensions and multiple forms of drug-related, territorial, political and everyday violence."[62]

The Antioquia area of the city of Medellín was designated as the "red-light district" in 1951. Riaño-Alcalá further noted, "Poor, distant from the city's downtown and with only one entry point, Barrio Antioquia . . . [kept] the 'undesirables' (prostitutes, homosexuals, drug addicts and alcoholics, thieves, blacks, and recently arrived poor immigrants) segregated from the rest of the city."[63] Needless to say, many residents objected to the "red-light" designation of their neighborhood, and while many moved, others stayed to protest; two years later the decree was ended, but the stigma and behaviors continued. Thus, while the spatial boundaries had been officially erased, in fact they remained "as a means of controlling, privatizing and marking territories of fear," according to Riaño-Alcalá.[64]

Antioquia became the main supplier of drugs for the rest of the city, in part because it was near the city airport. By the 1980s the drug business was booming in Medellín, and the cartel recruited unemployed local youth into its structures, as hired guns or transporters. In August 1989, the government began an aggressive attack on the Medellín cartel, and the drug

lords responded with bombings, kidnappings, and murders.[65] The army moved against youth gangs, among others; in June 1990, for example, 150 youth were killed "in twenty different massacres," and 160 police officers were killed by the drug cartel that same month, according to Riaño-Alcalá. Even with the weakening of the narcotics traffickers, youth gangs increased in number, and they and the militia were the two main armed groups with a "territorial presence in the barrios."[66] There were six gangs that divided up the territory in Barrio Antioquia; 1993 was one of the worst periods of gang warfare.[67]

While the early 1990s witnessed widespread violence, there were also "peaceful social expressions" and a broadly representative national assembly that drafted a new constitution. Various residents began to nurture ways to create community through local history and culture at the same time that the violence flared up. "Reconciliation," as Riaño-Alcalá wrote, "is thus rearticulated as a desire to face ourselves through the past, rather than *a silencing of the past.*"[68] For many residents of Barrio Antioquia, then, their memories "connected the local, family life and conflicts, to wider practices and histories such as the political violence of the 1950s, the global market of illicit drugs, and the policies of urban planning and social exclusion."[69] Many memories were *not* about crime and violence but rather about love and family ties.

The Bus-Museum

The barrio youth already had long-term relationships with Riaño-Alcalá and local activists. When they were introduced to Lacy at the beginning of *The Skin of Memory,* they were attracted to the large scale of her other projects and her deep knowledge of public art. An initial series of workshops involved over twenty leaders from the area. Out of those meetings came the idea for a display of about five hundred objects that held significant memories for the residents, accompanied by a public celebration. Collecting these objects was a community-building process. The team was trained in interviewing techniques because in addition to gathering objects, they recorded stories and transcribed letters narrated to them. In preparation for the display, lenders were asked to write (or dictate) an anonymous letter to an unknown neighbor, expressing a positive wish for another resident in Antioquia. The anonymity was crucial because it removed the possibility of negative personal feelings marring the wishes. Fifteen local women and youth, who were paid a stipend, relied on their personal contacts to work on the project.

What became the memory museum consisted of a borrowed school bus, the interior of which was revamped according to the designs of Colombian-born, U.S.-based graphic designer Raúl Cabra. Strung with lights and equipped with a sound system, the bus had aluminum shelving for the collected objects, which were displayed anonymously along with the letters on

thick white sheets of paper (Plate 11).[70] María Victoria Ramírez Lezcano was an architect who worked on-site to coordinate the installation.

The bus was then driven to four different areas of the barrio and to a nearby subway station, where it was stationed for two days in each place. The physical presence of the bus-museum drew four thousand visitors over a ten-day period, providing "a collective ritual that needs to take place to bring a minimum degree of resolution to the relationship to the past."[71] Lacy was most involved in the bus-museum as a gathering spot for the objects, in the aesthetic treatment of its interior, and in designing the final parade, which was produced by Riaño-Alcalá. Lacy had wanted to line the shelves with velvet *(terciopelo)*, a luxurious fabric frequently used inside coffins as well as to decorate home altars. While the community delivered the bus, the local people did not approve of the use of velvet, and so that idea was dropped. Perhaps the velvet was too direct a link to the frequent deaths in the community.

By 1998, Lacy had been working with youth in Oakland for over six years and was also involved with the *Turning Point* project in Vancouver. In those cities, she was well aware of social divisions that had geographic parallels. Neighborhoods in major metropolitan centers are often distinctly marked, with one group's turf being off-limits to another group. This was the case to an extreme degree in Medellín's Antioquia, which inspired the idea of a museum moving across the social and physical divides, rather than attempting to draw people to a single place in contested territory. Lacy was adamant about using a bus, not a truck or a cart.[72] Commercial bus drivers in Colombia often decorate their dashboards with small shrines, so this kind of display seemed consistent with that setting. The long, enclosed space of the bus, a mobile yet solid physical presence, had maps posted in some windows of its various locations during the ten-day period (Figure 55).

Lacy and Riaño-Alcalá grouped the objects—a picture of the Holy Trinity, dollar bills, newspaper clippings, gold-plated cutlery, a pewter jar, for example—in the display cabinets behind glass "according to visual narrative threads evoked by the objects: life cycles, marking events, sense of loss, cultural practices and local history."[73] The aluminum shelving had a bright cast and a connotation of wealth because people who could afford it installed aluminum doors on their houses. The shiny metal reflected the many strings of small white lights mounted on the interior. An audiotape of histories of the barrio drawn from Riaño-Alcalá's earlier research played during the exhibit.

The culminating celebration was held after the bus had finished its neighborhood tour. Riaño-Alcalá has noted that Barrio Antioquia "has the widest streets I have ever seen in a low-income barrio in Colombia" (Figure 56).[74] Sixty mimes gathered at a public park in the middle of the barrio and rode bicycles through the wide streets, reclaiming them from violence

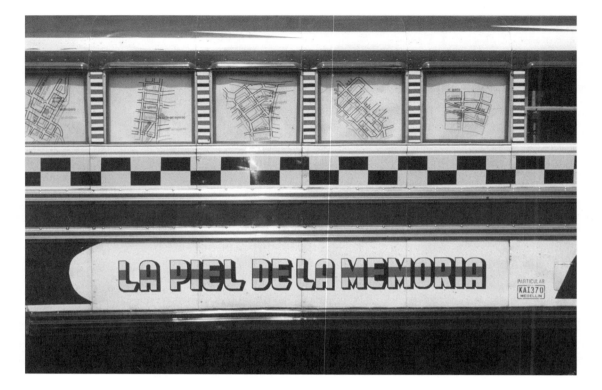

Figure 55. Exterior of bus-museum. Suzanne Lacy with Pilar Riaño-Alcalá, Raúl Cabra, Vicky Ramirez, Mauricio Hoyos, and others, *La Piel de la Memoria/The Skin of Memory*, July 1999, Barrio Antioquia, Medellín, Colombia. Photograph by Suzanne Lacy. Courtesy of the artist.

at least temporarily. Riaño-Alcalá wanted a celebratory, carnival atmosphere, and since most residents got around by bicycle, it was fitting that the mimes rode them as well. The almost two thousand anonymously written letters to unknown neighbors were delivered to most homes in the barrio during the festival portion of the project. Following the letter delivery, mimes got on top of the bus to convey messages from the letters to the crowd. There were also storytellers, musical performances, stilt-walkers, and observers filling the streets. "The processions took over the streets of barrio Antioquia as expressive spaces and routes to be retraced," Riaño-Alcalá wrote, "establishing connections between the present and future, between sectors and among neighbors, between visitors and the visited, and through anonymous letters to their neighbors."[75] The bus was then parked in Medellín's city center to provide wider exposure for *La Piel de la Memoria/The Skin of Memory*.

Active Neutrality

As Riaño-Alcalá noted in 2004, this one fleeting intervention was just part of a lengthy process; the structural causes and the violence continue.[76] She reported, "As organizers of this event, we were afraid that by bringing objects and photos of people involved in the conflict to the bus it would become a target of aggression. But this did not happen, and the bus crossed

symbolic and physical territorial borders as a moving cultural object, actually creating another type of topography and movement."[77] A number of the young people involved, who were once guided by drug lords and/or corrupt officials, have now gained respect within their community for leadership skills and have continued to be involved in positive community development, even going to university. This result is in part due to the approach that Riaño-Alcalá, Lacy, and their colleagues took: "to critically validate and re-situate approaches that focus on the local, the everyday, the symbolic, or the marginal, and look at dimensions such as gender, culture, memory, and representation."[78]

The Skin of Memory with its "itinerant museum that crossed territorial divisions" helped activate a neutral space.[79] "Active neutrality" is a concept that emerged in Colombia in the early 1990s from some of the indigenous leaders in the state of Antioquia. With violence so widespread and entrenched, people found themselves nearly forced to take sides with the army, the paramilitary groups, the gangs, or the guerillas. Instead, they declared themselves neutral to the conflicts but "not neutral to what we recognize as the systemic circumstances that give rise to much of the violence in Colombia. We are not neutral in looking for peaceful or negotiated solutions to the conflict."[80] While *The Skin of Memory* was hardly the only opportunity

Figure 56. People gathered in streets of Barrio Antioquia during *La Piel de la Memoria/The Skin of Memory*, July 1999, Medellín, Colombia. Photograph by Suzanne Lacy. Courtesy of Suzanne Lacy.

for neutrality—parades for religious holidays were others—still, because it was temporary, the residents did not have sufficient time to locate it in a particular (contested) territory. Because it was rich with multiple memories and various conflicts, visitors could not identify it with one particular viewpoint. Lacy further postulated that the neutrality of *The Skin of Memory* could have been due to its "betweenness" as a work of art. She concluded with the thought that its neutrality was due to its novelty, at least for a short period of time.[81]

Embodied Positionality and Performance, Again

Lacy found that art and culture provided a "space" to explore alternatives to violence, both in Colombia and in Oakland. Seeing ourselves and others differently, moving and gesturing differently, with awareness of patterns and habits, may contribute new configurations to human relationships. Let me stress the *awareness* that embodied, engaged practice can bring of both our old patterns and new movements. Without conscious attention, recalibrating ourselves every day, we fall back into destructive behaviors that we seem to perform so predictably. Poet Gary Snyder acknowledged our deep-seated ways of knowing: "We learn a place and how to visualize spatial relationships, as children, on foot and with imagination. Place and the scale of space must be measured against our bodies and their capabilities."[82] Of what are our bodies capable?

In summer 2002 when I was visiting Oakland, Lacy excitedly lent me a book that she had just come across, Wendy Palmer's *The Practice of Freedom: Aikido Principles as a Spiritual Guide.* In writing about the relationship between aikido etiquette, bodily form, and behavior, Palmer wrote:

> Form can also be seen as a map that helps us to locate ourselves. We can find our position, and we can change our position based on our knowledge of the map, which shows the locations of people and events. . . . A road map tells us where to go and the distance between the cities that we will encounter along the way. But once we have actually driven the road, we have a more visceral feeling for the names of places and the terrain the next time that we look at the map.

Palmer then discusses how practice can deepen our commitment to certain behaviors and that for "behavior to be moral, there has to be an emotional or heartfelt relationship to the actions."[83] Thus, by moving our bodies, not just our minds, into position, we gain a visceral understanding of the "map," according to Palmer. Our actions must be heartfelt and committed through practice.

CONCLUSION

SPACES BETWEEN, STILL (INTER)ACTING

At the time that Suzanne Lacy began her art practice in 1972 in California, many social and cultural currents were moving through and around her overlapping circles of multimedia, conceptual, and performance artists, feminists, community activists, psychologists, designers, and theorists. For Lacy, a white, working-class woman, aspects of her identity were starting points as well as tethers that informed and tied her early work together. Centered in her body, she also investigated and continues to explore intangible experiences that might be called spiritual. Because of her belief in interconnectedness, Lacy's spiritual practice has never been disengaged from her body. Philosopher Richard Shusterman posited: "Just as our world cannot make sense without a body, our bodies make no sense without a world. . . . [W]e can never feel our body purely in itself; we always feel the world with it."[1] Lacy's spirituality is the basis for her "feeling the world," her approach to power relationships in society: "The drive for social justice," she wrote in 2000, "is the desire for connection, and the desire to share and make equal—to experience a oneness."[2]

Lacy's embodied spirituality requires that we hold two seemingly contradictory entities together at the same time: body and spirit, self and not-self. In 1979, Lacy was introduced to Zen teacher Charlotte Joko Beck by both Allan Kaprow and her Buddhist psychotherapist. She began "sitting Zen" by the early 1980s.[3] Since then, her art making has been influenced by American versions of Zen (Chan) Buddhism. In addition to meditation, Lacy has valued Buddhist teachings on wisdom and ethics. Buddhist scholar Joanna Macy explained one concept, "dependent co-arising," that amplifies Lacy's social engagement: "[W]e see ourselves as co-participating in the existence of all beings and in the world we co-create with them. . . .

[E]very act we make, every word we speak, every thought we think is not only affected by the other elements in the vast web of being in which all things take part, but also has results so far-reaching that we cannot see or imagine them."[4]

In 2002, Meiling Cheng wrote about Lacy's desire for and commitment to connection: "Lacy has succeeded in creating a hybrid form of conceptual art practice that mixes aesthetic performance, community activism, and feminist politics with theoretical analysis, translating 'the dematerialization of art as object' into 'its rematerialization in the world of ideas.'" Cheng also noted Lacy's "indefatigable contemplation and practice of *the ethos of connection*."[5] The interconnections that emerge and shift as art rematerializes in embodied performances—the spaces between—are fundamental to Lacy's theory and practice and are rich sources of renewal, criticality, and inventiveness.

Aída Hurtado and Abigail J. Stewart noted that "[o]ne way to mitigate the impact of one's own social position may be to employ more complicating collaborative research practices."[6] By the late 1970s Lacy regularly used large collaborations to expand the reach, meanings, and forms of her artwork. Many voices told stories, and bodies enacted relationships as part of her projects in spaces across the United States as well as abroad; these previously muffled, vital stories and connections multiplied and were often in conflict with dominant stories. Lacy's large-scale projects occurred both because of the histories and locales that informed them and, to a certain extent, against the "grain" of those places. The projects discussed in this book demonstrate the ways in which Lacy grounded her big ideas in the particular locations in which she collaborated. While the settings were vastly different, her commitments to interactions among people and places have been consistent.

In 1970, in a special issue of *Arts in Society* devoted to CalArts, one of Lacy's mentors at CalArts, psychologist Richard Farson, wrote:

> We've always designed for efficiency and productivity and economy, but we haven't really designed for life yet. We haven't improved human relationships. I'm always impressed when I get on an elevator to see how beautiful the elevator is, how the ride is now almost perfect, but the experience remains for me, and I think probably for everybody, an embarrassing, difficult, anxious inter-personal situation. You never know quite what to do. Elevators hardly supply moments of joy. But they could. We must somehow see that it's possible for us to design situations which would enable good relationships to happen, to create joyful moments which would happen between floors. It's social architecture that we need to get into.[7]

It seems, then, that Lacy took Farson at his word.[8] From the beginning of her career in the early 1970s until the present, she has been creating "social architecture," among other structures. The building blocks for this "architecture" have included conversations, rituals, food, embodied movement and characterization, human and urban networks, and exchanges, refined over time through humor, private reflection, research, and theoretical writing. Lacy's art has concerned itself both with Farson's "joyful moments" and violent encounters.

Since Lacy's return to Los Angeles in 2002, she has seized upon the recent fascination with the 1970s: this interest has served her efforts to revisit many of the places and themes of her own work in the 1970s, as well as to rethink these earlier concepts in tandem with younger artists.[9] The Museum of Contemporary Art in Los Angeles was one venue for a 2008 retrospective exhibit on the work of Allan Kaprow, "Art as Life." Lacy's collaborative conversational artwork for that show, *Trade Talk,* with architect Michael Rotondi and another Kaprow collaborator, Peter Kirby, provided a literal opening at the center of the exhibit space in the form of a circle of wooden chairs on a dirt platform. *Trade Talk* featured a series of conversations and interviews performed weekly with friends, family, and colleagues of Kaprow, both as an homage to Kaprow's *Trading Dirt* (1983–86) and as an extended performance piece in its own right.[10] Lacy, Rotondi, and Kirby installed another conversational device, a phone in a booth, at the edge of the circle of wooden chairs. Between the recordings made from phone calls and the audio archived from the weekly live conversations, a complex network of memories, relationships, and actions was simultaneously recalled and created. Critic Jeff Kelley in his interview with Lacy during *Trade Talk* noted, "It's easy to theorize about Allan's work. In a way it's easier to theorize about it than it is to do it because doing it involves a physical commitment of time and effort that we are not used to being invited or asked to commit."[11] So, I return to the body, not just any body, but Lacy's, as well as those whom she, like Kaprow, asked to commit time, effort, and physical presence to her projects.

To conclude implies closure, and Lacy's work is open-ended, ambiguous, and "between" various spaces. Her projects certainly end, and participants in the projects move on, of course. Stepping back from single venues, we see that the significance of Lacy's work is both cumulative and elusive. Lacy's restlessness, what she has identified as "leaving art," points to her unwillingness to tidy things up, a deliberate political and spiritual stance. Yet, far from leaving art, in the first decade of the twenty-first century she has found new locations, new issues, and new people to link together in networks that alter her practice as she simultaneously joins them.[12] In a 2007 interview with Hans Ulrich Obrist, Lacy reflected, "The meanings of

the in-between spaces are what I am interested in, for example the notion of intimacy in public space. Many of my larger performance pieces have been what I would call multi-vocal, in a public space with moments of great intimacy between many, sometimes hundreds, of people who are talking in unstructured, but often quite personal ways."[13]

While the *desire* for oneness, for connection, may be strong, it exists in tension with our individual selves. We are beings in "'inoperative' or 'unavowable' communities of diversified and conflicting interests that are paradoxical and ambiguous."[14] Further, systems of patriarchy, white supremacy, and capitalism restrict many individuals' movements, networks, and power, thus seriously inhibiting connections as well as limiting some people's interest in *ever* connecting with others in the context of structures that have so damaged their cultures and individual members. The dynamic unease in much of Lacy's work aptly reveals these social divisions, which are seemingly intractable.

Lacy has often brought people into "unaccustomed" situations in order to foster the imagining of other possibilities. Sometimes these explorations are awkward, heated, painful, and sad, as people in their bodies move among each other. As unskilled as we are in coming together, if we come together in the contexts that artists such as Lacy provide, we may begin to envision respectful coexistence, communication, and exchange. In 1989, Lacy reflected:

> Meaning will be found not simply within the aesthetics of physical form. Process, relationship, the positioning of the work relative to popular culture, the artists' beliefs and values—even, perhaps, the very way an artist lives life—all might be considered in an expanded inquiry. As Allan Kaprow stated, "Art is a weaving of meaning making activity with any or all parts of our life . . . what is at stake now is to understand that of all the integrative roles art can play, there is none so crucial to our survival as the one which serves self knowledge."[15]

The embodied art of Lacy gives priority to self-knowledge through the medium of human relationships. This art is provocative, beautiful, calm, frustrating, and energizing.

Lacy's lifelike art has often used spatial relationships—between participants, inside galleries, and around a city—to give concrete form to power differences as well as to demonstrate interconnectedness. Lacy's art is liminal, located among people, across spaces, straddling art and life. Therein lies the opportunity to make distinctions among those people, asking "whose art?" "whose space?" and "whose life?" These spaces of questioning in Lacy's works also provide the conditions for simultaneous critique and celebration, for what Shannon Jackson asserted: "[A]n awareness of . . .

inter-dependency can yield both innovative aesthetic forms and an innovative social politics."[16]

Twenty years separate two key feminist books: *This Bridge Called My Back: Writings by Radical Women of Color,* which appeared in 1981, and *This Bridge We Call Home: Radical Visions for Transformation,* from 2002.[17] An editor of both books, Gloria Anzaldúa (1942–2004), in *This Bridge We Call Home* articulated the continuing struggle to create coalitions that could and would effectively challenge entrenched hatreds and move us toward liberation: "Twenty-one years ago we struggled with the recognition of difference within the context of commonality. Today we grapple with the recognition of commonality within the context of difference." For me, Anzaldúa accurately pinpointed the major shift in feminism from the 1970s until now. Suzanne Lacy's artistic projects also reflected this shift from commonality to difference. *This Bridge Called My Back* used a metaphor of the body, the back, to explore women's experiences of racism and class. Lacy also made use of the body in her art, her own and others, to resist representation, or at least to question it. When each individual presented themselves in a performance, they were visibly separate but also constituted a group.[18] The group, a coalition of human beings and their diverse interests, gathered in a place, however temporarily. This place-based performance—possibly a bridge toward home and connection—was an artistic expression of a web of relationships.

French philosopher Maurice Merleau-Ponty (1908–61) died suddenly at age fifty-three before completing his book *The Visible and the Invisible,* but his ideas in a chapter from that unfinished manuscript, "The Intertwining— The Chiasm," are echoed in Lacy's art and also support my analyses of her embodied art. Body(ies) and identities form nodes in a network, and meanings arise out of relationships among those nodes. Art historian Amelia Jones noted that "Merleau-Ponty's observations about the contingency and reciprocity of the embodied self/other, and the way in which his model enables a critique of vision-oriented theories that polarize subject/object relations and suppress or ignore corporeal relations, make his work particularly useful for the analysis of visual art."[19]

Merleau-Ponty believed that lived experience of specific, socially located, contingent bodies shapes our understandings of the world, which is a part of us, and we are a part of it. He argued that self and other, sensible and sentient, were not separate.[20] While he wrote about a range of embodied experiences, for my purposes he affirmed that the *artist's body,* social location(s), and those whom the artist addresses are intertwined. Merleau-Ponty asserted that "[t]he world seen is not 'in' my body, and my body is not 'in' the visible world ultimately. . . . There is a reciprocal insertion and intertwining of one in the other."[21] Psychiatrist Mindy Fullilove stressed a further reciprocity with place in her recent book *Root Shock*: "We—that is to

say, all people—live in an emotional ecosystem that attaches us to the environment, not just as our individual selves, but as beings caught in a single universal net of consciousness anchored in small niches we call neighborhoods or hamlets or villages."[22]

Lacy's projects over the past thirty-five years have resisted any single representation, constituting *and* representing multiple ideas, challenging us to move into new embodied positions in order to understand ourselves and others more fully. Choosing new positions are political acts with social consequences. Art provides literal and figurative spaces to explore new relationships. We are intertwined, with provocative, challenging spaces between us.

CHRONOLOGY OF SUZANNE LACY

1945 Born October 21 in Wasco, California, to parents Larry and Betty Little Lacy. Her brother, Philip, is born in 1947, and her sister, Jean, in 1962.

1963 Starts college at Bakersfield Community College in California.

1965 Receives AA degree in premedical sciences, Bakersfield Community College. Transfers to the University of California at Santa Barbara.

1968 Receives BA in zoological sciences from University of California at Santa Barbara.

1969 Joins Volunteers in Service to America (VISTA) but leaves after three months. Meets feminist organizers on East Coast. Moves to Fresno, California, to start graduate work in psychology at Fresno State. Establishes first feminist consciousness-raising group on campus with Faith Wilding.

1970 Artist Judy Chicago comes to Fresno State to teach sculpture and starts an all-female, off-campus experiment called the Feminist Art Program (FAP). Lacy convinces Chicago to admit her into the FAP.

 Bride, multimedia sculpture

1971 Moves to California Institute of the Arts (CalArts) in Valencia to enter the social design program. Works as teaching assistant to Sheila de Bretteville and studies with Allan Kaprow.

1972 *Car Renovation* (also known as *Pink Jalopy*) at Filmore, California, created for Judy Chicago's CalArts class Route 126

I Tried Everything with Nancy Youdelman, Dori Atlantis, and Janice Lester, documentation of mail event, CalArts

Menstruation: A Discussion among 12–14 Year Old Girls with Sheila de Bretteville and the Women's Design program, CalArts, videotaped interviews

Ablutions with Aviva Rahmani, Sandra Orgel, and Judy Chicago, performance, Venice, California

Rape Is, artist's book, edition of one thousand

Sheila de Bretteville, Judy Chicago, and Arlene Raven found the Feminist Studio Workshop located in the Woman's Building (1973–81).

1973 *Mother Venus* with Susan Mogul and Laurel Klick, performance, Los Angeles, California

Net Construction, performance, Santa Barbara, California

Lamb Construction, two performances, Womanspace and Woman's Building, Los Angeles

Maps, Happening for Allan Kaprow's class at CalArts, Los Angeles

Graduates from CalArts with an MFA in social design. Organized women's performance art exhibit at Womanspace Gallery. Works as a carpenter and an emergency medical technician in and around Los Angeles. The Woman's Building opens in Los Angeles (1973–91).

1974 *Exchange,* performance, Irvine, California

Body Contract, document prepared with legal assistance from Lawyers for the Arts, as part of *Anatomy Lessons*

Wall Construction, mailing and performance, Pacific Palisades, California

Three works from *The Teeth Series,* seven-minute black-and-white video with sound

Monster Series: Construction of a Novel Frankenstein, with Sarah Macy, performance, Woman's Building, Los Angeles

Prostitution Notes

Hired to teach performance art at Feminist Studio Workshop (through 1977). Organized monthlong "Performance!" events at Woman's Building with Ellen Ledley, Candace Compton, Roxanne Hanna, Signe Dowse, and Nancy Buchanan.

1975 *Three Love Stories,* three sets of photographs with captions, six in a set (also an artist's book created in 1978): *A Gothic Love Story; A True Romance, or She's Got Quite a Set of Lungs; Under My Skin: A Pornographic Novel,* 1975–76

Monster Series: Construction of a Novel Frankenstein, performance, Western Washington State University, Bellingham, Washington

Penis/Mice Series

Running to San Francisco, performance, en route Los Angeles to San Francisco

Under My Skin: A True-Life Story, performance, San Francisco (also performed in Chicago, 1977)

One Woman Shows, performance, Los Angeles

Evalina and I: Crimes, Quilts, and Art, series of performances and installations with Evalina Newman, Guy Miller Homes, Los Angeles (through 1978)

Basic Urine, circa 1975

Cold Hands, Warm Heart, aphorisms, circa 1975

Employed as artist by Comprehensive Employment and Training Act (CETA), Los Angeles, 1975–77. Taught at the San Francisco Art Institute.

1976 *The Anatomy Lesson #1: Chickens Coming Home to Roost,* for Pauline [Oliveros] and Rose Mountain [Linda Montano], four black-and-white captioned photographs; also an edition of two hundred of four sets of postcards

The Anatomy Lesson #2: Learn Where the Meat Comes From, set of twelve color photographs by Raul Vega; also fourteen-minute color video

The Anatomy Lesson #3: Falling Apart, five collages of black-and-white and color photographs

Inevitable Associations, two-part performance, Los Angeles

Edna, May Victor, Mary, and Me: An All Night Benediction, performance, Los Angeles

Cinderella in a Dragster, performance at Dominguez Hills State College and University of California, San Diego

Fallen Woman, artist's book, edition of twenty, dedicated to Arlene Raven (after the first two prototypes, title changed to *Falling Apart*)

Documentation drawings of *Prostitution Notes* performance exhibited at Los Angeles Institute of Contemporary Art

Women Against Violence Against Women (WAVAW) founded by Julia London

1977 *The Anatomy Lessons,* assorted color photographs: "Swimming," "Dreaming," "Floating," "Still Life," "Flying"

How to Deliver a Crippling Blow to Your Gynecologist If He Gets Fresh with You, photocollage

An Old Wives' Tale about How to Tell the Size of a Man's Penis . . . without Really Looking, two-part photocollage

Under My Skin, performance, Chicago (also performed in San Francisco, 1975)

The Life and Times of Donaldina Cameron with Kathleen Chang, performance, Angel Island, San Francisco

The Bag Lady, performance, De Young Downtown Center, San Francisco

Three Weeks in May, installation and series of performances with Barbara Cohen, Melissa Hoffman, Leslie Labowitz, Jill Soderholm, and others, Los Angeles; Lacy's installation, "She Who Would Fly"

Travels with Mona, twelve color prints and multisite performance in Europe and Mexico

In Mourning and in Rage with Leslie Labowitz and Bia Lowe, performance, Los Angeles

Travels with Mona with Arlene Raven, artist's book, edition of two thousand

1978 *Vaginal Valentines,* photocollages with text

The Lady and the Lamb, or The Goat and the Hag, performance, Mills College, Oakland, California

The Vigil/Incorporate with Barbara Turner Smith, two-part performance, Irvine, California ("The Vigil"), and Los Angeles ("Incorporate")

Here We Are There with Nancy Buchanan and Norma Jean Deak, a telephone piece from Lacy at the University of Nevada, Las Vegas, to Nancy Buchanan at the Center of Music Experiment, San Diego

The Bag Lady, performance, Los Angeles

Mona by Number, installation/performance, San Francisco Museum of Modern Art

From Reverence to Rape to Respect with Kathy Kauffman, Claudia King, and Leslie Labowitz, series of events, performances, and installations, University of Nevada, Las Vegas; Lacy's installation, "There Are Voices in the Desert"

Take Back the Night conference–performance with float by Lacy, Leslie Labowitz, Rosemarie Prins, Mónica Mayer, Betsy Irons, Ann Klix, San Francisco

Three Love Stories, artist's book, edition of five hundred: "A Gothic Love Story," "A True Romance, or She's Got Quite a Set of Lungs," "Under My Skin: A Pornographic Novel"

Critique of movie *Hardcore* with Leslie Lebowitz and Lois Lee, Los Angeles

Featured on the covers and inside of first issue of *High Performance.* Co-founded Ariadne: A Social Art Network (1978–82) with Leslie Labowitz to undermine sexually violent imagery in cultural production.

1979 *Making It Safe,* speak-outs, leaflets, art show, and small dinners before final dinner performance, Ocean Park, California

International Dinner Party with Linda Pruess, installation/performance, San Francisco

1980 *River Meetings: Lives of Women in the Delta* with Jeanne Nathan, Laverne Dunn, Betty Constant, Mary Ann Guerra, Marilee Snedeker, Mary Helen Matlick, performance, New Orleans

In the Last Throes of Artistic Vision, installation/performance, Los Angeles

Evalina Newman dies.

1981 *Tree: Women of Ithaca* with Marilyn Rivchin, Nancy Bereano, and Carolyn Whitlow, performance, Ithaca, New York

Visits Cuba with Jayne Cortéz, Mel Edwards, Lucy Lippard, Ana Mendieta, and Martha Rosler.

1982 *Freeze Frame: Room for Living Room* with Julia London, Ngoh Spencer, Natalia Rivas, Carol Szego, Joya Cory, and Jan Chattler, performance, San Francisco

Three Weeks in May, artist's book, edition of twenty

1983 *Immigrants and Survivors,* series of potlucks leading up to final dinner performance, Los Angeles

1984 *Whisper, the Waves, the Wind* with Sharon Allen, performance, La Jolla, California

Sofa, twenty-minute color video, directed by Lacy, with Douglas Gayeton Smith and Steven Hirsh, director of photography, based on *Freeze Frame* (1982)

Whisper Minnesota project launched.

1985 Artist in Residence, Minneapolis College of Art and Design, Minneapolis, Minnesota (through 1986)

1986 *The Dark Madonna* with Anne Bray, Carol Heepke, Yolanda Chambers Adelson, and Willow Young, performance, Franklin D. Murphy Sculpture Garden, University of California at Los Angeles

1987 *The Crystal Quilt* with Miriam Schapiro, Susan Stone, Nancy Dennis, and Phyllis Jane Rose, culminating performance of *Whisper Minnesota,* Minneapolis, Minnesota

Moved to Oakland, California. Dean of Fine Arts, California College of Arts and Crafts, Oakland, California (through 1997).

1989 "City Sites: Artists and Urban Strategies," a series of art events curated by Lacy with Judy Baca, Newton and Helen Harrison, Lynn Hershman, Marie Johnson-Calloway, Allan Kaprow, Mierle Laderman Ukeles, John

Malpede, and Adrian Piper, sponsored in Oakland by the California College of Arts and Crafts

1990 *The Road of Poems and Borders* with Allan Kaprow, Pirkko Kurikka, and Arthur Strimling, performances and radio transmission, Joensuu, Finland

1991 *Cancer Notes: Seven Day Genesis,* performance, Roswell Park Cancer Center, Buffalo, New York

Starts Teens + Educators + Artists + Media Makers (T.E.A.M., 1991–2001) with Chris Johnson and Annice Jacoby.

1992 *Teenage Living Room* with Chris Johnson and Lauren Manduke, performance, Oakland, California

Artist in Residence, Irish Museum of Modern Art, Dublin. Receives Guggenheim Fellowship.

1993 *Auto on the Edge of Time* projects: "Underground" with Carol Kumata and Jeannie Pearlman, installation, Pittsburgh; "Doing Time" with Charlotte Watson, Virginia Cotts, David Katsive, Sharon Smolick, installation, Bedford Hills Maximum Security Facility, New York

Full Circle: Monuments to Women with a coalition of Chicago women, installation in the Loop and dinner performance at Hull-House Museum, Chicago, Illinois

1994 *Auto on the Edge of Time* projects: "The Children's Car" with Carol Kumata and Susanne Cockerell, installation, Niagara Falls, New York, and Cleveland, Ohio; "Children Speak" with Virginia Cotts and David Katsive, televised public service announcement

Signs of Violence with Gail Smithwalker, Leslie Becker, Annice Jacoby, ten traffic signs, Oakland, California

The Roof Is on Fire with Chris Johnson and Annice Jacoby, performance, Oakland, California

Brother Philip Lacy diagnosed with cancer in December.

1995 *Alterations: A Series of Conversations* with Susanne Cockrell and Britta Kathemeyer, Capp Street Gallery, San Francisco

Youth, Cops, and Videotape with T.E.A.M. and the Oakland Police Department, videotaped workshops, Oakland, California

Turning Point project launched, Vancouver, British Columbia.

Mapping the Terrain: New Genre Public Art, book edited by Lacy, published by Bay Press (Seattle).

Founding faculty with Judy Baca, California State University at Monterey

1996 *No Blood/No Foul* with T.E.A.M., performance with murals and video, Oakland, California, and installation, Tokyo, Japan

1997 *Expectations* with Unique Holland, summer arts class for pregnant and parenting teens, Oakland, California, with poster and installation at Capp Street Gallery, San Francisco

Under Construction, culminating performance of *Turning Point* project, Vancouver, British Columbia

Code 33: Clear the Air preparations begin.

Brother Philip dies.

1998 Founded Center for Art and Public Life, California College of Arts and Crafts, director (until 2002).

1999 *Code 33: Clear the Air* with Unique Holland and Julio Morales, performance, Oakland, California

La Piel de la Memoria/The Skin of Memory: Barrio Antioquia, Past, Present, and Future with Pilar Riaño-Alcalá, Raúl Cabra, Vicky Ramirez, Mauricio Hoyos, and Sebastian Vargas Montoya, Medellín, Colombia

2000 *Eye 2 Eye at Fremont High,* performance, Oakland, California

Beneath Land and Water with Susan Leibovitz Steinman, Yutaka Kobayashi, Nina Aragon, Tim Belcher, and Peggy Pings, walking trail, tile quilt, landscaped riverside park, Elkhorn City, Kentucky (through 2005)

2002 *The Borough Project* with Tumelo Mosaka, curated by Mary Jane Jacob and Mosaka for Spoleto Festival USA, Charleston, South Carolina

Moves to Los Angeles. Chair of Fine Arts department, Otis College of Art and Design.

2003 *Latitude 32 Degrees: Navigating Home,* with Rick Lowe and Rob Miller, Spoleto Festival, Charleston, South Carolina

2004 *I_D_Entity* with Elisheva Gross, Unique Holland, and Arthur Ou, Internet discussion and performance for Cities on the Move, Taipei, Taiwan

2006 Starts PhD program, Gray's School of Art, Robert Gordon University, Aberdeen, Scotland.

2007 *SWARM* performance with Kim Abeles and Jeff Cain, Los Angeles County Museum of Art

 Stories of Work and Survival, performance and installation in conjunction with WACK! Art and the Feminist Revolution, Museum of Contemporary Art, Los Angeles

2008 *Trading Dirt,* installation with Peter Kirby and Michael Rotondi for Allan Kaprow—Art as Life, Museum of Contemporary Art, Los Angeles

 The Performing Archive, installation with Leslie Labowitz for Yerba Buena Center for Arts, San Francisco

 Designed and founded graduate studies program in public practice, Otis College of Art and Design.

2009 *The Performing Archive,* installation with Leslie Labowitz, re.act.feminism, Akademie der Künste, Berlin

 A newly formed caucus of the College Art Association, Public Art Dialogue (PAD), presented a dialogue with Lacy, "Recent Issues and Critical Concerns," in celebration of her award for Achievement in the Field of Public Art from PAD.

NOTES

Preface and Acknowledgments

1. Maurice Merleau-Ponty used the phrase "tactile palpation" to examine this relationship. "My hand," he wrote, "while it is felt from within, is also accessible from without, itself tangible, for my other hand, for example. . . . Through this crisscrossing within it of the touching and the tangible, its own movements incorporate themselves into the universe they interrogate, are recorded on the same map as it." Hands are touchable and touching at once; bodies are in the world and of the world. The phenomenologist noted that "the thickness of the flesh . . . is not an obstacle . . . , it is [the] means of communication." Merleau-Ponty, "The Visible and the Invisible," 251–52.

2. As the critic and art historian Jonathan Harris commented, "[A]rt history's core concerns and ideological values remain far too important and strategic to be left in the hands of conventional art historians!" Harris, "Introduction: Performance, Critiques, Ideology," 23.

3. Thyrza Nichols Goodeve, "Rainer Talking Pictures," *Art in America* 85, 7 (July 1997): 58, quoted in Chave, "Minimalism and Biography," 163, n. 67.

4. Phelan, *Unmarked,* 174.

Introduction

1. This image appeared in a film that was projected during the performance.

2. The phrase *spaces between* comes out of Lacy's own writing (about her work *One Woman Shows,* 1975; see chapter 2, this volume).

3. Lacy suggested the term *new genre public art* during the *City Sites* series that she organized in 1989.

4. Lacy's phrase, used in numerous conversations.

5. Harris, "Introduction—with Postmodernism Grounded," 4.

6. Fuchs, *Against Essentialism,* 168–69; also 176.

7. Lacy also shares with younger contemporaries the goals of "taking charge of social being here and now . . . engaging with social life as production, engaging with social life itself as the medium of expression." Stimson and Sholette, introduction to *Collectivism after Modernism,* 13.

8. Margot Leigh Butler, "Making Waves," 387–99, discusses media-savvy collective work by a group of San Diego artists in 1992, for example. Marsha Meskimmon, in "Chronology through Cartography," makes a similar point: "[F]or many feminist artists, collaborative working methods begun in the 1960s and 70s set the tone for continued successful collaborations later" (334).

9. These projects include *Making It Safe* (Ocean Park, Calif., 1979); her multiple projects in Oakland, Calif. (1992–2000); *The Skin of Memory* (Medellín, Colombia, 1998); and *Beneath Land and Water* (Elkhorn City, Ky., 2000–05). Lacy was not part of a collective such as Group Material (founded 1980), but she provided the groundwork for practices like theirs. "Tim Rollins Talks to David Deitcher," 78–82; "Group Material Talks to Dan Cameron," 200–203. See Moore, "Artists' Collectives Mostly in New York," 199–200, 210, on feminist collectivity.

10. Alexander Alberro, "Reconsidering Conceptual Art, 1966–1977," in *Conceptual Art,* ed. Alberro and Stimson; Camnitzer, Farver, and Weiss, eds., *Global Conceptualism;* Kester, *Conversation Pieces,* 52–53.

11. Amelia Jones, *Body Art,* 1, 11.

12. Wolff, "Reinstating Corporeality: Feminism and Body Politics," in *Feminine Sentences,* 120–41.

13. Broude and Garrard, eds., *The Power of Feminist Art;* Reckitt and Phelan, eds., *Art and Feminism.*

14. Roth, "Interview with Suzanne Lacy," 17.

15. Mary Kelly, with Silvia Kolbowski, "A Conversation on Recent Feminist Art Practices," *October* 71 (Winter 1995): 49–69, quoted in Molesworth, "House Work and Art Work," 74, n. 8. Thanks to Conrad Bakker for this reference.

16. One example of this sophisticated analysis is Ryan Griffis, "Meditations on Privilege," *Furthertxt.org* issue 3 (September 2003), http://www.furthertxt.org/ryan.html; for other examples by Griffis, see http://www.yougenics.net/griffis/.

17. Mary Jo Aagerstoun and Elissa Auther edited a special issue of the *National Women's Studies Association Journal* on feminist activist art: see 19, 1 (2007). See also González and Posner, "A Facture for Change." On "socially engaged" art, see Selz, *Art of Engagement;* on "social interventionist" art, see Daniela Salvioni, introduction to *Art, Women, California,* ed. Fuller and Salvioni, 8; on "political" art, see Lippard, *Get the Message?* 150.

18. For example, Carlson, *Performance;* Loeffler and Tong, eds., *Performance Anthology;* Roth, ed., *The Amazing Decade.*

19. For live art, see Lois Keidan, "Live Art UK Vision Paper: A Question of Live Art" (Live Art Development Agency, 2004); www.liveartuk.org. Thanks to Jennie Klein for telling me about this paper. See also Wark, *Radical Gestures,* 8.

20. Lacy's contemporary Vito Acconci has argued that visually oriented art that is "non-scripted, nonoral and played out in real time" should be called "performative," in contradistinction to the theatrical term "performance." Grace Glueck, "Work

That Is Performed, But Isn't Performance Art," *New York Times,* October 1, 2004, B30. For more on Acconci, see Linker, *Vito Acconci.*

21. Lacy, "Cultural Pilgrimages and Metaphoric Journeys," in *Mapping the Terrain,* 19.

22. Meiling Cheng had different points to make about Lacy's performance art. Thus, she simplified Lacy's diagram into three parts: "the creative center, the immediate witnesses, and the tertiary others." Cheng, *In Other Los Angeleses,* 131.

23. Michel Foucault, "Of Other Spaces," *Diacritics* 16 (1986), 22; quoted in Soja, *Thirdspace,* 155.

24. Fuchs, *Against Essentialism,* 3.

25. Ibid., 9.

26. Fuchs again: "The important conflicts in modern societies are not restricted to classes and status groups, but concern who is an observer, what this observer can and cannot see, and how significant or binding his [sic] observations are for other observers. An observer or observation is nothing in and of itself; it is what it is only in relation to itself, and to other observers and their observations"; ibid., 20.

27. Fuchs wrote, "Persistent back-and-forth level-switching triggers adventures in reflexivity, where one authorial voice is not enough"; ibid., 25.

28. Bettie, "Changing the Subject," 111, quoting Stuart Hall, "Cultural Identity and Cinematic Representation," *Framework* 36 (1989): 70, 72.

29. Wallen, "The Legacy of 1970s Feminist Artistic Practices on Contemporary Activist Art."

30. Women against Pornography was founded in 1979. See Brownmiller, *In Our Time;* and Lederer, ed., *Take Back the Night.*

31. Enke, *Finding the Movement,* 7.

32. Evans, *Tidal Wave,* 1.

33. Breines, *The Trouble between Us,* 31. In *Tidal Wave,* Sara Evans revised her earlier treatment. For her discussions of whiteness in the women's movement, see 32–38.

34. Breines, *The Trouble between Us,* 136.

35. On cultural feminism, see Rosler, "The Private and the Public," 66–74; see also Broude and Garrard, eds., *The Power of Feminist Art;* Amelia Jones, ed., *Sexual Politics;* Klein, "The Ritual Body as Pedagogical Tool," 177–214; as well as Wark, *Radical Gestures.* For one of many negative views of cultural feminism, see Echols, *Daring to Be Bad.*

36. Lacy and Lippard, "Political Performance Art," 24.

37. Klein, "The Ritual Body as Pedagogical Tool," 181. In the 1970s, many feminists were somewhat antitheoretical in the sense that theory appeared to them to exclude and prescribe rather than open up opportunities. Klein noted that for some cultural feminists, "The goddess is deliberately anti-intellectual, or at least anti-theory" (210). For more on the problem of theory, see Campbell, "Introduction: Matters of Theory and Practice," 4; and Wolff, "Postmodern Theory and Art Practice," 88–91.

38. Evans, *Tidal Wave,* 142 ff. On socialist feminism, see also Rosler, "The Figure of the Artist, the Figure of the Woman," in *Decoys and Disruptions.*

39. Suzanne Lacy, telephone conversation with author, December 31, 2008.

40. Maura Reilly, introduction to *Global Feminisms*, ed. Reilly and Nochlin, 31.

41. Fuchs, *Against Essentialism*, 15: "Operationally, essentialism is the failure to allow for variation." See also Fuss, *Essentially Speaking*. On "strategic essentialism," see Spivak, "Subaltern Studies: Deconstructing Historiography," in *In Other Worlds*, 197–221.

42. Kester, *Conversation Pieces*, 163.

43. Barry and Flitterman, "Textual Strategies." On Judy Chicago, Lacy's teacher, Parker and Pollock, *Old Mistresses*, claim that Chicago's homage to women's bodies opens her work "to appropriation in a cultural context which already positions women as closer to the body, nature and sexuality." Iversen, "Mary Kelly and Griselda Pollock in Conversation," 183.

44. Suzanne Lacy, telephone conversation with author, December 31, 2008. Lacy noted that the 1970s writings of Elizabeth Janeway were influential to her.

45. Emphasis in original; Julie Bettie, "Changing the Subject," 111, quoting Chandra Talpede Mohanty, "Feminist Encounters: Locating the Politics of Experience," in *Destabilizing Theory: Contemporary Feminist Debates,* ed. Michelle Barrett and Anne Phillips (Palo Alto, Calif.: Stanford University Press, 1992), 88.

46. Of many citations on the essentialism debate, a good place to start is Lippard, "Both Sides Now: A Reprise," in *The Pink Glass Swan*, 266–77.

47. Emphasis in original; Bettie, "Changing the Subject," 111.

48. Refer to Lugones, "Heterosexualism and the Colonial/Modern Gender System," 186–209. Lugones claims that "gender" and "race" are themselves colonial ideas. See also Quijano, *Modernidad, identidad y utopia en América Latina*; Oyewùmí, *The Invention of Women*; and Oyewùmí, ed., *African Women and Feminism*.

49. Emphasis in the original; Schneider, *The Explicit Body in Performance*, 29. Schneider coined "explicit body" to describe "the explosive literality at the heart of much feminist performance art and performative actions" that addressed "the ways such work aims to explicate bodies in social relation" (2).

50. See Cheng, *In Other Los Angeleses*, 36–44, especially.

51. Wolverton, *The Insurgent Muse*, 99–100.

52. Roth, "Marcel Duchamp in America," 17–30; Tomkins, *The World of Marcel Duchamp*. Schneider, *The Explicit Body in Performance*, 29: "[W]hile Duchamp could cross between artist and woman with bravado and a bad-boy aplomb that bordered on grace, it was something different for *women,* those bearing the literal markings of woman in their physical bodies, to cross as artists. . . ."

53. Haywood, "Revolution of the Ordinary," 321.

54. Lacy and Labowitz were also inspired by workers' protests and strike pageants, as well as mediagenic events such as Greenpeace activists harpooning a Toyota car to protest whaling. Suzanne Lacy, telephone conversation with author, December 31, 2008.

55. "White" is a social construct, although a powerful one. To underscore the arbitrariness of dividing people by phenotype, I use "identified as white." Useful for further exploration of this issue is Spelman, *Inessential Woman*.

56. Bailey, "Locating Traitorous Identities," 33 ff.

57. Schneider, 21, *The Explicit Body in Performance,* refers to Judith Butler, *Gender Trouble* (New York: Routledge, 1990).

58. Frye, "White Woman Feminist," in *Willful Virgin*, 151: "I think of whiteliness as a way of being which extends across ethnic cultural, and class varieties—varieties which may tend to blend toward a norm set by the elite groups within the race."

59. Shusterman, "Somaesthetics and *The Second Sex*," 106, 113.

60. Suzanne Lacy, telephone conversation with author, December 31, 2008. Lacy mentioned Joyce Kozloff as an exceptional artist who was involved in antiracist work.

61. Thanks to Lacy for pointing this intersection out to me. Lacy, telephone conversation with author, December 31, 2008.

62. Soja, *Thirdspace*, 7.

63. Enke, *Finding the Movement*, 4.

64. Kathy O'Dell in *Contract with the Skin* noted that Cindy Nemser's 1971 article "Subject-Object Body Art" "raised the possibility of considering more than one identification of the body in a particular spatial context" (8). Nemser was apparently the first writer to apply discourse of subject-object relations to performance art. Enke, *Finding the Movement*, 271, n. 14, noted, "a spatial analysis instead sees the consolidation of identities as an *effect* of spatial practices. . . . [S]patial practices included contestation, and thus consolidation [of identities] was never complete" (emphasis in the original).

65. Wark does a good job of summing up feminist coalitions, cautioning against what Tina Modleski dubbed "feminism without women"; *Radical Gestures*, 58. Wark refers to early work by Donna Haraway on affinities, alliances, and coalitions; ibid., 81.

66. Labowitz and Lacy, "Evolution of a Feminist Art," 76.

67. Lippard, "Speaking Up," 93.

68. Critic Hal Foster particularly recognized feminism as fostering the passage of art "into the expanded field of culture," where the "observer of art . . . is also a social subject . . . marked by multiple differences." Foster, "The Artist as Ethnographer," 305–6.

69. Lugones, *Pilgrimages/Peregrinajes*, 59. She continues to describe the limen: "a gap 'between and betwixt' universes of sense that construe a social life and persons differently, an interstice from where one can most clearly stand critically toward different structures." Alison Bailey suggested Lugones's framework of "traveling" between "worlds," when adopted carefully, can help white-identified people learn to "see multiply and perceive richly"; Bailey, "Locating Traitorous Identities," 40. Thanks to Alison Bailey for great discussions.

70. For Lugones, "women of color" is not a racial designation but a term of coalition, one that affirms giving up certainty, agreement, and simplicity in order to embrace radical multiculturalism. Lugones, "Colonial Modern Gender System," Society of Women in Philosophy (SWP) conference keynote lecture, November 13, 2005, Bloomington, Ill. Thanks to Alison Bailey for inviting me to this conference.

71. Lacy met Judy Baca through Sheila de Bretteville in 1974 or 1975 at the Los Angeles Woman's Building. Lugones wrote, "I think it is possible for white/Anglo women to think empathetically and sympathetically about those who are harmed seriously by racism and about their lives held in communities where culture flourishes through struggle. But I think that this takes the devotion of friendship";

Pilgrimages/Peregrinajes, 43. See also Bailey, "Privilege," 303; and Dill, McLaughlin, and Nieves, "Future Directions of Feminist Research," 629–37. Thanks to Angel Nieves for sending me the proofs of this article.

72. Larsen, "Social Aesthetics," 172.

73. In the 1990s, the theoretical "death of the author" had a corollary: the interpreting reader. While "participatory reception" involves greater action than reader responses, it is similar in concept. See Broude and Garrard, introduction to *Reclaiming Female Agency*, 13.

74. Lacy, "Debated Territory: Toward a Critical Language for Public Art," in *Mapping the Terrain*, 178.

75. Lacy, "Seeking an American Identity," 196.

76. Judith Butler reflected on this looping between reception and performativity: "I would suggest that performativity cannot be understood outside of a process of iterability, a regularized and constrained repetition of norms. And this repetition is not performed *by* a subject; this repetition is what enables a subject and constitutes the temporal condition for the subject. This iterability implies that 'performance' is not a singular 'act' or event, but a ritualized production, a ritual reiterated under and through constraint, . . . but not, I will insist, determining it fully in advance"; Butler, *Bodies That Matter*, 95.

77. See the forthcoming collection of her essays, Lacy, *Leaving Art*. Lacy also wrote for a wide variety of small publications, including the quarterly *Chrysalis*; *Frontiers*, a publication out of the women's studies program at the University of Colorado; *Heresies*, published by a collective of women in New York (launched in 1977); and *High Performance*.

78. Lacy, "Debated Territory," 174, 178.

79. Jacob, *Places with a Past*, 109.

80. Lacy, "Debated Territory," 178.

81. Schneider, *The Explicit Body in Performance*, 177.

82. Architect and theorist Jane Rendell wrote, "[W]e could say that art is functional in providing certain kinds of tools for self-reflection, critical thinking and social change. . . . [Art]works can be positioned in ways that make it possible to question the terms of engagement of the projects themselves. This type of public art practice is critically engaged; it works in relation to dominant ideologies yet at the same time questions them; and it explores the operations of particular disciplinary procedures—art and architecture—while also drawing attention to wider social and political problems. It might best be called critical spatial practice"; Rendell, *Art and Architecture*, 4.

83. Tromble, "A Conversation with Suzanne Lacy, Artist," 14–15.

84. Kester, *Conversation Pieces*, 3, 6, 9, 10, 12, 14. Connecting art such as Lacy's to prior artistic ideas at once gives it a certain resonance in history—it is not an anomaly, in other words—while at the same time demonstrating ways in which artists like Lacy have pushed beyond what Kester called "arid proceduralism" to lively exchanges.

85. Ibid., 10, 12.

86. Ibid., 123. See also Bishop, "The Social Turn," 178–83; and the discussion by Kester, "Another Turn," 22, 24.

87. Kester, *Conversation Pieces*, 68–69.

88. Bourriaud, *Relational Aesthetics*, 13. "Micro-community" is Bourriaud's word.

89. Lacy, "Speak Easy," 9. She helped find substantial funding to continue the *Whisper Minnesota* project for a year after the *Crystal Quilt* performance; she worked with people in Watts (Los Angeles) 1975–86; and in Oakland, California, 1991–2002, as well as periodically returning to New Orleans since 1980.

90. Ibid., 9.

91. Quoted in Burnham and Durland, *The Citizen Artist*, 11.

92. In addition to Bishop's and Downey's articles cited below, see also Dezeuze, "Everyday Life, 'Relational Aesthetics,' and 'Transfiguration of the Commonplace,'" 143–52; Ross, "Aesthetic Autonomy and Interdisciplinarity," 167–81; and Martin, "Critique of Relational Aesthetics," 369–86.

93. Bourriaud, *Relational Aesthetics*, 15–16, 9, 109.

94. Ibid., 21–22, 81.

95. Bishop, "Antagonism and Relational Aesthetics," 51–79. Thanks to Conrad Bakker for this reference. Also Bishop, "Art of the Encounter," 32–35; Watson, "Response to Claire Bishop's Paper on Relational Aesthetics," 36–38; Gillick, "Contingent Factors," 95–106; Bishop, "Claire Bishop Responds," 107.

96. Bishop, "Antagonism and Relational Aesthetics," 65. Bruno Latour has noted, "[W]e don't assemble because we agree, look alike, feel good, are socially compatible, wish to fuse together, but because we are brought by divisive matters of concern into some neutral, isolated place in order to come to some sort of provisional makeshift (dis)agreement"; Latour, "From *Realpolitik* to *Dingpolitik*—or How to Make Things Public," introduction to the catalog *Making Things Public*, ed. Latour and Weibel, accessed online, 4 of Internet version. Thanks to Ryan Griffis for this link.

97. Downey, "Towards a Politics of (Relational) Aesthetics," 270.

98. Jean-Luc Nancy, *The Inoperative Community*, xxxvii, uses "being-in-common" as an alternative to the term *community*. Near the end of his preface, he asks, "How can we be receptive to the *meaning* of our multiple, dispersed, mortally fragmented existences, which nonetheless only make sense by existing in common?" (xl). In answer, Nancy proposes "compearance," "a more originary order than that of a bond. . . . It consists in the appearance of the *between* as such: you *and* I (between us)—a formula in which the *and* does not imply juxtaposition, but exposition. What is exposed in compearance is the following, and we must learn to read it in all its possible combinations: 'you (are/and/is) (entirely other than) I'" (29; emphasis in original). Thanks to Andrea Phillips during her visit to UIUC in spring 2005 for calling this work to my attention, and subsequent discussion of the issue in the Critical Spatial Practices study group; see also Rendell, "between two," 222.

99. See, for example, Kwon, *One Place after Another*. For another response critical of a Lacy project, see Burnham, "Running Commentary," 8–9.

100. Lacy, "Broomsticks and Banners," 4.

101. Rabinovitz, *Points of Resistance*. Chapter 2 was particularly useful to me.

102. The area of South Central Los Angeles known as Watts suffered six days of concentrated violence during a heat wave in mid-August 1965, sparked by a

confrontation between an African American driver and a white highway patrolman. Thirty-four people were killed, one thousand people were injured, and four thousand people were arrested. See Horne, *Fire This Time*.

103. California Arts Council narrative proposal, Suzanne Lacy, personal collection; Lacy, "Art and Everyday Life," 91–96.

104. Lacy, "Broomsticks and Banners," 4.

105. Diana Fuss, "Inside/Out," in *Inside/Out: Lesbian Theories, Gay Theories* (New York and London: Routledge, 1991), 5, cited in Soja, *Thirdspace*, 118.

1. Visceral Beginnings

1. Spelman, "Gender & Race: The Ampersand Problem in Feminist Thought," in *Inessential Woman*, 128.

2. Roth, "Interview with Suzanne Lacy for the Archives of American Art," 4.

3. Lacy noted that the VISTA training was held at the Maryland School of Social Work and that Saul Alinsky's organizing methods were influential. See, for example, Alinsky, *Reveille for Radicals*. Suzanne Lacy, telephone conversation with author, December 31, 2008.

4. Roth, "Interview with Suzanne Lacy," 5.

5. Their course title was an obvious nod to Simone de Beauvoir's influential book of that name. *The Second Sex* was published in France in 1949; the first American translation appeared in 1953.

6. While some faculty were reinstated after lawsuits, and Black and Chicano Studies were reconstituted, Fresno State reeled from the administrative crackdowns for years. See http://zimmer.csufresno.edu/~geneb/gb.html; Seib, *The Slow Death of Fresno State*.

7. Seib, *The Slow Death of Fresno State*, 46. There were a few Asian Americans at the university, according to Faith Wilding; Wilding, interview with author, November 14, 2003, Chicago, Ill.

8. Faith Wilding was married at the time to Everett C. Frost, one of the English professors who was fired in February 1970, then reinstated, then fired again in December 1970. She and Frost were friends and colleagues with faculty in the ethnic studies programs as well.

9. Born Judith Cohen, she changed her last name to Chicago from Gerowitz in 1970; see Chicago, *Through the Flower*; and Wilding, "The Feminist Art Programs at Fresno and CalArts, 1970–75," in *The Power of Feminist Art*, ed. Broude and Garrard, 32–47; "Vanalyne Green," in *Women of Vision*, ed. Juhasz, 156–57.

10. Laura Meyer, "From Finish Fetish to Feminism: Judy Chicago's 'Dinner Party' in California Art History," in *Sexual Politics*, ed. Amelia Jones, 50.

11. Illustrated in Reckitt and Phelan, *Art and Feminism*, 56.

12. Maryse Holder, "Another Cuntree: At Last, a Mainstream Female Art Movement," in *Feminist Art Criticism*, ed. Raven, Langer, and Frueh, 1–21; see also Rosler, "The Figure of the Artist, the Figure of the Woman," in *Decoys and Disruptions*, 106: "The suggestions of essentialism and mysticism on the part of the California women upset many East Coast feminist artists, who were far less willing to accept the idea of a female essence that could be traced in style and form. (There was a fuss

over the 'central vaginal imagery' thesis, which in any case may have originated with the decidedly East Coast Lucy Lippard, at that time the best-known feminist art critic in America.)"

13. Laura Meyer, "The Los Angeles Woman's Building and the Feminist Art Community, 1973–1991," in *The Sons and Daughters of Los,* ed. David James, 39.

14. In addition to working in two-dimensional media and sculpture, Chicago had studied auto-body painting in the mid-1960s and pyrotechnics later that decade, both of which required her to work in male-dominated arenas. See Chicago, *Through the Flower,* 56–59; and Schapiro and Chicago, "Female Imagery," 14. *Woman/Atmosphere* (1971), for example, is illustrated in *Through the Flower.*

15. Meyer, "From Finish Fetish to Feminism," 54.

16. Suzanne Lacy, interview by author, November 2001, Urbana, Ill.

17. Amelia Jones, "Sexual Politics," in *Sexual Politics,* 24.

18. Chicago, *Through the Flower,* 75, 78; see also Faith Wilding, "Don't Tell Anyone We Did It!" http://www.andrew.cmu.edu/user/fwild/faithwilding/donttell.html (accessed August 22, 2005). Various feminist critics disagree about whether consciousness-raising practices were solipsistic or empowering. Katie King quotes Pam Allen's belief that consciousness raising "at its best, clear[ed] the ground for action"; Juhasz, *Women of Vision,* 36. See also Barbara Smith, "'Feisty Characters' and 'Other People's Causes': Memories of White Racism and U.S. Feminism," in *The Feminist Memoir Project,* ed. DuPlessis and Snitow, 478–79.

19. The "bare-all" aspect of consciousness-raising groups was both liberatory and limiting. It was liberating for those who felt safe enough to make themselves vulnerable and could find ways to cope with the emotional aftermath; it was limiting because consciousness-raising groups were not safe spaces for all women, in part because most white women were not challenging their own racisms. Philosopher María Lugones has reflected on this oppressive situation: "Even though I am told over and over by white feminists that we must reveal ourselves, open ourselves, I keep secrets. Disclosing our secrets threatens our survival"; Lugones, *Pilgrimages-Peregrinajes,* 11. Curator Lowery Sims has noted further complications of informal performance: "The act of performing also plays provocatively into certain stereotypes about women, black women in particular. 'Acting out' was the exclusive province of black American women long before it was accepted as a creative strategy for women as a whole"; Lowery Sims, "Aspects of Performance in the Work of Black American Women Artists," in *Feminist Art Criticism,* ed. Raven, Langer, and Frueh, 208. While many white women gained considerably from self-revelations in women-only groups, it is important to remember that these groups were often not safe spaces for women of color.

20. Wilding, "The Feminist Art Programs at Fresno and CalArts"; and Broude and Garrard, "Conversations with Judy Chicago and Miriam Schapiro," in *The Power of Feminist Art,* ed. Broude and Garrard, 32–47, 66–85.

21. Metzger's autobiographical *Tree* in 1978 included Suzanne Lacy among others. Metzger, *The Woman Who Slept with Men to Take the War Out of Them & Tree,* 149.

22. Holland Cotter, "Arlene Raven, 62, a Historian and Supporter of Women's Art," *New York Times,* August 6, 2006.

23. Raven and Pieniadz, "Words of Honor," 383. Raven studied at Hood College,

George Washington University, and Johns Hopkins, receiving an MFA in painting and a PhD in art history. See also Raven and Iskin, "Through the Peephole."

24. Lacy's sculpture for Chicago's Route 126 class *Car Renovation* is discussed and illustrated in Cheng, *In Other Los Angeles,* 94, 96; see color illustration in Broude and Garrard, eds., *Power of Feminist Art,* 30.–31.

25. David E. James, *The Most Typical Avant-Garde,* 206; also Plagens, *Sunshine Muse,* 161, quoting from the CalArts charter: "Interaction among the members of the schools is fundamental to the Institute. . . . [The Institute's] immediate concerns extend to the environment of the new city in which it is being built and to the surrounding megalopolis."

26. Suzanne Lacy, interview by author, October 2004, Elkhorn City, Ky.; Higgins, *Fluxus Experience.*

27. Crow, *The Rise of the Sixties,* 123. For example, Forti and Rainer had worked with Ann (now Anna) Halprin's San Francisco Dancers' Workshop, founded in 1955. Halprin's choreography fostered participation by nonprofessionals, and "movements, through improvisation and other devices, to develop according to inherent principles of physiology and everyday functions." See also Halprin, *Moving toward Life.*

28. Wilding, "The Feminist Art Programs at Fresno and CalArts," 39.

29. James, *The Most Typical Avant-Garde.* Herbert Blau authored *The Impossible Theater: A Manifesto* (New York: MacMillan, 1964), among other more recent publications.

30. Roth, "Interview with Suzanne Lacy," 16.

31. Suzanne Lacy, telephone conversation with author, January 1, 2009. Lacy noted that African American artist Faith Ringgold and Chicana artist Judith Baca were notable because there were so few artists of color in the mainstream art world.

32. Holland Cotter, "Allan Kaprow, Creator of Artistic 'Happenings,' Dies at 78," *New York Times,* April 10, 2006, 7B; Haywood, "Revolution of the Ordinary"; Kaprow, *Essays on the Blurring of Art and Life*; Kelley, *Childsplay.* The first Happening was *18 Happenings in 6 Parts* in 1959.

33. "Uncatalogued Transcript of Conversation between Allan Kaprow and Suzanne Lacy," 1981, 3–4; personal collection of Moira Roth, Oakland, California. Thanks to Lacy for permission to quote from this transcript.

34. As Jeff Kelley has told it, Kaprow rewrote philosopher John Dewey's *Art and Experience* in terms of himself starting about 1949; Kelley, introduction to *Essays,* by Kaprow, xi. The "presence" at Columbia of the recently departed John Dewey was still felt on campus, according to George Leonard; Leonard, "Misleading Surface Resemblance."

35. Allan Kaprow, *Assemblage, Environments and Happenings* (New York: Harry N. Abrams, 1966).

36. Kelley, *Childsplay,* 180.

37. Roth, "Interview with Suzanne Lacy," 15. Kaprow's work with saliva was seen in the booklet "Air Condition" (1975). Kelley, *Childsplay,* 188–89. Kaprow left CalArts for the University of California at San Diego in 1974.

38. Haywood, "Revolution of the Ordinary," 15.

39. See Bugni and Smith, "Getting to a Better Future through Architecture and Sociology," 2.

40. Lipsitz, *American Studies in a Moment of Danger*, 64.

41. Goffman, *Interaction Ritual*; Goffman, *The Presentation of Self in Everyday Life*; and Denzin, *Performance Ethnography*, 28–29, 32.

42. Bishop, "The Social Turn," 183.

43. "Vanalyne Green," in Juhasz, *Women of Vision*, 157; see also Stermer, "Sheila de Bretteville," 45. By the time that CalArts lost its temporary avant-garde designation in the mid-1970s, Lacy and her cohort of students, as well as De Bretteville, Chicago, and Schapiro, had moved on. See Schor, "Amnesiac Return," 16–17. Schor echoes many other CalArts feminists who noted the failure by CalArts to acknowledge the contributions of the Feminist Art Program to their institution, particularly in the exhibit "CalArts: Skeptical Beliefs" of 1987.

44. Cheng, *In Other Los Angeleses*, 105.

45. Roth, "Interview with Suzanne Lacy," 11. Z. Budapest came for a rape speak-out at CalArts in 1971, and Deena Metzger, a "reluctant feminist" at that time, spoke at the event, which was "huge" for her. Suzanne Lacy, Laurel Klick, Susan Mogul, and Jerri Allyn, group interview with author, January 24, 2005, Los Angeles.

46. Bevacqua, *Rape on the Public Agenda*, 9.

47. Roy Porter, "Rape—Does It Have a Historical Meaning?" in *Rape*, ed. Tomaselli and Porter, 216. Susan Brownmiller's *Against Our Will* (1975) posited that all men are potential rapists and rape is a symptom of the illness that is patriarchy.

48. Griffin, *Rape: The Power of Consciousness*, 3–5, 7. This essay originally appeared in Griffin, "Rape: The All-American Crime," *Ramparts* 10 (September 1971): 26–35. Another groundbreaking article appeared in 1971 as well: Barbara Mehrof and Pamela Kearon, "Rape: An Act of Terror," *Notes from the Third Year* (1971).

49. Bevacqua, *Rape on the Public Agenda*, 39, quoting Angela Y. Davis, *Women, Culture, and Politics* (New York: Random House, 1990).

50. Amelia Jones, "The 'Sexual Politics' of *The Dinner Party*," in *Sexual Politics*, 86.

51. Lacy credits Sheila de Bretteville with helping with the graphic design of that book, and Deena Metzger with framing the text. Suzanne Lacy, interview by author, January 24, 2005, Los Angeles. Two editions of the book were published, with the first one done by hand at CalArts. Suzanne Lacy, interview by author, August 22, 2006, Los Angeles.

52. Bevacqua, *Rape on the Public Agenda*, 53.

53. Tolstoy, *The Collected Works of Leo Tolstoy*, 158. Tolstoy based his story of Ivan Ilyich on *A Confession*, his first-person rumination on mortality. In *A Confession*, Tolstoy tells a fable of a man who escapes a beast by climbing into a dry well. At the bottom of the well, however, there is a dragon. Caught between beast and dragon, the man grabs hold of a twig growing out of the side of the well. Two mice—one black, one white—begin to gnaw at the twig. Lacy used black and white mice in her performance *Lamb Construction* (1973).

54. Lacy called *Ablutions* the "first contemporary feminist artwork on rape." Roth and Lacy, "Exchanges," 96. Sandra Orgel and Aviva Rahmani were both students with Lacy at CalArts. Rahmani also studied with Allan Kaprow.

55. Connell and Wilson, eds., *Rape* (1974) was a pioneering contribution according to Vivien Fryd, who kindly shared with me the manuscript version of her

introduction: Vivien G. Fryd, *Representing Sexual Trauma in Contemporary American Art*, forthcoming. In 1971, Chicago had made two offset photolithographs about violence against women: *Love Story*, a monochromatic image of a gun pointed between a woman's buttocks toward her vagina, with text from the novel, *The Story of O* (Jean Paulhan); and *Gunsmoke*, showing a gun shoved into the artist's mouth, forcing her head backward.

56. Lacy recalled that *A Clockwork Orange* (Stanley Kubrick, 1971) and *Straw Dogs* (Sam Peckinpah, 1971) both were films that graphically showed violence against women from the perpetrators' vantage points. Suzanne Lacy, telephone conversation with author, January 1, 2008.

57. Roth, *The Amazing Decade*, 86. According to Lacy, Sandra Orgel had shown her colleagues slides of her bathing in eggs. Roth, "Interview with Suzanne Lacy," 13.

58. Santner, "History beyond the Pleasure Principle," 144. See also Caruth, *Unclaimed Experience*, 4, 6. Thanks to Roann Barris for this reference.

59. Santner, "History beyond the Pleasure Principle," 152–53.

60. The collective efforts of INCITE! Women of Color against Violence continues this work, demonstrating the ways in which gender violence is a tool of racism and colonialism. Smith, *Conquest*; Smith, "Heteropatriarchy and the Three Pillars of White Supremacy," 66–73.

61. Farrington, *Art on Fire*, 155. Bevacqua, *Rape on the Public Agenda*, 11, 18, 21, does a good job of providing historical background for "the connection between lynching of black men (and some women) by whites and the rape of black women by white men." Ida B. Wells certainly understood that link.

62. Farrington, *Art on Fire*, 220, n. 2. The photographic records show nineteen, but in the 1989 Nadelman interview of Ringgold for the Archives of American Art, Ringgold said there were twenty-three. Ringgold's assistant, Grace Matthews, indicated there are sixteen. See also Farrington, "Faith Ringgold's 'Slave Rape' Series," 128–52. Farrington provides black-and-white illustrations of some of Ringgold's *thangkas*. Thanks to Ms. Matthews for her help on this series.

63. Gouma-Peterson, "Faith Ringgold's Story Quilts," 64–69, illustrates and discusses Ringgold's 1985 "Slave Rape Story Quilt."

64. Blocker, *Where Is Ana Mendieta?* 15–16; Herzberg, "The Iowa Years." Mendieta and Suzanne Lacy were together in Cuba in January 1981, along with Jayne Cortéz, Mel Edwards, Lucy Lippard, and Martha Rosler.

65. Yoko Ono in *Cut Piece* (1965) made herself vulnerable as a "victim," for example.

66. Cheng, "Renaming 'Untitled Flesh,'" 214.

67. Rape was a topic heretofore treated primarily in European epic paintings from the seventeenth through nineteenth centuries, e.g., Wolfthal, *Images of Rape*; Norman Bryson, "Two Narratives of Rape in the Visual Arts: Lucretia and the Sabine Women," in *Rape*, ed. Tomaselli and Porter, 152–265.

2. Embodied Networks

1. Linda Burnham, "Performance Art in Southern California: An Overview," in *Performance Anthology*, ed. Loeffler and Tong, 392.

2. Claudine Isé, "Considering the Art World Alternatives: LACE and Community Formation in Los Angeles," in *Sons and Daughters of Los*, ed. James, 93. Asco included Diane Gamboa and Pattsi Valdez as well, starting in 1973. Thanks to Diane Gamboa for clarifying the Asco membership; conversation with author, August 20, 2006, at Red Cat in Los Angeles. See also Griswold del Castillo, McKenna, and Yarbro-Bejarano, eds., *Chicano Art*, 125; and Sangster, catalog coordinator, *Outside the Frame*.

3. Faith Wilding, "Feminist Art Programs," in *Power of Feminist Art*, ed. Broude and Garrard, 291, n. 23.

4. See Cleveland, "Judy Baca: SPARC," 258–65. A short history also appears on SPARC's Web site: http://www.sparcmurals.org/.

5. With Ruth G. Waddy, Samella Lewis edited the two-volume *Black Artists on Art* (Los Angeles: Contemporary Crafts, [1969] 1971). See also Mesa-Bains, "Galeria de la Raza," 144–47.

6. Crow, *The Rise of the Sixties*, 71–72.

7. In 1971, with Kay Brown and Dinga McCannon, Ringgold organized Where We At, a Black artists' group working toward more exhibition opportunities. Ringgold, *We Flew Over the Bridge*; Roth, "Keeping the Feminist Faith"; Reilly, introduction to *Global Feminisms*, ed. Reilly and Nochlin, 24–25.

8. Lippard, "Feminist Space: Reclaiming Territory," in *The Pink Glass Swan*, 216.

9. Davis, *City of Quartz*, 48, 18. See also Crow, *Rise of the Sixties*; and Doss, *Twentieth-Century American Art*, 169.

10. See Carringer, "Hollywood's Los Angeles," 247–66.

11. Plagens, *Sunshine Muse*, 86–88.

12. In 1978, as an Ariadne project (a social art network that Lacy cofounded), Lacy organized a screening of *Hardcore* at Columbia Studios through a contact there. *Hardcore* (1979, directed by Paul Schrader, with George C. Scott) was a Hollywood take on the prostitution and pornography industries. The invited audience included feminist activists and theorists, who were asked to critique the movie. Lacy and Lois Lee, whom Lacy had met four years earlier in the course of one of her solo projects *(Prostitution Notes)*, cofacilitated the discussion. While George C. Scott and Paul Schrader did not attend, several studio executives did as well as reporters from two television stations, thereby bringing mainstream media attention to a feminist critique of a Hollywood production. Roth, "Interview with Suzanne Lacy for Archives of American Art," 30.

13. Blalack (born 1948, another CalArts MFA graduate, 1973) was part of the visual effects team on the first Star Wars movie (1977), doing composite optical photography. The team won an Oscar that year for their work.

14. Chicago then withdrew in 1974 to pursue *The Dinner Party*, among other projects. Miriam Schapiro remained at CalArts for two more years, until 1975. See *From Site to Vision*, ed. Hale and Wolverton; Laura Meyer, "Los Angeles Woman's Building," in *The Sons and Daughters of Los*, ed. James, 39–62; and Moravec, "Building Woman's Culture"; Wolverton, *Insurgent Muse*.

15. Meyer, "Los Angeles Woman's Building," 45. Along with Arlene Raven, de Bretteville launched the publication of *Chrysalis, A Journal of Women's Culture*, in 1977, which was produced at the Woman's Building.

16. Martha Rosler reflected that "Schapiro and Chicago were unfriendly to social-ist analyses and socialist feminism, though a number of younger faculty and stu-dents at the Woman's Building became interested in socialist versions of feminism and included class alongside gender in their analyses of oppression. The Woman's Building also made a number of rapprochements with the poor Mexican residents of their neighborhood, with modest success." Rosler, "The Figure of the Artist, the Figure of the Woman," in *Decoys and Disruptions*, 106.

17. Linda Nochlin's essay "Why Have There Been No Great Women Artists?" *Art News* (January 1971) has been reprinted frequently, as has Mary Beth Edelson's 1971 collage *Living American Women Artists/Last Supper*. See Broude and Garrard, introduction to *The Power of Feminist Art*, 17. For other classic texts, see *Feminism-Art-Theory*, ed. Robinson. The pioneering catalog by Ann Sutherland Harris and Linda Nochlin, *Women Artists 1550–1950* (1976) brought many forgotten Western artists to national attention. For historiography from a materialist feminist perspec-tive, see Parker and Pollock, *Framing Feminisms*; for a cultural feminist perspective, see Broude and Garrard, introduction to *The Expanding Discourse*.

18. According to Lacy, the 1973 Performance Conference at the Woman's Build-ing featured Linda Montano, Pauline Oliveros, Cheri Gaulke, Jerri Allyn, and oth-ers; Suzanne Lacy, e-mail to author, July 13, 2008.

19. Moira Roth, "Suzanne Lacy: Three Decades of Performing and Writing/ Writing and Performing," manuscript, February 17, 2006, 22, n. 12. Thank you to Moira Roth for sharing her work with me. Meyer, "Los Angeles Woman's Building," 47.

20. See also Springer, *Living for the Revolution*.

21. Metzger, *Writing for Your Life*, 36. Thanks to Carol Spindel for the loan of many books and our discussions about Deena, who was her teacher.

22. In the version at Womanspace, the net hung in front of the kidneys. Lacy, noting how bad it smelled, also said it looked "gestapoesque." Roth, "Interview with Suzanne Lacy," 13.

23. Suzanne Lacy, interview with author, October 2004, The Breaks, Virginia.

24. Mark, *WACK!* 504. This contract has fourteen typescript pages.

25. Labowitz and Lacy, "Evolution of a Feminist Art," 77.

26. In addition to the examples discussed here, Hannah Higgins illustrated and described a work by Geoffrey Hendricks, *Unfinished Business: Education of a Boy Child* (1976), in which locks of hair from the audience were exchanged for a lock of Hendricks's beard. Higgins, *Fluxus Experience*, 101–3.

27. Kelley, *Childsplay*, 190.

28. Ibid., 194–95.

29. Shelley, *Frankenstein*, 142, 143.

30. Lacy, draft of manuscript of *Leaving Art*. These words do not appear in the final version. Thanks to Lacy for sharing the early draft with me.

31. Federici, *Caliban and the Witch*, 16. Thanks to Michael Steinberg for alerting me to this book.

32. Cf. Olorenshaw, "Narrating the Monster," 158–76.

33. Photocopy of typescript in personal collection of Suzanne Lacy; underlining in original.

34. Ibid.

35. Ibid; Lacy also described the process to Betty Ann Brown, *Expanding Circles*, 164.

36. Atkinson, *Amazon Odyssey*. Thanks to Lacy for alerting me to this connection.

37. In 1969, Lacy's contemporary in Los Angeles Paul McCarthy (born 1945) had flung his body against walls in *Leap* and *Too Steep, Too Fast*.

38. Another student of Kaprow's, Lucas Samaras, enacted different characters as well. Samaras created a series of photographic self-portraits between 1969 and 1971 called *AutoPolaroids*. Some versions framed his face and upper torso (published in *Samaras Album* in 1971). With props and makeup, Samaras posed as a range of male, female, and transgender characters exhibiting a variety of emotions, from horror to sadness, from hostile to alluring. Lacy's characterizations—from *One Woman Shows* to her pieces where she performs as an old woman—explored similar territory. Ewing, *Lucas Samaras*, 5.

39. Daly, *Beyond God the Father*, 73.

40. Photocopy of typescript in personal collection of Suzanne Lacy.

41. Ibid.; emphasis added; capital letters in the original.

42. Lugones, *Pilgrimages/Peregrinajes*, 59.

43. Lacy has noted that many sexually violent depictions appear in pornography, a visual form with which most women are unfamiliar; Lacy, telephone conversation with author, January 13, 2009.

44. Goldberg, *Performance Art*, 176. Working as CETA artist, Lacy connected with James Woods of Studio Arts Workshop on various projects: "My friend Jim, a very large and very gay black man, was going to come out with Lois and me, so we wouldn't get 'hit on' by all the pimps." It did not work out that he was able to join them. Lacy, "Prostitution Notes," 166. *Prostitution Notes* was exhibited by Lacy in Los Angeles in spring and summer 2007 in WACK! at the Los Angeles Museum of Contemporary Art.

45. Suzanne Lacy, interview by author, October 2004, The Breaks, Virginia.

46. Lacy, "Prostitution Notes," 151.

47. Ibid., 149, 151; see also 159. Marina Abramović traded places with a prostitute in Amsterdam, for example.

48. Ibid., 158.

49. Pile, "The Un(known) City," 264.

50. Mark, *WACK!* 257–58, 504.

51. Cooking shows were then relatively new phenomena, along with the health food craze nourished by Davis's 1954 book *Let's Eat Right to Keep Fit*, and Child's television program *The French Chef*, dating from the early 1960s. Kirshenblatt-Gimblett, "Playing to the Senses," noted that as a television cook, Child was "legendary for [her] robust gestural style" (22). Thanks to the Video Data Bank in Chicago for use of their facilities to view *Learn Where the Meat Comes From*.

52. Maria Troy, "I Say I Am: Women's Performance Video from the 1970s" http://www.vdb.org/resources/isayiam.pdf; Kirshenblatt-Gimblett, "Playing to the Senses," 1–30.

53. Bible, John 1:35–36.

54. Levin, *Lucas Samaras*, 90–91.

55. Roth, "Interview with Suzanne Lacy," 19. Gilcher and Glenn, *Lucas Samaras*. Lacy does not recall if she saw the exhibit at California State University, Long Beach. Lacy, interview with author, August 22, 2006, Los Angeles.

56. See Juhasz, *Women of Vision*. Thanks to Susan Mogul for telling me about this book.

57. For a brief history of early video, see Drew, "The Collective Camcorder in Art and Activism," 94–113. Drew also provides further bibliography.

58. Rosler, "For an Art against the Mythology of Everyday Life," in *Decoys and Disruptions*, 7; see also Molesworth, "House Work and Art Work," 71–97, especially 91.

59. Caesar, "Martha Rosler's Critical Position within Feminist Conceptual Practices" (online version accessed November 18, 2005).

60. Lacy recalled that Mogul shot the photos for *Falling Apart*: unclothed, on the beach at dawn, Lacy leapt off a ladder. Lacy, Susan Mogul, Laurel Klick, and Jerri Allyn, group interview with author, January 24, 2005, Los Angeles.

61. Roth, "Interview with Suzanne Lacy," 19. See also Cheng, *In Other Los Angeleses*, 107–9.

62. Elder, *The Films of Stan Brakhage in the American Tradition of Ezra Pound, Gertrude Stein, and Charles Olson*, 398. *Pittsburgh Trilogy* included *eyes, Deus Ex, The Act of Seeing with One's Own Eyes*, 1971. Elder noted that Brakhage also equated seeing with one's own eyes with autopsy (auto = auto + opsis): "I am quite sure, given his interest in word play, that Brakhage would not have missed the pun that the historian (one who sees for oneself) is one who does autopsies, who goes over the corpse of a time past . . ." (526, n. 638).

63. Meiling Cheng wrote that Lacy "poses her gender identity as the gauge by which she measures other transgendered corporeal experiences . . . manifestly different from her own"; Cheng, *In Other Los Angeleses*, 109–10, 113.

64. *Dreamworks* 1, 3 (Fall 1980), archives of the Minneapolis College of Art and Design. This issue also had contributions from John Cage, Chris Burden, Deena Metzger, Barbara Smith, Nancy Buchanan, Linda Frye Burnham, Pauline Oliveros, and Paul McCarthy.

65. Lacy explored psychosomatic conditions in other works, such as *Three Love Stories* of 1975 and 1978.

66. *Dreamworks* 1, 3 (Fall 1980), 236, 240.

67. Metzger, *Skin*, 57. Thanks to Carol Spindel for the loan of her books by Metzger.

68. Metzger, *Writing for Your Life*, 40.

69. Jenni Sorkin gave 1977 as the date of *Cinderella*; Sorkin, "Envisioning *High Performance*," 37. *Running to San Francisco*, another piece that acted out Lacy's far-flung teaching assignments, was performed in 1975.

70. The owner met her on campus and allowed her to drive the dragster a short distance to the library. They had hauled the dragster to Dominguez Hills in a trailer. Suzanne Lacy, interview with author, August 22, 2006, Los Angeles.

71. *Cinderella in a Dragster* script, 1976, personal collection of Suzanne Lacy.

72. Ibid.

73. Lacy's description, phone conversation with author, January 13, 2009. When

her script was published in *Criss Cross Double Cross* (fall 1977), Lacy dedicated it to David Antin. Antin used found text and definitions in his poetry, much as Lacy did in her writing. Antin's "talk pieces" were improvised, often responding to the audience and the location.

74. Cheri Gaulke, a student and then colleague of Lacy's who was deeply involved at the Woman's Building in the 1970s, recalled her own performance as Cinderella, which was in contrast to Lacy's: "I created Cinderella, who runs from male-identification to self-definition in feminist community, and finds herself continually running, in a constant state of transformation"; Gaulke, "Acting like Women."

75. Moira Roth, conversation with author, July 29, 2002, Berkeley, Calif. Lacy achieved prominence in a marginal sort of way since she "was working in a medium that wasn't legitimated institutionally at that time." Klein, "Re-reading *High Performance*," 17. See also Burnham, "*High Performance,* Performance Art, and Me," 15–51; Sorkin, *"High Performance"*; and Sorkin, "Envisioning *High Performance*," 36–51.

76. Richard Schechner, "Extensions in Time and Space: An Interview with Allan Kaprow," in *Happenings and Other Acts,* ed. Sandford, 229.

3. The Urban Stage

1. Breines, *The Trouble between Us,* 151, 152. According to Breines, "35 percent of the delegates [at the International Women's Year Conference] were non-white and nearly one in five was low income."

2. Brownmiller, *Against Our Will,* 153; emphasis in the original.

3. As I understand 1970s feminisms, women of color were leaders in their own liberation struggles and in demanding that white feminists come to terms with their racism. I chose to quote a white woman, Susan Brownmiller, to acknowledge that some white women were indeed leaders in antiracist work as well.

4. Meiling Cheng noted that Los Angeles was known as the "Rape Capital of the Nation." Cheng, *In Other Los Angeles,* 117.

5. Bevacqua, *Rape on the Public Agenda,* 127–28. Some California feminists created the Inez Garcia Defense Committee, and national protests erupted when Garcia was convicted of second-degree murder in October 1974; that decision was overturned in December 1975 on appeal. Garcia was tried a second time in 1977 and acquitted.

6. Fryd, "Suzanne Lacy's Three Weeks in May," 23–38.

7. Lacy and Lippard, "Political Performance Art," 25.

8. Suzanne Lacy, telephone conversation with author, January 13, 2009.

9. Further information about sexual violence in the United States is available from the Centers for Disease Control, http://www.cdc.gov/ncipc/factsheets/svfacts. htm; Rape Crisis Information Pathfinder, http://www.ibiblio.org/rcip/; and the Rape, Abuse and Incest National Network, http://www.rainn.org/statistics.html.

10. Roth, "Interview with Suzanne Lacy," 25.

11. Kelley, "The Body Politics of Suzanne Lacy," 235.

12. Ibid., 236–37.

13. Other participating artists were Nancy Angelo, Barbara Cohen, Melissa Hoffman, and Jill Soderholm. Roth, "Interview with Suzanne Lacy," 22–23.

14. Lacy, "Made for TV," 55.

15. Labowitz and Lacy, "Evolution of a Feminist Art," 82; see also Cohen-Cruz, *Local Acts,* 45–46.

16. Lacy, "Tracing Allan Kaprow," 323.

17. Kaprow, *Assemblage, Environments, and Happenings,* 190–91; italics in the original.

18. Lacy, "Made for TV," 56.

19. Lacy, "Learning to Look," 8. Artists have continued to use popular media to take control of the environment. For example, Deborah Small, Elizabeth Sisco, Carla Kirkwood, Scott Kessler, and Louis Hock created *NHI—No Humans Involved* (1992), which used a billboard to highlight the unsolved assaults and murders of forty-five women in San Diego from 1985 to 1992. See Butler, "Making Waves," 392 ff.

20. Deena Metzger, *Skin,* 56; Delacorte and Newman, eds., *Fight Back!* 276.

21. Cheng, *In Other Los Angeleses,* 118–20.

22. On trajectories, see Massey, *For Space,* 10–11.

23. Using *Mona Lisa* harks back to her childhood in Wasco. She told Richard Newton: "I was exposed to art through the paintings of the Great Masters Series. That's all one really had in Wasco"; Newton, "She Who Would Fly," 7.

24. See Ettlinger, *The Complete Paintings of Leonardo da Vinci,* 105; see also Marling, "Hyphenated Culture." Andy Warhol also did a drawing in 1962 in colored crayon, *Do It Yourself,* with numbered areas delineated for later coloring. See Frieling, *The Art of Participation,* Plate 10, 90–91.

25. See http://www.ulrike-rosenbach.de/. Rosenbach had studied with Joseph Beuys at the Dusseldorf Academy 1964–69. She visited Los Angeles for the first time in 1974 (for the performance conference at the Woman's Building) and then returned in 1975 to teach for a year at CalArts at John Baldessari's invitation. See also Mark, *WACK!* 290. On Iole de Freitas, see Vergine, *Body Art and Performance,* 85–87, and Mark, *WACK!* 238.

26. Lacy's contribution was "Map Marking," a series of blueprinted maps marked with yellow tape, accompanied by a reading of rape statistics. Lacy, interview with author, August 22, 2006, Los Angeles. Lacy met Marina Abramović at this event. Also for the Floating Museum in 1977, Lacy created *The Life and Times of Donaldina Cameron* in San Francisco.

27. Thanks to Bea Nettles for telling me the correct name for this type of book.

28. The quotes from Raven are taken from pages 1 and 4 of the postcard book. The postcard sites are a European train cabin, a garret in Basel (photo by D. E. Steward), the piazza in front of Milan's duomo (photo by Iole de Freitas), a meadow overlooking the Swiss Alps (photo by D. E. Steward), in front of the Leonardo painting in the Louvre, holding an altered postcard (photo by Sylvie Hencoque), the castle in the Bergpark in Kassel (photo by Ulrike Rosenbach), the changing of the guards in the forecourt of London's Buckingham Palace, a dock on one of the cayes of Belize (photo by Rob Blalack), Temple II at Tikal in Guatemala (photo by Rob Blalack), the stone carving of Chac Mool at Chichen Itza in Mexico, a desert plain

in Texas (photo by Blalack), and on a balcony overlooking Los Angeles (photo by Cheri Gaulke).

29. Marling, "Hyphenated Culture," 63. Lacy's *Mona Lisa* preceded Paul Bridgewater's creation of an abstract set of five paint-by-number images in 1978.

30. Prisbrey's Bottle Village, damaged in the 1993 Northridge earthquake, was constructed between 1956 and 1972 in Simi Valley.

31. Suzanne Lacy, telephone conversation with author, January 13, 2009.

32. Lippard, "Making Something from Nothing (Toward a Definition of Women's 'Hobby Art')," in *Get the Message?* 102, originally published in *Heresies* 6 (1978). Judy Chicago was collaborating on *The Dinner Party* with china painters and needleworkers at this time, as well.

33. Angelo Buono Jr. and Kenneth Bianchi were apprehended several years later. Feminist artist Nancy Buchanan created a piece related to these murders as well, *Deer/Dear* (1978), which was performed in Las Vegas, Nevada. See Buchanan, "Deer/Dear"; Kelley, "Rape and Respect in Las Vegas."

34. Imagery that pandered to violent fantasies was hardly limited to mainstream media, as evidenced by photographer Les Krims's series *Wheat Cake Murders* (1972). See Newton, "She Who Would Fly," 10: "They are immoral because the reality of the world is that many women are murdered and when Krims picks up on those images and does not critique them, he just reinforces that kind of image of what is expected for women and of women."

35. Leslie Labowitz-Starus, interview with author, January 24, 2005, Los Angeles.

36. In 1971 as a graduate student at Otis Art Institute, Labowitz first performed a public vigil waiting for her menstrual period to start, *Menstruation-Wait*. *Menstruation-Wait* is illustrated and described in *Heresies*, Summer 1978, 78. While Labowitz had met Judy Chicago, she was not part of the CalArts activities nor initially involved in feminism. She received a Fulbright to Germany to study at the Kunstakademie in Dusseldorf in 1972. While she has sometimes been described as a student of Joseph Beuys (1921–86), it is more accurate to say that she was aware of him and briefly in his circle in Dusseldorf. In her words: "I did my 'Menstruation-Wait' in the hallway at the Kunstakademie in Dusseldorf. I did a huge billboard behind me and I sat there, like an idiot, . . . because they were very non-feminist, they were all socialist. . . . That one performance, 'Menstruation Wait,' was the only time I had anything to do with Joseph Beuys. He came to see me when I was doing this performance"; Labowitz-Starus, interview with author, January 24, 2005, Los Angeles.

37. In 1975, Labowitz directed a nighttime public performance in Bonn called *Paragraph 218*, just before the German Supreme Court upheld a ban on abortion in West Germany. Signs, imagery, and sounds told the story.

38. Lacy and Labowitz, "In Mourning and in Rage . . . ," 52–55; Grenier, ed., *Los Angeles 1955–1985*, 300.

39. Kelley, "The Body Politics of Suzanne Lacy," 241.

40. Moira Roth commented: "[W]hat I read as Lacy's essential contribution to 'In Mourning and In Rage' was the intensity of her sense of the gut-level connectedness of all women. It was from this sensibility that the archetypal underpinnings of this piece, the image of primitive female power juxtaposed with a modern power structure—the media—were drawn." Roth, *The Amazing Decade*, 32.

41. Bevacqua, *Rape on the Public Agenda*, 126, lists a number of movies, documentaries, and specials on TV between 1972 and 1977.

42. *In Mourning and in Rage* has received considerable attention in publications. Among the more important, besides Lacy and Labowitz, "In Mourning and in Rage . . . ," and Kelley, "The Body Politics of Suzanne Lacy," are the following: Askey, "In Mourning and In Rage"; and Lacy, "In Mourning and in Rage (with Analysis Aforethought)." A series of large photographs from the performance was included in the *Los Angeles* show at the Centre Pompidou in 2006. See also Vivien G. Fryd, *Representing Sexual Trauma in Contemporary American Art* (forthcoming).

43. Soja, *Thirdspace*, 206, 208. City Hall was designed by the firm of Austin, Parkinson and Martin and was completed in 1928.

44. Labowitz and Lacy, "Evolution of Feminist Art," 78, 80.

45. Publications by Labowitz and Lacy (or vice versa) include the following: "Evolution of a Feminist Art"; "In Mourning and in Rage . . . "; "Two Approaches to Feminist Media Usage"; "Feminist Artists" and in several other versions; "Mass Media, Popular Culture, and Fine Arts," reprinted in Richard Hertz, *Theories of Contemporary Art* (Englewood Cliffs, N.J.: Prentice-Hall, 1985), 171–78. Moira Roth assembled this bibliography in "Suzanne Lacy: Three Decades of Performing and Writing/Writing and Performing," unpublished Manuscript, February 17, 2006. Thanks to Roth for sending me this essay.

46. Lippard, "Advocacy Criticism as Activism," 245.

47. Breines, *The Trouble between Us*, 157–61; see also Becky Thompson, *A Promise and a Way of Life*, 146–48.

48. Labowitz and Lacy, "Evolution of a Feminist Art," 77.

49. Lugones, *Pilgrimages/Peregrinajes*, 34: "Curdling separation is a form of solidarity that does not begin or end within the 'safety' of communities of the same." See particularly her chapter "Purity, Impurity, and Separation," 121–48.

50. Quoted in Breines, *The Trouble between Us*, 171. The original version was a talk but has been frequently published. See Bernice Reagon, "Coalition Politics," 362. Also see Bystydzienski and Schacht, eds., *Forging Radical Alliances across Difference*.

51. Labowitz and Lacy, "Evolution of a Feminist Art," 88.

52. Robinson, ed., *Feminism-Art-Theory*, 105.

53. White feminists who were reframing this issue in the 1970s included Haskell, *From Reverence to Rape*; Brownmiller, *Against Our Will*; and Griffin, *Rape*. Bevacqua, *Rape on the Public Agenda*, 120, wrote about the disproportionate numbers of nonwhite men jailed for sexual assault and the severe impacts of such racism on nonwhite families. Tension about how to address racism in the antirape movement persists. See also Breines, *The Trouble between Us*, 126–27.

54. *Hardcore* (directed by Paul Schrader, with George C. Scott) was a Hollywood take on the prostitution and pornography industries. Ariadne's screening of *Hardcore* at Columbia Studios was set up through a contact there. The invited audience included feminist activists and theorists, who were asked to critique the movie. Lacy and Lois Lee, whom Lacy had met four years earlier during *Prostitution Notes*, cofacilitated the discussion. While George C. Scott and Paul Schrader did not attend, several studio executives did, as well as reporters from two television stations,

thereby bringing mainstream media attention to a feminist critique of a Hollywood production.

55. On the Incest Awareness Project, see Wolverton, *Insurgent Muse*.

56. Mayer, "On Life and Art as a Feminist" (accessed online November 18, 2005); and Roth, "Interview with Suzanne Lacy," 31.

57. An open acknowledgment of the importance of Molly Haskell's book *From Reverence to Rape*, Lacy and Labowitz used this title with Haskell's permission.

58. Suzanne Lacy, telephone conversation with the author, January 13, 2009.

59. By the time of the Las Vegas event, Labowitz wanted out of Ariadne. After *In Mourning and in Rage*, Labowitz reported that she "got really scared, I thought people were after me. . . . You feel like you are a target. I just wasn't ready. I said, 'That's it. I'm not doing more.' Suzanne coerced me into doing 'From Reverence to Rape to Respect' in Las Vegas. I was miserable. First of all, I don't like being that far away from home. . . . I was resentful through the whole thing, . . . even though I think it was very successful, in Las Vegas. . . . It was a collaboration that was more about who Suzanne was than who I was. We didn't know that then"; Leslie Labowitz-Starus, interview with author January 24, 2005, Los Angeles.

60. Kelley, "Rape and Respect in Las Vegas."

61. Ibid.

62. Lippard, "Acting Up," in *Get the Message?* 238.

63. Lynn Campbell was the organizer of this conference and also one of the founders with Diana Russell and Lynn Lederer of Women Against Violence and Pornography in the Media. Lederer edited the papers from the conference: Lederer, ed., *Take Back the Night*.

64. Maria Bevacqua suggested that the first TBTN action may have occurred in 1977 in Pittsburgh; in any case these annual marches reclaimed streets as well as the night beginning in the 1970s. Bevacqua, *Rape on the Public Agenda*, 71.

65. Roth, "Interview with Suzanne Lacy," 28–29. This performance-procession was painful for Lacy due to miscommunications between her and Labowitz, as well as logistical problems and Lacy's necessary but distressing research in porn shops.

66. Although I cannot explore it here, some feminist depictions of women beg further analysis regarding what Julia Kristeva called the "monstrous-feminine." See Wolff, "Reinstating Corporeality: Feminism and Body Politics," in *Feminine Sentences*, 120–41; as well as Russo, "Female Grotesques: Carnival and Theory"; and Kristeva, *Powers of Horror*.

67. Griffin, *Pornography and Silence*, 2–3.

68. Lacy, "The Greening of California Performance," 67.

4. Convergences

1. Twenty years ago Lisa Tickner wrote that "[f]eminist art history cannot stay art history: first, because the conventional premises of the discipline destroy its potential for radical readings; second, because feminism has to be interdisciplinary . . . ; and third, because feminism is politically motivated—it examines new tools for their use value and not for their novelty"; Tickner, "Feminism, Art History, and Sexual Difference," 94. Tickner's article supports my own move away from art

history and my assessment of Lacy's art in interdisciplinary ways. Further, Richard Shusterman has pointed out the obvious but often ignored fact that "we live, think, and act through our bodies"; Shusterman, "Somaesthetics and Care of the Self," 530, 533.

2. Kohn, *Radical Space*, 5.

3. Phillips, "Dynamic Exchange," online at www.publicartreview.org (accessed June 23, 2005); see also Buber, *I and Thou*.

4. Cheng, *In Other Los Angeleses*, 97, 99–100. Cheng argued that the "politics of marginality" suited Lacy's goals for "contest[ing] power from the (constantly oscillating) periphery . . . " (103). Art historian Irit Rogoff noted the growth in possibilities with a coalitional approach: "When something called 'art' becomes an open interconnective field, then the potential to engage with it as a form of cultural participation—rather than as a form of either reification, representation, or contemplative edification—comes into being"; Rogoff, "Looking Away," 126.

5. Cheng, *In Other Los Angeleses*, 103, 130, 129; emphasis in the original. Along the same lines, critic Homi Bhabha, quoted in Soja, *Thirdspace*, 143, seemed to describe dynamic coalitional public art like Lacy's: "What is theoretically innovative, and politically crucial, is the need to think beyond narratives of originary and initial subjectivities and to focus on those moments or processes that are produced in the articulation of cultural differences. These 'in-between' spaces provide the terrain for elaborating strategies of selfhood—singular and communal—that initiate new signs of identity, and innovative sites of collaboration, and contestation, in the act of defining the idea of society itself." Bhabha, *The Location of Culture*, 1–2. Many of Lacy's projects occurred on this "in-between" terrain.

6. Tickner noted that an image "means according to the context of its reception and the interpretative predilections and competencies of its viewers." Tickner, "Feminism, Art History, and Sexual Difference," 97. This underscores the complexity of "participatory reception," given the diversity of participants.

7. Cheng, *In Other Los Angeleses*, 130. Though Cheng does not mention Roland Barthes, it is intriguing that his essay "Death of the Author," first published in 1967 and then included in the 1977 collection *Image-Music-Text*, also "neutralized" the author's privilege and fostered the "birth" of the reader. While Barthes and other European cultural critics were pondering different matters, Lacy and her feminist colleagues were not giving up authorship but expanding it, at the same time that the "audience" willingly joined them as cocreators. Rebecca Schneider makes a similar point: "[A]udience members are active participants in the reciprocity or complicity that is performative exchange—just as readers are active participants in text"; Schneider, *The Explicit Body in Performance*, 9. Lisa Tickner, in her oft-cited article, quoted Jo-Anna Isaak regarding the undermining of women as authors: The "death of the author has different implications for those who have never acceded to that privileged position"; Tickner, "Feminism, Art History, and Sexual Difference," 101.

8. Cheng, *In Other Los Angeleses*, 129, used "responsive-ability." Cheng called Lacy's work "a precursor to the identity performance associated especially with multiculturalism and queer politics" (97). See also Carlson, *Performance*.

9. Some of the authors who have fostered "the spatial turn" in the humanities and social sciences in the past thirty-five years or so are listed in order of publica-

tions that contributed to this conversation: David Harvey (1973), Henri Lefebvre ([1974] 1991), Guy Debord (1977), Michel Foucault (1978), Michel de Certeau (1984), Fredric Jameson (1988), bell hooks (1984, 1990), Gloria Anzaldúa (1987), Rosalyn Deutsche (1988), Trinh T. Minh-ha (1989), Homi Bhabha (1990), Dick Hebdige (1990), María Lugones (1990), Daphne Spain (1992), Gillian Rose (1993), Doreen Massey (1994, 2005), Richard Sennett (1994), Dolores Hayden (1995), Victor Burgin (1996), Don Mitchell (1996), Edward Soja (1996), Lucy Lippard (1997), Malcolm Miles (1997), Denis Cosgrove (1998), Susan Stanford Friedman (1998), Alison Blunt (2000), Jane Rendell (2000), and Irit Rogoff (2000). The "dramaturgical turn" coincided more or less with the rise of performance studies.

10. Margaret E. Farrar spatializes social theory in her essay "Making the City Beautiful," 37–54.

11. Fried, "Art and Objecthood," 12–23. Butt, introduction to *After Criticism*, 5; "[C]riticism, in order that it *remain* criticism, of necessity has to situate itself *para*— against and/or beside—the *doxa* of received wisdom."

12. Lacy, "Seeking an American Identity," 204.

13. Kester, *Conversation Pieces*, 1.

14. Jeff Kelley, "Performance Lives," newspaper clipping in the Minneapolis College of Art and Design archives, Minneapolis.

15. One African American participant, Dona Evans, told reporter Cynthia Griffin, "My first group met in West LA and a woman from Watts, Virginia Sanford, came to pick me up and we discussed how difficult it [the traveling] was, so I decided I'd ask them to my house next time." Griffin noted, "That's when the group, which included blacks, Latinos, and whites, just sort of fell apart, said Evans. 'They were afraid to come to our community,' explained the crisis counselor, who was intrigued by the idea of a cross cultural exchange." Cynthia Griffin, "'Dark Madonna' Frames Women's Diversities," May 28, 1986, in newspaper article included in Lacy archival volume. Thanks to Lacy for sending me this volume.

16. Lacy, "Seeking an American Identity," 196.

17. Andrea Phillips, "Walking into Trouble: Ethics and Aesthetics in the Contemporary Pedestrian," paper presented at the "Walking as Knowing as Making" symposium, April 2005, University of Illinois, Urbana-Champaign. Thanks to Nicholas Brown and Kevin Hamilton for organizing this protracted symposium.

18. Roth, "A Family of Women?" 72–73. Roth's article drew on a taped conversation between London and Lacy about their collaboration. Julia London suggested the topic of survival: "How are women managing now? How did their mothers and grandmothers get by?" Lacy funded the project, which cost $6,000. London wanted acknowledgment as an organizer; Lacy thought of it as "my art," and the credit in the media coverage often went only to Lacy.

19. Lacy, "Speak Easy [originally called "Seam"]." Other women pictured in Lacy's article included Carol Szego and Jan Chattler. Carol Leigh had been active in the Bay Area since the late 1970s. She wrote and performed satire based on her experiences in massage parlors in San Francisco, was a spokesperson for COYOTE, founded BAY SWAN (Bay Area Sex Workers Advocacy Network), and organized among sex workers about AIDS prevention and decriminalizing prostitution. *Unrepentant Whore: The Collected Work of Scarlot Harlot* came out in 2004. http://

www/bayswan.org. Joya Cory cofounded MOTION: The Women's Performing Collective in 1971, and she also directed "The Adventures of Scarlot Harlot."

20. Roth, "A Family of Women?" 73.

21. Kelley, *Childsplay*, 144–45; Rorimer, *New Art in the 60s and 70s*, 31; *Pose* was reinvented in various locations around Southern California during the retrospective of Allan Kaprow's work at the Geffen Contemporary of the Museum of Contemporary Art in Los Angeles in 2008; http://www.moca.org/kaprow/index.php/category/pose/.

22. A failure of the piece was that two hundred of six hundred audience members in attendance never got inside after waiting for a long time.

23. Roth, "A Family of Women?" 72. Lacy told Roth, "The idea of these wonderful women revealing themselves in such a commercial and conventional setting is beginning to obsess me."

24. Bevacqua, *Rape on the Public Agenda*, 30.

25. A twenty-minute video, *Sofa*, was directed by Lacy, with Douglas Gayeton Smith and Steven Hirsh, director of photography. It was completed in 1984. *Freeze Frame* has sometimes been confused with this video made about it. See Sayre, *The Object of Performance*, 101.

26. Roth, "Interview with Suzanne Lacy," 39.

27. Suzanne Lacy, San Francisco International Theater Festival press release, n.p, no date. In 1976, Lynn Hershman had created twenty-six window installations at another commercial establishment, the Bonwit Teller department store in New York City. People and mannequins created tableaux for a week. See Roth, "Toward a History of California Performance: Part One," 102.

28. At the beginning of the 1980s, Lacy had come across a 1915 book by Ralph Davol, *Handbook of American Pageantry*, illustrated with photographs of civic pageants across the United States (Taunton, Mass.: Ralph Davol, 1915). Civic pageants flourished among reformers at the turn of the twentieth century, framing images in a landscape or an architectural setting for "civic uplift," literally to embody social, moral, religious, or political views. For more on the civic theater movement, see Glassberg, *American Historical Pageantry*; Blair, "Pageantry for Women's Rights," 34; see also Irish, "Shadows in the Garden," 98–115.

29. Sims, "Aspects of Performance in the Work of Black American Women Artists," 210.

30. Bhabha, "Conversational Art," 38–47.

31. Ibid., 40–41.

32. Ibid., 41–42.

33. Typescript, March 9, 1983, Lacy, personal collection.

34. Faith Wilding, Leslie Labowitz, and Barbara T. Smith staged a hunger strike in New Orleans during the conference. Lee Anne Miller, Mary Jane Jacob, Barbara Price, Ruth Weisberg, and Lacy teamed up to design many WCA offerings. The WCA exhibition in New Orleans, "A Decade of Women's Performance Art," curated by Mary Jane Jacob, featured thirty-seven artists or groups and resulted in the publication of *The Amazing Decade* in 1983, expanded and edited by Moira Roth. Lacy, as "conference performance designer," worked with local women to produce mock postcards set in various parts of the city, demonstrating "alternate sources of food

and how to prepare it." In one of these parodies of tourist views, for example, Lacy is shown with Laverne Dunn of New Orleans, cooking on the sidewalk. These post-cards were then shared with WCA conferees. Mary Jane Jacob, introduction to *The Amazing Decade*, ed. Roth, 11. Sharon Litwin, "When Protest Is a Picnic," *Times-Picayune*[?], Lacy, personal collection; Lacy, "The Battle of New Orleans."

35. The U.S. Mint, a National Historic Landmark, has been the Louisiana State Museum since 1981. William Strickland was the architect of the stuccoed brick structure with granite trim.

36. *River Meetings* was conceptually related to Judy Chicago's *The Dinner Party*, which had been exhibited in San Francisco in 1979 and had been the focus of Lacy's *International Dinner Party* at that time. Chicago and her collaborators, like Lacy and her collaborators, lifted overlooked women and their stories into public awareness. Publicity material, Lacy, personal collection. The twelve women were Juanita Gonzales, Pokey McIlhenny, Sarah Tew Mayo, Alice Dunbar Nelson, Elizabeth Lyle Saxon, Sarah McWilliams Walker, Baroness Micaela Almonaster de Pontalba, Henriette DeLille, Myra Clarke Gaines, Margaret Haughery, Zora Neale Hurston, and Marie Laveau. The historians for the project included Diana and Al Rose, Christine Halloran, Mery Gehman, Peg Murison, and Mildred Fossier.

37. Lacy, "The Forest and the Trees," 62–63.

38. The planning committee included Lacy, Andrea Alvarez, Betty Brown, Joan Hugo, Irene Levinson, Victoria Lewis, Carole Martin, Sucheta Mazumdar, Joyce Wexler Ballard, Carson Wiley, Sue Stamberger, Amy Goldman, and Kiki MacInnis. Other organizers were Karen Allen, Lois Red Elk, Dorace Deigh, Lois Tandy, Rosemary Weiner, Yen Lu Wong, and Cecilia Casey. Judy Williams was the press contact. Many women from the Woman's Building were also involved. Lacy restaged *Immigrants and Survivors* at the Museum of Contemporary Art in Los Angeles in 2007 with two hundred working-class women, *Stories of Work and Survival*. Together with UCLA's Center for Labor, Lacy convened dialogues in April 2007 at MOCA's Geffen with fifteen diverse groups of working women; this series culminated in a Lacy-organized public dinner for hundreds of people in June 2007.

39. Grant proposal narrative, Lacy, personal collection. "Their discussions serve as the source material for their events which have included (1) formation of the group called 'Women of Watts' (2) sponsorship of a tea to honor senior residents of Guy Miller Homes . . . (3) sponsorship of a potluck dinner/performance for 50 women from the community on the theme of honoring women who have been models for survival (4) trips including a tour of the Black Folk Art show [at the Craft and Folk Art Museum]. . . ."

40. Paraphrasing Sucheta Mazumdar in press release, Lacy, personal collection.

41. Betty Ann Brown, ed., *Expanding Circles*, 158.

42. Cheng, *In Other Los Angeleses*, 122.

43. Artists like Lee Mingwei in his *Dining Project* (1998–2005) have continued these sort of art-based interactions. Lee prepares a meal for one volunteer chosen by lottery and then eats with them in a gallery after hours. Lee tape-records their dinner conversation. Artist Rirkrit Tiravanija also cooks for and dines with others in a gallery setting.

44. Roth, "Interview with Suzanne Lacy," 42–43. See also Irish, "Shadows in the

Garden," 98–115. Thanks to Dianne Harris for so ably editing the special issue of *Landscape Journal*. Also thanks to the University of Wisconsin Press for permission to use portions of that article here.

45. See Cheng, *In Other Los Angeleses*, 123–25.

46. Lacy, "In the Shadows," 65.

47. One of the performers in *The Dark Madonna*, May Sun, had created her own response to racism in October 1984 at the Woman's Building: *Running Dog/Paper Tiger*. May Sun, interview with author, January 24, 2005, Los Angeles.

48. Of the seventy-two sculptures listed as on display in 2000, five were by women, five were by nonwhite men, and sixty-two were by male sculptors classified as white. See "Franklin Murphy Sculpture Garden Images," 1997–98, by Ruth Wallach, http://www.publicartinla.com/UCLAArt/ (accessed January 17, 2009).

49. Roth, "Interview with Suzanne Lacy," 43.

50. Lacy, "In the Shadows," 69. I have written elsewhere about the problematic use of the "dark Madonna" theme and its Jungian analog "the dark feminine" in this Los Angeles work; see Irish, "Shadows in the Garden."

51. Rich, "Disloyal to Civilization," 280–81. Rich noted the intertwining of slavery and patriarchy, while not absolving white women who were "active and passive instruments" of systemic racism: "[S]lavery and segregation were not conditions peculiar only to institutionalized racism, but dominant practices of patriarchy" (282–83).

52. Berg, *The Remembered Gate*. Rich, "Disloyal to Civilization," commented, though, that Berg does not label the activists "white" (286).

53. Lacy and Lippard, "Political Performance Art," 25; see also Raven, "Commemoration."

54. Rich, "Disloyal to Civilization," 287; emphasis in the original. See also Sondra Hale and Michelle Moravec, "At Home at the Woman's Building," in *From Site to Vision*, ed. Hale and Wolverton, 146. "[T]he claims of 'community' expounded by Woman's Building founders, staff and denizens set forth a tension that was to plague the house."

55. See Cheng, *In Other Los Angeleses*, 122–24. Also I am grateful to Lacy for her lengthy telephone call responding to my article on *The Dark Madonna* (Irish, "Shadows in the Garden"). Prior to that telephone conversation, I had not known about the roles of the Rich essay or of Mitoma. Lacy, telephone conversation with author, July 14, 2007.

56. Friedman, *Mappings*, 37.

57. Roth, "Interview with Suzanne Lacy," 44–45.

58. Rich, "Disloyal to Civilization," 304.

59. This letter was one of nineteen responses to Lacy's post-performance questionnaire in which she asked about participants' overall impressions, the meaning of the Dark Madonna in daily life, and what stayed with people after the performance. The signature on this letter is illegible, but it is dated July 11, 1986. Lacy, personal collection.

60. Lacy mentioned Maya Deren (1917–61) as a source for *In Mourning and in Rage* in several interviews with me. Linking *Ritual in Transfigured Time* to *The Dark*

Madonna is my own interpretation. See Franko, "Aesthetic Agencies in Flux"; Sitney, *Visionary Film*. Thanks to Robert Cagle for help with Deren bibliography.

61. Franko, "Aesthetic Agencies in Flux," 141.

62. Deren filmed this sequence in Yonkers, New York, in the "Grecian Garden" of the Samuel Untermeyer estate.

63. Cheng, *In Other Los Angeleses*, 127–28.

64. The institutions involved in *Whisper Minnesota* included the Minnesota Board on Aging (Elva Walker, chair; part of the National Council on Aging), the Gerontological Society of America, the Reflective Leadership Program of the Hubert Humphrey Institute on Public Affairs (directed by Sharon Roe Anderson), the Walker Art Center, the Minneapolis College of Art and Design, Carleton College, the Center for Art Criticism, and the University of Minnesota. The Wilder Foundation conducted a retreat for over fifty people to reflect on issues relevant to women and aging. Film in the Cities and the All University Council on Aging organized related events. A film made by Kathleen Laughlin of the Lacy-directed 1984 performance in San Diego *Whisper, the Waves, the Wind* was premiered in Minneapolis and also served to publicize the Minnesota project.

65. Mary Abbe Martin, "'Whisper Project' Designed to Celebrate Start of 'Golden Years,'" *Minneapolis Star Tribune*, October 24, 1986, 1C. Lacy dedicated *The Crystal Quilt* to her own mother, Betty Little Lacy. Betty Lacy died in October 2008.

66. Miriam Schapiro (born 1923) had been at CalArts in the early 1970s when Lacy was a student there. She returned to New York City in 1975. See also Gouma-Peterson, *Miriam Schapiro*. Sage Fuller Cowles is a Minneapolis-based choreographer and arts patron.

67. Some of the participants felt that dressing uniformly in black, as Lacy and Schapiro wanted them to do, was mournful; instead they wanted to focus on leadership and strength. Lacy and Schapiro felt, however, that a black ground "was the only 'color' that could 'hold down' the complex and chaotic space, and bring it together into a unified stage." The group eventually agreed that the women would dress in black—representing dignity—but instead of forming a processional into the space, reminiscent of a funeral, the women entered in groups of four from the perimeter of the seating area. "[T]he performers would never be seen apart from the quilt background"; Betty Brown, *Expanding Circles*, 178–79.

68. Koelsch, "The Crystal Quilt," 31.

69. The Minnesota Quilters Association made a version of Schapiro's drawing into a quilt for display.

70. Lacy talked about this "coalition of 'othered' people" as including lesbians, prostitutes, those who were raped, and versions of the older woman, such as crones and witches. Lacy, telephone conversation with author, January 16, 2009.

71. Cheng, *In Other Los Angeleses*, 109–11. Previous performances by Lacy where she enacted the role of an older woman included *Inevitable Associations* (1976), *Edna, May Victor, Mary and Me: An All Night Benediction* (1976), *The Bag Lady* (1977, 1978), *The Lady and the Lamb, or the Goat and the Hag* (1978), and *The Vigil* (1978).

72. KTCA, Channel 2, Emily Goldberg, producer.

73. Rothenberg, "Social Art/Social Action," 65.

74. The feminist theater group At the Foot of the Mountain used their 1986 comic play by Marilyn Severn, *Ladies Who Lunch,* as a tool to recruit participants for *The Crystal Quilt* and as a springboard for discussion, performing before audiences all around Minnesota. On At the Foot of the Mountain, see Harding and Rosenthal, eds., *Restaging the Sixties*; and Greeley, "Whatever Happened to the Cultural Feminists?" The artistic director of At the Foot of the Mountain, Phyllis Jane Rose, also served as associate director of *The Crystal Quilt.* Performing Arts Archives, University of Minnesota, Minneapolis; Rothenberg, "Social Art/Social Action," 68. Over a dozen artists contributed to the project, as did the Minnesota Quilters Association. Sound composer Leif Brush and photographer Gloria DeFilips Brush worked on a photographic collaboration called *The Season's Project* in Duluth: portraits of Minnesota women in a natural setting showed the changing seasons. (Other tableaux had been proposed for elsewhere, but plans were scaled back.) Film and video makers, photographers, graphic designers, and textile artists brought their skills in to the process, as did people interested in written documentation of the work as poets, critics, anthropologists, and historians. A San Diego performance artist, Sharon Allen (who had also worked on *Whisper, the Waves, the Wind*), New York theater director Arthur Strimling, and quilters Jeannie Spears and Judy Peterson were among them. Two photographic exhibitions were sponsored by banks, and at least two videos were produced. Potlucks and speaking engagements were also used to bring in participants. Art exhibits, dance performances (including the Liz Lerman Dance Exchange), internships, radio broadcasts, and conferences further leveraged the impact of Lacy's project. There were fifteen administrative positions, of which seven were paid; three of the seven were older women. Several weeks prior to the performance, there were forty-seven short-term key positions, with twenty-seven paid, and of those, four were older women.

75. *Whisper, the Waves, the Wind* began in April 1983 with Lacy's residency at the Center for Music Experiment in San Diego. Lacy taught performance at the University of California at San Diego in 1976, 1977, and 1979. See Rothenberg, "Social Art/Social Action," 61–70.

76. Lacy and Lippard, "Political Performance Art," 24. See also Roberta Smith, "An Ode to Old Age, Life's Gift," *New York Times,* July 16, 1999, B32. Smith described *Whisper, the Waves, the Wind* as having a "thrown together feel," as "a living Christo with Felliniesque undertones." The assistant director was Sharon Allen. There were twenty-six women on the north beach, eighteen women on the south.

77. This beach, called "The Children's Pool," has been overtaken by seals for quite some time; Randal C. Archibold, "Cute, Stinky and Beached, Seals Cause a Squabble," *New York Times,* July 31, 2006, A31. One possible inspiration for the beach setting is Tadeusz Kantor's 1967 *Panoramic Sea Happening*, performed two years after Kantor met Kaprow in New York. See Kristine Stiles, "Uncorrupted Joy," in *Out of Actions,* by Schimmel, 311.

78. A number of these women from the leadership seminar were profiled in publicity leading up to *The Crystal Quilt*: Avis Foley, an organizer of the Political Congress of Black Women; Etta Furlow, an African American community activist, former factory worker, and nurse; Frances Keahna, one of the founders of the Tribal Com-

munity Council; Margaret Pederson, a daughter of white missionaries who worked as a patient advocate in a hospital; Agnes Reick, a white woman who grew up in a rural area near Eau Claire, Wisconsin; Bea Swanson, an Ojibwa woman from the White Earth reservation who worked with a soup kitchen; and Muriel Vaughn, a former nun of Irish ancestry. Segments about these women were included in the public television broadcast of *The Crystal Quilt* performance. See also Basting, *The Stages of Age*, 119; Von Blon, "Leadership Seminar Expands Awareness of Older Women's Roles," 10–12. Thanks to Sharon Roe Anderson for use of her personal collection.

79. Lippard, "Lacy," 75.

80. Roth, "Suzanne Lacy," 49.

81. Rothenberg, "Social Art/Social Action," 61, 62.

82. Fisher, "Interperformance," 28.

83. Christo (born 1935, Christo Vladimirov Javacheff) and Jeanne-Claude (1935–2009, Jeanne-Claude Denat de Guillebon) have worked internationally with private landowners, municipalities, transportation authorities, and media to arrive at their temporary installations. The discussions, the hearings, the interactions that lead up to the culminating image are "integral, aesthetic element[s] of the work"; Becker, "Conversing with Christo and Jeanne-Claude," 27. Lacy and Susan Leibovitz Steinman included Christo in "Compendium," in *Mapping the Terrain*, ed. Lacy, 211–12. Large in scale, projects by Christo and Jeanne-Claude involved long-term organizing among varied constituencies, careful site selection, insightful use of mass media, and a use of bodies in ways that inspired and resembled the work of the younger Lacy, which she has readily acknowledged.

84. Established in 1984, the Grandparents Living Theater is now called the Senior Repertory of Ohio. See www.sro-theatre.org.

85. Basting, *Stages of Age*, 118–20; see also www.glt-theatre.org.

86. Rothenberg, "Social Art/Social Action," 62.

87. Basting cited María Lugones, "Purity, Impurity, and Separation," *Signs* 19, 2 (1994), 463, regarding the temporal density of Lacy's piece: " . . . [T]he older women in 'The Crystal Quilt' stand as symbols of the complexity and potential of thickness, of imagining the present past as 'thick'"; Basting, *Stages of Age*, 131.

88. Steinem, *A Revolution from Within*, 191. Thanks to Bea Nettles for telling me about this book.

89. I appreciate feedback from the UIUC Critical Spatial Practices reading group on my paper "Convergence: The IDS Center and 'The Crystal Quilt' Project," subsequently presented February 9, 2007, at the Fifth Savannah Symposium, "Building in the Public Realm," Savannah, Georgia.

90. Writing of the IDS Center at the time of Johnson's death in 2005, critic Paul Goldberger noted that the Minneapolis skyscraper marked "the beginnings of [Johnson's] late career as a major commercial architect. . . ." Goldberger called the IDS tower "the first of a generation of what might be called social skyscrapers: towers that did not merely house office workers but also contained myriad public spaces"; "Philip Johnson Is Dead at 98; Architecture's Restless Intellect," *New York Times*, January 27, 2005. Cenzatti and Crawford labeled atria like that in the IDS Center "quasi-public"; "Spazi pubblici e mondi paralleli," 120. See also Kent, "Inside the Liveable City"; Bednar, *The New Atrium*.

91. The exterior "funnels" enlarged the public spaces outside of the building, at the same time they redefined the building's base "as an enlarged entrance where the building instead of expanding outward is perforated and opened up"; Canty, "Evaluation," 54; see also blueprints at the Northwest Architectural Archives, University of Minnesota, Minneapolis. The structural engineers were Severud, Perrone, Sturn, Conlin, Bandel, with mechanical engineers Cosentini Associates; and the contractor was the Turner Construction Co. Diana Agrest noted that "the building is infiltrated by the irresistible forces of the city . . . "; Agrest, "Architectural Anagrams," 96, 100.

92. Baker saw movement as having commercial value. Architect Philip Johnson claimed that "IDS was the eye-opener for urban statements that could still be connected with the profit system. We could get to the heart of a city—unlike museums—and affect the lives of millions. . . . And we could make a building that from 100 miles away was a symbol of the town, at the same time that we could make a gathering place like an old fashioned market. It was the turning point of our work"; Dean, "Conversations," 48–49.

93. On those who share the costs of technologies without sharing the benefits, see Staudenmaier, "The Politics of Successful Technologies," 151. Thanks to John Staudenmaier for conversations about this topic and for sending me his article.

94. Jane Rendell, Barbara Penner, and Iain Borden phrased this idea well: "The experience, perception, use, appropriation and occupation of architecture need to be considered in two ways: first, as the temporal activity which takes place after the 'completion' of the building, and which fundamentally alters the meaning of architecture, displacing it away from the architect and builder, towards the active user; second, as the re-conceptualisation of architectural production, such that different activities reproduce different architectures over time and space. By recognising that architecture is constituted through its occupation, and that experiential aspects of the occupation of architecture are important in the construction of identity, such work intersects feminist concerns with aspects of 'the personal,' the subject and subjectivity"; Rendell, Penner, and Borden, "Editors' General Introduction," in *Gender Space Architecture*, ed. Rendell, Penner, and Borden, 10; see also Jonathan Hill, *Occupying Architecture*.

95. Lacy, "Unfinished Work," 22.

96. Massey, *For Space*, 9.

5. We Make the City, the City Makes Us

This title is a twist on Lacy's comment that "[w]e make the art and the art makes us"; Lacy, "Having It Good," 111.

1. Roth, "Interview with Suzanne Lacy," 30.

2. Lacy, "Wrestling the Beast," 15.

3. *City Sites* began in the same year that Richard Serra's *Tilted Arc* sculpture was removed from Federal Plaza in New York City (after a lengthy legal battle). The issues involved in *City Sites* were explored in print by many of the participants, then gathered into what became Lacy's edited book *Mapping the Terrain*.

4. Ibid., 15.

5. Camnitzer, Farver, and Weiss, eds., *Global Conceptualism*, viii.

6. hooks, *Yearning*, quoted in Soja, *Thirdspace*, 84–85.

7. Hooper, "The Poem of Male Desires," 108.

8. Ibid., 109.

9. Lefebvre, *The Production of Space*, 137, quoted in Kohn, *Radical Space*, 4.

10. Rendell, "'Places Between.'" Rebecca Schneider articulated a related idea, put in terms of performance studies: "The notion of 'performance,' when attentive to the reality effects of performativity, bears well the complexities of complicity. Performance implies always an audience/performer or ritual participant relationship—a reciprocity, a practice in the constructions of cultural reality relative to its effects. As such the study of performance and the trope of performativity have become integral to a cultural critical analysis which wants to explore the dynamic two-way street, the 'space between' self and others, subjects and objects, masters and slaves, or any system of social signification"; Schneider, *The Explicit Body in Performance*, 2.

11. Self, "'To Plan Our Liberation,'" 788, n. 4; also Self, *American Babylon*, 17–18.

12. Lacy, introduction to *Mapping the Terrain*, 19–20.

13. *Full Circle* sketchbook, unpaginated, Suzanne Lacy, personal collection; Kevin Gibson to Ronald Pinkowski, May 20, 1993, memo on sculpture placement, Item 53-19, "Culture in Action" Archive, Center for Curatorial Studies, Bard College, Annandale-on-Hudson, New York; hereafter cited as CCS/Bard.

14. "Planning Update: Hand to Hand," January 28, 1993, draft for internal use by Full Circle subcommittee, Item 47-03, CCS/Bard. Chicago designer and artist Ted Stanuga and Lacy walked the Loop, choosing placements; Leslie Becker designed the plaques that were affixed to the boulders.

15. On Matta-Clark, see, for example, Diserens, ed., *Gordon Matta-Clark*. Thanks to Ryan Griffis for reminding me of the source for "nonument."

16. I discussed this part of *Full Circle* at the "Exploring Jane Addams" conference at the University of Dayton, Dayton, Ohio, on November 9, 2002: "Rocking Chicago in Service to Women: Suzanne Lacy's 'Full Circle' Project." Thanks to Marilyn Fischer for the invitation to speak. Lacy asked in 1994: "[Should I] simply go into a shelter or center in Chicago and spend a week, morning til night, helping? The personal/aesthetic need did not get resolved in part because of my own questions about the efficacy or appropriateness of this action in real world terms. I don't think I have any illusions that this act, especially given its duration, would be of more meaning to me than to an organization. . . . But the impulse remained . . . and its elusive nature—what does make Mother Teresa do her work?—is what I searched for in this work. I don't think I found the answer. "Full Circle—Draft of Issues," June 22, 1994, 7, Lacy, personal collection.

17. A dinner performance at Hull-House Museum included an invited group of international leaders: Magdalena Abakanowicz, Cheryl Carolus, Chung Hyun Kyung, Johnnetta Cole, Mirna Cunningham, Nawal El Saadawi, Susan Faludi, Susan Grode, Anita Hill, Dolores Huerta, Devaki Jain, Wilma P. Mankiller, Gloria Steinem, and Addie Wyatt. Jacob, Brenson, and Olson, contributors, *Culture in Action*, 73. A video of the Hull-House dinner, *Dinner at Jane's*, produced and directed by Suzanne Lacy and edited by Michelle Baughan, was premiered November 9, 2002, at the "Exploring Jane Addams" colloquium at the University of Dayton.

18. Jacob, *Places with a Past*.

19. On "Places with a Past" in Charleston, see Michael Brenson, "Visual Arts Join Spoleto Festival USA," *New York Times*, May 27, 1991.

20. Robert E. Haywood wrote of Allan Kaprow's *Fluids*: "The mapping of these cities [Pasadena and Los Angeles] with giant ice structures also prefigured 'Places with a Past'"; Haywood, "Revolution of the Ordinary," 12.

21. Lacy to Mary Jane Jacob, July 29, 1992, Item 37-22, CCS/Bard; also Lacy to Dorothy Dizer Davis, Arts International, August 27, 1992, Item 37-26, CCS/Bard.

22. Presentation to Board [of Sculpture Chicago], October 18, 1992, Item 36-06, CCS/Bard.

23. Lynn Scherr and Jurate Kazickas, "Put More Women on a Pedestal," *New York Times*, June 14, 1993. In the early 1990s, Chicago was negotiating with artist Louise Bourgeois to make the first sculpture in Chicago to honor a nonmythical woman, in this case, Jane Addams. Bourgeois's work, *The Touch of Jane Addams*, was located near Navy Pier and dedicated in 1996.

24. The literature on Jane Addams is vast. In addition to Addams's own writings, good sources include Brown, *The Education of Jane Addams*; Knight, *Citizen*; Seigfried, *Pragmatism and Feminism*; and Spain, *How Women Saved the City*.

25. "Culture in Action Narrative, Full Circle Project," June 20, 1994, n.p., Lacy, personal collection.

26. Sources on Chicago nineteenth-century commercial architecture include Daniel Bluestone, *Constructing Chicago* (New Haven, Conn.: Yale University Press, 1991); Carl Condit, *The Chicago School of Architecture: A History of Commercial and Public Building in the Chicago Area, 1875–1925* (Chicago: University of Chicago Press, 1964); Sharon Irish, "Preservation, Polemics and Power," *Technology and Culture* 49: 1 (January 2008): 202–14; Joanna Merwood-Salisbury, *Chicago 1890: The Skyscraper and the Modern City* (Chicago: University of Chicago Press, 2009); David Van Zanten, *Sullivan's City: The Meaning of Ornament for Louis Sullivan* (New York: W. W. Norton, 2000); and John Zukowsky, ed., *Chicago Architecture, 1872–1922: Birth of a Metropolis* (Munich: Prestel-Verlag, 1987). Crucial for the site of the Daley Center is Ross Miller, "City Hall and the Architecture of Power."

27. Sophia Hayden was the first woman to receive an architecture degree from the Massachusetts Institute of Technology, in 1890. The Board of Lady Managers, headed by Bertha Honoré Palmer, sponsored a competition to select the building's architect. While Hayden's Beaux-Arts design was not remarkable, the idea of a Woman's Building was innovative. Women carried out all aspects of the project. The interior murals were by Mary Cassatt, for example. Elliott, ed., *Art and Handicraft in the Woman's Building of the World's Columbian Exposition*; see also Wolverton, introduction to *From Site to Vision*.

28. Hayden, *The Grand Domestic Revolution*, 162.

29. Spain, *How Women Saved the City*, 26.

30. Hayden, *The Grand Domestic Revolution*, 164, quoting Lerner, "Placing Women in History: Definitions and Challenges," *Feminist Studies* 3 (Fall 1975): 6.

31. Lacy's *Full Circle* was funny in the way that comic artist and honoree Nicole Hollander is funny: http://www.nicolehollander.com/.

32. Jacob, Brenson, and Olson, contributors, *Culture in Action*, 71.

33. The first phrase is from Michael Kimmelman, "Of Candy Bars and Public Art," *New York Times,* September 26, 1993; the next two words are from Lori Rotenberk, "Notable Women Take Rocky Road to New Tribute," *Chicago Sun-Times,* May 20, 1993.

34. "Steering Committee Members," Items 46-09 and 46-20, CCS/Bard.

35. Item 44-03, CCS/Bard.

36. The honorees from history were Jane Addams, Catherine DuSable, Lupe Perez Marshall Gallardo, Ellen Henrotin, Harriet Monroe, Agnes Nestor, Lucy Parsons, Hannah Greenebaum Solomon, Ida B. Wells, and Frances Willard.

37. Robert Davis, "Project Honoring 100 Women will 'Rock' City's Downtown," *Chicago Tribune,* April 20, 1993.

38. Correspondence, Amina Dickerson to John Steele, May 6, 1993, Item 34–13, CCS/Bard; emphasis in original. Quoted by permission of Amina Dickerson.

39. Some objected to the physical obstacles of the boulders. The Johnston County [Oklahoma] *Capital-Democrat* (published near the limestone quarry that supplied the rocks) queried: "Can you imagine the thoughts of all those Yankees stumbling around those rocks going to work?" Glenda Day, "Bromide Limestone Being Shipped to Chicago Sculptor," Johnston County [Okla.] *Capital-Democrat,* April 15, 1993, Item 53-18, CCS/Bard; at least three people complained to Sculpture Chicago after painful encounters with boulders, Items 54-02, 54-03, 54-07, CCS/Bard.

40. See, for example, Steve Neal, "'Rock Garden' Shuns Notable Women," *Chicago Sun-Times,* October 1, 1993.

41. The committee member also worried that others would be "worn out" and that the project was "too labor intensive, too expensive, so massive [and] out of balance with other artists' projects"; notes on conversation with committee member, March 4, 1993, Item 41-20, CCS/Bard.

42. Taylor, "The Politics of Recognition," 25–73. Thanks to the anonymous reviewer for the *Journal of Architectural Education* who alerted me to this essay.

43. Ibid., 51.

44. Claire Wolf Krantz, for example, wrote this of the whole "Culture in Action" process: Since the "structure determine[d] that the artists and sponsoring institutions derive[d] a good portion of the benefits, in terms of monetary reward and/or career development, it is important to be clear about what other kinds of value the art will bring to the community"; Krantz, "Art's Chicago Public/Part Two," 3 (accessed online June 23, 2005). Another critical response: Gamble, "Reframing a Movement."

45. Kwon, *One Place after Another,* 118.

46. Gayatri Spivak coined "strategic essentialism" to label the process by which a group of people used their marginalized social position consciously and strategically to achieve their political goals. The term has been widely adopted since the late 1980s. Spivak, *In Other Worlds.*

47. Jacob, "Full Circle," in Jacob, Brenson, and Olson, contributors, *Culture in Action,* 69.

48. Lacy, "Having It Good," 100.

49. Rogoff, "Looking Away," 119.

50. "Full Circle—Draft of Issues," June 22, 1994, 7, Lacy, personal collection.

51. Jacob, "Full Circle," in Jacob, Brenson, and Olson, contributors, *Culture in Action*, 64.

52. Edward Soja's term "socio-spatial dialectic" emphasizes the ways in which space shapes people at the same time that people shape space. Soja, *Postmetropolis*, 8, 69.

53. Rendell, "'Places Between.'"

54. Rendell, "Travelling the Distance/Encountering the Other" (accessed April 2005).

55. As I have previously noted, these categorizations are crude but at least acknowledge some positionalities of the honored women.

56. Kwon, *One Place after Another*, 108.

57. Ibid., 109. I agree with much of what Kwon wrote in her intelligent book about the problems of "community."

58. Betty Blum, "Oral History of Jacques Brownson," Art Institute of Chicago Department of Architecture, Chicago Architects Oral History Project, 1994, 195 (accessed November 2004), http://www.artic.edu/aic/libraries/caohp/brownson.html.

The other firms were Skidmore, Owings and Merrill, and Loebl Schlossman and Bennett. According to Carter Manny, John Burgee Jr. was project manager with Jacques Brownson on the civic center. See Franz Schulze, "Oral History of Carter Manny," Art Institute of Chicago Department of Architecture, Chicago Architects Oral History Project, 332.

59. Blum, "Oral History of Jacques Brownson," 174–75.

60. Ibid., 196–97.

61. Frenchman, "Event-Places in North America," 39, 37, 40–42.

62. Rendell, "Women in Architecture," 22.

63. Borden and Rendell, *Strangely Familiar*, xx.

64. "There is a two-way linkage which could be defined as an *interface*," wrote Elizabeth Grosz about bodies and cities, "perhaps even a cobuilding"; Grosz, "Bodies-Cities," 248. While I agree with the two-way linkage, I find the connotation of "cobuilding" to be too fixed.

65. Bhabha, "Conversational Art," 41–42. A felicitous extension of *Full Circle* occurred when Chinese artist Zheng Bo painted *Chicago Impression*, a large oil-on-panel (1994), in the international terminal of Chicago's O'Hare Airport. Part of the International Mural Project, the panel shows people walking through Grant Park with one woman turning to study a *Full Circle* boulder. Gray, *A Guide to Chicago's Murals*, 339.

66. "[P]laces—buildings, neighborhoods, cities, nations—are not simply bricks and mortar that provide us shelter. Because we dance in a ballroom, have a parade in a street, make love in a bedroom, and prepare a feast in a kitchen, each of these places becomes imbued with sounds, smells, noises, and feelings of those moments and how we lived them." Fullilove, *Root Shock*, 10.

67. Massey, *For Space*, 9.

6. Turning Point

1. Lippard, "Some of Her Own Medicine," 71. Lippard continued: "Her childhood vampire dreams and the early pieces in which she sported a pair of fangs are

not inapplicable to this assimilation of other women's power as they 'help themselves' to (or with) her power" (74).

2. Degen, DeSilvey, and Rose, "Experiencing Visualities in Designed Urban Environments," 1909, 1912.

3. In theatrical terms, Lacy has noted the influence on her of Open Theater, a leading avant-garde ensemble founded in 1963 by Joseph Chaikin (1935–2003) and Peter Feldman. See, for example, Gordon Rogoff et al., "Remembering Joseph Chaikin." It seems that younger artists (born after 1975, say) now recognize in their own visual art practices her pioneering contributions.

4. Susan Gordon and Joslin Kobylka, interview with author, February 18, 2004, Vancouver, B.C.

5. "The Turning Point Overview and Mission," 1995, 1, quoted by Miller, "Constructing Voices," xxi. Thanks to Barb Clausen for telling me about this dissertation.

6. Barb Clausen, telephone interview with author, January 14, 2004.

7. Susan Gordon, interview with author, February 18, 2004. In other words, the painting of a mural, for example, should follow identification of an issue and development of a vision.

8. This steering committee had a "commitment to diversity that we didn't manifest," in that they were all Anglo-Canadian, according to Susan Gordon, interview with author, February 18, 2004. The larger planning group included two from the Social Planning Department, one from the Vancouver Office of Cultural Affairs, three from the Vancouver Board of Parks and Recreation, two independent artists, one from the Vancouver Art Gallery and the Vancouver School Board. Carrie Nimmo, a local artist, helped develop questions for discussion; Bev Matsu was the public relations director; Jan Miller (who worked with CKNW radio, the Vancouver *Sun* and UTV) was in charge of sponsor relations; Mavis Dixon and Shari Graydon focused on the young women and media education; Pilar Riaño-Alcalá worked with the young women early on. Darlene Haber, a local freelance video producer, completed the video documentary in 1998; artists involved included Gwen Boyle, Skai Fowler, and Jan Berman.

9. Alix Sales, interview with author, February 18, 2004, Vancouver, B.C.

10. Suzanne Lacy, "Turning Point: Work Plan Summary Narrative Draft," December 14, 1996, Lacy, personal collection, 4. Orenstein, *School Girls*; and Pipher, *Reviving Ophelia*. Both these books present rather skewed portraits of young women, focusing on the pathological. See also Giroux, "What Comes between Kids and Their Calvins."

11. Lacy noted that linguistic anthropologist Shirley Brice Heath at Stanford was very influential to her own work. See, for example, Heath and McLaughlin, eds., *Identity and Inner-City Youth*. Also the funding priorities of the Nathan Cummings Foundation and the Surdna Foundation at that time included the arts and youth development.

12. They met at Camp Alexandra, Crescent Beach (White Rock), from January 5 to 7, 1996.

13. The media literacy sessions were led initially by Sherry Bie and Susan Rome at the Vancouver Art Gallery. Bie and Rome left the project early on. Shari Graydon then continued at the Emily Carr Institute of Art and Design.

14. Miller, "Constructing Voices," quoted Barb Clausen, 122: "[T]he zine . . . was not Suzanne's idea, and it was the young women's idea and it was encouraged and supported by Heather and me and we made sure that it happened."

15. Miller, "Constructing Voices," 98, 166. Kobylka and Gordon thought the *mehndi* idea came from an Ismaili girl who quit early in the project. From a *Turning Point* flier: "The action of hand-painting is an intimate experience for the two people involved—the young women share experiences, stories and ideas which will become the basis of upcoming events. The public witnessing this event becomes audience and, in turn, our intimate action becomes performance"; Lacy, personal collection.

16. Miller, "Constructing Voices," 98.

17. Ibid., 99; handbill dated February 23, 1997, Lacy, personal collection.

18. Miller, "Constructing Voices," 123.

19. Locations for a performance that were considered included the Museum of Anthropology at the University of British Columbia, the Botanical Gardens, City Hall, Commercial Drive, Chinatown, Ford Theatre, Roundhouse Community Center, Seawall by Stanley Park, Woodward's Building, the Lost Lagoon, the Vancouver Central Library, the steps of the classical revival Vancouver Art Gallery, and Queen Elizabeth Park. Ibid., 72–73, 75–76.

20. Lacy, "Turning Point: Work Plan Summary," 3.

21. Barb Clausen, telephone interview with author, January 14, 2004: "Suzanne was *very* committed to the idea of this restricted site." "Although out of 30 girls, only two mentioned use of the construction site." Clausen did not feel that Lacy was sneaky or insincere in her motives. Also, Clausen did not sense great resistance among the girls to the construction site. Miller noted that the girls favored the seawall, Woodward's, or Queen Elizabeth Park; "Constructing Voices," 76.

22. Lacy, telephone conversation with author, January 16, 2009.

23. Lacy, "Turning Point: Work Plan Summary," 19.

24. http://www.city.vancouver.bc.ca/commsvcs/currentplanning/urbandesign/Project6.PDF (accessed April 25, 2005).

25. Clausen, telephone interview with author, January 14, 2004.

26. Lacy, "Turning Point: Work Plan Summary," 2. Lacy reported, "The towers will be glazed up to the twenty-sixth floor or so by May. . . . Towers could be lit, sound could be projected well in the space between the two buildings. . . ."

27. Miller, "Constructing Voices," 176.

28. The Vancouver signage was designed by Will Pritchard of sillyboydesigns.

29. Gerald King was the stage designer.

30. Stuart Davis painted canvases like *Report from Rockport* (1940), which featured bold areas of pink, yellow, and blue with energetic lines and shapes depicting urban furniture and signage. See Kachur, "Stuart Davis's Word-Pictures," 29–40.

31. Suzanne Lacy, "Workplan," May 5, 1997, Lacy, personal collection, 5.

32. Ibid., 6. The video vignettes of girls making images were "meant to symbolize our framing of women's identity."

33. The sound consultant was Jacqui Leggett, and sound engineer, Dieter Piltz.

34. Lacy, "Workplan," 6

35. Ibid., 6. There were supposed to be five hundred participants, so the actual

number fell far short. Lacy hoped that the "girls . . . [would] seem to be whispering the secrets of their lives."

36. Clausen, telephone interview by author, January 14, 2004.

37. Barb Clausen, "Turning Point: A Final Report," August 18, 1998, n.p: "The constraints of the construction site, combined with the aesthetic imperative of the artist that every audience member be able to view an unobstructed visual panorama and hear the accompanying sound track meant that only a very small proportion [a hundred people] of the total audience was able to experience the work as originally conceived." Some VIPs, "whose presence marred the overall visual effect for many of the audience members," watched the whole thing. Three to five hundred people waited in line for over an hour and never got in. Thanks to Barb Clausen for sharing this report with me.

38. While Lacy had hoped for a turnout of five hundred to seven hundred girls, the date in June, after school let out, and time factors resulted in a much lower turnout. Still, Clausen said she and Sherry Bie worked very hard to be inclusive; while they did not have street kids, they had a range of income groups, from a variety of school settings, a couple of First Nation kids, others from foster homes, some Vietnamese working-class girls. Lorrie Miller acknowledged that the turnout for the final performance improved upon earlier participation: "By focusing energy on school recruitment, *Turning Point* excluded those girls and others not in school. As a result, the majority of participants were strong students. . . . they were typically middle-class. However, 'Under Construction,' the final performance of *Turning Point* did include a more diverse socio-economic group of girls (including a small group of young mothers) than did the core group of participating girls"; Miller, "Constructing Voices," 101.

39. Tradeswomen were on-site to work with girls to mix the concrete. In each corner of performance space there was an adult and then five Director Girls working with that adult. Some people were troubled by this hierarchy, which seemed to diminish the girls' directing. One participant reflected, "The idea of getting together and hanging out and being young women together seemed right, but actual practice of it sort of failed. Not entirely, it was good, but was hypocritical [because of directions from older women]"; Miller, "Constructing Voices," 182, 204.

40. "The failure of that piece, I believe, was that we didn't have enough girls to sufficiently create an array of color, a bed of color, within the visual environment"; Lacy, interview with author, February 3, 2001.

41. These are comments from Lacy in a telephone conversation with the author, January 16, 2009.

42. Correspondence, Suzanne Lacy to steering committee members, December 29, 1996, indicated that her brother was having surgery, just prior to her scheduled trip to Vancouver. Philip died in April 1997; Lacy, personal collection.

43. Clausen, telephone interview with author, January 14, 2004.

44. Clausen, "Turning Point: A Final Report."

45. Lacy, telephone conversation with author, January 16, 2009.

46. The project received $5,000 from Social Planning (Joyce Preston, director) to launch the process. Other funders were City of Vancouver, Governments of British Columbia and of Canada, the Vancouver Foundation, the United Way, the VanCity

Community Credit Union, the Vancouver School Board, Vancouver Board of Parks and Recreation, Emily Carr Institute of Art and Design, Opus Framing, Urban Source, Vancouver Art Gallery, and various individuals. The project took longer to come together than was expected. Clausen, telephone interview with author, January 14, 2004.

47. Clausen, "Turning Point: A Final Report."

48. Vancouver has a vibrant cultural life, with considerable municipal and provincial support for the arts, e.g., Creative Communities: http://www.creativecommunities .ca/ (accessed May 5, 2005).

49. Miller, "Constructing Voices," 156, 162.

50. Ibid., 195; italics in original.

51. According to Clausen, Sherry Bie was a very articulate theater person, enthusiastic about supporting a community of young women. She wanted the project to develop more slowly and essentially parted ways with the project and Lacy's vision due to her objections to what she perceived to be manipulation of the young women; Clausen, telephone interview with author, January 14, 2004.

52. Clausen, "Turning Point: A Final Report."

53. Ruth Nicole Brown, *Black Girlhood Celebration,* 3, 35, 49. Brown cites Marnina Gonick's work, "Between 'Girl Power' and 'Reviving Ophelia.'" *NWSA Journal* 18: 2 (2006): 1–23.

54. Suzanne Lacy, interview with author, February 3, 2001, driving to Walnut Creek, California.

55. Ibid.

56. Punter, *The Vancouver Achievement,* 247; italics in original.

57. The Kuok Group is a multinational conglomerate that started in Malaysia and Singapore in the 1950s and 1960s, then expanded to Thailand and Indonesia, then Hong Kong and China in the 1970s and 1980s. Cheng was trained at the University of Washington in Seattle and at Harvard, 1976–78, following a stint in Arthur Erickson's office, 1973–76.

58. Punter, *The Vancouver Achievement,* 247. This solution was one of several that James Cheng Architects refined in the late twentieth century: "slim and highly glazed view-articulated tower, the tower and the townhouse perimeter block or terrace model, [and] low-rise internal street/courtyard for ground-oriented housing"; Punter, *The Vancouver Achievement,* 382. At the west end of the block, at Jervis Street, sits the Harry B. Abbott House (720 Jervis), a residence dating from c. 1900, which holds its own on a hill next to the green-glazed tower. Harry Abbott was first Pacific superintendent of Canadian Pacific Railways. Abbott House was converted to five condominiums as part of the development of this complex. Early on, Lacy thought about using the Abbott House: "In addition, a small wood heritage house is being preserved and will still be in major construction for its siting—this might offer an opportunity for various tableaux of girls, with light, to be viewed from a distance"; Lacy, "Turning Point: Work Plan Summary," 2.

59. "Urban Housing: Family of Four," *Canadian Architect* 44 (August 1999): 25.

60. Li, "Unneighborly Houses or Unwelcome Chinese," 23. Thanks to Professor Li for sending me a copy of his article. Media coverage reflected these concerns, as cited by Li: "[A] reporter . . . wrote in a front-page article, entitled 'Hong Kong con-

nection: How Asian money fuels housing market', that 'prices are being driven up by Asian investors' . . ." (25).

61. Ibid., 17–18.

62. Punter, *The Vancouver Achievement*, xxiv.

7. Teens and Violence

1. National Criminal Justice Reference Service, Office of Juvenile Justice and Delinquency Prevention, citing Oakland Police Department, UCR records, 1998; http://www.ncjrs.gov/html/ojjdp/2000_9_3/fjgv_2.html (accessed August 23, 2008).

2. Charles Garoian examined the philosophical connections of Lacy's "empathic process" by considering writing by Susan Sontag, Arthur Koestler, Martin Buber, and Drew Leder. "Empathy," he noted, "is essential to aesthetic experience because it provides an embodied connection between the artist and the world;" Garoian, *Performing Pedagogy*, 149–50.

3. Rick DelVecchio, "Art for Community's Sake," *San Francisco Chronicle*, August 1, 1999, 4. Artist (of the Sandcrawler collective) and Berkeley graduate in geography, Gan Golan was quoted in this article: "Artists stand precariously in the middle of an ongoing spatial war in America. On the one side are posed the forces of impending gentrification, and on the other side, there are the low-income residents who risk being pushed from neighborhoods in which they have lived and worked for generations. We artists occupy the spatial middle ground in this war. . . ." See also Evelyn Nieves, "Oakland Joins the Bay Area Boom," *New York Times*, August 8, 2000, A12.

4. Self, *American Babylon*, 17.

5. Ryan Tate, "Unlikely Tenants Spur Recovery of Blighted Mall," *San Francisco Business Times*, March 11, 2005, http://www.bizjournals.com/sanfrancisco/stories/2005/03/14/story8.html (accessed July 10, 2006).

6. Thanks to Amelia Marshall for showing me doughnutting sites. The 1973 movie *The Mack* was set in East Oakland, starring Richard Pryor.

7. Self, *American Babylon*, 4.

8. Self, "'To Plan Our Liberation,'"763.

9. Self, *American Babylon*, 150.

10. Self, "'To Plan Our Liberation,'" 768, 770. The Black Panther Party was founded in Oakland in 1966, building on work of the Mississippi Freedom Democratic Party; it was also an early instance of African Americans moving into mainstream politics in the late 1960s. Community–police relations and local politics were two of the main arenas in which the Panthers chose to act in a "complicated fusion of race and geography. . . ." At odds with the Panthers were other African American activists, such as C. L. Dellums, of the Brotherhood of Sleeping Car Porters, and Tarea Hall Pittman, a representative of the National Association for the Advancement of Colored People, who saw the way out of poverty and unemployment in *de*racializing space. Thanks to the UIUC African American Studies and Research Program's conference "Race, Roots and Resistance: Revisiting the Legacies of Black Power," held in Champaign, Illinois, March 29–April 1, 2006, for stimulating my thinking on this. For further information, see Charles E. Jones, ed., *The Black Pan-*

ther Party Reconsidered; Cleaver and Katsiaficas, eds., *Liberation, Imagination, and the Black Panther Party*.

11. Andy Hamner was a drama teacher at Oakland Technical High School, and Lauren Manduke was a choreographer there.

12. Sociologist and writer Todd Gitlin focused on media issues; sociologist Troy Duster was at University of California, Berkeley, for twenty years, writing about race relations, education, and medicine. Herbert R. Kohl was a progressive educator who had worked with Allan Kaprow.

13. Clifton, "Parking Lot Stories," 13; McEver, "When Teens Confide," 20–21.

14. Thanks to Celeste Connor for sharing her unpublished talk "Teenage Living-room" with me. She presented it at the College Art Association annual meeting in 1993.

15. Lippard, "Speaking Up," 94.

16. Project model, 7, Lacy, personal collection.

17. T.E.A.M. projects also involved muralists Pak and Dream, filmmaker Jacques Bronson, the Alameda County Public Health Department, and KRON-TV staff, along with organizations mentioned in the text; Lacy, personal collection.

18. Lacy and Wettrich, "What It Takes," 15–16.

19. Garoian, *Performing Pedagogy*, 129.

20. In 1989, a grand jury indicted a number of Oakland school administrators on corruption charges, and the superintendent resigned, leaving a deficit of $70 million. Then–state assemblyman Elihu Harris took a bill to the state legislature in order to put the Oakland schools under state control.

21. Richard A. Walker, "Oakland: Dark Star in an Expanding Universe," http://geography.berkeley.edu/PeopleHistory/faculty/R_Walker/OaklandDarkStar.pdf (accessed July 7, 2006).

22. Garoian, *Performing Pedagogy*, 137, 128, 156.

23. Lacy, "Wrestling the Beast," 14.

24. Lacy and Wettrich, *What It Takes*, 14. Artists had been "wrestling with" the educational "beast" for quite some time. In 1968–69, Lacy's mentor Allan Kaprow and Herbert Kohl started "Project Other Ways," in Berkeley, which Kaprow wrote about in "Success and Failure When Art Changes" in Lacy, ed., *Mapping the Terrain*. In 1973, the anarchist Colin Ward and journalist Anthony Fyson published *Streetwork*, which aimed to use the whole city as a school. Wettrich and Lacy make the point that "[d]ifferent sites require different goals and establish values and criteria for the art that are often not clearly distinguished by critics"; Lacy and Wettrich, *What It Takes*, 15.

25. Lacy and Wettrich, *What It Takes*, 19.

26. Connor, "Rooftop T.E.A.M.-Building," 34–35; and www.suzannelacy.com. This project was funded by the Surdna Foundation, Nathan Cummings Foundation, and Oakland's Kids First Initiative, among other sources. The title is taken from a popular chant—"The roof is on fire, we don't need no water, let the mother burn"—suggested by Jacques Bronson, one of T.E.A.M.'s adult members. Jacques Bronson presentation with Roth, Lacy, and Holland at Mills College, Oakland, January 27, 2005.

27. A group of young people worked with graphic designers to create *Signs of Violence,* street signs about domestic violence, which were manufactured by CalTrans.

28. *Youth Cops and Videotape* were six videotaped dialogues with twenty youth and police officers, led by Captain Sharon Jones and U.S. Justice Department facilitators.

29. *Expectations* was the name of a summer art class held at the Oakland YWCA in 1997 for thirty-six pregnant teens and teen mothers, of whom thirty-two completed the program. *Expectations* was cosponsored by the Alameda County Office of Education. Unique Holland taught some of the classes and designed the video diaries. For the diaries, the students would talk on camera about a particular topic, from their perceptions about their pregnant bodies to family issues. Others involved besides Lacy and Holland included Leslie Becker, Amana Harris, Lisa Findley, Leuckessia Spencer, and Maxine Wyman. Challenges of that class included providing stipends, child care, and meals for the young women. The organizers wanted to challenge then-Governor Pete Wilson's accusation that societal ills were due to teens having babies outside of marriage. Fifteen teen interns by summer's end organized an exhibit at Capp Street Projects in San Francisco. Architect Lisa Finley designed a huge crib to fill the gallery. To enter the exhibition space, the visitor had to squeeze up against the wall to get past the crib to reach the door.

Once inside the crib-as-gallery, a number of classroom desks were set up in front of a large television screen. On-screen was a recording of Governor Wilson's speech condemning teen mothers; inside the desk units were audio recordings of the summer participants, heard through headphones attached to each desk. The interns also designed and published a poster, did a video news spot, and participated in a symposium for health care policy shapers.

30. *Eye 2 Eye* was a conversational piece with students at Fremont High School.

31. A brief look at Lacy's work with Susan Steinman in Elkhorn City, Kentucky: Stephanie Smith, "Suzanne Lacy and Susan Leibovitz Steinman."

32. Lacy commented: "The car was a symbol of achieving adulthood, but it also served as a convenient mini-stage, because the teens could carry on conversations in the cars with the audience observing from the outside," 16, Sam Quan Krueger, "arts/culture/community/change: Be Part of the Equation: A User's Guide on Arts in Community Service," www.nationalservice.org/research/fellows_reports/99/krueger.pdf (accessed February 2004).

33. According to Celeste Connor, "some student performers had [the perception] of being viewed as anthropological objects on display for middle-class whites . . ."; Connor, "Rooftop T.E.A.M.-Building," 35.

34. Mike Males provided journalistic treatment of the themes Lacy and her collaborators addressed in Oakland: Males, *The Scapegoat Generation.*

35. "Draft for planning committee review," n.p., Lacy, personal collection.

36. "Hearing Us Out: A Future for Oakland Youth," Lacy, personal collection.

37. Lacy, "Draft for Planning Committee Review: Developing a Youth Policy for the City of Oakland," November 28, 1995, Lacy, personal collection.

38. Draft of [Oakland] Youth Policy Initiative (OYPI), January 31, 1996, Lacy, personal collection.

39. Unique Holland, interview with author, July 31, 2002, Oakland, California; and Draft of YPI, Lacy, personal collection.

40. Draft of YPI, Lacy, personal collection.

41. Lacy was a member of the health club where the event was held. Collaborators included Stan Herbert, Sheila Jordan, Frank Williams, Officer Terrance West, Mike Shaw, Chris Johnson, and Annice Jacoby. In 2002, Unique Holland said she was still not "over" the stereotyping represented by the choice of basketball, but she did get to do a little directing for the first time in that piece; Holland, interview with author, July 31, 2002, Oakland, California. *No Blood/No Foul* was also an installation in Tokyo, Japan, in 1996. As part of an international exhibition of installation and conceptual art, ATOPIC, Lacy and her collaborators created a basketball court where a visitor could shoot hoops and simultaneously watch video interviews with youth and police as well as the Oakland performance. The court was defined by a graffiti mural made in Oakland. The Japanese event involved Lacy, Jacques Bronson, Mike Shaw, Unique Holland, Annice Jacoby, and Chris Johnson.

42. The game was covered by three cameras and projected on two large video screens.

43. This was called an "event" not an "art performance" since it was felt police would be more willing to participate. "Code 33" is used on police radios to signal an emergency and that all nonemergency communications should cease in order to "clear the air" for essential information. Russ Jennings was the technical director; artist Ann Maria Hardeman supervised technology installation; Patrick Toebe was stage designer with Raúl Cabra; Sergeant Jeff Israel coordinated police involvement; Uche Mowete was one of the students on the video production team; Linda Kiehle was the project administrator; Julio Morales played many roles.

44. Between April and May 1999, the eighteen youth were paid to attend with thirteen officers.

45. Partners for *Code 33* included Oakland Sharing the Vision, the Alameda County Department of Probation, the Oakland Unified School District, among others. See Roth, "Making and Performing Code 33," 47–62; Wilson, "Clearing the Air" (accessed online November 11, 2004).

46. Holland, interview with author, July 31, 2002.

47. The *Code 33* graphics intentionally recalled early-twentieth-century Russian Constructivism in their color scheme and geometric layout.

48. The body of lowrider cars is only a few inches off the ground, a result of heavy weight in the trunk, or actually altering the frame, or using hydraulic pumps; colorful custom paint jobs, chrome pipes, and interior ornaments are also features. See Parsons, Padilla, and Arellano, *Low 'n Slow*. The lowriders were recruited by installation artist Shane Hernandez.

49. The group supporting the release of Mumia Abu-Jamal from his Pennsylvania death-row prison cell was protesting the October 4, 1999, Supreme Court decision that denied Mumia's appeal. While Mumia had supporters among T.E.A.M., they were unable to divert the mainly youthful, mainly white demonstrators; the Supreme Court decision was just a few days old, the symbolic Federal Building was right next to the garage, and the media coverage already present for *Code 33* was just too convenient to pass up. Some of the Free Mumia protesters also objected to

Code 33 organizers working with the police; http://www.freemumia.org/; http://www.mumia.org/freedom.now/; http://www.mumia2000.org/, among other Web sources.

50. Roth, "Making and Performing Code 33," 51.

51. One of the neighborhood portraits featured Khadafy Washington, an athletic young man who was shot and killed at McClymonds High School, on August 4, 2000. He was eighteen; http://www.khadafyfoundation.org/. The *Code 33* video is dedicated to his memory.

52. Grant Kester in *Conversation Pieces,* 185, wrote that the helicopter buzzed the garage in a "reassertion of spatial mastery" by the police. In fact, the helicopter was always supposed to be part of the performance, and its presence was the result of long negotiation.

53. The eight neighborhoods were West Oakland, Central East, Downtown/Chinatown, Fruitvale, San Antonio/Lower Hills, North Oakland, North Hills, and Elmhurst/South Hills.

54. Roth, "Making and Performing Code 33," 59.

55. In May and June 2001 an exhibit of videos and documentation was held at Intersection for the Arts in San Francisco. Wilson, "Clearing the Air," n.p.

56. Whiting, *Pop L.A.,* 169–76; Kirby, *Happenings,* 262–88; also see Cheng, *In Other Los Angeleses,* 23.

57. Presentation on *Code 33* to Moira Roth's class at Mills College, January 27, 2005.

58. *Code 33* continued for a year after the event in downtown Oakland with small group activities with Oakland youth.

59. The title *The Skin of Memory* was suggested by one of the members of the Medellín coordinating team, according to Pilar Riaño-Alcalá. The organizing group substituted it for the working title, *Barrio Antioquia: Past, Present, and Future.* Pilar Riaño-Alcalá, interview with author, February 20, 2004, Seattle, Washington. See also Lacy and Riaño-Alcalá, "Medellín, Colombia," 96–112.

60. The Corporación Region para el Desarrollo y la Democracía was founded in 1989 by nineteen professionals to promote inclusive social policies and democratic strategies; www.region.org.co. Also involved were the Education Secretariat of Medellín, the Caja de Compensación Familiar (COMFENALCO); and the Presencia Colombo Suiza. Lacy wrote about the welcome differences in her working in Colombia versus the United States. She acknowledged that she was much more part of a team in Medellín and did not have a central role. Lacy, "Hacer arte público. Como memoria colectiva, como metáfora y como acción," in *Arte, memoria y violencia,* ed. Riaño-Alcalá, Lacy, and Hernández, 74.

61. Riaño-Alcalá, interview with author, February 20, 2004.

62. Riaño-Alcalá, "Encounters with Memory and Mourning," 212.

63. Riaño-Alcalá, *Dwellers of Memory,* 34. I appreciate being able to read this book in manuscript form.

64. Ibid., 47.

65. Stienen, "Welcome to Medellín," 242–53.

66. Riaño-Alcalá, "Remembering Place," 279; see also Juan Forero, "Where Violence Reigned, Camera Has Compassion," *New York Times,* April 19, 2005.

67. Riaño-Alcalá, "Encounters with Memory and Mourning," 216.

68. Ibid., 231; emphasis in the original.

69. Ibid., 212.

70. Lacy, "Hacer arte público," 75. Group Material did a project in 1981 called *The People's Choice (Arroz con Mango)*, which was a collection of valued items from residents on the New York City block on East Thirteenth Street, where the artists rented a storefront. I learned of this project from Lacy. "Tim Rollins Talks to David Deitcher," 78.

71. Riaño-Alcalá, interview with author, February 20, 2004.

72. Lacy really wanted to use a commercial bus, but that did not work out.

73. Riaño-Alcalá, "Encounters with Memory and Mourning," 221.

74. Riaño-Alcalá, "Remembering Place," 282.

75. Riaño-Alcalá, "Encounters with Memory and Mourning," 227–28.

76. Riaño-Alcalá, interview with author, February 20, 2004.

77. Riaño-Alcalá, "Encounters with Memory and Mourning," 227.

78. Riaño-Alcalá, "Introduction: Memory, Representation, and Narratives," 222.

79. Riaño-Alcalá, "Encounters with Memory and Mourning," 221.

80. Riaño-Alcalá, interview with author, February 20, 2004; Lacy, "Hacer arte público," 77.

81. Lacy, "Hacer arte público," 79.

82. Snyder, "Blue Mountains Constantly Walking," 98. Thanks to Nick Brown and Kevin Hamilton for this reference.

83. Palmer, *The Practice of Freedom*, 26–28.

Conclusion

1. Shusterman, "Somaesthetics and *The Second Sex*," 129.

2. Hills, "Suzanne Lacy, Comments on 'Code 33: Emergency, Clear the Air,'" 453.

3. Kelley, *Childsplay*, 200; and Suzanne Lacy, e-mail to author, November 15, 2005: Her recollection of the dates is vague; 1979 was the earliest.

4. Macy, "In Indra's Net," 171–72.

5. Cheng, *In Other Los Angeleses*, 99, 98; emphasis in the original. Cheng quotes Lacy, *Mapping the Terrain*, 176.

6. Hurtado and Stewart, "Through the Looking Glass," 309.

7. Farson, "California Institute of the Arts," 154.

8. Lacy recounted using the elevator in assessing her own working-class characteristics. She invariably starts conversations with fellow riders. Lacy, phone conversation with author, January 17, 2009.

9. In August 2006, Lacy organized *Necessary Positions: An Intergenerational Conversation* at Red Cat in Los Angeles. Eighteen artists of various generations spoke for an afternoon about feminism, art, politics, and gender. The women were paired to respond to prepared questions; they came together at the front of the stage in an informally choreographed arrangement. The artists included Cory Peipon, Susan Barnett, Barbara T. Smith, Kelli Akashi, Diane Gamboa, Herena Contreras, Haruko Tanaka, Susan Mogul, Mary Kelly, Anoka Faruqee, Anna Sue Hay, Emily

Roysdon, Andrea Bowers, Shirley Tze, Linda Vallejo, and Nancy Buchanan. In 2007, she created *SWARM,* a performance with Kim Abeles and Jeff Cain at the Los Angeles County Museum. *The Performing Archive* that Lacy created with Leslie Labowitz brilliantly connected the feminisms of the 1970s to a generation of young artists now working in California. "Restricted Access" was the first exhibit from *The Performing Archive.* Presented at the Eighteenth Street Art Center in Santa Monica in 2007, and subsequently at the Yerba Buena Arts Center in San Francisco, younger artists were invited by Lacy and Labowitz to interact with their archives. Each young woman "performed" responses to one or several artifacts selected from a wall of boxed materials and was recorded on video. These recordings were integrated into the exhibit and also archived. "Restricted Access" was then exhibited at "re.act.feminism" at the Akademie der Künste, Berlin, December 13, 2008 to February 8, 2009.

10. For an account of a re-creation of Kaprow's *Trading Dirt,* see Jori Finkel, "Happenings Are Happening Again," *New York Times,* April 13, 2008, 33.

11. http://www.moca.org/kaprow/audio/reflections/jeff_kelley_.mp3 (accessed August 24, 2008).

12. Lacy was a key participant in the show WACK! Art and the Feminist Revolution, which opened at the Geffen Contemporary at the Los Angeles Museum of Contemporary Art (MOCA) in spring 2007. WACK! not only included major work by Lacy from the 1970s but also provided the opportunity for her to organize new performances, *Stories of Work and Survival.* Together with UCLA's Center for Labor, Lacy convened dialogues in April 2007 at the Geffen with fifteen diverse groups of women; this series culminated in a Lacy-organized public dinner for hundreds of people in June 2007. Views of the WACK! show varied widely. For one important response, see Mira Schor, "I am not now nor have I ever been . . ." *The Brooklyn Rail,* February 2008, http://www.brooklynrail.org/2008/02/artseen/i-am-not-now-nor-have-i-ever-been (accessed February 9, 2008). Schor wrote: "[M]ost of *my entire generation* has been eliminated from the history of feminist art by the two major museum shows devoted to the subject in 2007–2008"; emphasis in the original.

13. Obrist, "Hans Ulrich Obrist Interviews Suzanne Lacy," 26.

14. Frances Daly, "The 'Non-citizen' and the Concept of Human Rights," *borderlands e-journal* 3, 1 (2004) (accessed August 2006), http://www.borderlandsejournal.adelaide.edu.au/vol3no1_2004/daly_noncitizen.htm. Daly writes of "Maurice Blanchot, Jean-Luc Nancy, Augusto Illuminati and Giorgio Agamben, all of whom wish to understand, and indeed reinterpret, a contemporary politics based on a type of praxis that is deemed able to overcome separations within social life and what it means to be human."

15. Lacy, "Fractured Space," 300, quoting Kaprow, "The Real Experiment," *Artforum* 25 (December 1985): 42.

16. Jackson, "Social Practice." Thanks to Sarah Kanouse for alerting me to this article.

17. Moraga and Anzaldúa, eds., *This Bridge Called My Back*; Anzaldúa and Keating, eds., *This Bridge We Call Home.*

18. Martin Jay has noted in an important article: "In resisting sublimation, metaphorization and representation, body art thus helps us avoid trying to construct a

mythical embodiment of 'the people,' an embodiment that can only be simulacral and deceptive because it covers over the inevitable distinctions, even conflicts, which always subtend it"; Jay, "Somaesthetics and Democracy," 66.

19. Jones noted also: "Merleau-Ponty, however, was not specifically sensitive to the ways in which reciprocity always entails aspects of *specific* differences such as those relating to gender and sexuality"; Jones, "Meaning, Identity, Embodiment," 74.

20. Merleau-Ponty described a "double belongingness to the order of the 'object' and to the order of the 'subject' [that] reveals to us quite unexpected relations between the two orders"; Merleau-Ponty, "The Visible and the Invisible," 254.

21. Ibid., 255. Jones stressed rightly that "[w]ith the interpreting subject thus immersed into the 'subject' of the work of art, identity—or the question of whose identity is at stake in viewing visual images—becomes all the more appropriately complex." Jones, "Meaning, Identity, Embodiment," 78. While Merleau-Ponty did not focus on gendered or sexual bodies in his phenomenological essays, his contemporary Simone de Beauvoir did, to an extent, and certainly Judith Butler and Iris Marion Young have adapted Merleau-Ponty to their feminisms.

22. Fullilove, *Root Shock*, 17.

BIBLIOGRAPHY

Archives

Archives of American Art, Smithsonian Institution, Washington, D.C.

The Ryerson and Burnham Libraries, Art Institute of Chicago, Chicago, Illinois, The Chicago Architects Oral History Project

Center for Curatorial Studies, Bard College, Annandale-on-Hudson, New York

Chicago Historical Society, Chicago, Illinois

Minneapolis College of Art and Design, Minneapolis, Minnesota

Minnesota Historical Society, St. Paul, Minnesota

Northwest Architectural Archives, University of Minnesota, Minneapolis, Minnesota

Personal Collections

Sharon Roe Anderson (Minneapolis)

Anne Bray (Los Angeles)

Suzanne Lacy (formerly Oakland, now Los Angeles, California)

Moira Roth (Berkeley and Oakland, California)

Alix Sales (Vancouver, British Columbia)

Interviews

Jerri Allyn, Sharon Roe Anderson, Anne Bray, Barb Clausen, Celeste Connor, Nancy Dennis, Susan Gordon, Amana Harris, Unique Holland, Mary Jane Jacob, Laurel Klick, Yutaka Kobayashi, Joslin Kobylka, Leslie Labowitz-Starus, Suzanne Lacy, Susan Mogul, Pilar Riaño-Alcalá, Joyce Rosario, Moira Roth, Alix Sales, May Sun, Linda Vallejo, Faith Wilding, Willow Young

Agrest, Diana. "Architectural Anagrams: The Symbolic Performance of Skyscrapers." In *Architecture from Without: Theoretical Framings for a Critical Practice*. Cambridge, Mass.: MIT Press, 1991.

Alberro, Alexander, and Blake Stimson, eds. *Conceptual Art: A Critical Anthology*. Cambridge, Mass.: MIT Press, 1999.

Alinsky, Saul. *Reveille for Radicals*. Chicago: University of Chicago Press, 1946; updated ed., New York: Random House, 1969.

Anzaldúa, Gloria, and Analouise Keating, eds. *This Bridge We Call Home: Radical Visions for Transformation*. New York: Routledge, 2002.

Apple, Jacki. "Resurrecting the 'Disappeared': Recollections of Artists in Absentia." *Art Journal* 56 (Winter 1997).

Armstrong, Carol, and Catherine de Zegher, eds. *Women Artists at the Millennium*. Cambridge, Mass.: MIT Press, 2006.

Arnold, Stephanie. "Whisper, the Waves, the Wind." *Drama Review* 29, 1 (Spring 1985): 126–30.

"Art Literacy." *Artweek* 26 (August 1995).

Askey, Ruth. "A Baker's Dozen: Oral Histories of Women Artists." MA thesis, Goddard College, 1981, 91–109.

———. "In Mourning and in Rage." *Artweek*, 14 January 1978.

Atkins, Robert. *Artspeak: A Guide to Contemporary Ideas, Movements, and Buzzwords*. New York: Abbeville Press, 1990.

Atkinson, Ti-Grace. *Amazon Odyssey*. New York: Links Books, 1974.

Bailey, Alison. "Locating Traitorous Identities: Toward a View of Privilege-Cognizant White Character." *Hypatia* 13, 3 (1998): 27–42.

———. "Privilege: Expanding on Marilyn Frye's 'Oppression.'" In *Oppression, Privilege, and Resistance: Theoretical Perspectives on Racism, Sexism, and Heterosexism*, ed. Lisa Heldke and Peg O'Connor. New York: McGraw Hill, 2004.

Barry, Judith, and Sandy Flitterman. "Textual Strategies: The Politics of Art-Making." In *Feminist Art Criticism: An Anthology*, ed. Arlene Raven, Cassandra L. Langer, and Joanna Frueh. Ann Arbor, Mich.: UMI Research Press, 1988.

Basting, Anne Davis. *The Stages of Age: Performing Age in Contemporary American Culture*. Ann Arbor: University of Michigan Press, 1998.

Beauvoir, Simone de. *The Second Sex*. Trans. and ed. H. M. Parshley. Alfred A. Knopf [1952]; New York: Vintage Books, 1980.

Becker, Jack. "Conversing with Christo and Jeanne-Claude." *Public Art Review* 9, 2 (Spring/Summer 1998).

Bednar, Michael J. *The New Atrium*. New York: McGraw-Hill Co., 1986.

Berg, Barbara. *The Remembered Gate: Origins of American Feminism*. New York: Oxford, 1978.

Berger, Martin A. *Sight Unseen: Whiteness and American Visual Culture*. Berkeley: University of California Press, 2005.

Bettie, Julie. "Changing the Subject: Male Feminism, Class Identity, and the Politics of Location." In *Identity Politics in the Women's Movement*, ed. Barbara Ryan. New York: New York University Press, 2001.

Bevacqua, Maria. *Rape on the Public Agenda: Feminism and the Politics of Sexual Assault*. Boston: Northeastern University Press, 2000.

Bhabha, Homi. "Conversational Art." In *Conversations at the Castle: Changing Audiences and Contemporary Art,* ed. Mary Jane Jacob with Michael Brenson. Cambridge, Mass.: MIT Press, 1998.

———. *The Location of Culture.* London: Routledge, 1994.

Bingaman, Amy, Lise Sanders, and Rebecca Zorach, eds. *Embodied Utopias: Gender, Social Change, and the Modern Metropolis.* New York: Routledge, 2002.

Bishop, Claire. "Antagonism and Relational Aesthetics." *October* 110 (Fall 2004): 51–79.

———. "Art of the Encounter: Antagonism and Relational Aesthetics." *Circa* 114 (Winter 2005): 32–35.

———. "Claire Bishop Responds." *October* 115 (Winter 2006): 107.

———. *Installation Art: A Critical History.* New York: Routledge, 2005.

———, ed. *Participation: Documents of Contemporary Art.* Cambridge, Mass.: MIT Press/London: Whitechapel, 2005.

———. "The Social Turn: Collaboration and Its Discontents." *Artforum* 44 (February 2006): 178–83.

Blackwood, Stephanie K. *Rape.* Columbus: Ohio State University, 1985.

Blair, Karen J. "Pageantry for Women's Rights: The Career of Hazel Mackaye, 1913–1923." *Theatre Survey* 31 (May 1990).

Blocker, Jane. *What the Body Cost: Desire, History, and Performance.* Minneapolis: University of Minnesota Press, 2004.

———. *Where Is Ana Mendieta? Identity, Performativity, and Exile.* Durham, N.C.: Duke University Press, 1999.

Bloom, Lisa. "Contests for Meaning in Body Politics and Feminist Conceptual Art: Revisioning the 1970s through the work of Eleanor Antin." In *Performing the Body/Performing the Text,* ed. Amelia Jones and Andrew Stephenson. New York: Routledge, 1999.

———, ed. *With Other Eyes: Looking at Race and Gender in Visual Culture.* Minneapolis: University of Minnesota Press, 1999.

Bogan, Neill. "Evoking History: The Memory of Land; The Memory of Water: Spoleto Festival USA: Charleston, South Carolina." *Public Art Review* 14, 1 (Fall/Winter 2002).

Borden, Iain, and Jane Rendell. *Strangely Familiar: Narratives of Architecture in the City.* New York: Routledge, 1996.

Borsa, Joan. "Making Space." *Gallerie Women's Art Annual.* 1989.

Bourriaud, Nicolas. *Relational Aesthetics.* Trans. Simon Pleasance and Fronza Woods with Mathieu Copeland. Dijon, France: Les presses du réel, [1998] 2002.

Bray, Anne. "The Community Is Watching, and Replying." *Leonardo* 35, 1 (2002).

Breines, Wini. *The Trouble between Us: An Uneasy History of White and Black Women in the Feminist Movement.* New York: Oxford University Press, 2006.

———. *Young, White, and Miserable: Growing Up Female in the Fifties.* Chicago: University of Chicago Press, 1992.

Broude, Norma, and Mary Garrard, eds. *The Expanding Discourse.* New York: HarperCollins, 1992.

———, eds. *The Power of Feminist Art: The American Movement of the 1970s, History and Impact.* New York: Harry N. Abrams, 1994.

————, eds. *Reclaiming Female Agency: Feminist Art History after Postmodernism.* Berkeley: University of California Press, 2005.

Brown, Betty Ann. *Expanding Circles: Women, Art and Community.* New York: Midmarch Arts Press, 1996.

Brown, Ruth Nicole. *Black Girlhood Celebration: Toward a Hip-Hop Feminist Pedagogy.* New York: Peter Lang, 2009.

Brown, Victoria Bissell. *The Education of Jane Addams.* Philadelphia: University of Pennsylvania Press, 2004.

Brownmiller, Susan. *Against Our Will: Men, Women and Rape.* New York: Simon and Schuster, 1975.

————. *In Our Time: Memoir of a Revolution.* New York: Dial Press, 1999.

Bryson, Scott, Barbara Kruger, Lynne Tillman, and Jane Weinstock, eds. *Beyond Recognition: Representation, Power, and Culture.* Berkeley: University of California, 1992.

Buber, Martin. *I and Thou.* Trans. Walter Kaufmann. New York: Charles Scribner's Sons, 1970.

Buchanan, Nancy. "Deer/Dear." *High Performance,* June 1978.

Bugni, Valerie, and Ronald Smith. "Getting to a Better Future through Architecture and Sociology." *AIA Las Vegas Forum Newsletter,* May 2002.

Burnham, Linda. "Performance Art in Southern California: An Overview." In *Performance Anthology: Source Book of California Performance Art,* ed. Carl E. Loeffler and Darlene Tong. San Francisco: Last Gasp Press and Contemporary Arts Press, 1989.

————. "Running Commentary: What Price Social Art?" *High Performance* 9, 3 (1986).

Burnham, Linda Frye. "*High Performance,* Performance Art, and Me." *Drama Review* 30, 1 (Spring 1986): 15–51.

Burnham, Linda Frye, and Steven Durland, eds. *The Citizen Artist: An Anthology from High Performance Magazine, 1978–1998.* New York: Gunk Foundation/ Critical Press, 1998.

Butler, Judith. *Bodies That Matter: On the Discursive Limits of "Sex."* New York: Routledge, 1993.

Butler, Margot Leigh. "Making Waves." *Women's Studies International Forum* 24, 3/4 (2001): 387–99.

Butt, Gavin, ed. *After Criticism: New Responses to Art and Performance.* Malden, Mass.: Blackwell, 2005.

Bystydzienski, Jill M., and Steven P. Schacht, eds. *Forging Radical Alliances across Difference: Coalition Politics for the New Millennium.* Lanham, Md.: Rowman and Littlefield, 2002.

Caesar, Catherine. "Martha Rosler's Critical Position within Feminist Conceptual Practices." *n.paradoxa* 14.

Camnitzer, Luis, Jane Farver, and Rachel Weiss, eds. *Global Conceptualism: Points of Origin, 1950s–1980s.* New York: Queens Museum of Art, 1999.

Campbell, Kate. Introduction to *Critical Feminism: Argument in the Disciplines,* ed. Kate Campbell. Philadelphia: Open University Press, 1992.

Canty, Donald. "Evaluation: Single Complex City Core: Johnson's IDS Center, Minneapolis." *AIA Journal*, June 1979.

Caringella-MacDonald, Susan. "The Mythology of Rape: Excusing the Inexcusable." In *RAPE*. Columbus: Ohio State University Gallery of Fine Art, 1985.

Carlson, Marvin. *Performance: A Critical Introduction*. New York: Routledge, 1996.

Carringer, Robert. "Hollywood's Los Angeles: Two Paradigms." In *Looking for Los Angeles: Architecture, Film, Photography, and the Urban Landscape,* ed. Charles G. Salas and Michael S. Roth. Los Angeles: Getty Research Institute, 2001.

Caruth, Cathy. *Unclaimed Experience: Trauma, Narrative, and History*. Baltimore: Johns Hopkins University Press, 1996.

Case, Sue-Ellen, ed. *Performing Feminisms: Feminist Critical Theory and Theatre*. Baltimore: Johns Hopkins University Press, 1990.

Cenzatti, Marco, and Margaret Crawford. "Spazi pubblici e mondi paralleli." *Casabella* 57 (January/February 1993).

Chadwick, Whitney. *Women, Art and Society*. London: Thames and Hudson, 1990.

Chave, Anna. "Minimalism and Biography." *Art Bulletin* 82, 1 (March 2000): 149–63.

Cheng, Meiling. *In Other Los Angeleses: Multicentric Performance Art*. Berkeley: University of California Press, 2002.

———. "Renaming 'Untitled Flesh': Marking the Politics of Marginality." In *Performing the Body/Performing the Text,* ed. Amelia Jones and Andrew Stephenson. New York: Routledge, 1999.

Chicago, Judy. *Through the Flower: My Struggle as a Woman Artist*. New York: Penguin, 1993.

Chicago, Judy, and Edward Lucie-Smith. *Women and Art: Contested Territory*. New York: Watson-Guptill, 1999.

Cleaver, Kathleen, and George Katsiaficas, eds. *Liberation, Imagination, and the Black Panther Party: A New Look at the Panthers and Their Legacy*. New York: Routledge, 2001.

Cleveland, William. "Judy Baca: SPARC—The Social and Public Arts Resource Center." In *The Politics of Culture: Policy Perspectives for Individuals, Institutions, and Communities,* ed. Gigi Bradford, Michael Gary, and Glenn Wallach, 258–65. New York: The New Press, 2000.

Clifton, Leigh Ann. "Parking Lot Stories." *Artweek*, June 18, 1992.

Cockrell, Susanne, and Suzanne Lacy. "Alterations: A Series of Conversations." *Fiber Arts* 23, 2 (September/October 1996): 36–40.

Cohen-Cruz, Jan. *Local Acts: Community-Based Performance in the United States*. New Brunswick, N.J.: Rutgers University Press, 2005.

———. "Mainstream or Margin? U.S. Activist Performance and Theater of the Oppressed." In *Playing Boal: Theatre, Therapy, and Activism,* ed. Mady Schutzman and Jan Cohen-Cruz. New York: Routledge, 1994.

———, ed. *Radical Street Performance: An International Anthology*. New York: Routledge, 1998.

Color of Violence: The INCITE! Anthology. Boston: South End Press, 2006.

Connell, Noreen, and Cassandra Wilson, eds. *Rape: The First Sourcebook for Women*. New York: Plume Books, 1974.

Connor, Celeste. "Rooftop T.E.A.M. Building." *Public Art Review* 13 (1995): 34–35.

Corrin, Lisa, and Gary Sangster. "Culture in Action: Action in Chicago." *Sculpture,* March 1994.

Cottingham, Laura. *Seeing through the Seventies: Essays on Feminism and Art.* Amsterdam: G&B Arts International, 2000.

Crow, Thomas. *The Rise of the Sixties.* New Haven, Conn.: Yale University Press, 2004.

Daly, Mary. *Beyond God the Father: Toward a Philosophy of Women's Liberation.* Boston: Beacon Press, [1973] 1985.

Davis, Mike. *City of Quartz: Excavating the Future in Los Angeles.* New York: Vintage Books, 1992.

Davol, Ralph. *Handbook of American Pageantry.* Taunton, Mass.: Ralph Davol, 1915.

Dean, Andrea O. "Conversations: Philip Johnson." *AIA Journal,* June 1979.

Dear, Michael J., and Steven Flusty, "The Resistible Rise of the L.A. School." In *From Chicago to L.A.,* ed. Michael J. Dear with J. Dallas Dishman. Thousand Oaks, Calif.: Sage Publications, 2001.

De Certeau, Michel. *The Practice of Everyday Life.* Trans. Steven Rendall. Berkeley: University of California Press, 1984.

Deepwell, Katy. *New Feminist Art Criticism: Critical Strategies.* Manchester: Manchester University Press, 1995.

Degen, Monica, Caitlin DeSilvey, and Gillian Rose. "Experiencing Visualities in Designed Urban Environments: Learning from Milton Keynes." *Environment and Planning A* 40 (2008).

Delacorte, Frédérique, and Felice Newman, eds. *Fight Back! Feminist Resistance to Male Violence.* Minneapolis: Cleis Press, 1981.

Denzin, Norman. *Performance Ethnography: Critical Pedagogy and the Politics of Culture.* Thousand Oaks, Calif.: Sage Publications, 2003.

Deutsche, Rosalyn. *Evictions: Art and Spatial Politics.* Cambridge, Mass.: MIT Press, 1998.

De Zegher, M. Catherine, ed. *Inside the Visible: An Elliptical Traverse of Twentieth Century Art/In, Of, and From the Feminine.* Cambridge, Mass.: MIT Press, 1995.

Dezeuze, Anna. "Everyday Life, 'Relational Aesthetics,' and 'Transfiguration of the Commonplace.'" *Journal of Visual Art Practice* 5, 3 (2006): 143–52.

Dill, Bonnie Thornton, Amy E. McLaughlin, and Angel David Nieves. "Future Directions of Feminist Research: Intersectionality." In *Handbook of Feminist Research: Theory and Praxis,* ed. Sharlene Nagy Hesse-Biber, 629–37. Thousand Oaks, Calif.: Sage, 2007.

Diserens, Corinne, ed. *Gordon Matta-Clark.* London: Phaidon, 2003.

Doss, Erika. *Twentieth-Century American Art.* New York: Oxford University Press, 2002.

Dougherty, Cecilia. "Stories from a Generation: Early Video at the LA Woman's Building." *Afterimage* 26, 1 (July/Aug. 1998).

Dovey, Kim. *Framing Places: Mediating Power in Built Form.* London: Routledge, 1999.

Downey, Anthony. "Towards a Politics of (Relational) Aesthetics." *Third Text* 21, 3 (May 2007): 267–75.

Drew, Jesse. "The Collective Camcorder in Art and Activism." In *Collectivism after Modernism: The Art of Social Imagination after 1945.* Minneapolis: University of Minnesota Press, 2007.

DuPlessis, Rachel Blau, and Ann Snitow, eds. *The Feminist Memoir Project: Voices from Women's Liberation.* New York: Three Rivers Press, 1998.

Echols, Alice. *Daring to Be Bad: Radical Feminism in America, 1967–75.* Minneapolis: University of Minnesota Press, 1989.

Elder, R. Bruce. *The Films of Stan Brakhage in the American Tradition of Ezra Pound, Gertrude Stein, and Charles Olson.* Waterloo, Ontario: Wilfred Laurier University Press, 1998.

Elliott, Maud Howe, ed. *Art and Handicraft in the Woman's Building of the World's Columbian Exposition.* Chicago: Rand, McNally, 1894; available electronically from Open Content Alliance, San Francisco, 2007.

Enke, Anne. *Finding the Movement: Sexuality, Contested Space, and Feminist Activism.* Durham, N.C.: Duke University Press, 2007.

Ettlinger, L. D. *The Complete Paintings of Leonardo da Vinci.* New York: Harry N. Abrams and Rizzoli, 1967.

Evans, Sara. *Tidal Wave: How Women Changed America at Century's End.* New York: New Press, 2003.

Ewing, William. *Lucas Samaras: Photos Polaroid Photographs 1969–1983.* New York: International Center of Photography, 1983.

Farrar, Margaret E. "Making the City Beautiful: Aesthetic Reform and the (Dis)placement of Bodies." In *Embodied Utopias: Gender, Social Change, and the Modern Metropolis,* ed. Amy Bingaman, Lise Sanders, and Rebecca Zorach, 37–54. New York: Routledge, 2002.

Farrington, Lisa. *Art on Fire: The Politics of Race and Sex in the Paintings of Faith Ringgold.* New York: Millennium Fine Arts Publishing, 1999.

———. "Faith Ringgold's 'Slave Rape' Series." In *Skin Deep Spirit Strong: The Black Female Body in American Culture,* ed. Kimberly Wallace-Sanders, 128–52. Ann Arbor: University of Michigan Press, 2002.

Farson, Richard E. "California Institute of the Arts: Prologue to a Community." *Arts in Society* 7, 3 (Fall-Winter 1970).

Federici, Silvia. *Caliban and the Witch.* Brooklyn, N.Y.: Autonomedia, 2004.

Ferguson, Russell, Martha Gever, Trinh T. Minh-ha, and Cornel West, eds. *Out There: Marginalization and Contemporary Cultures.* Cambridge, Mass.: MIT Press, 1990.

Fisher, Jennifer. "Interperformance: The Live Tableaux of Suzanne Lacy, Janine Antonin, and Marina Abramović." *Art Journal* 56, 4 (1997): 28–33.

Foster, Hal. "The Artist as Ethnographer." In *The Traffic in Culture: Refiguring Art and Anthropology,* ed. George E. Marcus and Fred R. Myers. Berkeley: University of California Press, 1995.

Fox, Howard N. *Eleanor Antin.* Los Angeles: Los Angeles County Museum of Art, 1999.

Franko, Mark. "Aesthetic Agencies in Flux." In *Maya Deren and the American Avant-Garde,* ed. Bill Nichols. Berkeley: University of California Press, 2001.

Frenchman, Dennis. "Event-Places in North America: City Meaning and Making." *Places* 16, 3 (2004).

Fried, Michael. "Art and Objecthood." *Artforum* 5 (June 1967): 12–23.

Friedman, Susan Stanford. *Mappings: Feminism and the Cultural Geographies of Encounter.* Princeton, N.J.: Princeton University Press, 1998.

Frieling, Rudolf, Boris Groys, Robert Atkins, and Lev Manovich. *The Art of Participation, 1950 to Now.* San Francisco: San Francisco Museum of Art/New York: Thames and Hudson, 2008.

Fryd, Vivien Green. "Suzanne Lacy's Three Weeks in May: Feminist Activist Performance Art as 'Expanded Public Pedagogy.'" *NWSA Journal* 19, 1 (Spring 2007): 23–38.

Frye, Marilyn. *Willful Virgin: Essays in Feminism, 1976–1992.* Freedom, Calif.: Crossing Press, 1992.

Fuchs, Stephan. *Against Essentialism: A Theory of Culture and Society.* Cambridge, Mass.: Harvard University Press, 2001.

Fuller, Diana Burgess, and Daniela Salvioni, eds. *Art, Women, California, 1950–2000: Parallels and Intersections.* Berkeley: University of California Press, 2002.

Fullilove, Mindy Thompson. *Root Shock: How Tearing Up City Neighborhoods Hurts America, and What We Can Do About It.* New York: Ballantine Books, 2005.

Fuss, Diana. *Essentially Speaking: Feminism, Nature and Difference.* New York: Routledge, 1989.

Gablik, Suzi. *Conversations before the End of Time.* London: Thames and Hudson, 1995.

———. *The Reenchantment of Art.* New York: Thames and Hudson, 1991.

Gamble, Allison. "Reframing a Movement: Sculpture Chicago's 'Culture in Action.'" *New Art Examiner* 21 (January 1994): 18–23.

Garoian, Charles R. "Performance Art as Critical Pedagogy in Studio Art Education." *Art Journal* 58, 1 (Spring 1999).

———. *Performing Pedagogy: Toward an Art of Politics.* Albany: SUNY Press, 1999.

Gaulke, Cheri. "Acting like Women: Performance Art of the Women's Building." *High Performance* 3, 3–4 (Fall 1980): 156–63; also available online at http://www.communityarts.net/readingroom/archivefiles/2002/09/acting_like_wom.php.

Gilcher, Arnold B., and Constance Glenn. *Lucas Samaras, Photo-transformations.* Long Beach, Calif.: California State University Art Museum, 1975.

Gillick, Liam. "Contingent Factors: A Response to Claire Bishop's 'Antagonism and Relational Aesthetics.'" *October* 115 (Winter 2006): 95–106.

Giroux, Henry. "Art, Education and Memory." *Sculpture* 16, 3 (March 1997).

———. "What Comes between Kids and Their Calvins: Youthful Bodies, Pedagogy, and Commercialized Pleasures." *New Art Examiner* 23 (February 1996): 16–21.

Glassberg, David. *American Historical Pageantry: The Uses of Tradition in the Early Twentieth Century.* Chapel Hill: University of North Carolina Press, 1990.

Glowen, Ron. "Suzanne Lacy's 'Under Construction' Performance at the Residences on Georgia." *Artweek* 28 (September 1997): 29.

Goffman, Erving. *Interaction Ritual: Essays in Face-to-Face Behavior.* Chicago: Aldine Publishing Co., 1967.

———. *The Presentation of Self in Everyday Life.* Garden City, N.Y.: Doubleday, [1956] 1959.

Goldbard, Arlene. *New Creative Community: The Art of Cultural Development*. Oakland, Calif.: New Village Press, 2006.

Goldberg, RoseLee. *Performance Art: From Futurism to the Present*. New York: Thames and Hudson, 2001.

Goldfarb, Jeffrey C. *The Politics of Small Things: The Power of the Powerless in Dark Times*. Chicago: University of Chicago Press, 2006.

González. Jennifer, and Adrienne Posner. "A Facture for Change: U.S. Activist Art since 1950." In *A Companion to Contemporary Art since 1945*, ed. Amelia Jones. Malden, Mass.: Blackwell Publishing, 2006.

Gouma-Peterson, Thalia. "Faith Ringgold's Story Quilts." *Arts* 61 (January 1987): 64–69.

———. *Miriam Schapiro: Shaping the Fragments of Art and Life*. New York: Harry N. Abrams, 1999.

Gouma-Peterson, Thalia, and Patricia Mathews. "The Feminist Critique of Art History." *Art Bulletin* 69, 3 (September 1987).

Graham, Dan, and Robin Hurst. "Corporate Arcadias." *Artforum* 26, 4 (December 1987): 68–74.

Gray, Mary Lackritz. *A Guide to Chicago's Murals*. Chicago: University of Chicago Press, 2001.

Greeley, Lynne. "Whatever Happened to the Cultural Feminists? Martha Boesing and At the Foot of the Mountain." *Theatre Survey* 46: 1 (2005): 49–65.

Grenier, Catherine, ed. *Los Angeles, 1955–1985: Birth of an Art Capital*. Paris: Centre Pompidou, 2006.

Griffin, Susan. *Pornography and Silence: Culture's Revenge against Nature*. New York: Harper and Row, 1981.

———. *Rape: The Power of Consciousness*. San Francisco: Harper and Row, 1979.

Grimaldo Grigsby, Darcy. "Dilemmas of Visibility: Contemporary Women Artists' Representations of Female Bodies." In *The Female Body, Figures, Styles, Speculations*, ed. Laurence Goldstein. Ann Arbor: University of Michigan Press, 1995.

Griswold del Castillo, Richard, Teresa McKenna, and Yvonne Yarbro-Bejarano, eds. *Chicano Art: Resistance and Affirmation, 1965–85*. Los Angeles: Wight Art Gallery, University of California at Los Angeles, 1991.

Grosz, Elizabeth. "Bodies-Cities." In *Sexuality and Space*, ed. Beatriz Colomina. New York: Princeton Architectural Press, 1992.

"Group Material Talks to Dan Cameron." *Artforum International* 41, 8 (April 2003): 200–203.

Hale, Sondra, and Terry Wolverton, eds. *From Site to Vision: The Woman's Building in Contemporary Culture*. http://womansbuilding.org/fromsitetovision/. Los Angeles: The Woman's Building, 2007.

Halprin, Anna. *Moving toward Life: Five Decades of Transformational Dance*. Ed. Rachel Kaplan. Hanover, N.H.: Wesleyan University Press, 1995.

Harding James Martin, and Cindy Rosenthal, eds. *Restaging the Sixties: Radical Theaters and Their Legacies*. Ann Arbor: University of Michigan Press, 2006.

Harris, Ann Sutherland, and Linda Nochlin. *Women Artists 1550–1950*. Los Angeles: Los Angeles County Museum of Art, 1976.

Harris, Jonathan. "Introduction: Performance, Critiques, Ideology/Contemporary

Art and Art History in an Age of Visual Culture." In *Dead History, Live Art? Spectacle, Subjectivity, and Subversion in Visual Culture since the 1960s*, ed. Jonathan Harris. Liverpool: Liverpool University Press + Tate Liverpool, 2007.

———. "Introduction—with Postmodernism Grounded: Prospects for Renewal in Critical Art History." In *Value, Art, Politics: Criticism, Meaning and Interpretation after Postmodernism*, ed. Jonathan Harris. Liverpool: Liverpool University Press, 2007.

Haskell, Molly. *From Reverence to Rape: The Treatment of Women in the Movies*. New York: Holt Rinehart and Winston, 1974.

Hayden, Dolores. *The Grand Domestic Revolution: A History of Feminist Designs for American Homes, Neighborhoods, and Cities*. Cambridge, Mass.: MIT Press, 1981.

Haywood, Robert E. "Revolution of the Ordinary: Allan Kaprow and the Invention of Happenings." PhD diss., University of Michigan, 1993.

Heath, Shirley Brice, and Milbrey W. McLaughlin, eds. *Identity and Inner-City Youth: Beyond Ethnicity and Gender*. New York: Teachers College Press, 1993.

Hertz, Richard. *Jack Goldstein and the CalArts Mafia*. Ojai, Calif.: Minneola Press, 2003.

Herzberg, Julia P. "The Iowa Years." In *Ana Mendieta: Earth Body Sculpture and Performance, 1972–1985*, ed. Olga M. Viso. Washington, D.C.: Hirshhorn Museum and Sculpture Garden in association with Hatje Cantz Publishers, 2004.

Hicks, E. "Restricted Access to Public Space [Artists Missing in Action—Guerrilla Performance: Media Event Organized by Suzanne Lacy and Ruth Weisberg, Los Angeles]." *Artweek* 12 (15 August 1981).

Higgins, Hannah. *Fluxus Experience*. Berkeley: University of California Press, 2002.

Hill, Jonathan. *Occupying Architecture: Between the Architect and the User*. London and New York: Routledge, 1998.

Hill, Leslie. "Suffragettes Invented Performance Art." In *The Routledge Reader in Politics and Performance*, ed. Lizbeth Goodman with Jane deGay, 150–56. London: Routledge, 2000.

Hills, Patricia. "Suzanne Lacy, Comments on 'Code 33: Emergency, Clear the Air,' Letter to author [Hills], May 23, 2000." In *Modern Art in the USA: Issues and Controversies of the 20th Century*. Upper Saddle River, N.J.: Prentice Hall, 2001.

hooks, bell. *Feminist Theory: From Margin to Center*. Boston: South End Press, 1984.

———. *Yearning: Race, Gender, and Cultural Politics*. Boston: South End Press, 1990.

Hooper, Barbara. "The Poem of Male Desires: Female Bodies, Modernity, and 'Paris, Capital of the Nineteenth Century.'" *Planning Theory* 13 (1995).

Horne, Gerald. *Fire This Time: The Watts Uprising and the 1960s*. Charlottesville: University Press of Virginia, 1995.

Hurtado, Aída, and Abigail Stewart. "Through the Looking Glass: Implications of Studying Whiteness for Feminist Methods." In *Off White: Readings on Race, Power and Society*, ed. Michelle Fine et al. New York: Routledge, 1997.

Irish, Sharon. "Physical Spaces and Public Life ['Full Circle']." *Nordic Journal of Architectural Research* 4 (1994): 25–34.

———. "Shadows in the Garden: 'The Dark Madonna' Project by Suzanne Lacy." *Landscape Journal* 26, 1 (2007): 98–115.

Isé, Claudine. "Considering the Art World Alternatives: LACE and Community For-

mation in Los Angeles." In *Sons and Daughters of Los: Culture and Community in L.A.*, ed. David E. James. Philadelphia: Temple University Press, 2003.

Iskin, Ruth. "Politics and Performance in New Orleans." *Artweek,* March 22, 1980, 2–3.

Iversen, Margaret. "Mary Kelly and Griselda Pollack in Conversation." In *Critical Feminism: Argument in the Disciplines,* ed. Kate Campbell. Philadelphia: Open University Press, 1992.

Jackson, Shannon. "Social Practice." *Lexicons: Special Issue of Performance Research,* January 2007.

Jacob, Mary Jane. *Places with a Past: New Site-Specific Art at Charleston's Spoleto Festival.* New York: Rizzoli, 1991.

Jacob, Mary Jane, with Michael Brenson, eds. *Conversations at the Castle: Changing Audiences and Contemporary Art.* Cambridge, Mass.: MIT Press, 1998.

Jacob, Mary Jane, Michael Brenson, and Eva M. Olson, contributors. *Culture in Action: A Public Art Program of Sculpture Chicago.* Seattle: Bay Press, 1995.

James, David, ed. *The Sons and Daughters of Los: Culture and Community in L.A.* Philadelphia: Temple University Press, 2003.

James, David E. *The Most Typical Avant-Garde: History and Geography of Minor Cinemas in Los Angeles.* Berkeley: University of California Press, 2005.

Jay, Martin. "Somaesthetics and Democracy: Dewey and Contemporary Body Art." *Journal of Aesthetic Education* 36, 4 (Winter 2002).

Johnstone, Mark, and Leslie Aboud Holzman, ed. *Epicenter: San Francisco Bay Area Art Now.* San Francisco: Chronicle Books, 2002.

Jones, Amelia. *Body Art: Performing the Subject.* Minneapolis: University of Minnesota Press, 1998.

———, ed. *The Feminism and Visual Culture Reader.* New York: Routledge Press, 2003.

———. "Meaning, Identity, Embodiment: The Uses of Merleau-Ponty's Phenomenology in Art History." In *Art and Thought,* ed. Dana Arnold and Margaret Iversen. Malden, Mass.: Blackwell Publishing, 2003.

———. *Sexual Politics: Judy Chicago's* Dinner Party *in Feminist Art History.* Los Angeles: UCLA Armand Hammer Museum/Berkeley: University of California Press, 1996.

Jones, Amelia, and Andrew Stephenson. *Performing the Body/Performing the Text.* New York: Routledge, 1999.

Jones, Charles E., ed. *The Black Panther Party Reconsidered.* Baltimore: Black Classic Press, 1998.

Juhasz, Alexandra, ed. *Women of Vision: Histories in Feminist Film and Video.* Minneapolis: University of Minnesota Press, 2001.

Kachur, Lewis. "Stuart Davis's Word-Pictures." In *Stuart Davis,* ed. Philip Rylands. Milan: Electa, 1997.

Kaprow, Allan. *Assemblage, Environments, and Happenings.* New York: Harry N. Abrams, 1966.

———. *Essays on the Blurring of Art and Life.* Ed. Jeff Kelley. Berkeley: University of California Press, 1993.

Karasov, Deborah. "Urban Counter-Images: Community Activism Meets Public Art."

In *Imaging the City: Continuing Struggles and New Directions,* ed. Lawrence J. Vale and Sam Bass Warner Jr., 331–60. New Brunswick, N.J.: Center for Urban Policy Research, 2001.

Kaye, Nick. *Site-Specific Art: Performance, Place and Documentation.* New York: Routledge, 2000.

———. "Telling Stories: Narrative against Itself." In *The Routledge Reader in Politics and Performance,* ed. Lizbeth Goodman with Jane deGay, 270–76. London: Routledge, 2000.

Keith, Michael, and Steve Pile. *Place and the Politics of Identity.* New York: Routledge, 1993.

Kelley, Jeff. "The Body Politics of Suzanne Lacy." In *But Is It Art? The Spirit of Art as Activism,* ed. Nina Felshin, 221–49. Seattle: Bay Press, 1995.

———. *Childsplay: The Art of Allan Kaprow.* Berkeley: University of California Press, 2004.

———. "Rape and Respect in Las Vegas." *Artweek,* May 20, 1978, 4.

Kent, Cheryl. "Inside the Liveable City: The Atrium." *Inland Architect* 33 (January/February 1989): 36–43.

Kester, Grant. "Aesthetic Evangelists: Conversion and Empowerment in Contemporary Community Art." *Afterimage,* January 1995.

———. "Another Turn." *Artforum* 44 (March 2006): 22, 24.

———. "Beyond the White Cube: Activist Art and the Legacy of the 1960's." *Public Art Review* 14, 2 (Spring/Summer 2003).

———. *Conversation Pieces: Community and Communication in Modern Art.* Berkeley: University of California Press, 2004.

Kirby, Michael, ed. *Happenings: An Illustrated Anthology.* New York: E. P. Dutton, 1965.

Kirshenblatt-Gimblett, Barbara. "Playing to the Senses: Food as a Performance Medium." *Performance Research* 4, 1 (1999): 1–30.

Klein, Jennie. "Acting the Icon, Indexing the Body." *New Art Examiner* 26, 1 (September 1998).

———. "The Body's Odyssey." In *The 21st Century Odyssey Part II: The Performances of Barbara T. Smith,* 9–22. Pomona, Calif.: Pomona College Museum of Art, 2005.

———. "Re-reading *High Performance*: Jennie Klein Interviews Jenni Sorkin." *n.paradoxa* 12 (July 2003).

———. "The Ritual Body as Pedagogical Tool: The Performance Art of the Woman's Building." In *From Site to Vision: The Woman's Building in Contemporary Culture,* ed. Sondra Hale and Terry Wolverton. http://womansbuilding.org/fromsitetovision/. Los Angeles: The Woman's Building, 2007.

Knight, Keith, Mat Schwarzman et al. *Beginner's Guide to Community-Based Arts.* Oakland, Calif.: New Village Press, 2005.

Knight, Louise W. *Citizen: Jane Addams and the Struggle for Democracy.* Chicago: University of Chicago Press, 2005.

Koelsch, Patrice Clark. "The Crystal Quilt." *Heresies* 23 (1988): 31.

———. "A Performance and Its Legacy." *Gallerie Magazine* 9 (1990).

Kohn, Margaret. *Radical Space: Building the House of the People*. Ithaca, N.Y.: Cornell University Press, 2003.

Kohtaamisia rajojen tiellä = Encounters on the Road of Borders: Documenting a Collaborative Performance Directed by Suzanne Lacy. Karen Sharpe, collaborator. Helsinki, Finland: PostiTele, 1992.

Krantz, Claire Wolf. "Art's Chicago Public/Part Two: Culture in the Community." *New Art Examiner,* Summer 1996, http://www.clairewolfkrantz.org/writing/essays/mural_2_cult.html.

Kristeva, Julia. *Powers of Horror: An Essay on Abjection*. New York: Columbia University Press, 1982.

Kwon, Miwon. *One Place after Another: Site-Specific Art and Local Identity*. Cambridge, Mass.: MIT Press, 2002.

Labowitz, Leslie, and Suzanne Lacy. "Evolution of Feminist Art: Public Forms and Social Issues." *Heresies* 6 (Summer 1978): 76–85.

————. "Feminist Artists: Developing a Media Strategy for the Movement." In *Fight Back! Feminist Resistance to Male Violence,* ed. Frédérique Delacorte and Felice Newman. Minneapolis: Cleis Press, 1981.

————. "Mass Media, Popular Culture, and Fine Arts: Images of Violence against Women." *Social Works*. Los Angeles: Los Angeles Institute of Contemporary Arts, 1979; republished as "Learning to Look: The Relationship between Art and Popular Culture Images." *Exposure: Journal of Photographic Studies,* September 1981.

————. "Two Approaches to Feminist Media Usage." *Proceedings of the Caucus for Art and Marxism,* January 1979.

Lacy, Suzanne, as Bush, T. C. [pseudonym]. "Great Masterpiece Series No. 2: The Last Throes of Artistic Vision." *High Performance* 3, 3–4 (Fall–Winter 1980): 68–69.

Lacy, Suzanne. "Affinities: Thoughts on an Incomplete History." In *The Power of Feminist Art,* ed. Norma Broude and Mary Garrard, 264–74. New York: Harry N. Abrams, 1994.

————. "Art and Everyday Life: Activism in Feminist Performance Art." In *A Boal Companion: Dialogues on Theatre and Cultural Politics,* ed. Jan Cohen-Cruz and Mady Schutzman, 91–102. New York: Routledge, 2006.

————. "The Battle of New Orleans." *High Performance* 3, 2 (Summer 1980): 2–9.

————. "Broomsticks and Banners: The Winds of Change." *Artweek,* May 3, 1980, 3–4.

————. "Finding Our Way to the Flag: Is Civic Discourse Art?" *Public Art Review* 14, 2 (Spring/Summer 2003): 26–32.

————. "Finland: The Road of Poems and Borders." *Journal of Dramatic Theory and Criticism* 5 (Fall 1990): 210–21.

————. "The Forest and the Trees." *Heresies* 15 (Winter 1982): 62–65.

————. "Fractured Space." In *Art in the Public Interest,* ed. Arlene Raven, 287–301. Cambridge, Mass.: MIT Press, 1989.

————. "The Greening of California Performance: Art for Social Change—A Case Study." *Images & Issues* 2 (Spring 1982): 65–67.

————. "Having It Good: Reflections on Engaged Art and Engaged Buddhism." In

Buddha Mind in Contemporary Art, ed. Jacquelynne Baas and Mary Jane Jacob, 97–111. Berkeley: University of California Press, 2004.

———. "In Mourning and in Rage (with Analysis Aforethought)." *IKON Magazine* 2, 1 (Fall/Winter 1982): 60–67. Republished in *Femicide: The Politics of Women Killing*, ed. Jill Radford and Diana H. Russell. New York: Twayne Publishers, 1992.

———. "In the Shadows: An Analysis of the Dark Madonna." *Whitewalls* 25 (Spring 1990).

———. "Learning to Look: The Relationship between Art and Popular Culture Images." *Exposure: Journal of Photographic Studies* 19 (September 1981): 8–15; excerpted and reprinted in *Media Report to Women* 10 (March 1, 1982).

———. *Leaving Art: Writings on Performance, Politics and Publics*. Durham, N.C.: Duke University Press, forthcoming.

———. "Love, Cancer, Memory: A Few Stories." *Public Art Review* 14 (Spring/Summer 1996): 5–13.

———. "Made for TV: Media in California Performance." *Performing Arts Journal* 6, 2 (Spring 1982): 52–61.

———. "Mapping the Terrain: The New Public Art, Parts 1 and 2." *Public Art Review* 8 and 9 (Spring/Summer 1993 and Fall/Winter 1993).

———, contributor and ed. *Mapping the Terrain: New Genre Public Art*. Seattle: Bay Press, 1995; Chinese Edition: Yuan-Liou Publishing Co., Ltd. Taiwan, 2004.

———. "The Name of the Game." *Art Journal* 50, 2 (Summer 1991): 64–68. Republished as "Name of the Game," in *Source Book of Artist's Writings*, ed. Kristine Stiles and Peter Selz. Berkeley: University of California Press, 1996.

———. "New Genre Public Art a Decade Later." In *The Practice of Public Art*, ed. Cameron Cartiere and Shelly Willis, 18–32. New York: Routledge, 2008.

———. "Prostitution Notes." In *Veiled Histories: The Body, Place and Public Art*, ed. Anna Novakov, 149–69. New York: Critical Press, 1997.

———. "Seeking an American Identity (Working Inward from the Margins)." In *Civic Dialogue, Arts and Culture: Findings from Animating Democracy*, ed. Pam Korza, Barbara Schaffer Bacon, and Andrea Assaf. Washington, D.C.: Americans for the Arts, 2005.

———. "Some Notes on the Crystal Quilt." In *Expanding Circles: Women, Art and Community*, ed. Betty Ann Brown. New York: Midmarch Arts Press, 1996.

———. "Speak Easy." *New Art Examiner* 10, 1 (October 1982): 7, 9.

———. "Take Back the Night." *High Performance* 2, 4 (1979).

———. "Time Between Is the Spine of This Book." *interReview* 7 (2007): 47–54.

———. "Time in Place: New Genre Public Art Ten Years Later." In *Taipei on the Move*, 22–33. Taipei City: Department of Cultural Affairs, 2005.

———. "Tracing Allan Kaprow." *Artforum* 44 (Summer 2006).

———. "Unfinished Work." In *Making Space*, ed. Joan Borsa. North Vancouver, B.C.: Preservation House Gallery, 1988.

———. "Wrestling the Beast." *Public Art Review* 4 (Fall/Winter 1990).

Lacy, Suzanne, and Leslie Labowitz. "Feminist Media Strategies for Political Performance." In *Cultures in Contention*, ed. Douglas Kahn and Diane Neumaier, 122–33. Seattle: Real Comet Press, 1985.

————. "In Mourning and in Rage . . ." *Frontiers: A Journal of Women* 3, 1 (1978): 52–55.

————. "The Performing Archive." *interReview* 7 (2007): 36–46.

Lacy, Suzanne, and Lucy Lippard, "Political Performance Art: A Discussion by Suzanne Lacy and Lucy R. Lippard." *Heresies* 17 (1984): 24.

Lacy, Suzanne, and Linda Palumbo. "The Life and Times of Donaldina Cameron." *Chrysalis Magazine* 7 (Winter 1978): 29–35.

Lacy, Suzanne, and Pilar Riaño-Alcalá. "Medellín, Colombia: Reinhabiting Memory." *Art Journal* 65, 4 (Winter 2006): 96–112.

Lacy, Suzanne, and Rachel Rosenthal. "Saving the World: A Dialogue between Suzanne Lacy and Rachel Rosenthal." *Artweek,* September 12, 1991, 14–16.

Lacy, Suzanne, and Barbara Smith. "The Vigil/Incorporate." *High Performance* 1, 3 (September 1978): 16–17.

Lacy, Suzanne, and Ann Wettrich. "What It Takes." In *Co-Lab: New Generations: Creative Partnerships in Art and Learning.* San Francisco: San Francisco Arts Commission Gallery and Fine Arts Gallery, San Francisco State University, 2002.

Larsen, Lars Bang. "Social Aesthetics." In *Participation: Documents of Contemporary Art,* ed. Claire Bishop. Cambridge, Mass.: MIT Press; London: Whitechapel, 2005.

Latour, Bruno, and Peter Weibel, eds. *Making Things Public—Atmospheres of Democracy.* Cambridge, Mass.: MIT Press, 2005.

Lederer, Laura, ed. *Take Back the Night: Women on Pornography.* New York: W. Morrow, 1980.

Lefebvre, Henri. *The Production of Space.* Trans. Donald Nicholson-Smith. Malden, Mass.: Blackwell Publishing, [1974] 1984.

Leonard, George J. "Misleading Surface Resemblance [Review of *Essays on the Blurring of Art and Life*]." *American Book Review* 16, 3 (August/September 1994). http://128.138.144.71/abr/leonard.html.

Levin, Kim. *Lucas Samaras.* New York: Abrams, 1975.

Li, Peter S. "Unneighborly Houses or Unwelcome Chinese: The Social Construction of Race in the Battle over 'Monster Homes' in Vancouver, Canada." *International Journal of Comparative Race and Ethnic Studies* 1, 1 (1994).

Linker, Kate. *Vito Acconci.* New York: Rizzoli, 1994.

Lippard, Lucy. "Advocacy Criticism as Activism." In *Cultures in Contention,* ed. Douglas Kahn and Diane Neumaier. Seattle: Real Comet Press, 1985.

————. *Get the Message? A Decade of Art for Social Change.* New York: E. P. Dutton, 1984.

————. *The Lure of the Local: Senses of Place in a Multicentered Society.* New York: The New Press, 1998.

————. *Mixed Blessings: New Art in a Multicultural America.* New York: Pantheon Books, 1990.

————. *On the Beaten Track: Tourism, Art and Place.* New York: New Press, 1999.

————. *The Pink Glass Swan: Selected Essays on Feminist Art.* New York: New Press, 1995.

————. "Lacy: Some of Her Own Medicine." *Drama Review* 32, 1 (Spring 1988): 71–76.

———. "Speaking Up." *Z Magazine* (July/August 1993).

Lipsitz, George. *American Studies in a Moment of Danger.* Minneapolis: University of Minnesota Press, 2001.

Loeffler, Carl, and Darlene Tong, eds. *Performance Anthology: Sourcebook of California Performance Art.* San Francisco: Last Gasp Press/Contemporary Arts Press, 1989.

Lugones, María. "Heterosexualism and the Colonial/Modern Gender System." *Hypatia* 22, 1 (Winter 2007): 186–209.

———. *Pilgrimages/Peregrinajes: Theorizing Coalition against Multiple Oppressions.* New York: Rowman and Littlefield, 2003.

Macy, Joanna. "In Indra's Net: Sarvodaya and Our Mutual Efforts for Peace." In *The Path of Compassion: Writings on Socially Engaged Buddhism,* ed. Fred Eppsteiner. Berkeley: Buddhist Peace Fellowship and Parallax Press, 1988.

Maksymovicz, Virginia. "Artists Talking: Creating a New Space for Public Discourse." *Sculpture* 19, 4 (May 2000).

Males, Mike. *The Scapegoat Generation: America's War on Adolescents.* Monroe, Maine: Common Courage Press, 1996.

Mark, Lisa Gabrielle, ed. *WACK! Art and the Feminist Revolution.* Cambridge, Mass.: MIT Press/Los Angeles: Museum of Contemporary Art, 2007.

Marling, Karal Ann. "Hyphenated Culture: Painting by Numbers in the New Age of Leisure." In *As Seen on TV: The Visual Culture of Everyday Life in the 1950s.* Cambridge, Mass.: Harvard University Press, 1994.

Martin, Stewart. "Critique of Relational Aesthetics." *Third Text* 21, 4 (July 2007): 369–86.

Massey, Doreen. *For Space.* Thousand Oaks, Calif.: Sage, 2005.

Mayer, Mónica. "On Life and Art as a Feminist." *n.paradoxa* 9 (1999).

McEver, Catherine. "When Teens Confide." *Express,* May 29, 1992, 20–21.

McKenzie, Jon. *Perform or Else: From Discipline to Performance.* New York: Routledge, 2001.

Melville, Stephen. "What Was Postminimalism?" In *Art and Thought,* ed. Dana Arnold and Margaret Iversen. Malden, Mass.: Blackwell Publishing, 2003.

Merleau-Ponty, Maurice. "The Visible and the Invisible: The Intertwining—The Chiasm." In *The Merleau-Ponty Reader,* ed. Ted Toadvine and Leonard Lawlor. Evanston, Ill.: Northwestern University Press, 2007.

Mesa-Bains, Amalia. "Galeria de la Raza: A Study in Cultural Transformation." In *Reimaging America: The Arts of Social Change,* ed. Mark O'Brien and Craig Little. Philadelphia: New Society Publishers, 1990.

Meskimmon, Marsha. "Chronology through Cartography: Mapping 1970s Art Globally." In *WACK! Art and the Feminist Revolution,* ed. Lisa Gabrielle Mark. Cambridge, Mass.: MIT Press, 2006.

Metzger, Deena. *Skin: Shadows/Silence: A Love Letter in the Form of a Novel.* Reno, Nev.: West Coast Poetry Review, 1976.

———. *The Woman Who Slept with Men to Take the War Out of Them and Tree.* Culver City, Calif.: Peace Press, 1981.

———. *Writing for Your Life: A Guide and Companion to the Inner Worlds.* New York: HarperCollins, 1992.

Meyer, Laura. "From Finish Fetish to Feminism: Judy Chicago's 'Dinner Party' in California Art History." In *Sexual Politics: Judy Chicago's Dinner Party in Feminist Art History,* ed. Amelia Jones. Los Angeles: Armand Hammer Museum and Cultural Center/Berkeley: University of California, 1996.

———. "The Los Angeles Woman's Building and the Feminist Art Community, 1973–1991." In *The Sons and Daughters of Los: Culture and Community in L.A.,* ed. David E. James. Philadelphia: Temple University Press, 2003.

Miles, Malcolm. *Art, Space and the City.* New York: Routledge, 1997.

———. *Urban Avant-Gardes: Art, Architecture and Change.* London: Routledge, 2004.

Miller, Lorrie Anne. "Constructing Voices: A Narrative Case Study of the Processes and Production of a Community Art Performance." PhD diss., University of British Columbia, 2002.

Miller, Ross. "City Hall and the Architecture of Power: The Rise and Fall of the Dearborn Corridor." In *Chicago Architecture and Design, 1923–1993,* ed. John Zukowsky. New York: Prestel, [1993] 2000.

Molesworth, Helen. "House Work and Art Work." *October* 92 (Spring 2000): 71–97.

Montano, Linda. "Interview with Suzanne Lacy: Food and Art." *High Performance* 4, 4 (1981–82).

———, comp. *Performance Artists Talking in the Eighties: Sex, Food, Money/Fame, Ritual/Death.* Berkeley: University of California Press, 2000.

Moore, Alan W. "Artists' Collectives Mostly in New York." In *Collectivism after Modernism: The Art of Social Imagination after 1945,* ed. Blake Stimson and Gregory Sholette. Minneapolis: University of Minnesota Press, 2007.

Moraga, Cherrie, and Gloria Anzaldúa, eds. *This Bridge Called My Back: Writings by Radical Women of Color.* New York: Kitchen Table: Women of Color Press, 1983.

Moravec, Michelle. "Building Woman's Culture." PhD diss., University of California Los Angeles, 1998.

Nadelman, Cynthia. "Interview with Faith Ringgold for the Archives of American Art." Washington, D.C.: Smithsonian Institution, 1989.

Naidus, Beverly. *Arts for Change: Teaching outside the Frame.* Oakland, Calif.: New Village Press, 2009.

Nancy, Jean-Luc. *The Inoperative Community.* Ed. Peter Connor; trans. Peter Connor, Lisa Garbus, Michael Holland, and Simona Sawhney. Minneapolis: University of Minnesota Press, 1991.

Nast, Heidi, and Steve Pile, eds. *Places through the Body.* London: Routledge, 1998.

Newton, Richard. "She Who Would Fly: An Interview with Suzanne Lacy." In *The Citizen Artist, An Anthology from High Performance Magazine, 1978–1998,* ed. Linda Burnham and Steven Durland. Gardiner, N.Y.: Critical Press, 1998.

———. "Suzanne Lacy." *High Performance* 1, 1 (1978).

Nochlin, Linda. *Women, Art, and Power and Other Essays.* New York: Harper and Row, 1988.

Obrist, Hans Ulrich. "Hans Ulrich Obrist Interviews Suzanne Lacy." *interReview* 7 (2007): 25–35.

Ockman, Joan, ed. *The Pragmatist Imagination: Thinking about "Things in the Making."* New York: Princeton Architectural Press, 2000.

O'Dell, Kathy. *Contract with the Skin: Masochism, Performance Art, and the 1970s.* Minneapolis: University of Minnesota Press, 1998.

Olorenshaw, Robert. "Narrating the Monster: From Mary Shelley to Bram Stoker." In *Frankenstein, Creation and Monstrosity,* ed. Stephen Bann. London: Reaktion, 1994.

Orenstein, Peggy. *School Girls: Young Women, Self-Esteem, and the Confidence Gap.* New York: Anchor Books, 1995.

Owens, Craig. *Beyond Recognition: Representation, Power, and Culture.* Ed. Scott Bryson. Berkeley: University of California Press, 1992.

Oyewùmí, Oyèrónké, ed. *African Women and Feminism: Reflecting on the Politics of Sisterhood.* Trenton, N.J.: Africa World Press, 2003.

———. *The Invention of Women: Making an African Sense of Western Gender Discourses.* Minneapolis: University of Minnesota Press, 1997.

Paget-Clarke, Nick. "An Interview with Suzanne Lacy: Art and Advocacy." *In Motion Magazine,* November 2000. http://www.inmotionmagazine.com/sl1.html.

Palmer, Wendy. *The Practice of Freedom: Aikido Principles as a Spiritual Guide.* Berkeley: Rodmell Press, 2002.

Parker, Rozsika, and Griselda Pollock. *Framing Feminisms: Art and the Women's Movement 1970–1985.* New York: Pandora, 1987.

———. *Old Mistresses: Woman, Art, Ideology.* New York: Pantheon Books, 1982.

Parsons, Jack, Carmella Padilla, and Juan Estevan Arellano. *Low 'n Slow: Lowriding in New Mexico.* Santa Fe: Museum of New Mexico, 1999.

Peterson, William. "Mobilizing Communities for Change: Suzanne Lacy's Large-Scale Works." *Journal of Dramatic Theory and Criticism* 5 (Fall 1990): 202–9.

Phelan, Peggy. *Unmarked: The Politics of Performance.* London: Routledge, 1993.

Phillips, Patricia C. "Dynamic Exchange: Public Art at this Time." *Public Art Review* 21 (1999).

Pile, Steve. "The Un(known) City . . . or, an Urban Geography of What Lies Buried below the Surface." In *The Unknown City: Contesting Architecture and Social Space,* ed. Iain Borden, Joe Kerr, and Jane Rendell, with Alicia Pivaro. Cambridge, Mass.: MIT Press, 2001.

Pipher, Mary. *Reviving Ophelia: Saving the Selves of Adolescent Girls.* New York: Ballantine Books, 1995.

Plagens, Peter. *Sunshine Muse: Art on the West Coast, 1945–70.* Berkeley: University of California Press, [1974] 1999.

Pollock, Griselda, ed. *Generations and Geographies in the Visual Arts: Feminist Readings.* London: Routledge, 1996.

Punter, John V. *The Vancouver Achievement: Urban Planning and Design.* Vancouver: University of British Columbia Press, 2003.

Quijano, Aníbal. *Modernidad, identidad y utopia en América Latina.* Quito, 1990.

Rabinovitz, Lauren. *Points of Resistance: Women, Power and Politics in the New York Avant-garde Cinema, 1943–1971.* Urbana: University of Illinois Press, 1991.

Radford-Hill, Sheila. *Further to Fly: Black Women and the Politics of Empowerment.* Minneapolis: University of Minnesota Press, 2000.

Raven, Arlene, ed. *Art in the Public Interest.* Ann Arbor: UMI Research Press, 1989.

———. *At Home.* Long Beach, Calif.: Long Beach Museum of Art, 1983.

———. "Commemoration: Public Sculpture and Performance." In *Crossing Over: Feminism and Art of Social Concern*. Ann Arbor: UMI Research Press, 1988.

———. "We Did Not Move from Theory, We Moved to the Sorest Wounds." In *RAPE*. Columbus: Ohio State University Gallery of Fine Art, 1985.

Raven, Arlene, and Ruth Iskin. "Through the Peephole: Toward a Lesbian Sensibility in Art." *Chrysalis: A Magazine of Women's Culture* 4 (1977).

Raven, Arlene, Cassandra L. Langer, and Joanna Frueh, eds. *Feminist Art Criticism: An Anthology*. Ann Arbor, Mich.: UMI Research Press, 1988.

Raven, Arlene, and Jean Pieniadz. "Words of Honor: Contributions of a Feminist Art Critic." *Women and Therapy* 17, 3/4 (1995).

Reagon, Bernice. "Coalition Politics: Turning the Century." In *Home Girls: A Black Feminist Anthology*, ed. Barbara Smith. New York: Kitchen Table/Women of Color Press, 1983.

Reckitt, Helena, and Peggy Phelan, eds. *Art and Feminism*. London: Phaidon, 2001.

Reilly, Maura, and Linda Nochlin, eds. *Global Feminisms: New Directions in Contemporary Art*. New York: Merrell, 2007.

Rendell, Jane. *Art and Architecture: A Place Between*. London: IB Tauris, 2006.

———. "between two." *Journal of Architecture* 8 (Summer 2003).

———. "'Places Between': Three Tactics in Critical Spatial Arts." http://www.ub.es/escult/papers/rendell.htm. 2001.

———. "Travelling the Distance/Encountering the Other." http://akad.se/Rendell_TthD.pdf.

———. "Women in Architecture: What Is a Feminist Aesthetics of Space?" *Make, the Magazine of Women's Art* 89 (September/November 2000).

Rendell, Jane, Barbara Penner, and Iain Borden, eds. *Gender Space Architecture: An Interdisciplinary Introduction*. New York: Routledge, 2000.

Riaño-Alcalá, Pilar. *Dwellers of Memory: Youth and Violence in Medellín, Colombia*. New Brunswick, N.J.: Transaction, 2006.

———. "Encounters with Memory and Mourning: Public Art as Collective Pedagogy of Reconciliation." In *Public Acts: Disruptive Readings on Making Curriculum Public*, ed. Francisco Ibáñez-Carrasco and Erica R. Meiners, 211–35. New York: RoutledgeFalmer, 2004.

———. Introduction: Memory, Representation, and Narratives: Rethinking Violence in Colombia." *Journal of Latin American and Caribbean Anthropology* 7, 1 (2002).

———. "Remembering Place: Memory and Violence in Medellín, Colombia." *Journal of Latin American and Caribbean Anthropology* 7, 1 (2002).

Riaño-Alcalá, Pilar, Suzanne Lacy, and Olga Cristina Agudelo Hernandez, eds. *Arte, Memoria y Violencia: Reflexiones sobre la ciudad*. Medellín, Colombia: Corporacion Region, 2003.

Rich, Adrienne. "Disloyal to Civilization: Feminism, Racism, Gynephobia." In *On Lies, Secrets, and Silence: Selected Prose, 1966–1978*. New York: W. W. Norton, 1979.

Ringgold, Faith. *We Flew over the Bridge: The Memoirs of Faith Ringgold*. Boston: Little Brown, 1995.

Robinson, Hilary, ed. *Feminism-Art-Theory: An Anthology 1968–2000*. Malden, Mass.: Blackwell Publishers, 2001.

Rogoff, Gordon, et al. "Remembering Joseph Chaikin." *Theater* 34: 3 (2004): 100–133.

Rogoff, Irit. "Looking Away: Participations in Visual Culture." In *After Criticism: New Responses to Art and Performance,* ed. Gavin Butt. Malden, Mass.: Blackwell, 2005.

Rorimer. Anne. *New Art in the 60s and 70s: Redefining Reality.* London: Thames and Hudson, 2001.

Rosler, Martha. *Decoys and Disruptions: Selected Writings, 1975–2001.* Cambridge, Mass.: MIT Press, 2004.

———. "The Private and the Public: Feminist Art in California." *Artforum* 16 (September 1977): 66–74.

Ross, Toni. "Aesthetic Autonomy and Interdisciplinarity: A Response to Nicolas Bourriaud's 'Relational Aesthetics.'" *Journal of Visual Art Practice* 5, 3 (2006): 167–81.

Roth, Moira, ed. *The Amazing Decade: Women and Performance Art in America 1970–1980.* Los Angeles: Astro Artz, 1983.

———. "The Crystal Quilt." *High Performance* 10, 3 (1987).

———. "A Family of Women?" *Village Voice,* September 28, 1982, supplement, 71–74.

———. "A History of Performance." *Art Journal* 56 (Winter 1997): 73–81.

———. "Interview with Suzanne Lacy for the Archives of American Art." Washington, D.C.: Smithsonian Institution, 1990.

———. "Keeping the Feminist Faith." In *Faith Ringgold: Twenty Years of Painting, Sculpture, and Performance, 1963–83,* ed. Michele Wallace. New York: Studio Museum, 1984.

———. "Making and Performing Code 33: A Public Art Project with Suzanne Lacy, Julio Morales and Unique Holland." *Performing Arts Journal* 23, 3 (September 2001): 47–62.

———. "Marcel Duchamp in America: A Self Ready-Made." In *Difference/Indifference: Musings on Postmodernism, Marcel Duchamp and John Cage.* Amsterdam: G+B Arts International, 1998.

———. "Suzanne Lacy: Social Reformer and Witch." *Drama Review* 32, 1 (Spring 1988): 42–60.

———. "Suzanne Lacy's Dinner Parties." *Art in America* 68 (April 1980): 126.

———. "Toward a History of California Performance: Parts One and Two." *Arts Magazine* 52 (February and June 1978): 94–103, 114–23.

———. "Visions and Revisions: Rosa Luxemburg and the Artist's Mother." *Artforum* 19, 3 (November 1980): 36–45.

Roth, Moira (moderator), Steve French, Hung Liu, Suzanne Lacy, Chris Johnson, Michael Grady, and Carlos Villa. "Relearning in Further Education: Curriculum, Hiring, Recruitment." In *Worlds in Collision: Dialogues on Multicultural Art Issues,* ed. Louie Reagan and Carlos Villa, 278–93. San Francisco: International Scholars Publications: San Francisco Art Institute, 1994.

Roth, Moira, and Suzanne Lacy. "Exchanges." In *Art, Women, California 1950–2000: Parallels and Intersections,* ed. Diana Burgess Fuller and Daniela Salvioni, 295–309. Berkeley: University of California Press, 2002.

Rothenberg, Diane. "Social Art/Social Action." *Drama Review* 32, 1 (Spring 1988): 61–70.

Russo, Mary. "Female Grotesques: Carnival and Theory." In *Feminist Studies/Critical Studies,* ed. Teresa de Lauretis. London: MacMillan, 1986.

Ryan, Barbara, ed. *Identity Politics in the Women's Movement.* New York: New York University Press, 2001.

Samaras, Lucas. *Lucas Samaras: Objects and Subjects, 1969–1986.* New York: Abbeville Press, 1988.

———. *Lucas Samaras: Photos: Polaroid Photographs, 1969–1983.* Paris: Centre Pompidou, 1983.

Sandford, Mariellen R., ed. *Happenings and Other Acts.* New York: Routledge, 1995.

Sangster, Gary, catalog coordinator. *Outside the Frame: Performance and the Object: A Survey History of Performance Art in the USA since 1950.* Cleveland: Cleveland Center for Contemporary Art, 1994.

Santner, Eric. "History beyond the Pleasure Principle: Some Thoughts on the Representation of Trauma." In *Probing the Limits of Representation,* ed. Saul Friedlander. Cambridge, Mass.: Harvard University Press, 1992.

Sayre, Henry M. *The Object of Performance: The American Avant-Garde since 1970.* Chicago: University of Chicago Press, 1989.

Schapiro, Miriam, and Judy Chicago. "Female Imagery." *Womanspace Journal* 1 (Summer 1973).

Schechner, Richard. "Extensions in Time and Space: An Interview with Allan Kaprow." In *Happenings and Other Acts,* ed. Mariellen Sandford. London and New York: Routledge, 1995.

Schimmel, Paul. *Out of Actions: Between Performance and the Object, 1949–1979.* Los Angeles: Museum of Contemporary Art; London: Thames and Hudson, 1998.

Schneider, Rebecca. *The Explicit Body in Performance.* New York: Routledge, 1997.

Schor, Mira. "Amnesiac Return." *Tema Celeste* 37–38 (Autumn 1992): 16–17.

———. "Contemporary Feminism: Art Practice, Theory, and Activism—An Intergenerational Perspective." *Art Journal* 58, 4 (Winter 1999): 8–29.

Seib, Kenneth. *The Slow Death of Fresno State: A California Campus under Reagan and Brown.* Palo Alto, Calif.: Ramparts Press, 1979.

Seigfried, Charlene Haddock. *Pragmatism and Feminism: Reweaving the Social Fabric.* Chicago: University of Chicago Press, 1996.

Self, Robert O. *American Babylon: Race and Struggle for Postwar Oakland.* Princeton, N.J.: Princeton University Press, 2003.

———. "'To Plan Our Liberation': Black Power and the Politics of Place in Oakland, California, 1965–1977." *Journal of Urban History* 26, 6 (September 2000).

Selz, Peter. *Art of Engagement: Visual Politics in California and Beyond.* Berkeley: University of California Press, 2006.

Shelley, Mary. *Frankenstein.* New York: Pyramid Books, 1957.

Sholette, Gregory. "Counting on Your Collective Silence: Notes on Activist Art as Collaborative Practice." *Afterimage* 27, 3 (November/December 1999).

Shusterman, Richard. *Performing Live: Aesthetic Alternatives for the Ends of Art.* Ithaca, N.Y.: Cornell University Press, 2000.

————. "Somaesthetics and Care of the Self: The Case of Foucault." *The Monist* 83, 4 (2000).

————. "Somaesthetics and *The Second Sex*: A Pragmatist Reading of a Feminist Classic." *Hypatia* 18, 4 (Fall/Winter 2003).

Sims, Lowery Stokes. "Aspects of Performance in the Work of Black American Women Artists." In *Feminist Art Criticism: An Anthology,* ed. Arlene Raven, Cassandra Langer, and Joanna Frueh. Ann Arbor: UMI Research Press, 1988.

Sitney, P. Adams. *Visionary Film: The American Avant-Garde, 1943–2000.* 3d ed. New York: Oxford University Press, 2002.

Slatkin, Wendy. "Leslie Labowitz and Suzanne Lacy, In Mourning and In Rage." *Women Artists in History: From Antiquity to the Present.* 3d ed. Upper Saddle River, N.J.: Prentice Hall, 1997.

Smith, Andrea. *Conquest: Sexual Violence and American Indian Genocide.* Boston: South End Press, 2005.

————. "Heteropatriarchy and the Three Pillars of White Supremacy: Rethinking Women of Color Organizing." In *Color of Violence: The Incite! Anthology,* 66–73. Cambridge, Mass.: South End Press, 2006.

Smith, Barbara. "'Feisty Characters' and 'Other People's Causes': Memories of White Racism and U.S. Feminism." In *The Feminist Memoir Project: Voices from Women's Liberation,* ed. Rachel Blau DuPlessis and Ann Snitow. New York: Three Rivers Press, 1998.

Smith, Stephanie. "Suzanne Lacy and Susan Leibovitz Steinman—The Confluence of Conservation Ecology and Community Economics." *Art Journal* 65, 1 (Spring 2006): 58–60.

Snyder, Gary. "Blue Mountains Constantly Walking." In *The Practice of the Wild.* San Francisco: North Point Press, 1990.

Soja, Edward W. *Postmetropolis: Critical Studies of Cities and Regions.* Malden, Mass.: Blackwell Publishers, 2000.

————. *Thirdspace: Journeys to Los Angeles and Other Real-and-Imagined Places.* Malden, Mass.: Blackwell Publishers, 1996.

Sorkin, Jenni. "Envisioning *High Performance.*" *Art Journal* 62, 2 (Summer 2003): 36–51.

————. "*High Performance*: The First Five Years, 1978–1982." Master's thesis exhibition, May 12–26, 2002, Bard Center for Curatorial Studies, Annandale-on-Hudson, N.Y.

Spain, Daphne. *How Women Saved the City.* Minneapolis: University of Minnesota Press, 2001.

Spelman, Elizabeth. *Inessential Woman: Problems of Exclusion in Feminist Thought.* Boston: Beacon Press, 1995.

Spivak, Gayatri. *In Other Worlds: Essays in Cultural Politics.* New York: Methuen, 1987.

Springer, Kimberly. *Living for the Revolution: Black Feminist Organizations, 1968–1980.* Durham, N.C.: Duke University Press, 2005.

Staudenmaier, John M. "The Politics of Successful Technologies." In *In Context: History and the History of Technology—Essays in Honor of Melvin Kranzberg,* ed. Stephen Cutcliffe and Robert C. Post. Bethlehem, Pa.: Lehigh University Press, 1989.

Steinberg, Michael. *The Fiction of a Thinkable World: Body, Meaning and the Culture of Capitalism*. New York: Monthly Review Press, 2005.

Steinem, Gloria. *A Revolution from Within: A Book of Self-Esteem*. Boston: Little, Brown and Co., 1993.

Steinman, Susan. "Artists Writing in Public." *Public Art Review* (Spring/Summer 1995).

Stermer, Dugald. "Sheila de Bretteville." *Communication Arts*, May/June 1982.

Stienen, Angela. "Welcome to Medellín—The Capital of the 21st Century." In *Possible Urban Worlds: Urban Strategies at the End of the 20th Century*, ed. Richard Wolff et al., 242–53. Basel: Birkhauser Verlag, 1998.

Stiles, Kristine. "Uncorrupted Joy: International Art Actions." In *Out of Actions: Between Performance and the Object, 1949–1979*, ed. Paul Schimmel. Los Angeles: Museum of Contemporary Art, 1998.

Stimson, Blake, and Gregory Sholette, eds. *Collectivism after Modernism: The Art of Social Imagination after 1945*. Minneapolis: University of Minnesota Press, 2007.

Stofflet-Santiago, Mary. "Global Space Invasion." *Artweek*, August 12, 1978.

Sullivan, Shannon. *Living Across and Through Skins: Transactional Bodies, Pragmatism, and Feminism*. Bloomington: Indiana University Press, 2001.

"Survival Tactic (Roche-Bobois Showroom, San Francisco; Performance)." *Artweek* 13 (September 4, 1982).

Taylor, Charles. "The Politics of Recognition." In *Multiculturalism*, ed. Amy Guttmann, 25–73. Princeton, N.J.: Princeton University Press, 1994.

Teather, Elizabeth Kenworthy, ed. *Embodied Geographies*. London: Routledge, 1999.

Thompson, Becky. *A Promise and a Way of Life: White Antiracist Activism*. Minneapolis: University of Minnesota Press, 2001.

Thompson, Nato, and Gregory Sholette. *The Interventionists: Users' Manual for the Creative Disruption of Everyday Life*. North Adams, Mass.: MassMoCA, 2004.

Tickner, Lisa. "Feminism, Art History, and Sexual Difference." *Genders* 3 (Fall 1988).

"Tim Rollins Talks to David Deitcher." *Artforum International* 41, 8 (April 2003): 78–82.

Tolstoy, Leo. *The Collected Works of Leo Tolstoy*. New York, 1928.

Tomaselli, Sylvana, and Roy Porter, eds. *Rape*. New York: Basil Blackwell, 1986.

Tomkins, Calvin. *The World of Marcel Duchamp, 1887–1968*. New York: Time-Life, [1966] 1972.

Trinh, T. Minh-ha. *Woman Native Other*. Bloomington: Indiana University Press, 1989.

Tromble, M. "A Conversation with Suzanne Lacy, Artist." *Artweek* 26 (August 1995): 14–15.

Tucker, Daniel, and Nato Thompson. "Town Hall Meetings: Five Cities Discuss Regional Models of Art and Activism." *Journal of Aesthetics and Protest* 6 (2008): 86–99.

Vergine, Lea. *Body Art and Performance: The Body as Language*. Milan: Skira, 2000.

Vogel, Amos. *Film as Subversive Art*. New York: Random House, 1974.

Von Blon, Joanne. "Leadership Seminar Expands Awareness of Older Women's Roles." *HHH Institute Newsletter* 9: 3 (December 1986): 10–12.

Wallen, Ruth. "The Legacy of 1970s Feminist Artistic Practices on Contemporary Activist Art." *n.paradoxa* online 14 (2001). http://web.ukonline.co.uk/n.paradoxa/ 2001panel3.htm.

Ward, Colin, and Anthony Fyson. *Streetwork: The Exploding School.* London: Routledge and K. Paul, 1973.

Wark, Jayne. *Radical Gestures: Feminism and Performance Art in North America.* Montreal: McGill-Queen's University Press, 2006.

Warr, Tracey, and Amelia Jones, eds. *The Artist's Body.* London: Phaidon Press, 2000.

Watson, Grant. "Response to Claire Bishop's Paper on Relational Aesthetics." *Circa* 114 (Winter 2005): 36–38.

Whiting, Cécile. *Pop L.A.: Art and the City in the 1960s.* Berkeley: University of California Press, 2006.

Wilding, Faith. *By Our Own Hands: The Women Artists' Movement, Southern California, 1970–1976.* Santa Monica, Calif.: Double X, 1977.

Wilson, Megan. "Clearing the Air." *Afterimage* 29, 1 (July/August 2001).

Wolff, Janet. *Feminine Sentences: Essays on Women and Culture.* Berkeley: University of California Press, 1990.

Wolfthal, Diane. *Images of Rape: The "Heroic" Tradition and Its Alternatives.* New York: Cambridge University Press, 1999.

Wolverton, Terry. *The Insurgent Muse: Life and Art at the Woman's Building.* San Francisco: City Lights, 2002.

Wyrick, Mary. "Teaching Feminist Art and Social Activism." In *Gender Issues in Art Education: Content, Context, and Strategies,* ed. Georgia Collins and Renée Sandell. Reston, Va.: National Art Education Association, 1996.

Yoshimoto, Midori. *Into Performance: Japanese Women Artists in New York.* New Brunswick, N.J.: Rutgers University Press, 2005.

Younger, Cheryl, ed. *Public Strategies: Public Art and Public Space.* New York: American Photography Institute, 1999.

INDEX